MONDRIAN
The Art of Destruction

MONDRIAN

The Art of Destruction

Carel Blotkamp

REAKTION BOOKS

For Jasper B.

Published by Reaktion Books Ltd
11 Rathbone Place
London W1P 1DE, UK

First published 1994

Translated by Barbara Potter Fasting
The translation was made possible by a
grant from the Nederlandse Organisatie voor Wetenschappelijk Onderzoek (NWO).

Designed by Ron Costley
Photoset by Rowland Phototypesetting Ltd
Bury St Edmunds, Suffolk
Printed and bound in The Netherlands
by Waanders, Zwolle

British Library Cataloguing in Publication Data available

Blotkamp, Carel
 Mondrian: Art of Destruction
 I. Title
 759.9492

ISBN 0-948462-61-2

Contents

Acknowledgements

Writing a text is a solitary business, but making a book is a collective enterprise. During my study of Mondrian's work, extending over a period of more than twenty years – but with long intervals – all kinds of support and cooperation were forthcoming from many people. I remember with gratitude my interviews and correspondence with those who were acquainted with Mondrian himself: Nelly van Doesburg, César Domela, Mrs M. van Domselaer-Middelkoop, C. van Eesteren, Mrs E. Hoyack, Harry Holtzman, H. H. Kamerlingh Onnes, J. Maronier, Arthur Müller Lehning, A. Roland Holst, P. F. Sanders and Michel Seuphor; for me they bridged a gap in time. Over the years, I have also been provided with information and stimulating criticism and comments by many colleagues and friends; first of all Joop Joosten, who has always been willing to share with me his profound knowledge of Mondrian's work, and Els Hoek, my sparring partner in Mondrianology. Likewise I want to express my thanks to Jean-Louis Andral, Marty Bax, Hoos Blotkamp, Frans van Burkom, Sjarel Ex, Jonneke Fritz, Nicolette Gast, W. de Graaf, Bram Hammacher, Lien Heyting, Cees Hilhorst, Geurt Imanse, Hans Jaffé, Martin James, Ankie de Jongh, Frits Keers, Ype Koopmans, Marijke Kuper, Jean Leering, Fritz Löffler, Aleid Loosjes-Terpstra, Tony de Meyere, Wies van Moorsel, Sergio Polano, Harry Prick, Mieke Rijnders, Evert van Straaten, Peter Struycken, Frauke Syamken, Nancy Troy, Evert van Uitert, Eveline Vermeulen, Martin Visser, Pien van der Werf and Beat Wismer; and to the staff of various libraries, archives and museums, especially the Theosofische Vereniging (Mrs N. van der Schoot) in Amsterdam; the Gemeentemuseum (Peter Couvee, Herbert Henkels, Hans Jansen, Vincent Keijzer, Hans Locher), the Rijksdienst Beeldende Kunst and the Rijksbureau voor Kunsthistorische Documentatie, all in The Hague; the Rudolf Steiner Nachlassverwaltung (R. Friedenthal) in Dornach; and the Fondation Custodia (Maria van Berge, Carlos van Hasselt, Anne van der Jagt) in Paris. Finally, I want to thank all those who have given their unstinting support to the production of the book: those many owners of works who provided photographs, the staff of my publishers; and last, but not least, Barbara Potter Fasting, for her fluent translation of my text.

In this book, the artist's name is consistently spelt Mondrian (except in quotations and book titles), although he only adopted this form in 1912 (the family name is spelt Mondriaan).

The titles of Mondrian's abstract compositions have more or less been standardized. Mondrian himself was far from consistent in this respect. Entering a painting for an exhibition, he usually added a number or a letter to the title but at the next exhibition the same painting might bear a different number or letter, or even a different title. Thus I prefer a descriptive title, e.g. *Composition with Red, Yellow and Blue* to the more haphazard *Composition No. 9* or *Composition B*.

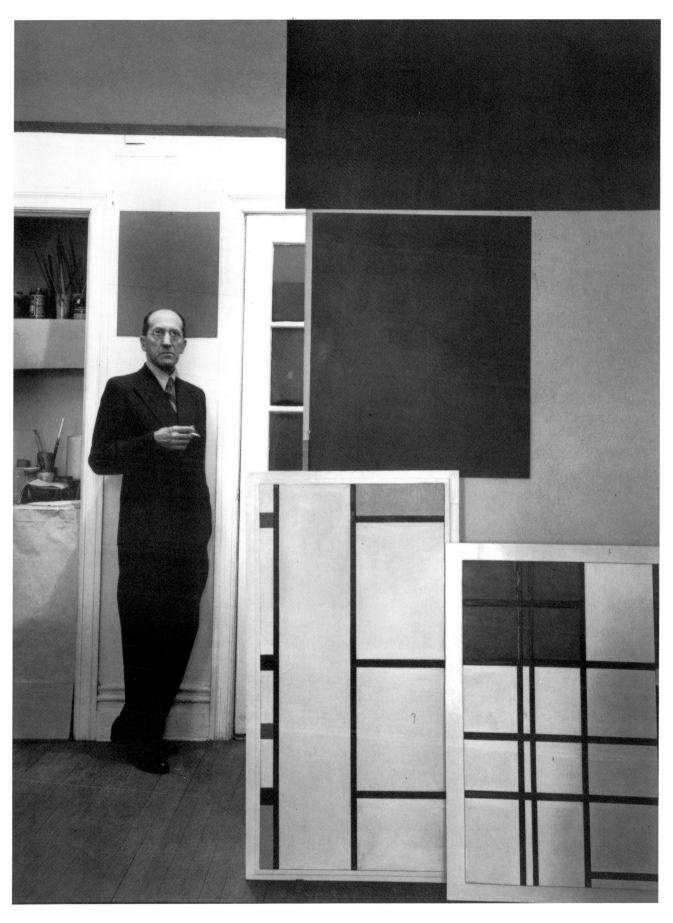

Introduction

But let us note that art – even on an abstract level – has never been confined to 'idea'; art has always been the 'realized' expression of equilibrium.
Mondrian, *c.* 1930.[1]

When one considers Mondrian's status as one of the great artists of the twentieth century, it is surprising to discover that relatively little has been written about him. During his fairly long life – he reached the age of 71 – there was almost nothing of any substance in print: no books or catalogues, only exhibition reviews and a few magazine articles. After his death, there was a growing interest in his work and writings, and the number of publications increased accordingly. Today they fill a fair-sized shelf, but even this is modest in comparison with the shelves taken up with publications on Matisse and Picasso, Duchamp and Kandinsky or, more recently, on Beuys, Johns and Warhol.

There are a number of possible explanations for this fact. In the first place, Mondrian's abstract paintings, on which his fame largely rests, are so spare that they seem almost to defy interpretation. Indeed, they offer art historians precious little opportunity to display their detective skills by ferreting out the artistic inspiration and thematic sources underlying Mondrian's work. In the second place, Mondrian's theoretical writings are extremely difficult to fathom, even for those who are fluent in the three languages he employed, Dutch, French and English. The arguments are so laborious and long-winded that the reader's staying-power is often sorely taxed. Even the most persevering devotee is forced to admit, after repeated readings, that not everything in these texts is clear to him.

A third factor that complicates the task of anyone writing on Mondrian is that his uninterrupted striving to see the individual absorbed by the universal was carried almost to extremes in his own life. He permitted the outside world very few glimpses of his own individuality. When he died, in New York, on 1 February 1944, his entire estate consisted of little more than painting materials, a few pieces of furniture made out of orange crates, several dozen drawings and paintings (some of them unfinished), a pile of papers (mainly published articles), six or seven books, some gramophone records, and several pipes and pairs of spectacles. The only personal papers he had kept were items such as his birth certificate, a certificate of vaccination, his Dutch passport, an immigration Identification Card, the certificate qualifying him to teach drawing and his membership card of the Theosophical Society. There were virtually no letters addressed to him.

But Mondrian could not prevent those with whom he had corresponded from saving *his* letters. Extensive bodies of correspondence, such as those with fellow artist Theo van Doesburg, the architect J. J. P. Oud and the collector Sal Slijper, have been preserved. Nor could he erase the powerful impression he had made on certain friends and acquaintances. Already, in his own lifetime he had been portrayed in various novels, such as *Maalstroom* (Maelstrom) by Henriëtte Mooy, *De Vader en de Zoon* (The Father and the Son) by Louis Saalborn and Michel Seuphor's *Les évasions d'Olivier Trickmansholm* (The Escapes of Olivier Trickmansholm), as well as an inane crime story that appeared in *Het gulden Meisjesboek*

Frontispiece:
A photograph by Arnold Newman of Mondrian in his studio, 353 East 56th Street, New York, 1942.

(The Golden Girls' Book). After his death a number of people who had been acquainted with him at different periods in his life recorded their recollections or provided interviews: Nelly van Doesburg (Theo's widow), Max Ernst, the historian of anarchism Arthur Lehning, the music critic Paul Sanders, and the painter Charmion von Wiegand were among them.

By far the most charming of these recollections are those of M. van Domselaer-Middelkoop, who together with her husband, the composer Jakob van Domselaer, shared a house with Mondrian in 1915–16 at Laren, a village about ten miles east of Amsterdam. She concentrates mainly on this period, which is recorded in a combination of anecdotes and sidelights on his work and his theories. But there were few people with whom Mondrian had enjoyed such a close relationship. For almost his entire adult life he lived alone, without a family, without a partner. Thus we will have to make do without the inside information that possessive or competitive widows provide, or the recorded memoirs of children growing up in the shadow of a famous father, which often lend colour to the literature on the greats of modern art.

Hermetic paintings and writings, a solitary and unexciting life, and a meagre legacy: clearly not the sort of material likely to attract droves of art historians in pursuit of literary fame. But while relatively little has been written about Mondrian, the last thirty or forty years have been anything but uneventful. In the 1950s, research led to the first major monograph, by Michel Seuphor, complete with a provisional œuvre catalogue (1956); the dissertation of Aleid Loosjes-Terpstra (1958), who placed Mondrian's early development within the context of modern art in the Netherlands in the period 1900–14; and the dissertation of Hans Jaffé (1956), who focused on Mondrian's position within the circle of artists associated with the journal De Stijl. Since that time, many larger and smaller publications of various kinds have appeared in Europe, as well as in the USA and Japan.

The interested reader can now consult general monographs, as well as studies devoted to a particular period in Mondrian's œuvre or even a single work; detailed stylistic, formal and technical analyses of his paintings; essays focusing on specific aspects of his theoretical views; articles on the psychology of the artist; editions of source material such as sketchbooks and notes, and a number of separate bodies of correspondence, recollections of friends, and reissues and translations of his publications, culminating in the English edition of his writings, collected by his heir, Harry Holtzman, with Martin James (1986). And 1994–5, which marks the fiftieth anniversary of Mondrian's death, adds extra momentum, with the publication of catalogues of various exhibitions being held in The Netherlands and the USA, and the long-awaited œuvre catalogue by Joop Joosten and Robert Welsh. It is to be hoped that the integral edition of the letters will soon follow.

This growing body of literature, whether scientific or popular, reflective or factual, interpretive or speculative, testifies not only to the worldwide regard for Mondrian's work, but also to the diversity of views on that work. Like all great art, it continues to offer openings for new approaches. The present book incorporates much that has already appeared in print, but I hope that it also contains sufficient new material and new insights to increase the reader's pleasure in viewing and studying the work of Mondrian. That is the purpose of my writing. Mondrian's art is very dear to me, and I have tried to convey something of my regard to those who read this book.

This is a monograph rather than a biography. As such, it focuses not on the life, but on the production of the artist, which I take to mean those things he presented to the outside world, that is his work and the writings that were intended for publication. A great deal of attention is given to the relationship between the two. Mondrian often took pains to stress that his art was not the product of rational considerations, but came about intuitively: first there was practice, and only later was there theory. In my view, this pronouncement was a strategic move on Mondrian's part, designed to silence those critics who were inclined to see his work as cerebral, the embodiment of a preconceived theory. Indeed, it is possible to demonstrate that practice often followed theory. Whatever was the case, neither Mondrian's theory nor his practice was static. Both were constantly evolving and developing in a mutually enriching interaction, whereby new accents were laid, new problems addressed, and tentative solutions broached.

In this book these developments are traced more or less chronologically. I have tried to confine myself as closely as possible to 'the moment', and to avoid the anachronisms that, in the past, have cropped up in much of the literature on Mondrian. Authors have often been too readily influenced by the artist's own habit of projecting theoretical notions or visual characteristics back onto earlier phases of his activity, in order to fit everything into a consistent and straightforward process of evolution. But what Mondrian maintains in an autobiographical text dating from 1942 cannot be seen as a full explanation or motivation for the work he did back in 1908 or 1916. To gain a proper insight into the interaction between theory and practice, the two must be examined together, in relation to 'the moment'.

For this reason, I focus largely on the origins of Mondrian's paintings and texts. I try to establish which factors guided the developments that took place in his painting and his writing: what he learned from earlier experiences, what he saw or read, what he discussed with colleagues and friends, what inspired or encouraged him, and what he reacted against. I have made use of visual material such as sketches and drawings, oral and written communications by people who knew Mondrian and – above all – his own letters, which tell us a great deal about the manner in which his paintings and his theoretical writings came about. Most of Mondrian's published articles are of a quite general and philosophical nature, and the tone is calm and measured. In his letters, on the other hand, he is often direct, even emotional. In many cases the articles served a polemical purpose and were directed against specific individuals. In the published writings their identity is never revealed; in his letters Mondrian gives their names.

Like all historians, I am aware that by its very nature the past can only be known imperfectly. Sources are invariably fragmentary and more or less subjective, whether one is dealing with reminiscences, which are often formulated long after the fact, or statements made in letters, where there is invariably a conscious or unconscious colouring in the direction of the correspondent to whom they are addressed. Besides, someone who is working on a painting or a theoretical text is himself not completely aware of what is going through his mind, and an outsider can never hope to fathom his thoughts. Even if it were possible to do so, it would take a lifetime to portray the life and work of another person, and few are eager to take on such a thankless duplication. While acknowledging the limitations of both the material and the historian (who can never fully rise above his own subjec-

tivity), I nevertheless see the historicity of Mondrian's practical and theoretical work as the foundation of my approach. What I try to clarify is the genesis of that work, and thus, in a way, the intention of the artist – an approach that, at present, is much disputed in art-historical circles.

What I say about Mondrian's intentions touches on a discussion that has been going on for decades. For some authors, in particular Americans, Mondrian's abstract painting is the epitome of Modernism in the strict sense of the word as employed by Clement Greenberg: 'The essence of modernism lies, as I see it, in the use of the characteristic methods of a discipline to criticize the discipline itself – not in order to subvert it, but to entrench it more firmly in its area of competence.'[2] This vision is elaborated most consistently by Greenberg's follower Kermit Champa in his *Mondrian Studies* (1985). In this work Mondrian's theories are largely disregarded, and his endeavours totally identified with formal concerns: 'In my view nearly everything of fundamental importance to Mondrian finds its way visibly into the paintings, not as imagery in the proper sense, but as a series of constantly shifting notions of pictorial structure.'[3] Infinitely richer and more subtle is the formalistic approach of the French art historian Yve-Alain Bois, although he, too, situates the meaning of Mondrian's work primarily in what is visible in the paintings, and displays the same tendency to isolate them from the theories, except where the latter are related to perceptual aspects.

I would venture to question whether a formal-analytic approach does justice to Mondrian's art and his motives in producing that art – which is, in effect, what this approach claims to do. My impression is that this makes Mondrian into a contemporary artist of a type that did not actually emerge until the 1950s and 1960s: Mondrian as a representative of Post-Painterly Abstraction, or as an older brother of Robert Ryman. In this book, Mondrian is presented as a somewhat 'old-fashioned' artist who, for all his apparent modernity, has his roots in nineteenth-century ideas.

Without doubt Mondrian attached considerable importance to the visual appearance of his paintings; during his active life most of his time and energy was put into weighing, adjusting and assessing what he put down on canvas. The subtleties of tone and facture his paintings display bear witness to a command of his medium worthy of an Old Master, and an obsession with the 'right' placement of the compositional elements that has become legendary (although scant attention is paid to the odd remarkable lapse, as when he set down precise perpendicular lines on a canvas that was clearly crooked – an example of nonchalance that I find quite endearing). And yet I cannot believe that the visual manifestation of the work of art was an aim in itself. I find it both characteristic and fascinating that, in his letters as well as his published texts, formal, aesthetic considerations are invariably embedded in a wider context of considerations of a philosophical and ethical nature. The epigraph for this Introduction – taken from a book that he worked on between 1927 and 1931 but which was not published during his lifetime – makes clear what I mean. In Mondrian's view, art was not to be confined to an idea, it had to be realized. But in its realization in the work of art there is the expression of something (equilibrium) that has wider implications than its own physical and visual manifestation. It should be noted that in the epigraph both 'idea' and 'realize' appear in quotation marks, a typographical device that he often used to suggest multiple layers of meaning. That is how Mondrian saw all art,

and it is certainly how he intended his own art to be seen. Whether we like it or not, it is art with a message.

While an artist's race, gender or religious persuasion may have little or no bearing on his art, in Mondrian's case both his art and his art theory were inextricably bound up with his philosophy of life, which in turn was strongly influenced by Theosophy, that curious late nineteenth-century antidote for positivist and materialist thinking. As far back as 1910–14, there were critics who mentioned his theosophical background in their exhibition reviews – he himself apparently made no secret of his views – and from the 1950s onward there were again regular references to Theosophy in the literature on him. The most extensive and detailed treatment of this aspect of Mondrian's life and work is contained in an article by Robert Welsh published in 1971.[4] According to Welsh, the influence of Theosophy was not limited to Mondrian's early efforts to formulate his theory, but extended to his paintings as well. Welsh cites examples from the period 1908–11, notably the triptych *Evolution* (illus. 40), and from his Cubist period, 1912–14.

Those art historians who advocate a formalist interpretation usually deny that Theosophy could have played any role of importance in Mondrian's art and art theory: he strayed, but quickly found his way back onto the straight and narrow. Bois speaks disparagingly of 'the theosophical nonsense with which the artist's mind was momentarily encumbered'; Champa holds that the influence of Theosophy lasted only a short time, and was reflected mainly in the choice of certain subject-matter, 'the alliance with theosophy ultimately having demanded more in illustrative reverence than it supported in pictorial instinct'.[5]

These two authors, and many others too, apparently find it difficult to accept that a philosophy that is deemed to be rather obscure could have played a significant role in the formation of the sublime, crystal-clear art of Mondrian. But one need not be a believer – my own affinity with Theosophy is minimal – to see that this philosophy was indeed of great importance to him. Its influence is clearly traceable around 1910 but also later, during the development of his abstract painting, and, in fact, right to the end of his life.

The attentive reader will find in Mondrian's theoretical writings many indications that his ideas were indeed based on theosophical doctrine, and that he made use of concepts drawn from the ancient wisdom of both Eastern and Western cultures, as embodied in Theosophy. While such references often lie well below the surface, Mondrian is more open in his letters regarding his philosophical inspiration, at any rate when addressing correspondents who might be expected to be kindly disposed towards such confidences. In a letter of 1918 to Theo van Doesburg, for example, he claims 'I got everything from the Secret Doctrine', a reference to the major work by the founder of the Theosophical Society, Helena Petrovna Blavatsky. The most telling example, however, is a letter of 1921 to the famous spiritual leader Rudolf Steiner (illus. 132), in which he states that his abstract art, which by then he called Neo-Plasticism, is 'the art of the near future for all true anthroposophists and theosophists'.

Mondrian's correspondence with the philosopher Louis Hoyack, which covers a period from the late 1920s until *c.* 1940, is also enlightening in this respect. Mondrian discusses their differing opinions on the effect of cosmic laws on culture and society, referring to a number of books that Hoyack had published. On 2 April 1933 he wrote that he had read *L'Enigme du destin* (The Enigma of Destiny):

'To the extent that you refer back to ancient wisdom, I find it splendid; also the exposition on reincarnation and karma.' But this is followed by a deluge of criticism: by personalizing 'God' and 'soul', Hoyack was in effect reinstating the old religion, which addresses people at a primitive stage of their existence. 'Just as they need a naturalistic kind of art, with actual representations, they no doubt need to understand life in terms of things.' Mondrian saw in Hoyack's views a frantic attempt to hold on to traditional religious and social forms which, like the natural forms that appeared in traditional art, are no more than the historically determined outer shell enclosing the eternal truths. Hoyack's theories are contrary to what Mondrian referred to as 'the growth of mankind'. He maintained that just as the mature human being would ultimately be able to live without 'things' and 'forms', he would accept a form of art without 'representation', because he would be capable of fathoming the deeper truth that lay behind it. Here again, the link between Mondrian's views on art and his philosophy of life is clearly discernible. His criticism of publications by Hoyack, although couched in somewhat more veiled terms, is also voiced in 'L'Art et la vie' (written 1927–31), to which I will return in chapter Four.

In a sense, Mondrian's theosophical inspiration brings him closer to the Symbolist and 'Ideist' artists of the late nineteenth century, as Martin James and Carlo Ragghianti, among others, have shown.[6] It is for this reason that I called Mondrian a somewhat old-fashioned artist. What we know of his favourite reading material points in the same direction. The handful of books he left at his death consist solely of titles that breathe the atmosphere of Theosophy and related movements: works by Mabel Collins and Rudolf Steiner, and others by or about Krishnamurti, some of the editions dating from as late as the 1920s and 1930s.

It is telling in this respect that in 1919, at a time when he was in the process of developing his Neo-Plasticism, Mondrian wrote from Paris to his good friend Willy Wentholt in the Netherlands, saying that he had just finished reading a most remarkable book by Sâr Joséphin Péladan, *Comment on devient fée* (How to Become a Fairy), which he highly recommended: 'You will find much of me in this work; he takes his inspiration from the same ancient sources (occult), as you are perhaps aware. I do not believe that *you* will learn anything new from it, but you will doubtless approve what he says.' The book in which Péladan unfolded his esoteric world view appeared in 1893, as part of a series called 'Amphithéatre des sciences mortes' (Amphitheatre of the Dead Sciences). *Comment on devient fée* centres on Péladan's view of women and their relationship to men, in which the transcendence of sexuality is considered an exalted ascetic goal. The fact that Mondrian saw himself in this work by the high-priest of the Rosicrucian movement of the 1890s might strike the reader as no more than a piquant psychological detail, if it were not for the fact that in his own theoretical writings (the 1912–14 Sketchbook notes, in particular, but also later texts) the position of the artist with respect to women, the Man/Woman relationship, and the role of the sexes in human evolution are all related in various ways to art in general, and to his own art in particular.

It is abundantly clear that Theosophy was of crucial importance to Mondrian. But how did he incorporate his theosophical views into his art theory, and how were they reflected in his painting? What is the import of his confession to van Doesburg that he got 'everything' from Blavatsky's *The Secret Doctrine*, and his

remark in the letter to Steiner that Neo-Plasticism is the art most suited to theosophists and anthroposophists?

Perhaps we would do well first to establish what it does not mean. In my view, it makes little sense to scrutinize Mondrian's abstract paintings for symbolic elements à la Blavatsky and related authors. There is no demonstrable connection between the cosmological schemas which illustrate *The Secret Doctrine*, or the traditional symbols from various ancient cultures discussed in the book, and the constellations of lines and colour planes in Mondrian's paintings. These schemas and symbols have nothing to do with his Cubist works – here I part company with Welsh – and still less with the later Neo-Plastic paintings. Nor do his paintings have anything to do with the auras and thought-forms that appear in the books of the theosophists C. W. Leadbeater and Annie Besant. Apart from the triptych *Evolution* (illus. 40) and a few other works dating from *c.* 1910, Mondrian seldom employed symbolism of a clearly theosophical nature. What he did borrow from theosophical sources is the firm conviction that all life is directed towards evolution, and that, as he said in his letter to Steiner, it is the goal of art to give expression to that evolution. To Mondrian evolution was 'everything'. Not only are his theoretical articles imbued with evolutionary thinking, this concept also generated the process of change that characterized his work to the very end of his life.

In order to understand this, we must take into account that in Mondrian's thinking evolution was closely bound up with destruction. He did not view this as a negative concept: on the contrary, the destruction of old forms was a condition for the creation of new, higher forms. Initially this was expressed in his choice of subject-matter, exemplified in the paintings and drawings of flowers in states of decay. Later, in his Cubist period, he came to the realization that abstraction, which implies the destruction of the incidental, outward image of reality, could be used to portray a purer image of that reality, and to represent a higher stage in evolution. And finally, the principle of destruction was applied to the means of expression themselves: his Neo-Plastic work is, in effect, the result of an entire series of destructive actions.

By 1917–18 Mondrian had removed from his paintings the last vestiges of spatiality, capturing the planes within a network of lines. This step was followed in 1920–21 by other, equally momentous changes which led to the first paintings featuring highly eccentric compositions. One of the most striking things about these works is the fact that the colour planes have been destroyed as form: they are either pushed over the edge of the painting or traversed by lines, while the lines enclosing them always continue far beyond the planes. Starting in the mid-1920s, Mondrian did a number of paintings that consist almost exclusively of lines. He was aware that these lines conducted themselves in such an independent fashion that they were in danger of becoming 'form', and in the early 1930s he attempted to prevent this by doubling the lines or occasionally executing them in colour. Ultimately, during the last two years of his life, he began to break up the lines altogether. The unfinished painting *Victory Boogie Woogie* is a sparkling construction of tiny colour accents in which he came very close indeed to his goal: the cancellation of form in favour of relationships.

The destruction of the representation – and on a more abstract level the destruction of the form – that Mondrian demonstrated in his paintings was the visual expression of what, according to his evolutionary theories, was taking place every-

where: in the arts, in society and in life itself. He never tired of stressing this fact in his published writings and in the letters. His painting was the model, on the basis of which Man would transcend the limitations of matter and the closed forms imposed by conventions and institutions. It was the model for the pure relationships which, in that ideal situation, would dominate in all areas. It would take mankind many centuries before this would be realized, but the road to utopia was clearly indicated by his paintings and writings.

In my opinion, the tragedy of Mondrian's life was the fact that, despite all his efforts, his art and his vision did not meet with a single positive response in those circles where he expected to find the appropriate spiritual attitude. An article he wrote in 1914 for a theosophical journal was rejected; his reading of an art-theoretical text at a meeting of a theosophical lodge in 1917 met with little success; in 1921 Rudolf Steiner did not even reply to his letter; in 1932 he confided to Hoyack that his bid to become a freemason had been unsuccessful (quite a number of theosophists were freemasons); they had not even read the submitted manuscript for his book 'L'Art et la vie' all the way through, or, in any case, had not understood what they had read. The almost total lack of understanding Mondrian met with within those circles occasionally prompted a bitter outburst, as in 1922, when he wrote to van Doesburg of 'those people who are now so fond of calling themselves theos. or anthroposophist – they are all half-baked'. And when in 1932 the sale of a painting to the Rotterdam industrialist van der Leeuw fell through, Mondrian complained to Hoyack, 'If I'm not mistaken, that van der Leeuw is a theosophist! They are always against my work.' Apparently theosophists, like the rest of mankind, were clinging to the old forms, oblivious to the clear signals that Mondrian was sending out, proclaiming the coming of the new life.

To the end of his life Mondrian presumably remained a member of the Theosophical Society, which he had joined in 1909. In any case, in 1939 he asked to have his name transferred from the branch in Paris to the one in London. However, in later life he embraced the theosophical world of ideas without aspiring to any particular involvement in the Society as such. This is confirmed by certain remarks of the painter Charmion van Wiegand, a kindred spirit and intimate friend, who provides a neat characterization of Mondrian's attitude towards art and life: 'Mondrian had gone beyond organisations or groups of any kind for himself, by that time, just as he had gone beyond closed form. To him, they represented limitations, a division in the total unity he sought to achieve, and a restriction in the context of his universal philosophy.'[7]

The many disappointing experiences that were his lot did not diminish Mondrian's faith in the exemplary value of his art and the evolution of humankind. His gaze was firmly fixed on the future, the distant future. In the letter of 1932 to Hoyack in which he described his rejection by the freemasons, he went on to say, 'I stand alone, with only a very few others'. And around this time he wrote to another friend that in 'L'Art et la vie' he was using art to demonstrate that evolution really only takes place within an elite:

This elite gradually makes its influence felt upon the masses, and in the end life itself will evolve as well. But this is almost indiscernible. So, to retain one's faith in human evolution, one must constantly look to that elite, and then life is quite wonderful. All that is base in the masses is temporary, no doubt serving only to prevent evolution (that of the elite, as well) from proceeding too quickly and thus not becoming 'reality'. In art it has been ever thus: through the ages, only an elite has ever gradually succeeded in expressing pure relationship through the

pure means of expression (line and colour devoid of individual form). And it is this which must happen in life. We must look not to the negative (the misery, the bestial in life), although we undergo it and sympathize with it, but rather to the burgeoning life around us, which is strengthened by the negative.[8]

It will be clear that Mondrian's elite is not an elite in the ordinary sense of the word, one which has political or economic power or derives its status from social inequality. It is a spiritual elite. And the touchstone Mondrian employed was the response to his Neo-Plastic painting and his Neo-Plastic theories. If the theosophists, anthroposophists, and similar groupings failed to understand him, there were fortunately a few people who were aware of the importance of what he was trying to do. In 1920, for example, he wrote to van Doesburg that he liked to read his texts aloud for Tonia and Wim Stieltjes, a Dutch couple living in Paris: 'They are receptive to the new, although they do not know what it is. Thus I do occasionally feel that my effort has not been in vain. They find the idea of the N.B. [Neo-Plasticism] sound and quite magnificent, but think that it will be quite a long time before people are ready for it!' (Tonia Stieltjes was Mondrian's best woman friend in Paris, and her death in the early 1930s was a severe blow to him.) And the first time he sold a number of paintings to collectors in the USA, he wrote to a friend that there were now people there who were 'beginning to see'. While there is a touching naivete about these remarks, they are understandable in the light of Mondrian's obsessive dedication to his task and the meagre recognition his work received during the greater part of his life.

Today Mondrian's art is known and accepted worldwide. The characteristic compositions he created can be seen all around us, not only as original works on the walls of the world's most prestigious museums, but also as reproductions in books, on posters and cards, and paraphrased on everything from place-mats to cycling-shirts. But the philosophy he was striving to express in his work has been largely ignored, or dismissed as an oddity. Odd as it may appear, it is at the same time utterly fascinating to see how this philosophy helped shape one of the most impressive bodies of work in twentieth-century art. If I have tried in this book to provide an insight into Mondrian's theory and the relationship between that theory and his work, then this in no way means that I believe this to be the one and only approach to his art. On the contrary, I am convinced that changes in the reading, interpretation and use of artistic manifestations serve to demonstrate the dynamics inherent in culture. But even in the midst of change, Mondrian's paintings stand tall, splendid and unapproachable.

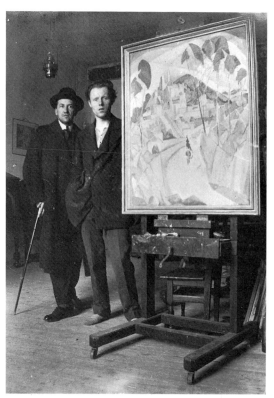

1
Piet Mondrian (*left*) and Lodewijk
Schelfhout in the latter's studio at
26 rue du Départ, Paris, 1912.

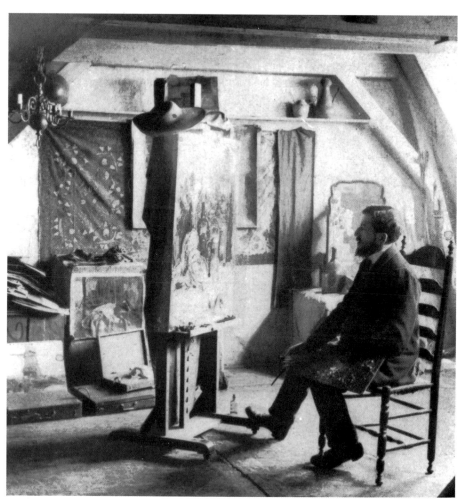

2
Piet Mondrian in his studio, 10
Rembrandtplein, Amsterdam, 1905.

1

The Path of Ascension, away from Matter: The Years to 1914

A photograph of a painter in his studio (illus. 2). The location is the upper floor of 10 Rembrandtplein, a house in Amsterdam. The year is 1905. It is a very ordinary photograph, barely capable of holding our attention, until we learn the identity of the person portrayed: Piet Mondrian, aged thirty-three. While he is not exactly posing, he does seem to have spruced up himself for the occasion: neatly trimmed hair, moustache and beard, a suit complete with high-collared white shirt, and a precisely knotted tie. When he puts on the wide-brimmed hat that hangs on the easel and walks out into the street, he undoubtedly has quite an artistic air about him.

Indeed, artistic is precisely the word that springs to mind when we look more closely at the interior in the photograph: threadbare oriental carpets on the floor, an old Dutch country chair, a copper chandelier with candles in it hanging from the beam, a length of batik fabric against the wall, and above that a shelf with a few still-life objects, including a copper flagon and the ubiquitous ginger-jar. It is the very cliché of the painter in his garret studio. And what he paints fits that image. In the background, to the left, we see two small studies painted in a ready style, both probably done out of doors: a landscape with windmill, and a cow lying in the grass. The large painting in progress which stands on the easel is a conventional still-life of bottles, dried flowers, copper pots and pans, and fruit arranged on a draped cloth. This type of work gains Mondrian a modicum of success at Dutch exhibitions: 'Copper good, lemons not transparent enough' is the judgement of a critic in 1906.[1]

Another photo (illus. 1) was taken seven years later, in 1912. The location is the studio of Lodewijk Schelfhout, 26 rue du Départ, Paris. Schelfhout is the young man beside the easel on which rests a recently completed painting of his, a view of the little town of Les Angles in the Provence. The unsmiling visitor standing behind him is Piet Mondrian, aged 40. He has shaved off his beard and moustache, and his clothing is formal but unobtrusive: hat, suit, overcoat. There is something jaunty in his stance and the way he holds his walking-stick: he has the air of a man of the world.

Mondrian had arrived in Paris several months before, and he had a studio in the same building as Schelfhout's. But the pictures he paints there are a good deal more radical than the middle-of-the-road Cubism of his younger colleague. When shortly thereafter his *Woman* (1913; illus. 49) and another painting are exhibited at the Salon des Indépendants, they receive considerable attention from Guillaume Apollinaire in his exhibition chronicle. He refers to

the highly abstract cubism of Mondrian – a Dutchman – (it is well known that cubism has made its entrance into the museum in Amsterdam; while here they make fun of the young painters, there they exhibit the work of Georges Braque, Picasso, etc. alongside that of Rembrandt), though a product of cubism, Mondrian in no way imitates this style. He seems above all to have

undergone the influence of Picasso, but his personality has remained intact. His trees and his female portrait display a sensitive cerebral quality. This kind of cubism clearly follows a different path from that of Braque and Picasso, artists whose 'recherche de matière' is presently arousing such interest.[2]

In the period that lay between these two photographs momentous changes had taken place in Mondrian's work and in his ideas on art. His vision of the artist's role and the image he projected to the outside world had both altered radically, along with his surroundings. Between his thirty-fifth and his fortieth year, the rhythm of his entire existence began to gain momentum. It was as if he realized that it was high time he defined his position as a modern artist in a modern society. To that end, he finally took the decision to go to Paris. But it was a decision that may have also been prompted by the need of an artist *in media vita* to distance himself from the circles in which he had been accustomed to move.

The evolution that took place in Mondrian's artistic thinking from *c.* 1908 on was as swift and far-reaching as the preceding period had been calm and uneventful. Clearly, he lacked the élan of many of the prominent avant-garde artists of this century, who at an early age were already such great innovators (although admittedly they often had difficulty in maintaining that high level of accomplishment). Nor could he fall back on the excuse that his was a 'late vocation', as in the case of Wassily Kandinsky and Jean Dubuffet, who started out in other careers. From the start, Mondrian had been a professional artist.

When examining the development of famous artists, there is a tendency to upgrade the early work, to see in it elements that foreshadow the more mature accomplishments, thus shaping the entire *œuvre* into a convenient structure. Mondrian, evolutionary thinker *par excellence*, was later fond of describing his early landscapes and architectural pieces as 'logical' steps leading to his abstract paintings, and many writers have echoed his interpretation. However, if we make the effort to view his early work impartially, we shall see that it is not only of uneven quality, but also essentially inconsistent. It would be fair to say that Mondrian simply got off to a slow start. Up until about the age of thirty-five, the work he produced was not particularly distinguished: not in itself, not in relation to the Dutch context, and certainly not in comparison with developments on the international scene, about which he knew very little. He seldom travelled, and his acquaintance with the work of foreign contemporaries could only have been based on reproductions and the occasional exhibition in the Netherlands. By both temperament and circumstances, he was far more suited to embrace convention than to challenge it. Given this contrast between the period before and the one after 1908, it may be helpful to examine certain aspects of his early years: his training, his position as an artist, the people around him, and the significance they had for his work.

Mondrian's early career

Mondrian was born on 7 March 1872, and grew up with his older sister and three younger brothers in a somewhat inward-looking Calvinist milieu. His father was a primary school principal, first in Amersfoort, near Utrecht, and from 1880 onwards in Winterswijk in the eastern part of the country, close to the German border. He played an active role in the political, social and cultural life of the

community, and was acquainted with the leaders of the new Protestant political parties, such as Guillaume Groen van Prinsterer and Abraham Kuyper.[3]

Although Calvinism is often thought to be antagonistic towards the arts, this was certainly not the case in Mondrian's family. His father had qualified as an art teacher, and was quite a good draughtsman. He designed a great many prints commemorating historical events, as well as covers for children's books, and for his own stories. Mondrian's uncle Frits, who was a barber by profession, painted on a semi-professional basis, mainly landscapes in the Impressionistic style of the Hague School, and in later life devoted himself entirely to painting. Another uncle, Johannes Jacobus, was also a barber and sometime actor, while a third uncle, Dirk Ernst, alongside his work as book-keeper, was active in the spiritualist movement and occasionally acted as a medium. These members of the clan may have had a somewhat more liberal attitude towards Calvinism than the family in which Mondrian grew up.[4]

Circumstances were undoubtedly favourable to the budding artistic talent of the young Mondrian. This may be surmised from a brief biographical sketch (which he probably wrote himself) that appeared in 1907 in *Onze moderne meesters* (Our Modern Masters) by F. M. Lurasco:

Piet Mondriaan, born 7 March 1872 in Amersfoort, first began to draw under the guidance of his father, who was an enthusiastic draughtsman. At the age of fourteen he started to paint, under the tutelage of his uncle, Frits Mondriaan of The Hague, who came to Winterswijk in order to paint out of doors. Obtained teaching certificates in drawing for both primary and secondary school, and studied for a time with Joh. Braedt van Uberfeldt before going on to spend three years at the Rijksacademie in Amsterdam.[5]

It was probably at his parents' prompting that he gained the necessary qualifications to teach drawing in the Dutch primary and secondary school system (in 1889 and 1892 respectively), which afforded him a measure of security. The young Mondrian was, however, determined to become a painter. In late 1892, at the age of twenty, he moved from Winterswijk to Amsterdam, in order to undertake further studies at the Rijksacademie. The necessary funds were forthcoming from the royal family in the form of a grant for one year of study. After attending daytime painting classes for two years, he switched to evening classes in drawing, which he followed, with a one-year break, until 1897. At that time, Academy courses were strictly classical in emphasis, chiefly directed towards the portrayal of the human figure in epic, historical or biblical scenes, or in a domestic context. This was not Mondrian's strong suit, a fact made eminently clear when he entered the Prix de Rome competition in 1898, and again in 1901. Awarded high marks for aesthetics, art history and perspective, he was ultimately rejected on the grounds of his figure pieces. A study of a male nude that he did for the 1901 competition survives, and it is difficult to argue with the judgement passed on it by the members of the jury. They were likewise critical of two small paintings with set biblical themes: the figures were either too theatrical or not vivid enough, while 'the distribution of the groups is dull and unimaginative'.[6]

If Mondrian had been successful in his bid for the Prix de Rome and the four-year grant that went with it, he would have had no financial worries for some time to come; it would also have enabled him to travel abroad and to work in Rome. The prospect of financial reward probably meant more to him than the opportunity to live for a time in another country. As far as we know, the only time

that the young Mondrian ventured abroad on his own initiative was the brief visit he made to England (probably in 1900). But all things considered, the rejection had no serious consequences for his future career. The prestige attached to the Prix de Rome had already declined, not least because the type of figure pieces it prescribed were much less in demand among the art-buying public of the Netherlands than were landscapes, still-lifes and rural genre pieces.[7] The demand for such works was one that Mondrian was able to meet. He had made his debut at Kunstliefde, the Utrecht artists' society, back in 1892, during his first year at the Academy, presenting several painted still-lifes and a landscape drawing. From 1896 he regularly submitted work for membership-only shows at Arti et Amicitiae and from 1897 at Sint Lucas, both of which were artists' groups in Amsterdam. Regarding Mondrian's contributions, the catalogues of the annual shows refer mainly to still-lifes and landscapes, along with the occasional portrait or farmhouse interior. In some cases it is impossible to say with any certainty exactly which works he showed, and the references contained in reviews do not provide us with much to go on. However, the scanty information that is available indicates that in his initial public appearances as a professional artist Mondrian was more concerned with supplying a product that would sell than with defining his own personal style. He was clearly trying to please various sectors of the market at the same time.[8]

The still-lifes that he did at this time, such as the *Still-life with Herring* of 1893 (illus. 3), but also the kind of painting we can discern on the easel in the 1905 photograph (illus. 2), reflect the taste of buyers for whom even the moderately Impressionistic style of the Hague School was a bit too daring. The choice of objects and the arrangements are highly conventional; the colour is muted, and the technique, while not slick, is nevertheless aimed at a faithful representation of the subject-matter. The impression is of a rather clumsy variation on the realistic still-life tradition of the second half of the nineteenth century. Mondrian's painted portraits dating from this period, presumably all of which were commissions, are equally traditional.[9] When a portrait was, on occasion, exhibited, as at the 1897 show organized by Kunstliefde, the main aim was to bring in new commissions. Only when we turn to the landscapes and interiors of barns and farmhouses do we find work that may have held some appeal for art-lovers of less conventional tastes, indeed, that might appeal to us today. In addition to fully worked-out, realistic paintings, Mondrian showed works that display a looser, more impressionistic touch, and not only paintings but also drawings and watercolours, in response to the recent surge of interest in works on paper.

We know virtually nothing of the volume of his sales in those early years. There was certainly a favourable market for art during the latter part of the nineteenth century, thanks to the economic upsurge in the Netherlands in general, and Amsterdam in particular. There was, however, also a great deal of competition. After the expiration of the grant that Mondrian had enjoyed during his early years at the Academy, he probably had trouble keeping his head above water. He did his best by taking on all sorts of other activities alongside his free work: he gave private lessons, painted portraits (even beloved family pets), and did copies of famous seventeenth- and nineteenth-century works in the Rijksmuseum. He also received the odd commission in the area of applied art, such as illustrations for books published by the Amsterdam firms of Höveker & Zoon and J. A. Wormser (from 1892 to 1895 Mondrian actually lived with the Wormsers). These publica-

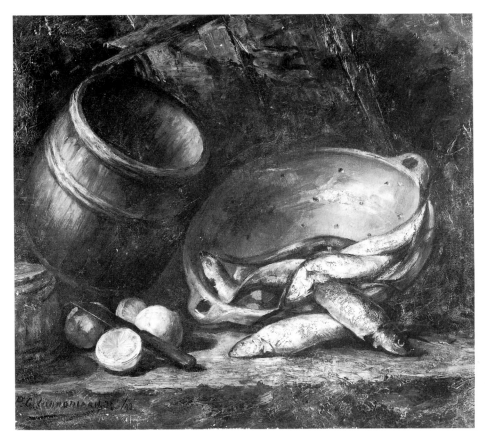

3
Still-life with Herring, 1893, oil on canvas mounted on cardboard, 66.5 x 74.5. Stedelijk Museum, Amsterdam.

tions were entirely in keeping with his own upbringing, and included such titles as *Medeërfgenamen van Christus* (Joint Heirs of Christ, 1896–7), a series of gruesome accounts of the torture of Protestants during the Eighty Years War, the struggle for independence from Spain, somewhat woodenly portrayed by the young Mondrian (illus. 4).[10]

Two projects undertaken some time later were more ambitious, at least in scale. In 1899 he executed a ceiling painting for a monumental house on the Keizersgracht in Amsterdam in a kind of neo-Rococo style, complete with *putti*. The year before he had designed several wooden reliefs for a pulpit of the English Church at the Beguinage in the same city: a winged angel above a coat of arms, and a number of beguines engaged in good deeds. These were occasional, competently executed works, although not particularly inspired.[11] But to make a long story short, in the course of his training and during the early years of his career as a professional artist, there was very little evidence of the qualities by which Mondrian was later to distinguish himself. The image he presented to the outside world, through his exhibition entries and his commissioned work, was one of thoroughness, together with a certain tendency to play it safe. As young as he was, Mondrian was a rather old-fashioned artist.

4
Illustration from D. P. Rossouw, *Medeërfgenamen van Christus* (*Joint Heirs of Christ*), Amsterdam, 1896–7.

This characterization is perhaps even more striking when we consider that in the period during which he was maturing as an artist there were abundant alternatives to be found all around him. The artistic climate of the Netherlands, and above all Amsterdam, was effervescent and internationally oriented.[12] The Hague School had already been absorbed into the establishment, but during the 1880s a younger generation of artists, generally referred to as the Amsterdam School,

23

had appeared on the scene. G. H. Breitner and Isaac Israëls were the most talked-of exponents of the group, which documented city life down to the last heart-rending detail. In the final years of that decade, French and Belgian Neo-Impressionism had broken into the Netherlands, attracting many followers. In late 1892, about the time that Mondrian arrived in Amsterdam, the city was the scene for the first big van Gogh exhibition. There had been a few smaller shows elsewhere, but this exhibition caused a minor sensation. This was also the year that the Symbolists gained a firm foothold in the Dutch art world, thanks to the efforts of Jan Toorop and Johan Thorn Prikker. These and other innovations in painting, the influence of which would continue to be felt for many years to come, were picked up with great enthusiasm by young artists like R. N. Roland Holst, Jan Verkade, J. J. Aarts and H. P. Bremmer. But not by Mondrian. Nor did the new developments in monumental art (that is, art applied to architecture) appear to have interested him. Apparently Mondrian was oblivious to the discussion centring on so-called community art, which was beginning to cause such a stir among artists and critics. Fellow students at the Academy, including Antoon and Theo Molkenboer and the architect K.P.C. de Bazel, were receptive to these new ideas. Mondrian was not. His book illustrations, ceiling painting and pulpit are far removed from the symbolic representations, in an austere, hieratical style, that Derkinderen, Roland Holst and others were employing for walls, stained-glass windows, and book-covers.

If Mondrian kept a certain distance between himself and the avant-garde movements taking root all around him during the 1890s, this may have been because he still felt very little affinity with the lifestyle and the view of the artist's role that was epitomized by these new movements. The painters of the Amsterdam School, with their bohemian ways, seemed to be in a permanent state of intoxication; their aim was to record their impressions of harsh city life as directly as possible, and they displayed scant regard for either ethical or aesthetic considerations. They shared with the poets and writers of the Eighties ('Tachtigers') Movement, whom they counted among their friends, an exaltation of the artistic personality. 'I am a god in my deepest thoughts', wrote Willem Kloos, thereby shocking many a God-fearing soul among the Dutch public.[13] The Symbolist artists saw themselves as priests, kings and magi, in the words of Sâr Péladan. While they did not wholly disregard life's more idealistic and spiritual dimensions, many of them rejected all existing religious and secular institutions. For a time pantheism and anarchism enjoyed a certain popularity among the Symbolists, in the Netherlands as elsewhere, while within community art there were also strong voices in favour of using art to promote a Roman Catholic revival, or to further exalted socialist aims.[14]

Artistic ideas and manifestations of this sort were not kindly received in Calvinist circles, and on the basis of the scant information available we may assume that Mondrian still felt a close kinship with these circles. In 1893 he did permit himself one small liberty that went against his parental upbringing: he switched allegiance from the Dutch Reformed Church to the breakaway Reformed Church, also adhered to by his host family, the Wormsers.[15] But this decision to forsake one branch of Dutch Calvinism for another only serves to underscore the importance he attached to the norms and values of his youth during the early years of his artistic development.

At the turn of the century

The image projected by Mondrian the artist in the period from the late 1890s to *c.* 1908 – roughly between his twenty-fifth and his thirty-fifth year – was not significantly different from that of the previous years. There was no about-face, no break. He continued to make his living by painting portraits and copying museum art, alongside the odd commission for a historical print or an ex-libris. And if we look at the work that he exhibited during this period, we see that both genre and style still display a certain orientation towards the current market. But alongside the conventional still-lifes and landscapes, there was other work, work that was freer, bolder and more personal, such as the many oil sketches he started to do at this time. In general, this technique was reserved for his own personal use, providing practice material and serving as preliminary sketches for 'the main work'. He may, however, have sold one from time to time, as there was growing interest among collectors for this type of oil sketch, as there was for drawings and watercolours.

If we take into account the Dutch situation during this period, we can no longer label Mondrian's work – the bulk of that work, at any rate – as old-fashioned. But our judgement will indeed depend on that proviso. To be honest, there was nothing very spectacular going on at the time. The turbulent years of the late 1880s and early 1890s, when the Dutch art world had welcomed foreign innovation, were followed by a period of relative calm. Both Neo-Impressionism and Symbolism, in modified form, retained considerable influence, but the artistic dynamism of the day was manifested in architecture, the applied arts and monumental art, rather than in easel painting of the kind practised by Mondrian. It was here, in the lee of the storm, so to speak, that his talent came to fruition. Oblivious to what was happening abroad, he was busy mastering the various styles then being practised by the more progressive of the Dutch painters. He needed the example of others: through emulation, he was able to discover where his strengths and his preferences lay.

The first signs of this development were reflected around 1900 in a series of small paintings, gouaches and drawings depicting motifs in and around Winterswijk. During the 1890s Mondrian had regularly returned to the rural surroundings of his parents' home to paint landscapes, often in the company of his uncle Frits. Initially, their work appears very much alike, and where the paintings are unsigned it is sometimes difficult to say which of the two was the artist. In the Winterswijk paintings dating from 1898 and shortly thereafter, however, Mondrian gradually distanced himself from the muted landscape art of the Hague School-type to which his uncle was partial. He heightened his colour contrasts and began to concentrate more on structural elements. Undifferentiated greenery made way for tree-trunks and branches, introducing a sense of rhythm into the painting, while walls, doors and beams reinforced the composition. The contours of objects became more pronounced, especially in the transitional area between earth and sky. In these paintings the demarcation of the image is less accidental, and the image itself is positioned to meet the observer face to face. Art historians have often read into these characteristics the prefiguration of his abstract work, as indeed Mondrian himself did. Others relate them to certain aspects in the work of his great French contemporaries and direct predecessors, such as Cézanne, no

doubt assuming that on Olympus the gods converse only with one another. There are, however, no real grounds for such assumptions. The work that Mondrian produced during this period was to a considerable extent culled from contemporary Dutch sources, upon which he tried – with varying degrees of success – to place his personal stamp. He concentrated mainly on the painters of the Amsterdam School, men like G. H. Breitner, Isaac Israëls, Floris Verster, Eduard Karsen, Jan Voerman and Piet Meiners, and echoes of their work appear in his art.

One of the more interesting examples of work from the Winterswijk period is *Women and Child in front of a Farm* (illus. 6). It is done in robust strokes, and the details and modelling of the figures have clearly been sacrificed to the overall effect. One is struck by the imposing shapes and vivid colours of the barns in the background, which tend to dwarf the human figures. The women do not seem to enter into any real relationship with their surroundings, or with one other, while the placement of the two barns creates a kind of imbalance. It was presumably on

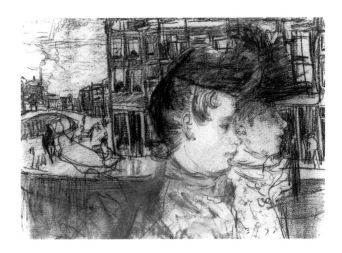

5
Isaac Israëls, *Two Women on a Canal in Amsterdam*, *c.* 1894, pastel and crayon on paper, 17.5 x 25. Van Voorst van Beest Gallery, The Hague.

the basis of such considerations that the canvas was later cut into two separate paintings. The facture, the use of colour, and the manner in which the figures in the foreground are cut off from the rest of the painting are all reminiscent of the work of Breitner and of Isaac Israëls (illus. 5). The similarity to both these artists is even more striking in *The Lappenbrink* (illus. 7). The architectural background is less overpowering, and the spatial placement of the figures in action is convincing. But the partial figure of a girl in the foreground remains a somewhat foreign element here, like the human figures in the previous painting.

In a number of landscapes probably dating from this same period, Mondrian pursued other artistic venues. The best of these is a gouache entitled *Village Church* (illus. 10), exhibited at Arti et Amicitiae in 1898. There are no figures in the work, and again we see a clear distinction between foreground and background, between the bare branches of hedge and trees, and the church and houses silhouetted against the solid grey sky. But using only the two thin lines formed by the ditches cutting across the meadow, the artist has subtly re-established the relationship between the chief components of the composition.

The motif of a centrally placed village church caught within a network of branches is highly reminiscent of the drawing *Vicarage Garden*, which van Gogh did in 1884 at Nuenen.[16] But it is by no means certain that Mondrian was familiar

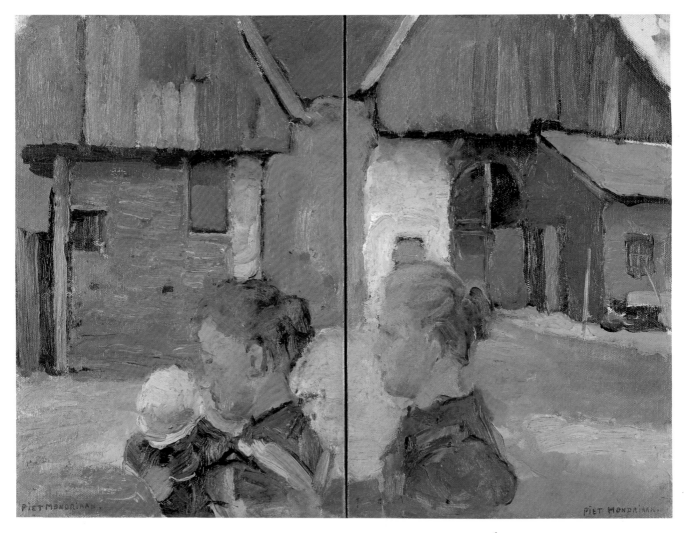

6
Women and Child in front of a Farm,
c. 1900, oil on canvas, two panels,
33 x 22 and 33.5 x 22.5. Haags
Gemeentemuseum, The Hague.

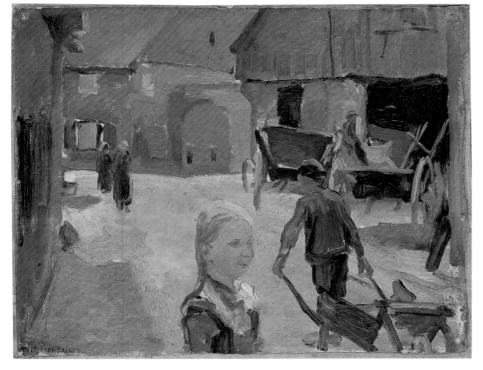

7
The Lappenbrink, *c.* 1900, oil on
canvas mounted on cardboard.
Private collection.

8
View of Winterswijk, c. 1898, gouache on paper, 52 x 63.5. Private collection.

9
Jan Voerman, *Cattle by the River IJssel, near Hattem*, c. 1895, watercolour and gouache on paper, 63 x 82.5. Private collection.

with this drawing, and the work he was doing around the turn of the century provides no indication that he took any particular interest in van Gogh. In fact, from a technical and stylistic viewpoint, and in the manner in which the composition is set down, Mondrian's *Village Church* is perhaps closer to Verster, Karsen or Voerman. The same might be said of the gouache *View of Winterswijk* (illus. 8). Spatially, the work is somewhat ambiguous. The figure of the girl with the cow in the foreground is isolated, although the sheaving woman on the left and the path in the centre do provide a transition of sorts to the little town in the background. On the right-hand side, however, the foreground and background have simply been juxtaposed. The right half, as well as the entire background, with the town silhouetted in the evening light against a darkening sky, are undisguised citations from the work of Jan Voerman (illus. 9).

There is a remarkable drawing by Mondrian that serves to link various works from the Winterswijk group (illus. 11). It is a kind of montage: in the foreground we see two partial figures of a girl – a shadowy one, slightly to the right of centre, and another, sharper image further to the right – that are almost identical to those in *The Lappenbrink*. The man with the wheelbarrow also resurfaces here, underneath the figure of the girl at the lower right. In the background there are farmhouses and barns in the region's vernacular style. The motif that is given in the greatest detail in the drawing, and emphasized by means of heavy lines, is the tree in the middle. In the foreground there are a few sketchy leaves and clusters of flowers. The latter two elements reappear almost literally in the painting *Spring Idyll*, which Mondrian entered at the spring exhibition of Sint Lucas in 1901 (illus. 12). It is an ambitious work. Here, as in the drawing, a number of motifs are combined: the clusters of flowers in the foreground, now recognizable as rhododendrons, the two partial female figures with the tree behind them, and in the distance the dark outlines of a farmhouse roof and the church-tower of Winterswijk. It is not a particularly good painting. The cropping of the figures is not as brusque as in the other paintings, due in part to the addition of the flowers, which direct the eye of the viewer inward, but the various planes do not merge to form an entity. Nor is the unity of the work fostered by the reddish-brown sauce in which it appears to have been dipped – 'a red confection' was the sarcastic comment penned by the critic Albert Plasschaert in the margin of his exhibition

catalogue.[17] The painting lacks the freshness of colour and the lively technique that make the other Winterswijk paintings at least palatable. The expression of the girls is also rather sentimental.

In the small group of works under discussion here dating from *c.* 1900, two clear developmental lines can be distinguished. On the one hand, we have *Women and Child in front of a Farm* and *The Lappenbrink*, which have no greater pretension than to represent a slice of life, expressed in the idiom of the Amsterdam Impressionism of Breitner and Israëls. On the other hand, there are *Village Church, View of Winterswijk*, and the failed apotheosis *Spring Idyll.* The faintly stylized forms, the dreamlike atmosphere, and the presence of elements with symbolic undertones all point to a supernatural reality, in the tradition of Dutch Symbolism.[18] Contemporaries were quick to see this, and it was no accident that in reviewing the 1901 exhibition, critics compared *Spring Idyll* to the work of Matthijs Maris and Jan Toorop. Mondrian had come to a fork in the road, and was uncertain which path to take. It is obvious now that he was examining the opportunities that each offered to paint scenes containing human figures. This was apparently an ambition of his, albeit one he could not quite bring off. He had difficulty in placing his figures convincingly in space, and even more difficulty in portraying them involved in action or interaction. The jury of the Prix de Rome for 1901 made it painfully clear to Mondrian that in this respect he had a great deal to learn. It is, of course, tempting to interpret this failing in psychological terms, and such an interpretation may indeed be justified. Perhaps Mondrian's inability to portray the human form reflected a repression of things physical that was rooted in his youth, or even an aversion to the nearness of others. In his interesting study on Mondrian's artistic personality, the historian Peter Gay draws attention to this characteristic flaw, without, however, linking it to the artist's problems with figure studies.[19]

After completing *Spring Idyll* and the works intended for the Prix de Rome, it was years before Mondrian again embarked on a work in which the human figure was of major importance, with the exception of routine commissioned portraits. As we shall see, this theme does not re-emerge until the period 1908–12, when it plays a crucial role. In the meantime Mondrian concentrated on the genre for which he displayed the most talent: landscape.[20] It was here that he developed the qualities already present in *Village Church* and other work completed around the turn of the century. His trees, cattle and buildings – such as farmhouses, windmills and factories – were often positioned parallel to the picture plane and in a carefully planned relationship to the edge of the painting (illus. 14). Many works display a subtle symmetry, often achieved by means of reflections in still water (illus. 15). He skilfully avoided the pitfalls of a rigid, stagey decor, making full use of the lively, flowing style of painting he was now developing. Mondrian's prowess as a landscape painter ultimately placed him head and shoulders above his uncle and artist friends such as A. G. Hulshoff Pol and Simon Maris, with whom he often painted out of doors in the neighbourhood of Amsterdam and in the country's eastern provinces. It is possible to analyze these qualities at length, but this would only confirm what has already been argued: that he was firmly anchored in a proven Dutch artistic tradition, to which he added some personal accents. Only a confrontation with the international avant-garde would induce him to take up a new position.

10
Village Church, *c*. 1898, gouache on
paper, 75 x 50. Private collection.

11
Farmyard at Winterswijk, c. 1900,
crayon on paper. Private collection.

12
Spring Idyll, 1900, oil on canvas,
75 x 64. Private collection.

Mondrian between Sluyters and Spoor

The Stedelijk Museum in Amsterdam was the scene for the first Group Exhibition of Living Masters, held in January 1909. It featured the work of Mondrian, Jan Sluyters and Cornelis Spoor. Jan Toorop had also been invited to participate, but he declined. All three painters were represented by large groups of paintings and drawings. The idea behind the exhibition, mounted by the museum's chief curator, H. P. Baard, was to counterbalance the overcrowded shows put on by artists' societies, and the even more massive exhibition of living masters held every year, the Dutch Salon. The text of the invitation reflected the artists' delight at having been offered this opportunity: 'The reason for the present show is that large exhibitions do not permit us to present a proper image of our artistic development, and the more individual facets of our work.'[21]

The exhibition received extensive coverage in the press, and much of the furore was generated by Mondrian's contribution. In general, the critics praised the earlier landscapes, mainly works which had been seen at previous shows: they displayed a sensitive talent, though the painter tended to neglect the form, which often remained somewhat sketchy. The fruits of his later artistic development, by contrast, were viewed with positive alarm. The reviews bristled with negatively charged terms such as 'visionary' and 'fantastic art'. The landscapes, flowers and female figures in Mondrian's more recent work, some painted in a 'riot of colour', were regarded as sinister visions that had very little to do with the reality of sensory experience. Presumably they reflected the over-emotional or melancholy state of mind of the maker himself; at best, Mondrian was seen as an earnest and sincere seeker who had lost his way. In the view of the critic and painter Conrad Kickert, he was labouring under a delusion, and his art was no longer in harmony with his own sensitive nature.[22] Even harsher was the judgement passed on him by Frederik van Eeden, a prominent writer of the Eighties Movement, and a physician and psychiatrist by profession. In an extensive article he branded the work of both Mondrian and Sluyters manifestations of decadence, and clear evidence of psycho-pathological tendencies. He held up to them the well-balanced and seemly work of their colleague Spoor as an example of wholesome art.[23]

Thus the three artists who manifested themselves at this exhibition were by no means all given the same reception by van Eeden and other critics. This might suggest that the combination was a more or less *ad hoc* affair, devised by the curator of the museum. However, the exhibition was mounted on the initiative of the artists themselves. And, in any case, it was a faithful reflection of the position that Mondrian then occupied in the Amsterdam art world: the link between the traditionalist Spoor, who was five years older, and the modernist Sluyters, nine years his junior. Sluyters was the pace-setter in the wave of innovations that had recently begun to sweep the world of Dutch art. In the course of his travels abroad as a Prix de Rome winner, he had lived in Paris during the second half of 1906, and it was there, at the Salon d'Automne, that he discovered the Fauves. The revolution this brought about in his work, following his return to Amsterdam, provoked one scandal after the other (illus. 13). The grant that accompanied the Prix de Rome was withdrawn, and in 1907 his painting *Femmes qui s'embrassent* was refused for an exhibition on the grounds that it was morally offensive.

13
Jan Sluyters, *Spanish Dancer*, 1906, oil on canvas, 95 x 107. Private collection.

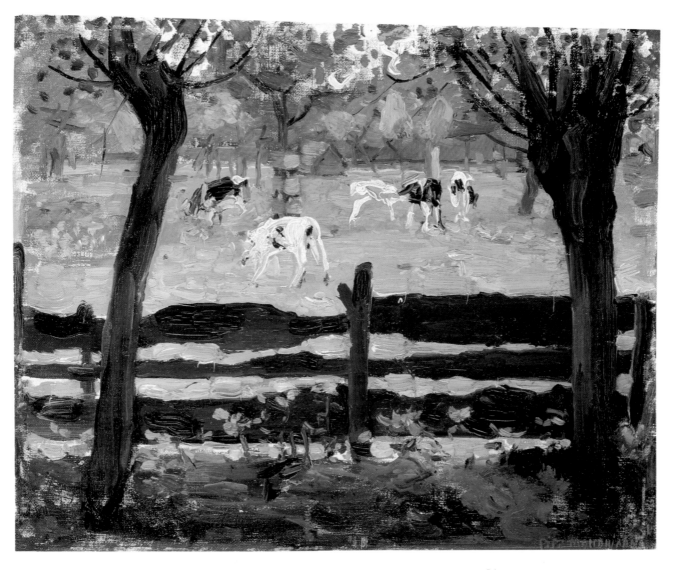

14
Calves in a Field bordered by Willow Trees, c. 1904, oil on canvas mounted on cardboard, 31.5 x 39. Private collection.

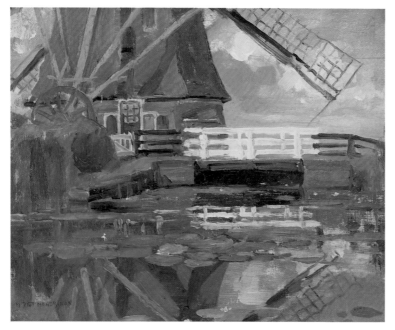

15
Mill by the Water, c. 1905, oil on canvas mounted on cardboard, 30 x 38. Museum of Modern Art, New York.

But Sluyters was not alone. The Dutch painters Kees van Dongen and Otto van Rees, both of whom lived in Paris, regularly exhibited work in the Netherlands, thereby ensuring that their compatriots were kept abreast of the latest developments in the French art world. Their work, especially that of van Dongen, displayed an intense and expressive use of colour and an extremely free, almost crude, application of the pointillist technique. This trio of young artists was joined by the old master himself, Jan Toorop; Francophile that he was, and always a bit impressionable, Toorop set about radicalizing his own pointillist technique. Thanks to the work of these four artists, Neo-Impressionism and the Post-Impressionism of Gauguin, van Gogh and Cézanne had gained a new and heightened topicality in the Netherlands, as indeed it had in France for Braque, Matisse, and the other Fauve painters. For the Dutch, it was important that in 1907 and 1909 two major private collections containing large groups of works by van Gogh and Cézanne found a semi-permanent home in the Rijksmuseum in Amsterdam.[24]

All this made an enormous impression on Mondrian, as witness the radical changes that – to the horror of the critics – were becoming apparent in his work around 1908, changes that placed him alongside Sluyters in the forefront of Dutch art. Mondrian actively sought the company of the young rebel, and the two were on good terms; together with Leo Gestel and other young artists, they were part of a circle which revolved around the Amsterdam collector J. F. S. Esser, a staunch supporter of their work.[25] In all probability, their friendship was not without an element of self-interest, for their collaboration and the protection they afforded one another served to strengthen their position within the artists' society Sint Lucas, where they exhibited their work.

The background to Mondrian's simultaneous friendship with the painter Cornelis Spoor was quite different.[26] At the time of the controversial exhibition at the Stedelijk Museum, there were already considerable differences between their work, and the two were to grow even further apart in the years to come. Spoor was a painter of capable but somewhat conventional portraits, landscapes and cityscapes, but what he shared with Mondrian was an intense interest in things spiritual. He had been an active member of the Theosophical Society since 1905, while Mondrian himself joined the Society on 25 May 1909. His application form, dated 14 May 1909, bears the signature of Spoor and the Sanskrit scholar J. W. Boissevain, beneath the solemn statement that 'the above applicant will, in our opinion, show himself to be a worthy member of the Society' (illus. 16). Early in 1912 Mondrian, in his turn, placed his signature alongside that of Spoor on the application for membership of the architect I. R. L. Adema.[27]

While his friendship with Spoor may have been a factor in Mondrian's decision to apply for membership, his interest in Theosophy had been awakened much earlier. Looking back, his younger brother Louis placed Mondrian's 'theosophical period' between 1903 and 1909.[28] According to Albert van den Briel, a lifelong friend, Mondrian's interest in theosophical literature had begun c. 1900, when after a fierce religious crisis he turned his back on the Calvinist faith of his parents.[29] What probably held the greatest appeal for him was the fact that the theosophical doctrine which Helena Petrovna Blavatsky (illus. 17) had developed in her search for truth did away with all the existing boundaries between the world religions and religious organizations. Theosophy apparently had no trouble in fusing the Judeo-Christian tradition with the religions, philosophies and mysteries

16
Mondrian's application form for membership of the Theosophical Society, dated 14 May 1909.

of ancient Greece, Egypt and India. At the same time it was receptive to new scientific developments, from Darwin's theory of evolution to the study of the human psyche. The formulation of the objectives of the Theosophical Society is brief and to the point: '1. To form a nucleus of the Universal Brotherhood of Humanity, without distinction of race, creed, sex, caste or colour. 2. To encourage the study of comparative religion, philosophy and science. 3. To investigate the unexplained laws of Nature and the powers latent in Man.'

It is possible that around 1900 Mondrian somewhere became acquainted with certain artists then active in the Vahana Lodge of the Theosophical Society. He had in any case been at the Academy with de Bazel, a founder member of the Vahana Lodge, while other theosophical artists were neighbours of his at various addresses in Amsterdam. But this remains a matter for speculation. Nor is there any documentary evidence that in the years which followed he associated his own art with theosophical ideas. In his landscapes, with their often mysterious atmosphere, he may well have been striving to 'investigate the unexplained laws of nature'. But, again, this is pure speculation. It is quite a different story when we come to the period during which he associated most closely with Spoor, and ultimately joined the Theosophical Society. After 1909 there is considerably more information available concerning Mondrian's intentions, not only in his own correspondence, but also in publications by writers with whom he was personally acquainted. An especially enlightening source is a letter written by Mondrian in the summer of 1909 to the author Israël Querido, whom he had met through Spoor. In a series of articles in the weekly magazine *De Controleur*, Querido had discussed the Spoor–Mondrian–Sluyters exhibition at great length, and he was one of the few critics who greeted Mondrian's more recent work with enthusiasm.[30] Querido had based his interpretation of Mondrian's work on information obtained from the artist, but there had been a few minor misunderstandings that Mondrian was anxious to set right. Querido published the letter in its entirety in the magazine, the first publication of a text by Mondrian. The letter is worth quoting at length, not only because in it Mondrian discusses his recent work, but also because of his reference to the desirability of a link between one's art and one's philosophy of life. He felt that it was this standpoint that distinguished him from other leading Dutch modernists, such as Sluyters and van Dongen.

17
Helena Petrovna Blavatsky, *c.* 1888.

Once more I must admire your deep sensitivity to so much, but I seem to have expressed myself to you incorrectly, if I made you believe that I wanted that girl to express a prayerful act. With that work I only envisaged a girl conceived devotedly, or viewed devotedly, or with great devotion, and, by giving the hair that sort of red, to tone down the material side of things, to suppress any thoughts about 'hair', 'costume', etc. and to stress the spiritual. I believe that colour and line can do much towards this end; moreover, I should not wish to do without line (regarding this I certainly must have expressed myself incorrectly). It is precisely the overall line of a thing which I find fundamentally important and, also, the colour. I said, indeed, that for me 'actions' were always such temporal things. They can develop into one great cosmic action, and accomplish great general things and thus can be very beautiful, but I meant to say that this was not my task. You have sensed and explained why human movement is a hindrance to me; but I did not mean to say that I could not find it beautiful in the work of others and in older, earlier periods. I find the work of the great masters of the past very beautiful and very grand, but you will agree with me that everything in our own time must be expressed very differently, even through a different use of technique. I believe that in our period it is definitely necessary that, as far as possible, the paint is applied in pure colours set next to each other in a pointillist or diffuse manner. This is stated strongly, and yet it relates to the idea which is the basis of meaningful expression in form, as I see it. It seems to me that the clarity of ideas should be accompanied

18
Devotion, 1908, oil on canvas,
94 x 61. Haags Gemeentemuseum,
The Hague.

by a clarity of technique. [. . .]

And further you write at the end that what I have achieved was obtained through my talent as a painter, etc., and you consider my work like that of others, who do the same. And yet I know that, despite much similarity, there is a great difference. It seems to me that you too recognize the important relationship between philosophy and art, and it is exactly this relationship which most painters deny. The great masters grasp it unconsciously, but I believe that a painter's conscious spiritual knowledge will have a much greater influence on his art, and that it is merely a weakness in him – or a lack of genius – should this spiritual knowledge be harmful to his art. Should a painter progress so far that he attains certain firsthand knowledge of the finer regions through development of the finer senses, then perhaps his art will become incomprehensible to mankind, which as yet has not come to know these finer regions. And you wish to warn me against this danger. I do not know how I shall develop, but for the present I am continuing to work within ordinary, generally known terrain, different only because of a deep substratum, which leads those who are receptive to sense the finer regions. Therefore my work still remains totally outside the occult realm, although I try to attain occult knowledge for myself in order better to understand the nature of things. Accordingly I observe my work attaining greater consciousness and losing all that is vague.

I hope that I have expressed myself clearly, although with your great talent you will discern my meaning in any case.

For the present at least I shall restrict my work to the ordinary world of the senses, since that is the world in which we still live. But nevertheless art can even now form a transition to the finer regions, which perhaps I am incorrect in calling spiritual, for everything that has form is not yet spiritual, as I read somewhere. But it is nonetheless the path of ascension away from matter. Well, dear Querido, with many heartfelt wishes, Piet Mondriaan.[31]

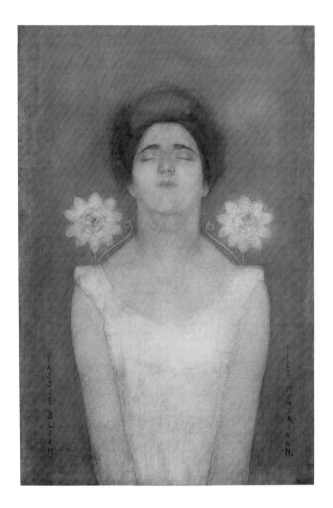

19
Passion-flower, c. 1908, watercolour on paper, 72.5 x 47.5. Haags Gemeentemuseum, The Hague.

20
Woman at Prayer, c. 1908, crayon on paper, 82 x 60. Private collection.

Visionary figures

The painting Mondrian discussed in such detail in his letter to Querido is *Devotion* (illus. 18). It was shown at the exhibition of January 1909, together with several other recent figure pieces, characterized by the critic H. L. Berckenhoff as 'draw-ings and watercolours of female figures (torsos) of an exceptionally strong, albeit somewhat sinister, expression'.[32] Since 1900 Mondrian had done few, if any, figure pieces, but now he apparently felt that this genre fulfilled a real need, at a time when he was preoccupied with the philosophical foundations of his art, and attempting to define his position with respect to other modern artists. *Devotion* may be under-stood as a sequel to the *Spring Idyll* of 1901 (illus. 12), but then in a modern version. It is executed in long, flowing strokes and vivid colours; the figure is no longer situated in a natural decor, but in an undefined space. There are no rhododendrons growing on bushes, but a single, isolated flower of indeterminate species hovering before the open eyes of the girl, an object of meditation.

In explaining this work to Querido, Mondrian placed special emphasis on the value of line and colour. The 'overall line', which here probably refers to the largely vertical direction of the brush strokes and to the colourful contours of face and hair, is deemed to be of great significance for the expression of a work. If we compare the painting in its present state with a photograph of *Devotion* published in February 1909, we see that Mondrian later even accentuated those lines.[33] As important as the overall line is the colour: the unnatural red of the girl's hair is

intended to suppress the material, and accentuate the spiritual. In his letter Mondrian does not seem to be implying that this was based on a particular theory of colour. Red is not by definition anti-materialistic or spiritual, even though it is allocated that role here. It is typical of his modern views that the expressivity of the painting is related not to its subject-matter, but first and foremost to the use of line and colour, and to the painting technique: 'It seems to me that the clarity of ideas should be accompanied by a clarity of technique.'

And yet Mondrian was still unable to break with Symbolist conventions, as witness the use of the familiar girl-and-flower motif in *Devotion*, signifying purity and a spiritual orientation. Another residual Symbolist element appears in the watercolour *Passion-flower* (illus. 19), where the female figure is similarly combined with 'hovering' flowers. The dating of this work is problematic. Robert Welsh believes that it must have been done around 1900. Cor Blok agrees that the detailed painting technique points to an early work, but he believes that thematically it is closer to the work done around 1908; it might well be one of the 'sinister' female torsos that the critic Berckenhoff saw at the exhibition in January 1909.[34] Moreover, Els Hoek notes the great similarity in composition, theme and dimensions between *Passion-flower* and the drawing *Woman at Prayer* (illus. 20), which is generally thought to date from 1908. She makes a good case for seeing the two works as an unfinished diptych, thus foreshadowing the triptych *Evolution* of 1911 (illus. 40), discussed below.[35] In *Passion-flower* the woman's expression is sad, and her eyes are closed. According to friends, Mondrian used the greenish colour of the throat to symbolize a venereal disease. Her earthly suffering is set off by the exalted *Woman at Prayer*. The fine lines of the underlying drawing betray that this figure, too, was originally depicted with her arms at her sides; corrected, her hands are shown raised before her breast. This is a gesture not so much of prayer – for that concept with its Christian connotations had already been rejected in *Devotion* – but rather of respect and surrender. Her eyes are open, and she is flanked by somewhat sketchy sunflowers.

There are other drawings and paintings consisting of figure studies presumably done around 1908; these, too, address the problems surrounding figure pieces that plagued Mondrian at the turn of the century, but now in a more topical manner. One of the most intriguing of these is the oil study *Two Women in the Woods* (illus. 22). Here Mondrian has placed the women in a natural setting, including a hill in the background, in contrast to the other figure pieces from this period, in which the figure is isolated, surrounded by individual attributes. The brusque truncation of the two females in the woods is reminiscent of the *Women and Child in front of a Farm* and *The Lappenbrink* (illus. 6 and 7). However, the free and flowing technique that characterizes the oil sketch points unmistakably to a date somewhere around 1908. In that year the forest-with-hill motif reappears in the large and impressive painting *Woods near Oele* (illus. 23).

Judging by the frequency with which figure pieces again began to feature in Mondrian's work in the years after 1908, and by the fact that he sent them to exhibitions, his ambitions in this direction had not waned. He appears to have reserved a special role for the human figure. In any case, this enabled him to demonstrate most clearly that his view differed from that of the painters with whom he exhibited: Sluyters's nudes were sensuous women of the world, while Mondrian portrayed pre-pubescent girls and sexless ladies with flowers next to

their heads. The internal and external differences between the work of these two leading lights of Dutch painting can no doubt be traced to their sources of inspiration. Sluyters was personally acquainted with the newest trends in French art, while Mondrian had only indirect knowledge of the Paris art world, gleaned from reproductions and the work of Sluyters and the 'Parisians' van Dongen and van Rees. Moreover, it is conceivable that Mondrian's search for inspiration was not confined to France. As several authors have noted, not only *Woods near Oele*, but also *Devotion* and other figure pieces done around 1908 bear a marked resemblance to the work of the Norwegian painter Edvard Munch.[36] His work could only have been known to Mondrian through reproductions, for none of it had ever been exhibited in the Netherlands.

It is possible that Mondrian was more directly influenced by the work of an artist whose style was somewhat similar to Munch's – Ferdinand Hodler. A one-man show of this Swiss painter was staged in 1907 in the building of the artists' society Sint Lucas in Amsterdam, of which Mondrian was a member.[37] Some sixty paintings and twenty drawings were on exhibit, both landscapes and figure pieces, among them the well-known *Communion with the Infinite* of 1892 (illus. 21). In view of his own ambitions, Mondrian cannot but have been attracted by the style of Hodler – and of Munch – which clothed the Symbolist legacy in a modern, colourful and expressive garb. This is the line of communication that links his work to what Robert Rosenblum calls the 'Northern Romantic tradition', which goes back to Caspar David Friedrich and Philip Otto Runge.[38] The influence of this tradition, alongside that of French art, is reflected in Mondrian's landscapes and flower paintings, as well as in the figure pieces done during this period. The fact remains, however, that those same figure pieces mercilessly expose Mondrian's weaknesses. While *Devotion* and *Passion-flower* are interesting, they are not of the calibre of his landscapes and flowerpieces of the same period. In the letter to Querido quoted above, Mondrian wrote that he was striving to ban from his work all action, all human movement, which he viewed as a 'temporary thing'. The state of the soul was now expressed in rigid poses. I suspect, however, that Mondrian was in fact using a philosophical argument to mask his own shortcomings.

Theosophy and art

Leaving aside their somewhat dubious quality, Mondrian's figure pieces immediately give rise to the question of the theosophical content of his art. The terminology he employed in the letter to Querido – 'the ordinary region of the senses', 'finer regions', 'finer expressions', 'path of ascension, away from matter' – justifies the conclusion that the philosophical foundation with which he was striving to endow his art was indeed Theosophy, though he did not use the exact word. But what did this actually mean? What did Theosophy have to do with the making of art? And was he able to find support and inspiration in the work of other theosophical artists, or in the theosophical literature? We know that at the time that Mondrian became interested in Theosophy, culminating in his decision to join its Society in 1909, art was at the very centre of attention in Dutch theosophical circles.[39] The Society counted among its members a large number of artists, not only painters but also architects and artists working in the applied arts; in Amsterdam there was even a special lodge for them, the Vahana lodge (although Mondrian

21
Ferdinand Hodler, *Communion with the Infinite*, 1892, oil and tempera on canvas, 159 x 97. Kunstmuseum, Basel.

22
Two Women in the Woods, c. 1908, oil on canvas mounted on cardboard, 27.5 x 38. Musée Départemental Maurice Denis, Le Prieuré, St-Germain-en-Laye.

23
Woods near Oele, 1908, oil on canvas, 128 x 158. Haags Gemeentemuseum, The Hague.

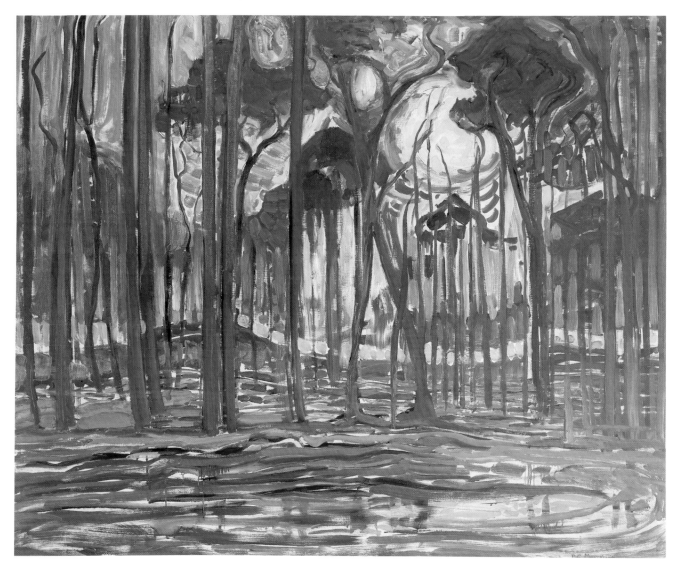

and Spoor were members of the regular Amsterdam lodge). Art was also one of the favourite topics of discussion in theosophical magazines, brochures and books. This did not, however, result in the formulation of unambiguous views concerning the relationship between Theosophy and art, let alone a clear-cut and recognizable theosophical style. In her comparative studies *Isis Unveiled* (1877) and *The Secret Doctrine* (1888), Blavatsky had scrutinized all existing religions and cultures, examining not only their scriptures, but also their visual manifestations and symbols. But she did not draw any final conclusions that might form the basis for something that could be termed theosophical art. She left her followers free to be guided by their own preferences, eclectic or otherwise.

Thus Mondrian saw around him a number of theosophical artists, each of them working out his own individual approach. In the work of his friend Cornelis Spoor there is little trace of a specific theosophical mind-set. His landscapes and portraits are quite ordinary, with only a barely discernible idealization in his children's portraits that might possibly have some special significance. By contrast, the architects K. P. C. de Bazel, J. L. M. Lauweriks and H. J. M. Walenkamp had already produced much that bears the unmistakable stamp of theosophical symbolism. We can assume that Mondrian was familiar with such work, if only through publications.[40] An interesting case in point is a woodcut by Lauweriks, which from 1896 onwards appeared on the cover of the magazine *Theosophia* (illus. 24). Within a decorative border of stylized buds and seed fluff, he placed, at the moment of opening, a lotus bud. A six-pointed star, also known as Solomon's Seal, the traditional emblem of the Theosophical Society, was formed by a white triangle pointing upwards entwined with a black triangle pointing downwards, signifying spirit and matter respectively. The sign in the middle of the star, a Tau cross with circle, is the Egyptian hieroglyph Ankh, which symbolizes life. The star itself is placed against the background of an open flower – presumably the open lotus as seen from above – and is surrounded by the symbols of reincarnation and the eternal cycle: the serpent Ouroboros biting its tail, while holding in its mouth a circle with a swastika motif. At the top of the page there is a winged circle inscribed with the sacred syllable *Om*.[41]

Around 1895, Walenkamp, whom Mondrian probably met personally some time later (the architect owned a painting of his dating from 1907), completed a number of works on paper that may originally have been conceived as designs for murals or leaded glass windows. These include an interesting untitled watercolour (illus. 25) that displays the same theosophical emblem featured in Lauweriks's work, here formed by a red triangle pointing downward (material forces) overlaid with a yellow triangle pointing upward (spiritual forces), both within a circle. The entire emblem functions as a kind of aureole for the figure of a man with large eyes and a long beard, a kind of priestly figure, presumably an artist. His spiritual orientation is given extra emphasis by his triangular forehead, which points upward.[42]

Not only the visual arts but also the theosophical literature then available in the Netherlands apparently displayed a fairly wide disparity of views. On the one hand, there were works like *Man Visible and Invisible* (1902, Dutch translation 1903) by C. W. Leadbeater, and *Thought Forms* by Leadbeater and Annie Besant (1905, Dutch translation 1905), in which a major role is reserved for auras. These writers believed that, whether through practice or innate aptitude, it was possible to distinguish the shapes and colours that go to make up the auras of both persons

24
J.L.M. Lauweriks, cover for the journal *Theosophia*, 1896. Private collection.

25
H.J.M. Walenkamp, *Enlightened Figure*, c. 1895, watercolour on paper, 61.5 x 44. Nederlands Architectuurinstituut, Rotterdam.

26
Anonymous, *Musical Forms
(Gounod's Faust)*, illustration from A.
Besant and C. W. Leadbeater,
Thought Forms, London, 1905.

and objects, and to 'read' their character traits, thoughts and feelings (illus. 26). On the other hand, in the lectures which Rudolf Steiner held in 1908 in the Netherlands and elsewhere, he took pains to stress that the exalted knowledge of the theosophist is drawn from the ordinary, visible world, through 'conscious observation'.[43]

All this means that Mondrian was more or less free to define his own position as a theosophical artist. He was even free, as Spoor had been, to allow little or nothing of his theosophical convictions to shine through in his art. However, it is clear from his letter to Querido that Mondrian was already decided on that point: for him, art and philosophy were inseparable. And it is equally clear that he made every effort to avoid the arcane symbolism that is accessible only to the initiated, such as that employed by Lauweriks and Walenkamp. He said as much in his letter to Querido: his work was 'totally outside the occult realm', remaining within 'the ordinary world of the senses'. His portrayals of female figures surrounded by floating blossoms, as in *Devotion*, *Passion-flower*, and later in *Evolution* represent the extremes of irreality to which he felt he could go. In other figure pieces dating from 1908 and later, such as his painted portraits of girls and farmers in Zeeland, and his self-portraits drawn in charcoal and crayon, even these attributes have been omitted, and in the main the quality of these works is better. Indeed, in the drawing *Self-portrait* (illus. 27) he had no need of symbolic attributes: the en face pose, the large, staring eyes and the way the face seems to loom out of the darkness are suggestive enough of the painter's contemplative mind-set and his 'visionary gifts', as the critics were inclined to call them. That is not to say that no symbolism exists in Mondrian's work; it is, however, a natural symbolism of the simple, everyday sort, and not a system of signs requiring occult or other specialized knowledge.

This same detachment is evident in Mondrian's attitude to the portrayal of auras. Neither in his figure pieces, nor in any other genre does he make use of thought forms with which Leadbeater and Besant illustrated their books; presumably he found them too artificial to be entirely compatible with his art. What he did do in many of his works was to surround the motifs – whether human figures, flowers, buildings, or elements of the landscape – with a light that bore some resemblance to an aura, so that the motifs seem to vibrate, radiating an energy that brings their entire surroundings to life (illus. 28). In general, Mondrian remained faithful to the ordinary subjects he had always preferred and which he was best at: landscapes, with or without buildings, and flowers. He shared Steiner's opinion that visible reality provided more than enough opportunity for 'conscious observation'. Tellingly, one of the few books with which he never parted was the published text of Steiner's Dutch lectures of 1908.[44] What Mondrian was trying to do was to suggest the 'finer regions' by means of his portrayal of reality. He did so by linking specific subjects with a special use of the formal means he had at his disposal: line and colour.

27
Self Portrait, *c.* 1909, charcoal on paper, 30 x 25.5. Haags Gemeentemuseum, The Hague.

28
Portrait of a Man, *c.* 1909, charcoal on paper, 72.5 x 51. Private collection.

The cycles of nature

From around 1900 onwards, Mondrian was drawing, painting and exhibiting flower pieces. But, as in the case of his figure pieces, the frequency with which he produced works of this type increased markedly after *c.* 1908.[45] Of particular interest is a series of works executed in an extremely elongated format, each of which portrays a single, long-stemmed flower in a state of decay. Some of them are sunflowers, inviting the obvious association with van Gogh. He was not the only Dutch painter to seize on this motif; whether prompted by veneration for van Gogh or for other reasons, there was a veritable boom in sunflower paintings. For years an equally popular motif had been chrysanthemums, which Mondrian frequently depicted. While he was not particularly original in his choice of subject-matter, he did place his unmistakable stamp on the renderings of those flowers. It is their expressive rather than their decorative qualities that are displayed here: they are not a component in a pleasing decor, but living creatures. *Dying Chrysanthemum* (illus. 29), the most fully worked out of all the flower paintings from this period, shows a curved stem with drooping leaves and a corolla inclined downward, indicating that the flower is beginning to wither; the petals on the underside are limp. The fact that the corolla calls to mind a human skull seen in profile is probably no coincidence. Not only is the process of dying visible in the shape and colour of the flower, it seems to manifest itself in the surrounding space as well. On the right, the brush strokes display an upward movement, and at the level of the corolla twisted strokes in shades of yellow, pink and green seem to echo the shape of the flower in bloom. On the left, the decay is paralleled by downward

29
Dying Chrysanthemum, 1908, oil on
canvas, 84.5 x 54. Haags
Gemeentemuseum, The Hague.

44

30
Tiger-lilies, 1909, watercolour on
paper, 39 x 44. Private collection.

31
Cat's-tail, *c.* 1909, charcoal on paper,
46 x 69. Haags Gemeentemuseum,
The Hague.

strokes, accentuated by the dark vertical strip at the edge of the painting, which forms a kind of curtain. In his seminal essay, 'Mondrian and Theosophy', Robert Welsh associates the painting with theosophical theories of evolution, in which the process of dying is seen as a positive phenomenon, crucial to the emergence of new and higher forms of life.[46] We may safely assume that Mondrian did indeed have such a symbolic meaning in mind, not least in view of the fact that he entered the painting under the name *Metamorphosis* at an exhibition in Brussels.

It is a moot point whether all the flower motifs Mondrian painted during this period should be seen in this light. There are, however, some paintings and drawings that decidedly lend themselves to a similar theosophical interpretation. A particularly fine example is the watercolour *Tiger-lilies* (illus. 30); it was probably painted in 1909, judging by the manner in which the strokes of colour are applied, in a somewhat looser version of pointillism. Here the artist has juxtaposed two stages in a process that encompasses both flowering and decay: one tiger-lily, straight and tall, is positioned at the centre, en face, in all its glory. The other, lower and in profile, is already wilting. In his watercolours of amaryllises (flowers that resemble the six-pointed star of the Theosophical Society), Mondrian sketches the same process in three or four stages. Yet another variation on the cycle of nature is seen in a series of lovely charcoal drawings of cat's-tails (illus. 31) done about the same time. In these species all the various stages of growth are displayed on a single stalk: at the top, Mondrian has depicted the flowers in bud form; further down, their tiny star-shaped crowns are open, while at the very bottom of the stalk the flowers hang limp and wilted, and finally drop to the ground.

In these paintings and drawings of flowers Mondrian was portraying natural processes: in a single flower, in a composite, or in a group of two or more flowers. What he had found so difficult in those early scenes with two figures – the convincing representation of their interrelation – is pulled off with aplomb when he undertook to depict two tiger-lilies or callas. The comparison may seem somewhat forced, but it touches on a knotty problem that is relevant to all his work of this period, regardless of the individual theme or technique.

In his letter to Querido, Mondrian voiced his aversion to portraying action or human motion, because it was only a 'temporary thing'. This objection has about it the ring of purism, in the tradition of Lessing's *Laokoon*: visual art should portray spatial situations, leaving temporal events to other arts, such as literature and music. Mondrian did indeed shun everything that might be suspected of having a narrative content. But he apparently considered it important for his art to express the basic tenets of the theosophical ideology, in which the doctrine of evolution occupies such a prominent place. That in itself implies the portrayal of a process of change and growth within the cosmos. This must have formed something of a dilemma for Mondrian. A possible solution presented itself in the flower theme, where the process of change is a natural given, one which can occur visually in the space of a single moment. Another alternative was to portray each developmental stage on a separate canvas or sheet of paper, and then display them as a unit. It has already been suggested that *Passion-flower* and the unfinished *Woman at Prayer* (illus. 19 and 20) were originally intended as a diptych, possibly even as two parts of a triptych. The triptych *Evolution* (illus. 40) is, in any case, a complete work in which the action or development is spread over the various parts.

It might be worthwhile to re-examine Mondrian's *œuvre*, to determine whether

there are other works that by virtue of theme, expression and format can be seen in a cyclic connection. Admittedly, research of this kind is hampered by various factors. In the first place, we know that Mondrian occasionally copied his own work, or came up with a variation on a previous work if there was a perceived demand for a particular theme or subject-matter. In the second, he was in the habit of using certain drawings as the basis of paintings done over an extended period of time. The 'series' that result are often seized on in popular art literature to illustrate Mondrian's evolution toward abstraction, despite the fact that they were not made with such a didactic aim in mind, and certainly did not originate in such a neat sequence. Replicas and variations of this nature were part of his studio routine. Thus care should be taken to distinguish such pieces from works that may have been intended as a cycle. We must also establish whether Mondrian ever presented 'cyclical' works at an exhibition. There is very little material to go on, but there is one clear example, which comes from a source that may be presumed to be reliable. In his review of the exhibition of January 1909, the critic W. J. Steenhoff, who knew Mondrian, said of three landscapes with haystacks: 'These three little paintings form a cycle; they belong together' (illus. 32–4).[47] According to Steenhoff, the haystacks had been painted under different weather conditions, at different moments of the day (or rather, at evening and night). Monet had of course already done something similar, even using the same theme, but Steenhoff's phrasing leads us to believe that in his haystack landscapes Mondrian was striving to depict different stages of dematerialization. That specific aim clearly brings these landscapes closer to his cyclic figure pieces, such as the 'diptych' and the triptych *Evolution*.

Landscapes in Zeeland

During this period Mondrian's landscapes, traditionally his forte, underwent radical changes, changes that were related to his discovery of new locations. It was in September 1908 that he and Spoor first visited the seaside resort of Domburg in the province of Zeeland. For Mondrian, a visit to Domburg was to become an annual event, and he often remained there for extended periods. Jan Toorop, whom Mondrian had met in Amsterdam, was at the centre of the Domburg coterie of artists and art-minded summer guests. Spiritually, Mondrian must have felt quite at home in this circle. It included the Neo-Impressionist painter Ferdinand Hart Nibbrig, who was a theosophist, and the painter Jacoba van Heemskerck, to whom for a time Mondrian even gave drawing lessons, and her friend, the collector Marie Tak van Poortvliet. The two women joined the Theosophical Society in 1910 and 1912 respectively.[48] His relationship with Toorop, who was a Roman Catholic, was equally close. In October 1910 Mondrian wrote from Domburg to Spoor, saying he had again had an 'intimate conversation' with Toorop, and that they were in agreement on the weightier matters: 'He sees the Catholic faith as A. Besant views it in its primeval period: the Catholic religion as it was originally is the same as Theosophy, is it not? I remained broadly in agreement with Toorop, and I could tell that he goes to the depths, and that he is searching for the spiritual.'[49]

There is a kinship between the Zeeland work of Toorop and Mondrian, which is anchored in technique, notably the free use of pointillism (although Mondrian

32
Haystacks, 1908, oil on canvas
mounted on cardboard, 34 x 44.
Private collection.

33
Haystacks, 1908, oil on canvas
mounted on cardboard, 30.5 x 43.
Private collection.

34
Haystacks, 1908, oil on canvas
mounted on cardboard, 34 x 44.
Private collection.

was admittedly far bolder in this respect), and in the choice of subject-matter. Almost all Mondrian's new motifs – the dunes and the sea, the church steeples and lighthouses, and heads of farmers and young girls – appear in the work of Toorop as well. However, the difference is that Mondrian invariably presents these motifs on their own: there are no figures in the landscapes, and in the figure pieces there is no indication of the surroundings. The objects must speak for themselves. In Toorop's work, by contrast, there is invariably some picturesque touch or added symbolic detail. In the drawing *Trust in God*, for example, dating from 1907 (illus. 35), Toorop's farmer is portrayed en face, his eyes cast devoutly upwards. Behind him the lighthouse of Westkapelle (an old Gothic church-tower) rises into the sky, an emblem of the steadfastness of the farmer's Christian faith. This is reinforced by the cross-shaped window behind his head.[50] Not only is Mondrian's *Lighthouse in Westkapelle* (illus. 36) a far cry from Toorop's drawing, it also contrasts sharply with his own earlier works in which the towers of churches featured – *Village Church* (illus. 10), *View of Winterswijk* (illus. 8) and *Spring Idyll* (illus. 12). There they are placed within a context, the churches serving either as the actual centre of a village, or the idealized centre of a community of the faithful. In the paintings dating from 1908 and later there is no indication of the position of the buildings in relation to their surroundings, or their function as ecclesiastical institutions. They are apparently intended quite simply as symbols of spiritual edification found in cultures the world over; this finds direct expression in the vertical shapes, and is accentuated by the vertical format of the paintings themselves. The towers and church facades are seen from street-level; they reach almost to the upper edge of the painting, or are cut off by the frame, which gives them the air of immense monoliths, rising up from the base of the painting.

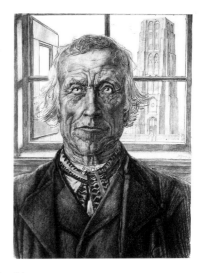

35
Jan Toorop, *Trust in God*, 1907, crayon on paper, 55.5 x 42. Museum Boymans-van Beuningen, Rotterdam.

Contrasting sharply with the overpowering verticality of the paintings with a tower motif are the seascapes and the beach and dune scenes, in which the horizontal orientation is reinforced by the horizontal format. In texts dating from only a few years later, Mondrian himself associates the vertical with the masculine principle, and the horizontal with the feminine principle.[51] He does so not in a restricted sexual sense, but rather in the broader sense in which Western and Oriental cultures – and Theosophy – view such concepts, and see them symbolized in a variety of forms. We may assume that Mondrian was aware of such symbolism when he painted his first upright towers, and the reclining seas and dunes. In paintings like *Dune II* (illus. 37), in particular, there are strong associations with the female body in the contours of the dunes and the inner lines applied with the brush in between the large dots. Perhaps such works refer to 'mother' Earth, just as the sea, whose vast horizontal expanse is traditionally seen as feminine, embodies a reference to water or the ocean as the source of all creation. Elaborating on this natural symbolism, we might choose to see the fascinating painting *Sea after Sunset* (illus. 38) as an integration of the four elements – earth, air, fire and water.

At least as important as the choice of motifs and any symbolic meaning they may have is the way they are portrayed. Decisions as to form, colour and the technical execution of a painting were also of great importance to Mondrian. The form expressed his vision of matter, a vision that was unmistakably bound up with Theosophy: his repression of the material side served to highlight the spiritual side. For example, in the *Lighthouse in Westkapelle*, the pointillism in both the building and the sky is accentuated to such an extent that the stone mass seems

37
Dune II, 1909, oil on canvas,
37.5 x 46.5. Haags
Gemeentemuseum, The Hague.

etherealized by the sunlight. This kind of light symbolism remained with him even after he forsook pointillism. In a painting like *Church in Domburg* of 1911 (illus. 39) the dematerialization under the influence of light is intensified: while the base of the tower is in shadow, the upper part is almost transparent, as if its substance was not of this world. The almost totally abstract paintings from 1914 (illus. 57) and 1916 (illus. 67), with their architectural motifs, still suggest the immaterial in the way the colours pale and fade upwards.

It was quite clear to contemporary critics that Mondrian made use of such expressive means in order to portray his theosophically coloured vision of the material world, and to provide a receptive audience with some idea of the 'finer regions', as he wrote to Querido. M. D. Henkel, who first met Mondrian in 1908, wrote in a review of 1910 of the Sint Lucas exhibition that

as a result of his marked subjectivism and his theosophical-mystical philosophy of life, the sensual impression has evolved into a kind of vision: gazing in contemplation, he loses himself in the things he wishes to portray, surrendering to them with such intensity that the force of his observation lends them an entirely new aspect, and they seem to be immersed in strange currents of colour.[52]

36 (opposite)
Lighthouse in Westkapelle, 1909, oil on canvas, 39 x 29. Galleria d'Arte Moderna, Milan.

At that same exhibition W. J. Steenhoff, also an acquaintance of Mondrian's,

38
Sea after Sunset, 1909, oil on
cardboard, 63.5 x 76. Haags
Gemeentemuseum, The Hague.

noted a tendency among the modern painters to search for the essence of things,
and found this to be most evident in the case of Mondrian:

Such inclinations, but then with a pronounced tendency towards symbolization, are recognizable
in the work of Mondrian – in his portrayal of the old church, whose contours [. . .] rose before
him as in a vision, and which he placed en face, in an almost primitive interpretation, within a
narrow framework, in order to complete the total domination of the monumental image.

After discussing several figure pieces, landscapes, and flower pieces, Steenhoff
remarks that Mondrian's

observation is highly sensitivistic, the astounded vision of a gazing eye, striving to fathom in
planes of radiant colour the secrets of living organisms [. . .]. The insatiable eye plumbs the
immeasurable depths, the infinite self-multiplication of the myriad legions of Chaos, in search
of the world of Nothingness. And the eye transcends its own limitations, distilling from its
observations that which lives and has its being in the person, not in the visual world. There is
a drift from the material to the abstract, a blurring of the line between objective and subjective.[53]

39 (opposite)
Church in Domburg, 1911, oil on
canvas, 114 x 75. Haags
Gemeentemuseum, The Hague.

In this piece of purple prose Steenhoff, like Henkel before him, maintains that
Mondrian's art flows from a meditative, trance-like mode of contemplation, and
that the painter looks beyond the world of things, to the world of abstractions.

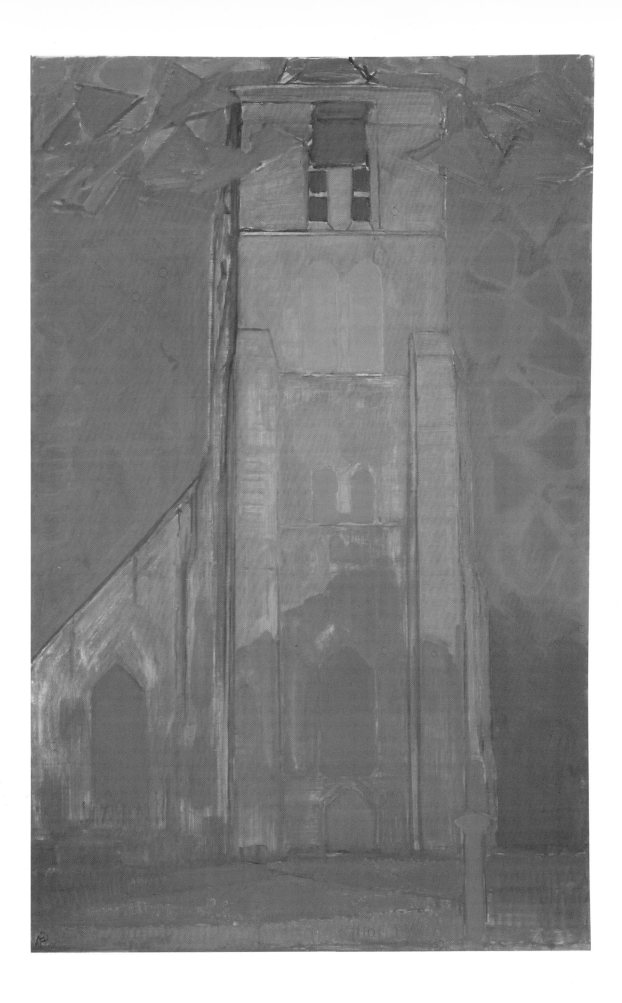

We may assume that the interpretations voiced by such sympathizers were based on a knowledge of Mondrian's own views and intentions, views and intentions that – as is clear from the general reaction to his work – set him apart from the other modernist artists then active in the Netherlands.

The first taste of Cubism

Critics may well have felt compelled to explain to the general public that Mondrian's Zeeland landscapes, with their *couleur locale*, were actually the work of an artist with a 'theosophical-mystical' ideology. There was, however, no need for such clarifications in the case of his entry for the first exhibition of the Moderne Kunst Kring, held in October 1911 at the Stedelijk Museum in Amsterdam. On that occasion he exhibited his most eminently theosophical work, the triptych *Evolution* (illus. 40). Robert Welsh has gone into great detail to explain that this triptych portrays what theosophical doctrine saw as the development by which Man is transported from a lower, material state to a state of spiritualization and insight.[54] This process, by which Man rises above matter, is depicted in three stages, starting with the left-hand panel, going on to the right-hand panel, and ending with the middle section. The female figure on the left is gazing upward, with a sorrowful expression on her face; she is flanked by red flowers, and the dark centres of the flowers, together with her nipples and her navel, form triangles that point downward. The female figure on the right is also gazing upward, but her pose is less constrained. The flowers beside her, yellow six-pointed stars with white triangular hearts pointing upwards, are less earthly in colour and shape. Nipples and navel form a diamond made up of two triangles, one pointing up, the other down. In the centre panel the female figure has reached a state of supreme insight: her eyes are wide open, her head is framed in radiant yellow and white, and the triangle of nipples and navel points upward. To underscore the fact that this represents the culmination of the development, the centre panel is a few centimetres larger, and elevated slightly in relation to the side panels.

Here, by way of exception, Mondrian is harking back to the figure pieces of 1908 with their symbolic attributes: *Passion-flower* and the *Woman at Prayer* (illus. 19 and 20). The remaining paintings at the 1911 exhibition portrayed 'ordinary' subjects drawn from visible reality: a flower piece (lost), two dune scenes, *Church in Domburg* (illus. 39) and *Windmill* (illus. 41). And yet these, too, display a strange sort of kinship with *Evolution.* The flowers and the Zeeland motifs have appropriated some of the same forms, and while their symbolism is less explicit than that of *Evolution*, they are not without significance. It is no coincidence that the shape and position of the windmill are so similar to those of the female figure in the triptych. Viewed from below, the cap of the windmill follows roughly the contours of the head of the female in the side panels, while the fantail forms a triangle pointing downward; the axle-hub for the sails, which is normally round, is in the form of a diamond. The sails themselves do not form a cross, but are set diagonally, a more dynamic angle, perhaps to suggest the ultimate cycle of all creation. Like the diamond hub, the sails combine to form an upward triangle with a downward one. This anthropomorphic mill bears the most resemblance to the right-hand panel of the triptych, which also depicts an intermediate stage of evolution by means of triangles facing up and down. In the large *Dune* we see the same formal

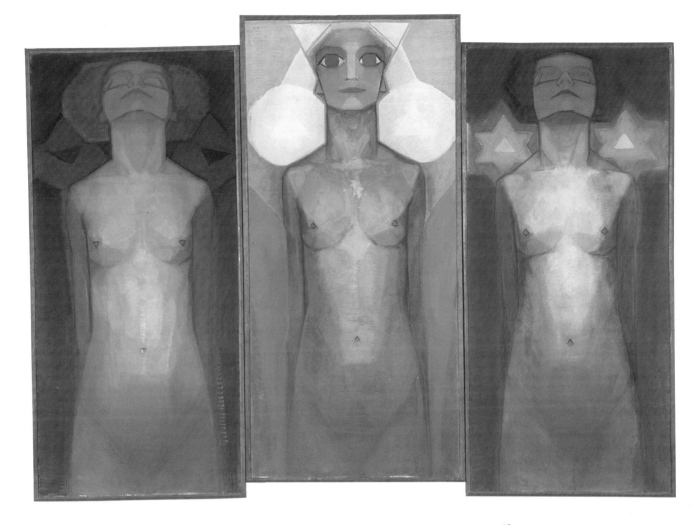

40
Evolution, 1911, oil on canvas,
triptych, 178 x 84, 184 x 87,
178 x 84. Haags Gemeentemuseum,
The Hague.

elements, albeit somewhat shrouded. It is only in the *Church in Domburg* that
almost all the triangular shapes point upwards, in accordance with the more exalted
motif. The colour, too, is more ethereal than in *Windmill* or *Dune*. As regards the
expression of the *Church in Domburg*, it is closer in feeling to the centre panel of
the triptych. The large wide eyes of the female figure correspond to the belfry
arches.

These paintings represent a marked departure in technique and form of lan-
guage from Mondrian's previous work. The motifs are presented in sharply
defined, geometric shapes, and the palette has been reduced to accords of two or
three strong, mainly contrasting, colours. The flatness of the paintings is enlivened
only by the vigorous and confident brush strokes, the effect of which is largely
lost in reproduction. However, this departure does not mean that the objects
portrayed are more concrete and material than before: on the contrary, they are
more phantom-like than the earlier towers, church facades, and dunes painted in
a diffuse pointillist style.

The critics reviewing the exhibition in October 1911 were quick to note the
momentous visual changes that had taken place in Mondrian's work, changes not
to their liking. In the past he had enjoyed little-enough support, but now almost
all the reactions to his recent work were highly critical. Cornelis Veth, for example,
jokingly referred to the three women in *Evolution* as the 'Theosophical Graces',

55

41
Windmill, 1911, oil on canvas,
150 x 86.
Haags Gemeentemuseum,
The Hague.

while J. H. de Bois said it displayed the profundity of a 'tailor who subscribes to *De Vrije Gedachte*' (a journal of the Free Thinkers). In his review of the large dune landscape, Frans Vermeulen jibed that this 'unimaginative combination of barren triangular planes' seemed to be stamped with the seal of the Theosophical Publishing Society. Other critics too, among them N. H. Wolf, rejected the 'system of triangles and pyramids' into which Mondrian was twisting visible reality, because they felt that unbiased observation was being sacrificed to a theoretical principle.[55] Some of the blame was attributed to the pernicious influence of Cubism, which was then just beginning to attract attention in the Netherlands and which featured prominently in the exhibition where Mondrian showed these paintings.

The Moderne Kunst Kring, founded towards the end of 1910 by the painter and critic Conrad Kickert, Mondrian and Sluyters, with Jan Toorop as president, was intended as an alternative to the existing societies of artists with their heterogeneous membership.[56] The idea was to organize exhibitions at which the Dutch modernists could present a united front, together with selected kindred souls from abroad. Thanks to the extensive contacts of Schelfhout, who had lived in Paris for many years, and Kickert, who had recently moved there, there was a strong Parisian showing at the first exhibition of the Moderne Kunst Kring in October 1911. There were no works by Matisse, although he had been invited, but the exhibition did include seven pieces by Picasso, three by Braque, several by Maurice de Vlaminck, Dufy and Othon Friesz, and no fewer than fifteen by Henri le Fauconnier and nineteen by Auguste Herbin. Thus there was a strong accent on Cubism, although this was primarily the Cubism of the Montparnasse circle, frequented by both Kickert and Schelfhout. The originators of the new style, Picasso and Braque, were represented by relatively modest entries, and then only older work loaned by the collector and dealer Wilhelm Uhde, among others; no recent work had been entered by the artists or by the dealer Daniel–Henry Kahnweiler (illus. 42). Cézanne, generally viewed as the father of Cubism, was represented by a large number of works that had been given on loan to the Rijksmuseum in 1909 by the collector Hoogendijk.

It has always been assumed that this was the first time that Mondrian came face to face with examples of Cubist art. He was supposed to have heard some talk of Cubism from the 'Parisians' Kickert and Schelfhout – the latter had been the first Dutch painter to adopt a Cubist style – and from Sluyters and Gestel, who had been to Paris in the spring of 1911 and paid a visit to Uhde's collection. And he might have seen some of the few reproductions of Cubist art then in circulation. But such information as could be gleaned from these sources would have been too limited and second-hand to be of immediate use to him. However, from Mondrian's letters to a friend, the violinist Aletta de Jongh, that have recently come to light, it is now known that he actually made a visit himself to Paris at some time during that year. In an undated letter, probably written in the late spring, he announced his plans for a ten-day trip that he expected to be 'very instructive'. On 17 August, obviously after a long interval in their correspondence, he confirmed that he had been to Paris, without giving any further details of what he had seen. It is tempting to think that his main purpose had been to visit the Salon des Indépendants, held in April–May, in which his painting *Soleil* was shown: his Paris debut. If so, he must also have seen the rooms at the Salon where Albert Gleizes, Jean Metzinger, Le Fauconnier, Robert Delaunay and Fernand

42
Installation photograph of works by Braque and Picasso at the 'Moderne Kunst Kring' exhibition, Amsterdam, 1911.

43
Mertites, portrayed twice, with the young scribe and priest Chennoe, Sakkara, 5th Dynasty, *c.* 2400 BC, painted limestone, 69 x 55 x 34. Rijksmuseum van Oudheden, Leiden.

Léger, the Cubists of Montparnasse, exhibited as a group, causing a sensation. But although Mondrian may have seen their work and have been impressed by it, there are still no grounds for labelling as Cubist either *Evolution*, *Dune* or any other of the paintings dating from 1911, as a few critics did. The stylization and structure of these works owe far more to the geometric principles that had long been a tradition in Dutch monumental and applied art, and which prominent artists such as Willem van Konijnenburg and Toorop had recently introduced into painting.[57] They had done so on ethical and aesthetic grounds, and this was equally true of Mondrian, although his work was coloured by his own particular philosophy of life. The rigid frontality and geometrization of the female figures in *Evolution*, for example, can be linked to Egyptian art, to which great significance was attached in theosophical circles. It is possible that Mondrian took a sculpture in Leiden's Museum of Antiquities as his model (illus. 43). His interest in Egyptian art is also clear from several postcards he sent in 1911–12 to the critic W. J. Steenhoff, showing Egyptian sculptures from the collection of the Leiden museum as well as those of the Louvre.

The somewhat exalted nature of the work that Mondrian did in 1911 is ample proof of the fact that he was something of a loner within the Dutch avant-garde, an individual who did not meet with a great deal of sympathy from the critics or from his fellow artists. At the time of the Moderne Kunst Kring exhibition, Ferdinand Hart Nibbrig, himself a theosophist, wrote to the critic Albert Plasschaert: 'I can muster no great enthusiasm for these astral outpourings [. . .]. For a time Mondrian aroused my interest, but this did not last long.'[58] And it is said that at the sight of Mondrian's entries to the exhibition, fellow modernist Schelfhout laughed so hard that he fell against a sofa.[59] This is perhaps understandable in the case of *Evolution*: it is a melodramatic painting, and one more example of Mondrian's lack of prowess in the execution of figure pieces, especially when he was trying to imbue them with a deep symbolic significance. The other works he

entered were clearly better. These shortcomings were not lost on the artist himself. In 1914, looking back on the work of three years earlier, he wrote to Schelfhout that 'it was still not good'. It was 'very serious work [. . .] although it should have been done differently'.[60]

Differently, yes, but in what sense? In a Cubist mode, but then truly Cubist. The work of the French Cubists, now including Picasso, that he saw at the Amsterdam exhibition must have been a challenge. Here was a clear formal method, which seemed eminently suitable for portraying the development from a material to an immaterial world. On 20 December 1911 Mondrian had his name removed from the municipal register in Amsterdam; on 2 January of the following year he co-signed the above mentioned application form for a theosophist friend. He must have left for Paris shortly after. This was a major step, which involved leaving behind family and friends and even a fiancée,[61] and launching himself into an utterly new environment, one in which he knew no one except a few Dutch artists like Kickert and Schelfhout. Mondrian was then almost forty years old. It was only in the past four years or so that he had made his presence felt in the ranks of the Dutch avant-garde. Except for group shows in Brussels in 1910, and Paris in 1911, he had not exhibited abroad. He had travelled little, and had seen little of what was going on in other countries. No doubt his confrontation with Cubism, both in Paris and at the exhibition of the Moderne Kunst Kring, had suddenly brought it home to him that he was doomed to remain a provincial painter if he did not take measures to escape from the too-familiar world of Amsterdam and Domburg. To realize his ambitions as a modern artist, he would have to go to the capital of modern art – Paris.

Mondrian's first year in Paris

When he arrived in Paris Mondrian briefly made use of a guest-room at the headquarters of the French Theosophical Society.[62] From there he moved first to a studio at 33 avenue du Maine and then to a studio complex at 26 rue du Départ, where Kickert and Schelfhout also lived and worked. They introduced him to several French artists, and at the Monday meetings organized by Kickert, who was fairly well-off, he regularly saw Le Fauconnier and sometimes Léger. In fact, this was the beginning of Mondrian's lifelong admiration for Léger's work. Elsewhere he met other foreign artists: Otto Freundlich from Germany; the Mexican Diego Rivera, who lived at 26 rue du Départ, and Gino Severini from Italy. He was also on good terms with several younger Dutch artists, including Otto and Adya van Rees, the painters Peter Alma, Jan Verhoeven, Jacob Bendien and Jan van Deene, as well as the painter and sculptor John Rädecker.[63]

In one sense, Mondrian did attract attention in avant-garde circles. According to van Deene, Mondrian never failed to put in an appearance at openings, indeed someone christened him 'Here-I-am-again-Piet'.[64] But such contacts as he made were largely casual, and he remained somewhat isolated. He had no artistic relationships of any depth or intensity, and even his friendship with Kickert (who was something of a schemer) and Schelfhout gradually fizzled out. In the letter of 1914 to Schelfhout in which he looked back on his years in Paris, he affirmed that he 'was not a professional hermit', and that he wanted to be part of life:

44
Copy by Piet Mondrian after
Enguerrand Quarton, *Pietà of
Avignon*, 1913, oil on canvas,
105 x 140. Haags
Gemeentemuseum, The Hague.

But in my view a 'false life' as in the Kickert circle, is no life, which is why I preferred nothing
at all. I was also in great difficulty at that time, trying to find my own means of expression, and
it annoyed me greatly when I received a letter from Kickert saying that you thought I wasn't
working at all, while for myself I was searching seriously, but did not have a great deal to show
for it.[65]

Back in the Netherlands Mondrian had had a reputation for being a great
innovator. In Paris, however, he was considered part of the second echelon. The
circles that revolved around his heroes Picasso and Braque, whose work he
undoubtedly studied closely, remained closed to him. With the exception of Apol-
linaire's favourable review in 1913, critical response to his work was virtually
non-existent. He was not acquainted with any art dealers, and had to depend on
the Salon des Indépendants – and in one instance the Salon d'Automne – to get his
work exhibited. He sold nothing, either there or at those exhibitions in Germany,
Czechoslovakia and Switzerland to which he received invitations. For the time
being he was dependent on the meagre financial support that was forthcoming
from the Netherlands, where there were occasionally buyers for some of his older
work. From time to time he received commissions to copy Old Masters in the
Louvre; Marie Tak van Poortvliet, for one, commissioned a copy of the so-called
Pietà of Avignon, which has been preserved (illus. 44).[66] It was not until 1914 that
sales of his Paris work began to pick up, and characteristically, it was again in his
native country that some measure of success came his way, this time at his first
one-man show at the Walrecht gallery in The Hague.

Those early years in Paris were not easy for Mondrian, as is clear from the
letter he wrote to Schelfhout in 1914. It was a time in which he was 'searching
earnestly, but did not have a great deal to show for it'. This earnest search was a
reference to his adaptation of Cubism: in the beginning he had great difficulty in
mastering the new language of form, while at the same time remaining faithful to
his goal of uniting art and philosophy. At times he allowed the former to take
precedence; this, at any rate, is the impression given by the first and second

versions of *Still-life with Ginger-Jar*, probably done in the spring and summer of 1912. For years, still-lifes had been absent from his serious work, apparently because they did not offer the thematic significance he sought. The decision to return to this genre appears to have been motivated primarily by practical considerations. The still-life, the theme *par excellence* of the Cubist work of Picasso and Braque, offered the best opportunity to acquire proficiency in the Cubist jargon. The first *Still-life with Ginger-Jar*, painted in a ready style, is still reminiscent of Cézanne, in its composition and rendering of space. The larger, second version of the same motif (illus. 45) has been worked out more carefully; many areas have been painted over, and the familiar green ginger-jar is surrounded by a dense structure of planes in unmodulated colours, enclosed by dark lines. Any suggestion of spatiality or plasticity has been radically repressed, notably through the almost total absence of chiaroscuro effects. It is only in the transparent left-hand portion of the painting that some suggestion emerges of glass objects positioned one behind the next.

In the other paintings dating from his first year in Paris, Mondrian continued to explore the themes he had favoured before leaving the Netherlands. Two of these works depict female figures. One is an extremely dark portrait of the artist Adya van Rees; in letters written during the 1920s he repeatedly refers to this

45
Still-life with Ginger-Jar II, 1912, oil on canvas, 91.5 x 120. Haags Gemeentemuseum, The Hague.

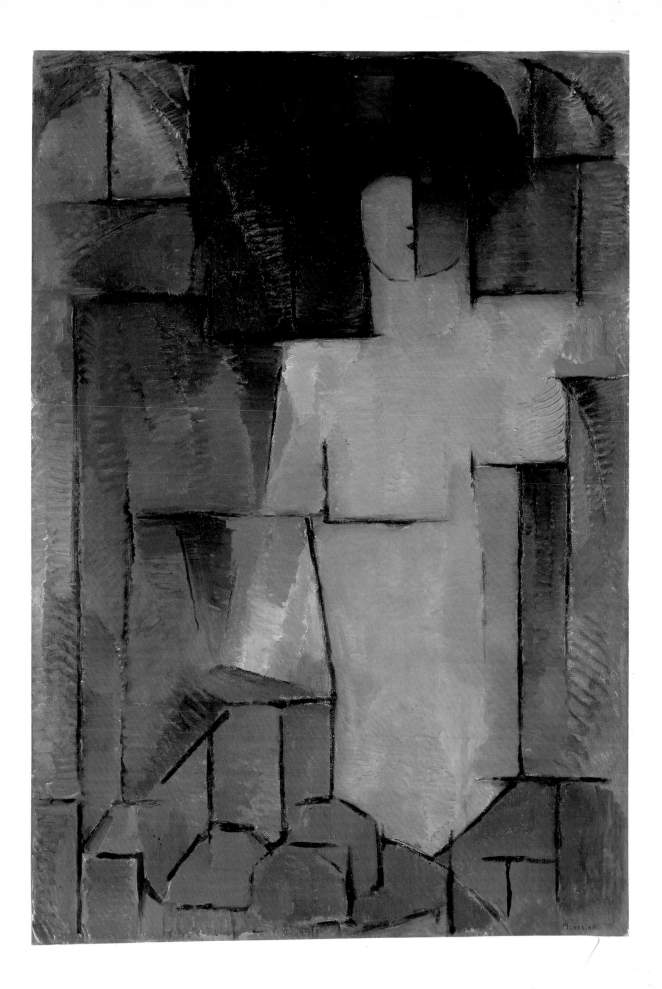

47
Nude, 1912, pencil on paper,
21 x 13.5. Rijksbureau voor
Kunsthistorische Documentatie,
The Hague.

48
Lodewijk Schelfhout, *Still-life with
Jug*, 1912, pencil on paper,
21 x 13.5. Rijksbureau voor
Kunsthistorische Documentatie,
The Hague.

painting with satisfaction as 'the black cubist portrait of a lady'. The other is a nude, and as in the case of the still-lifes, one might think that the choice of subject-matter betrays the influence of his Cubist models. But Mondrian's *Nude* (illus. 46) is a far cry from the nudes that Picasso, Braque and others produced in such numbers. In their renditions, there is always some suggestion of the sensuality and elegance of the female body, whether in pose or gesture, in the rounding of hip or breast, or in a lock of hair. Mondrian's nude, with her square breasts and hair that looks more like a helmet or a kind of dark nimbus, has been radically de-sexualized. Certain aspects of the painting link it to his figure pieces from the period 1908–11, while it is also suggestive of intentions he expressed at that time. We are struck by the single, staring, trance-like eye of the woman, which harks back not only to the central panel of *Evolution* (illus. 40), but also to the *Woman at Prayer* (illus. 20). The transcendental character of the figure is reinforced by the Gothic arches either side of the head, and the pale pink polygonal forms in the lower part of the work, probably stylized flowers. Their position with respect to the figure and their symbolic function can even be traced back to *Spring Idyll* (illus. 12).

A sketch has been preserved (illus. 47) that lends credence to the supposed link between *Nude* and *Evolution*. It shows a female figure en face with one large eye, open wide, and a few fine lines signifying the other eye, the nose and the mouth, details that also appear in *Nude*. Other similarities include the curve of

46 (opposite)
Nude, 1912, oil on canvas, 140 x 98.
Haags Gemeentemuseum, The
Hague.

the shoulder and upper arm, barely visible at the right of the painting, and the suggestion of several rectangular sections in the background. A large six-pointed star has in some strange way been superimposed on the female figure. It is positioned at a different angle from that of the theosophical emblem as it appears on the right-hand panel of *Evolution*. There is a curious story concerning the provenance of this sketch. It was found on one of the blank pages at the back of a catalogue of the Moderne Kunst Kring exhibition of 1911; the catalogue itself was part of the estate of Lodewijk Schelfhout. The opposite page bears a sketch that is closely akin to a still-life of 1912 by Schelfhout (illus. 48), and elsewhere in the catalogue there are various other scribbles and scrawls that are clearly his work: the pencil lines are thick and forceful, with added shading. The nude, by contrast, displays the sensitive, free signature of Mondrian that we know from the sketchbooks from the same period. The probable explanation for the presence of a sketch by Mondrian in Schelfhout's catalogue lies in a meeting between the two men that took place in Paris in 1912: they were apparently anxious to give one other an idea of their current work, which resulted in Schelfhout's *Still-life with Jug*, and Mondrian's *Nude*.[67]

The portrait of Adya van Rees and the *Nude* are somewhat unfamiliar, hybrid exercises carried out within the – for Mondrian – unaccustomed domain of Cubism. They form the link between the heavy, earthy colouring of the Cubists of Montparnasse, like Le Fauconnier, Gleizes and Metzinger, and the rigorous abstraction Picasso and Braque had pursued in 1910–11. Mondrian's own contribution lies in the accentuation of the horizontal and, above all, the vertical lines, a reduction in the number of planes, and the avoidance of any chiaroscuro transitions suggestive of plasticity. These paintings are certainly not without their merits. The composition is strong, there is a nice variation in lightness within the limited range of colour, and a sensitive undertone, without the religious sentimentality that rendered his earlier figure pieces somewhat difficult to swallow. These qualities came to full fruition in *Woman*, a painting completed in early 1913 (illus. 49). It was this work that elicited from Apollinaire the words of praise cited near the beginning of this chapter. With the exception of a few portraits that in all fairness cannot seriously be considered part of Mondrian's *œuvre*, this was his last figure piece. Before taking leave of the genre, he succeeded in producing a masterpiece. By that time he had made the Cubist language of form his own, following in the footsteps of Picasso and Braque, rather than in those of lesser gods. His point of reference was the work they had done in 1911, when both were at the pinnacle of their abstract work. As Apollinaire observed, Mondrian did not accompany them in their 'recherche de matière', which in 1912 led to the introduction of found materials; their *papiers collés* and three-dimensional constructions gave an entirely new meaning to the relationship between a work of art and the material world. Mondrian, by contrast, was striving to break free from matter, throwing open the windows on a more spiritual world – 'the path of ascension, away from matter', as he had expressed it some years earlier in his letter to Querido.

In *Woman* we see a fine network of lines that all but disappear towards the edges of the painting, but are more sharply defined in the centre, without ever entirely delineating forms. Subtle shades of pale grey and ochre are distributed lightly and somewhat arbitrarily over the surface, with a slightly greater concentration at the top of the painting. The surface is enlivened by rhythmic, horizontal

49 (opposite)
Woman, 1913, oil on canvas, 76 x 57.5. Rijksmuseum Kröller-Müller, Otterlo.

64

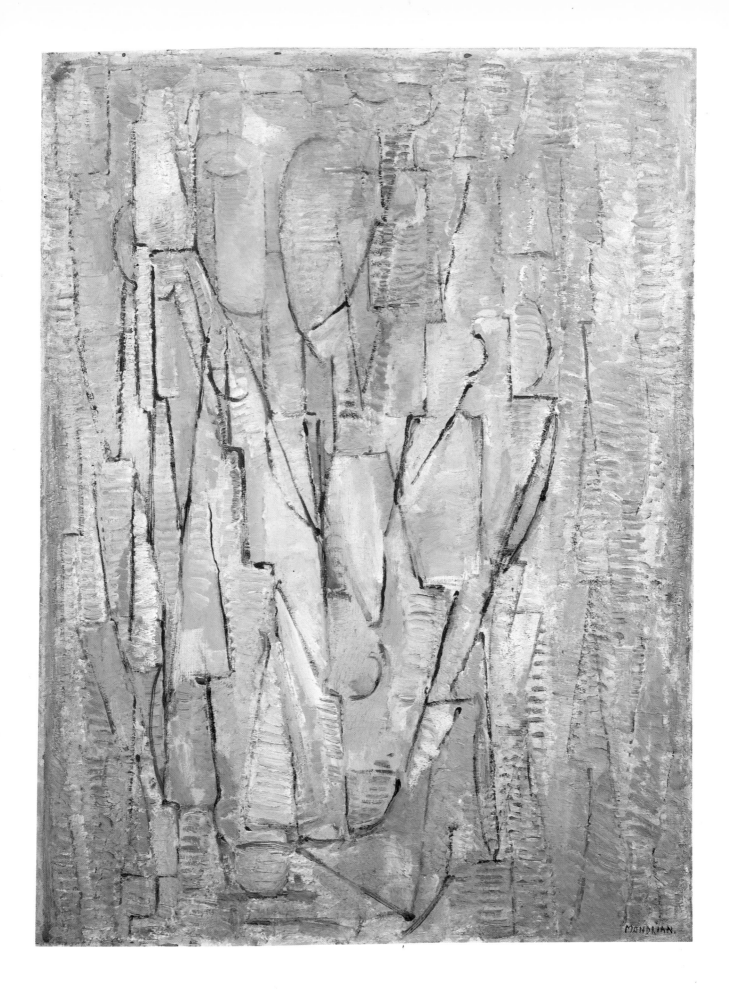

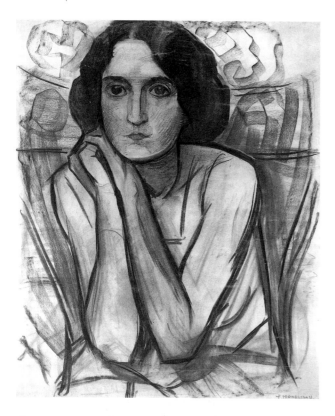

50
Study for *Woman*, c. 1912, charcoal on paper, 75 x 63. Haags Gemeentemuseum, The Hague.

brush strokes. The technique, the structure and the palette, verging on monochromatic, all bear comparison with the very best work done by Picasso and Braque in 1911. But Mondrian has given his painting a transparency, an ethereal atmosphere lacking in the work of those artists: expressive qualities suited to his subject-matter. We know that *Woman* is based on a drawing (illus. 50) in which the model is portrayed less stiffly and hieratically than in his earlier figure pieces: she is shown clothed, leaning forwards, with her elbows on her knees, or perhaps table. And yet with her hands entwined and pressed against her cheek, her solemn expression and, again, the large eyes, there is something contemplative, almost hallowed about the figure, reminding us in a way of the well-known photograph of Madame Blavatsky (illus. 17).[68] The lines fanning out beside the woman's arms accentuate the upward movement of the painting as a whole, ending in random curving lines next to her head: perhaps one last suggestion of flower-like forms. In spite of the abstraction of the painting, certain features of the drawing have been retained: the upward sweep of the lines, the oval shape of the head with the single eye open wide, and the circular shapes alongside the head. In this work Mondrian appears to have captured the exaltation for which he had striven in the centre panel of *Evolution*, but which failed so miserably due to the contrived symbolism and the artificiality of the style.

Cubist landscapes

It is not only in his figure pieces that Mondrian displays signs of a highly idiosyncratic choice and treatment of motifs. There are a number of drawings and paintings of sunflowers and eucalyptus branches, and other works featuring the sea and sand-dunes, and also trees, in isolation or as part of a wood or forest. There

is even a painting of 1913 that features a windmill. Such motifs are totally absent from the work of other Parisian Cubists, but to Mondrian they were intimately familiar. Although the paintings done at this time were highly abstract, he was not able to relinquish nature. He needed the visual impression of specific surroundings as a point of departure for his work. As far as we know, while in Paris he no longer referred back to studies or finished works from his past. Nor is it likely that he took any of them with him when he moved to France. For some of these motifs, like flowers and trees, he could find inspiration anywhere. But others, such as the sea, the dunes and the windmill, were typically Dutch. In all probability they grew out of two trips to his native country that he made in 1912: in August he went to Domburg for his customary summer stay, and in October he was in Amsterdam on the occasion of the second exhibition of the Moderne Kunst Kring, where he had eight new works on show. We know that these included a somewhat sketchy Cubist painting depicting a dune motif; this is now lost, but we do have a number of sketchbook pages that may be related to the painting, as well as a very large drawing (illus. 51 and 52). The latter was presumably a

51
Dunes, 1912, sketch, pencil on paper, 10.5 x 17. Haags Gemeentemuseum, The Hague.

52
On the Dunes, 1912, charcoal on paper, 94 x 160. Private collection.

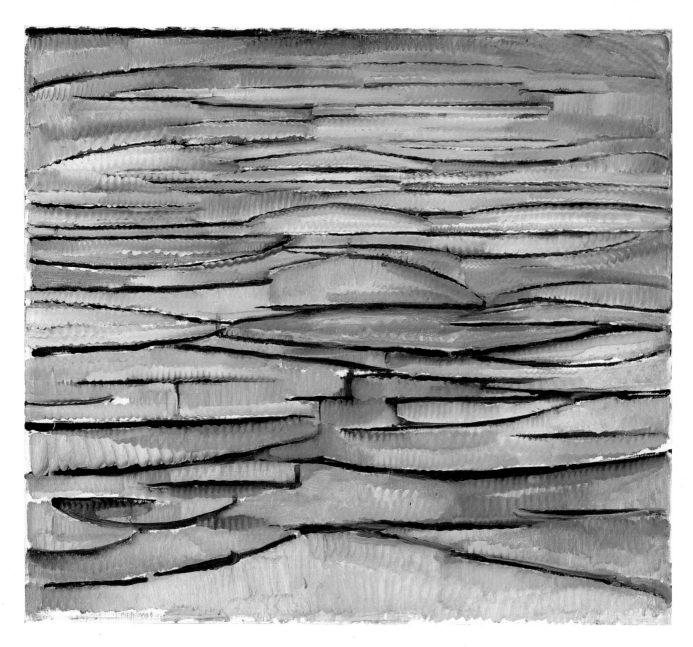

53
Sea, 1912, oil on canvas, 82 x 92.
Private collection.

54 (opposite)
Trees, 1912, oil on canvas, 94 x 70.
Carnegie Museum of Art, Pittsburgh.

preliminary sketch for the painting, which was exhibited at the above mentioned exhibition in 1912 as 'No. 161, On the dunes (sketch)'. It must have been a striking work, for it was mentioned by various critics. One referred to it as a 'sketch in lines', with a great deal of yellow in it, and a powerful spatial effect; another wondered if it was meant to portray a crashed aeroplane.

While we may not agree with the mischievous identification of the theme of the lost work and the preliminary drawing, the drawing still poses something of a problem. It seems that Mondrian during the last years of his life, when he was living in New York, initialled it upside down and dated it, incorrectly, 1910 (*if* the initials and date were, in fact, added by the artist himself). Also, Harry Holtzman has reported that Mondrian once told him that it portrayed a reclining nude. I believe, however, we are justified in continuing to interpret the Cubist drawing as a dune landscape, while taking note of the fact that Mondrian saw in wide, horizontal landscapes an expression of the feminine, and reinforced this association by giving

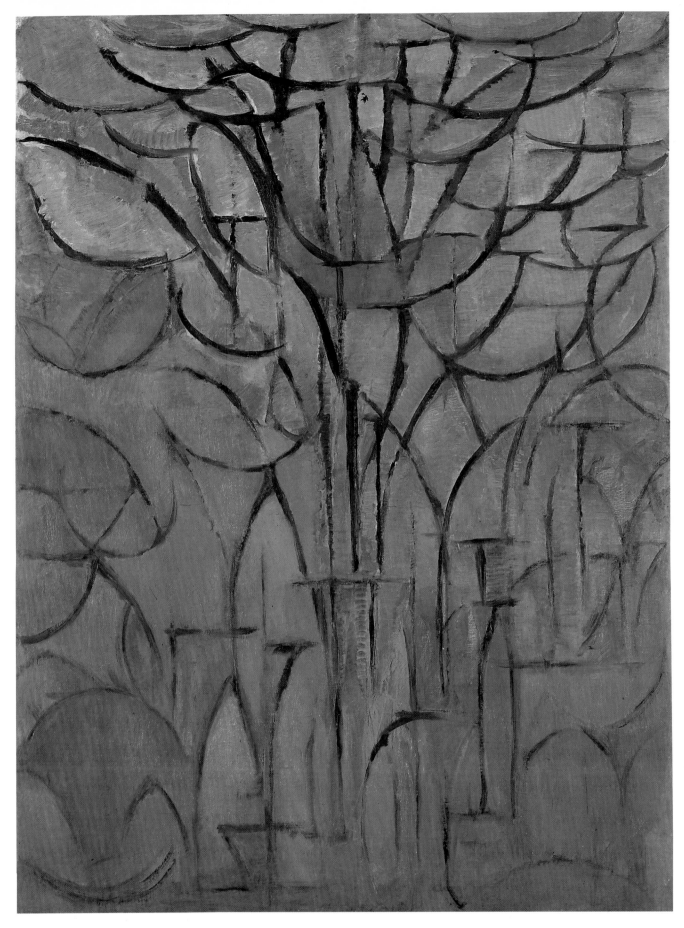

the dunes female contours, as he had done in earlier dune landscapes (illus. 37).[69] Similar forms recur in *Sea*, dating from 1912 (illus. 53), another work with a horizontally oriented motif from nature. This painting was exhibited at the 1912 show in Amsterdam as 'No. 160, Seascape (sketch)'. It does indeed make a somewhat sketch-like impression: while the structural lines were still wet, Mondrian filled in the spaces in between with rapid, zig-zag strokes of muted colour. The mobility of the water, the repetitive pattern of the waves, and the infinity of space are magnificently portrayed.

At variance with the above works with their horizontal format and female contours, we have a number of paintings that display largely vertically oriented, masculine forms. A good example is the painting *Trees* (illus. 54), probably also part of the 1912 exhibition in Amsterdam ('No. 157, Trees'), where it would have formed a nice contrast with *Sea*. Critics mentioned paintings with a tree motif that were reminiscent of leaded glass windows, and this characterization is indeed appropriate in the case of the present work: with its tracery of vertical lines and curves, it seems to echo the vaults and windows of a Gothic cathedral. We know that from the outset of his career Mondrian portrayed Gothic architecture in his paintings, and that he did so with a certain symbolic intent (illus. 10 and 12). This was most obvious in his views of the church towers and lighthouses of Zeeland (illus. 36 and 39). In Paris he discovered that the Cubists, in particular, displayed considerable interest in Gothic forms. Delaunay's paintings of the facades and interiors of churches are an obvious example, but many Cubist landscapes and figure pieces also display Gothic features. The late-Gothic *Pietà of Avignon* had been popular in avant-garde circles ever since its spectacular arrival at the Louvre in 1905, and Schelfhout was not the only artist to have a reproduction of the work hanging in his studio. Both Otto van Rees and the Swiss Cubist Oscar Lüthi painted paraphrases of it, and there was, of course, Mondrian's commissioned copy too (illus. 44). In his own work the spirituality associated with Gothic forms was expressed in paintings like *Trees*, where the lines curve and the colours brighten in the upper regions.

Unlike the preceding period, there is considerable documentary material available on the views which Mondrian held during his years in Paris, largely in the form of letters and his own notes. The following passage from one of his sketchbooks is of particular relevance for the interpretation of *Sea* and *Trees* as contrasting and complementary works:

If the masc. is the vertic. line, then a man will recognize this element in the rising line of a forest; in the horizont. lines of the sea he will see his complement. Woman, with the horizont. line as element, sees herself in the recumbent lines of the sea, and her complement in the vert. lines of the forest.[70]

Not all paintings with a common theme can be interpreted in the same way, as we saw in the case of the flower motifs. This applies equally to the tree motifs. What is decisive is not the theme in itself, but rather the combination of motif and manner of expression. While in Paris Mondrian did several paintings with tree motifs that are quite different from *Trees*, with its Gothic elements. *Grey Apple-tree* (illus. 55) and *Flowering Apple-tree* (illus. 56), from 1912, for example, both have a horizontal format, while in the entire representation there are almost no straight lines, only curving and arching ones, with a slight concentration around the horizontal and, to a lesser extent, the vertical axis. In *Grey Apple-tree*, trunk

and branches have acquired more substance, while the brush strokes are rougher and sketchier, suggesting that it was made somewhat earlier than the other painting. As regards composition, there are striking similarities. It is probable that a large drawing of a bare tree served as a preliminary study for both paintings.[71] They are almost identical in format, and could be seen as companion pieces, although, as far as we know, Mondrian never exhibited them as such. (While *Flowering Apple-tree* was shown in Amsterdam in 1912, *Grey Apple-tree* was not.) In any case, the two paintings employ the same motif to represent two different stages in a natural cycle, something that Mondrian was fond of doing in his early years. Here, *Grey Apple-tree* stands for the death-like stage of winter, and the other tree, with its delicate blossom colour, for the life force that nature displays anew each spring.

Cubist architectural pieces

If we consider Mondrian's choice of motifs from nature couched in a Cubist form of language as proof of his continuing striving to provide a glimpse of a spiritual world by means of his art, then we are perhaps justified in seeing the architectural motifs that dominate his work in the period 1913–14 in a similar light. With the exception of the above mentioned Dutch windmill, which was the point of departure for *Composition in Line and Colour* (1913),[72] these motifs were all taken from his Paris surroundings. Several sketchbook pages and a single oil sketch depict the front of Notre Dame des Champs, but more important than sacred architecture as a source of inspiration were the tall facades which are so much a part of residential Paris. The sketchbooks dating from this period are full of quick impressions of the view from the window of his studio, and sketches of the roofs and sides of houses, with the tell-tale outlines of walls, floors and chimney flues made visible by the demolition of adjoining buildings.[73] These motifs recur in various larger and more detailed studies in charcoal on paper, and in some ten actual paintings that together represent some of his very best Paris work (illus. 57 and 58).

The motif of these facades is new for Mondrian, but the content bears a certain similarity to the dying sunflowers and chrysanthemums of several years earlier. Just as he saw in the withered flowers the source of new life, he probably regarded the demolition and reconstruction of houses in a city as a metaphor for Man's evolution to higher spheres. Indeed, Mondrian later expressed himself along similar lines: in a stage text written in 1919–20, a painter who is presented as the protagonist of all that is modern observes that the mature culture of a city like Paris is 'beautiful in its perfection, but perfection means death and decay. Thus interfering with the process of dying is a crime against perfection: it stands in the way of a higher perfection'.[74] It may be a question of being wise after the fact, but I believe that Mondrian did gradually come to take such a favourable and 'evolutionary' view of the metropolis – one which was theosophically inspired – during his years in Paris, notably during the period 1913–14, when he was so taken up with secular architecture as a motif for his paintings. He could find support for this vision in theosophical literature. *Le Lotus Bleu*, the magazine of the French Theosophical Society, which he probably read, published an interesting article by C. W. Leadbeater in its December 1912 issue, entitled 'Centres du

57 (opposite)
Composition, 1914, oil on canvas,
140 x 101. Stedelijk Museum,
Amsterdam.

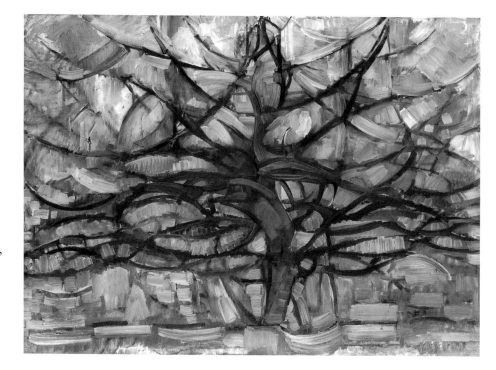

55
Grey Apple-tree, 1912, oil on canvas,
78.5 x 107.5. Haags
Gemeentemuseum, The Hague.

56
Flowering Apple-tree, 1912, oil on
canvas, 78 x 106. Haags
Gemeentemuseum, The Hague.

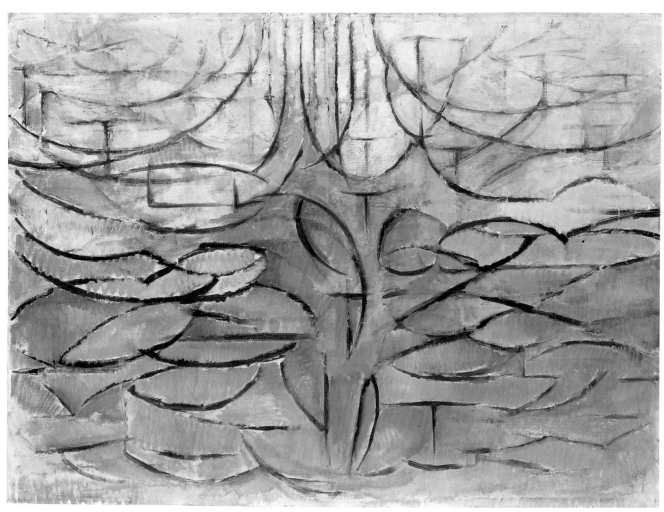

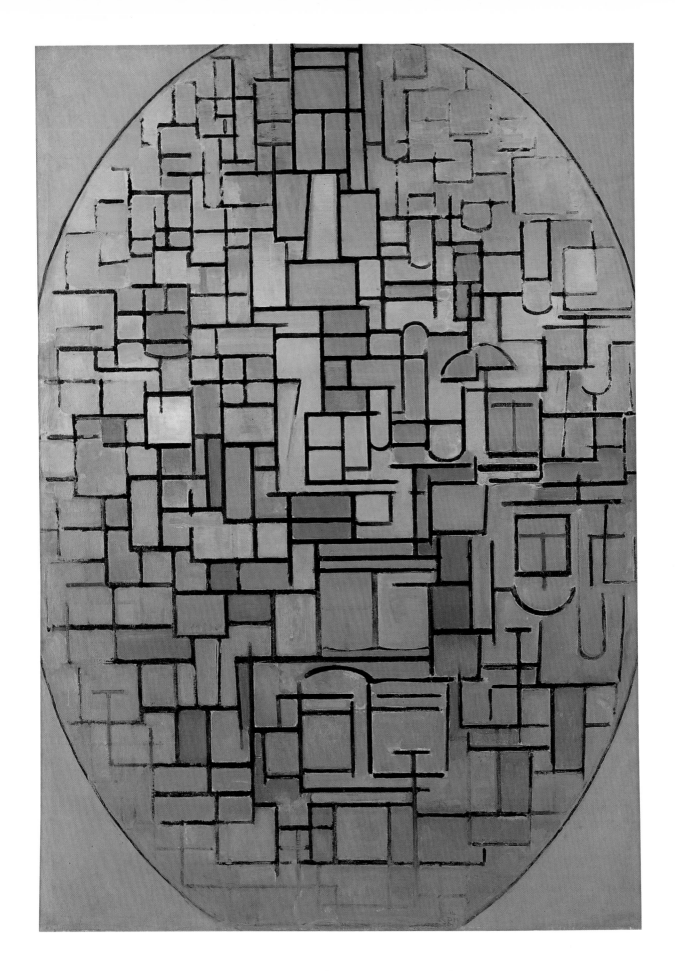

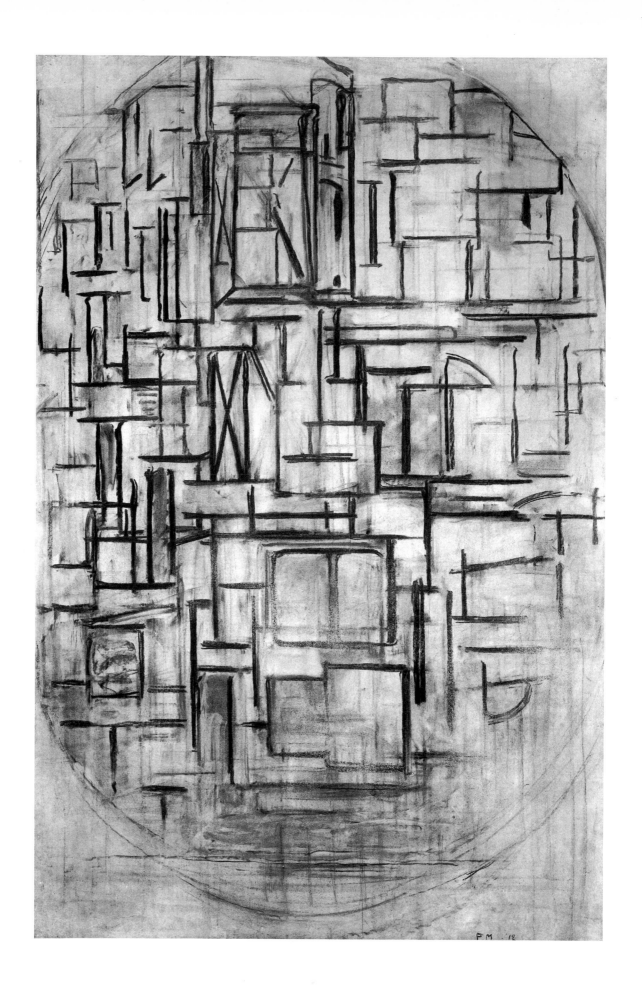

74

Magnétisme – Cités modernes' (Centres of magnetism – modern cities).[75] Lead-beater described the wholesome or pernicious radiation of buildings and cities, and their influence on the inhabitants. He mentions Rome and the Dutch towns around the Zuyder Zee as examples of places where the past is too dominant, and considers modern cities a far more favourable environment for mankind. It is probable that Mondrian saw Paris in this way, and that this was one reason why he preferred the French capital to the towns and cities of the Netherlands.

In comparison with the dying sunflowers and chrysanthemums, the 'dying houses' were not only less bound up with nature, but also much more contemporary in flavour. This was not a factor to which Mondrian had given much thought at home in the Netherlands, but in Paris the situation was different. Encouraged by avant-garde examples all around him, above all the Futurists with their boisterous glorification of *modernitá*, he now opted for subject-matter that was more 'of his own time'. As he noted in one of his Paris sketchbooks, 'A form must be of its own time if it is to be recognized: one cannot relate to what one is not or does not have – Thus all that is of the past is to be rejected.'[76] Judging by a letter of 1914 to the art critic and art consultant H. P. Bremmer, he was convinced of the modernity of his art, in both form and content, and the significance of that modernity for the evolution of art:

It is clear to me that this is art for the future. Futurism, although it has advanced beyond naturalism, occupies itself too much with human sensations. Cubism – which in its content is still too much concerned with earlier esthetic products, and thus less rooted in its own time than Futurism – Cubism has taken a giant step in the direction of abstraction, and is in this respect of its own time and of the future. Thus in its content it is *not* modern, but in its effect it is –.[77]

I have put forward two possible explanations for Mondrian's remarkable choice of the built environment of the metropolis as subject-matter for his art: his theosophically coloured vision of reality, and his ambition to be a truly modern artist. These two explanations do not conflict with one another. On the contrary, Theosophy was considered by its own adherents to be a modern doctrine, one which combined fundamental truths with new scientific insights in the fields of physics, biology and psychology. However, there is a third possible explanation, one that is equally valid, namely, that the geometrical structures of the roof sections and facades of houses were eminently suited for the Cubist representation envisioned by Mondrian. Other Cubist artists had made the same discovery. Unlike the motifs from nature that Mondrian favoured during his early years in Paris (trees, flowers, the sea), city scenes did recur with some regularity in the work of the Cubists, especially Léger. In 1912–13 Léger painted various views of rooftops as seen from a high vantage-point. In *The Roofs of Paris* (illus. 59) the façade sections, chimneys and roofs are piled one on top of the other, with only a sliver of sky visible in between. These block-like architectural shapes contrast with the circles of the trees. Such cityscapes also occupy an important place in the work of Delaunay. In a series of paintings entitled *Windows* begun in the spring of 1912, there are still vague traces of the flowing lines of the Eiffel Tower, but otherwise the canvases are divided into rectangular planes of prismatic colour, some further subdivided diagonally (illus. 60). All the solid forms of the buildings have been dissolved through the action of light.

In Léger and Delaunay, Mondrian found artists against whom he could measure

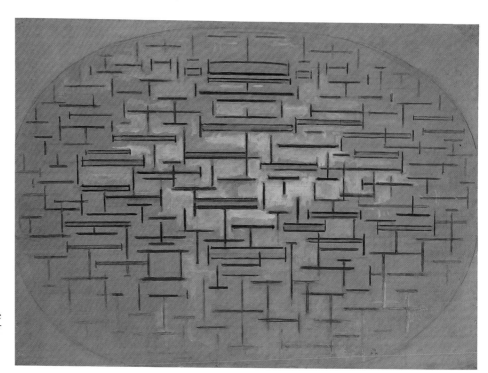

61
The Sea, 1914, charcoal and gouache
on cardboard, 90 x 123. Museum of
Modern Art, Venice (Peggy
Guggenheim Collection).

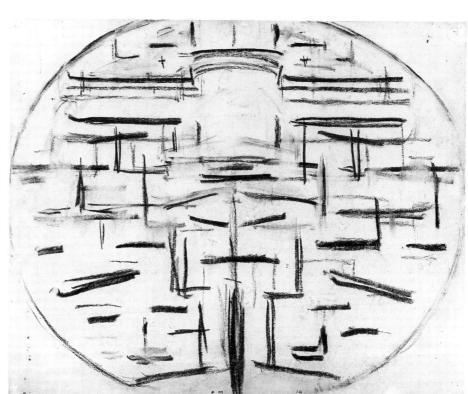

62
Pier and Ocean, 1914, charcoal on
paper, 52.5 x 66. Private collection.

himself. Léger crammed his canvases so full of volumes of varying shapes and sizes that they seem in danger of bursting out of their frame. By contrast, Mondrian's paintings dealing with the same subject-matter are devoid of any suggestion of volume or material. The contrasts he employed – straight versus curved, and above all, horizontal versus vertical – are all worked out on the flat surface. In his renunciation of matter, Mondrian is perhaps closer to Delaunay, although his approach is rather more abstract. In the facade paintings of 1914, in particular, there is less use of colour for purposes of atmosphere, and the lines are heavily accented; some images are enclosed in a sharply defined oval (illus. 57). In this way Mondrian was able to create a painting that was not so much a window looking out over buildings as a building in its own right, one made up of planes of colour.[78]

On the basis of a number of examples, I have drawn parallels between Mondrian's Cubist work and the work he did during the preceding period in the Netherlands when – explicitly – he proclaimed a theosophically inspired view of life and of art. The thematic continuity is obvious. Despite the differences, the expressivity of his language of form also displays a continuity, or more precisely, a radicalization, which was made possible by his adaptation of Cubism. I believe that we are equally justified in relating his work in Paris to key concepts within the theosophical doctrine: not to symbols, perhaps, but to theories on the relationship between the material and the spiritual world, and the evolution of all being. Cubism was not a purely formal exercise for Mondrian; it enabled him to give shape and form to his aspirations. And, as we know from his letters, he was aware that these aspirations reflected a different vision of art than that of the majority of avant-garde artists. He strived tirelessly to impart to his paintings 'a deep substratum, which leads those who are receptive to sense the finer regions'.[79] There was recognition for that striving and, although scepticism predominated, there were those who voiced their respect for his courage and commitment. Following the second exhibition of the Moderne Kunst Kring in October 1912, where he exhibited his Cubist work for the first time in his old environment, the critic Steenhoff responded in the following way:

In spite of the extreme daring of his abstraction, I see a favourable development, in spiritual depth and self-restraint. The work has fewer pretensions, the artist has found himself more completely, although it seems to me that he is still groaning under the constraints of a dogma which proclaims that the supreme aim of art is the total negation of matter.[80]

Mondrian's first theoretical writings

Mondrian himself never found Theosophy to be a constraint, and he freely acknowledged that it helped him to give form both to his art and to his ideas on art. In 1914, after their reconciliation, he and the Catholic Lodewijk Schelfhout discussed at length the spiritual basis of their art. In a letter Mondrian wrote:

You write that you could never be a Theosophist. Well, I suppose I could say the same thing, if you're referring to what most theosophists are. But that does not alter the fact that I believe that the principles of Theosophy are true, and that it leads to clarity in one's spiritual development. Which means that we quite agree on this point. Self-awareness is, in my view, of crucial importance to all human beings. I can understand how the Catholic doctrine may lead to vagueness, but Theosophy, which is a spiritual science, can never do so.[81]

And in that same year he expressed his thoughts in a letter to Bremmer: 'My idea of Evolution in art is entirely consistent with Theosophical thinking.'[82]

In the light of the somewhat controversial status that the literature on Mondrian has bestowed on Theosophy as a component of his art, it is doubly unfortunate that his very earliest theoretical piece intended for publication, a long article on art and Theosophy written during the winter of 1913–14, never appeared; the manuscript was afterwards lost. It was written at the invitation of the editors of the Dutch periodical *Theosophia*, but 'it was too revolutionary for those people', as he told Schelfhout in the letter cited above, and 'they've decided not to publish it'. It was no doubt this disappointing experience that occasioned the critical reference to 'the Theosophists', despite the fact that he continued to view theosophical doctrine as 'quite correct'. The chances of Mondrian's manuscript draft ever reappearing are slim, but we can get some idea of the contents of the article from the notes to be found in two of his Paris sketchbooks, and from incidental remarks contained in his letters. The problem with Mondrian's sketchbooks, from which numerous individual drawings have been removed, is that they are difficult to date with any certainty. By means of painstaking research, Joop Joosten has established that between 1911 and 1914 Mondrian filled no fewer than eight books.[83] On the basis of style and subject-matter, and a comparison with certain of his paintings, we know that they were often used over a long period of time and in various locations.

Written texts appear only in Sketchbooks I and II, which Welsh and Joosten have published in facsimile, and given the overall date 1912–14.[84] (In a letter to Bremmer of April 1914, Mondrian wrote that he had 'for years' been in the habit of recording his thoughts, which in itself is not particularly enlightening.[85]) There are, however, differences between Sketchbooks I and II, with respect to both the drawings and the notes, which enable us to date them somewhat more accurately. Judging by the word 'Schetsboek' on the cover, Sketchbook I must have been purchased in the Netherlands. It contains several drawings of trees that could have been made anywhere, but there are also a great many motifs, such as the sea, the dunes and the church tower, which indicate that they were done at Domburg, where Mondrian stayed in the summers of 1911, 1912 and 1914. From a stylistic point of view, there is considerable variation in the drawings: some are fairly naturalistic; others – mainly the tree motifs – display the Cubist language of form that Mondrian was using in late 1912 and early 1913; still others – primarily the sea motif, and some of the trees – are set in an oval *cadre*, similar to that used in a number of paintings, none of which were made until the second half of 1913. One drawing is of an even later date: a small variation on one of the large 'pier and ocean' drawings (illus. 62), which cannot have been done before the second half of 1914. Thus the drawings in Sketchbook I were clearly produced over a period of several years. The same could be true of the text, which consists of separate sections written in different directions on the page. However, on the basis of indications in the text itself, it appears most likely that they were written at the beginning of his Paris period, 1912–13. For one thing, Mondrian refers several times to reviews of his work which appeared in print. He counters Steenhoff's critical observation at the close of the passage mentioned above, which dates from late 1912, using exactly the same wording: 'The principle of this art is not a negation of matter, but a great love of matter, whereby it is seen in the highest, most intense manner possible, and depicted in the artistic creation.'[86] Sketchbook I also contains lengthy discourses on the male and female principles in all their

various connotations, reflected in separate motifs from nature – the male in the vertical forest, the female in the horizontal sea – such as those used in paintings dating from 1912. The text points clearly to motifs from visible reality; in some cases there is a direct link between text and drawing, as in a reminder that natural colour and form should be intensified in the ultimate painting. There is also a remark pertaining to the human figure:

red face – green
red – outwardness
green – inwardness.[87]

As Mondrian never again painted serious figure pieces after late 1912 or early 1913, this passage, too, can really only be related to paintings done in 1912, such as the Cubist portrait of Adya van Rees and *Nude* (illus. 46).

In Sketchbook I a specific symbolism or expressiveness is attributed to both the motifs and to line and colour, as depicted in an art which, in accord with the spirit of the times, was evolving in the direction of a heightened spirituality. In many of its notes Mondrian associates his views on art with theosophical ideas, although Theosophy as such is not mentioned by name. Such links are, however, made explicit in Sketchbook II. The drawings in Sketchbook II cover only a short period: the motifs, all buildings in Paris, are similar to those employed in his paintings during the second half of 1913 and the first half of 1914. As there is no relationship between the drawings and the notes, this does not in itself provide any certainty as to the date of the notes. However, they must have originated at the same time as the drawings, representing as they do a slightly later stage in Mondrian's thinking than those in Sketchbook I. On the basis of the content and argumentation of the second sketchbook, we may assume that its notes comprise a first draft of the 'big article' on art and Theosophy that Mondrian wrote during the winter of 1913– 14, intended for a select audience of theosophists. For one thing, he refers to the various world religions as different forms for the same basic contents, a notion to which Blavatsky devoted a great deal of attention in her books. In the same way, Mondrian says, the form that art takes is a product of its time. But, like religion, it is a means of furthering 'the evolution of mankind'. To fulfil this function, art must break free of the material world and 'all that is human', turning away from the surface and towards the inner world: 'We arrive at a portrayal of other things, such as the laws governing matter. These are the great generalities. – Which do not change.' Abstract art is the expression of these 'great generalities'.[88]

This new art requires a special attitude, on the part of the observer as well as the maker, an attitude which, in Mondrian's view, is as yet rare. Most people cannot break free of matter: the rich are surrounded by it, the common people are forever dreaming of it. But those who in spirit, at any rate, have risen above it, 'are receptive to abstract art'.[89] Apparently, Mondrian expected to find this philosophy of life and sensitivity to abstract art among the theosophists to whom his text was addressed. It must have been a great disappointment to him that the editors of *Theosophia* declined to publish it.

The texts in Sketchbook II contain no further mention of motifs or symbolism (such as the links sea/female and woods/male in Sketchbook I), and only general references to underlying meaning. Mondrian confined himself to such incidental observations as 'colour and facture are sufficient representation of matter for the spirit(ual) art(ist)'.[90] The emphasis is on abstraction, as a means of getting through

to the essence. There is an unmistakable Neoplatonic element here, one that also appears in the writings of other pioneers of abstract art, such as Kandinsky and František Kupka.[91] This Neoplatonism links them to the generation of Gauguin and the Symbolists, who came to the fore around 1890. Indeed, some years later Mondrian gave evidence that he was aware of that tradition: writing in *De Stijl*, he quoted Gauguin in affirming that Neo-Plasticism was the ultimate result of 'the search for beauty in its true essence, the Form'.[92] However, there are also significant differences. Mondrian – like van Gogh before him, with his direct criticism of Gauguin – ultimately appears to have distanced himself from two aspects of abstraction that Gauguin and company held sacred: the symbolic and the decorative. With respect to this latter aspect, we know that, unlike Gauguin and, later, Matisse, who were fond of comparing their paintings with the colourful patterns found in Oriental carpets, Mondrian was not happy with the associations with decorative art that his paintings invariably elicited from critics. Sketchbook II contains a somewhat cryptic remark that in this connection may well be significant:

Art and ornament
art and Rembrand[t]
are we going astray or are we not?[93]

It should be noted here that the work of Rembrandt was considered the epitome of meaningful art. For painters like Mondrian, who operated on the frontiers of abstraction, there was the constant danger of falling into the abyss of meaningless ornament. I believe that this remark is the product of a bout of self-examination, in which Mondrian wondered whether the chosen path would lead him into error. For the rest of his life, all his theorizing and all his published texts would be dominated by a need to prove to himself and to others that such doubts were unfounded, that his art was not just decoration. He affirmed over and again, in various formulations, the fundamental meaning of his art.

As far as the symbolic aspect is concerned, I have already stressed the fact that Mondrian was wary of symbols that required specialist knowledge. In tune with the German Romantic tradition, he had always acknowledged the symbolism of motifs from nature, which was accessible to the general public. And like Rudolf Steiner, who was very much part of that same tradition, he was convinced that the true visionary need look no further than the visible world around him. The importance of this type of symbolism in his work gradually declined, as the motifs in his paintings became less recognizable. But it is important to realize that the symbolism of nature was not replaced by the symbolism of signs. Although in Sketchbook I Mondrian associated the vertical and the horizontal line with male and female, and the colours red and green with outwardness and inwardness, these were more or less isolated phenomena. In later life, too, the attribution of specific meaning to abstract elements in his art was of an incidental nature; such elements were never codified or classified by means of a system, and were constantly being replaced by others. It is for this reason that Sketchbook II marks an important point in the development of his thinking: for the first time he proclaims that he is searching for 'the general'.

These same ideas, expressed largely in the same terminology, are to be found in a letter written on 29 January 1914, about the time Mondrian was working on his article for *Theosophia*. It was his first letter to H. P. Bremmer, the former pointillist painter now engaged primarily in teaching, writing about art, and advising

collectors. Bremmer had recently expressed his interest in Mondrian by purchasing one of his paintings, and Mondrian hastened to inform this influential gentleman at length concerning his views on art:

Now that I have an opportunity to write to you, perhaps you would like to hear something about the view which *I* take of my work. The general public finds my work quite vague; at best they say that it reminds them of music. Well, I have no objection to that, unless they take it a step further, and say that for that reason my work is outside the realm of the visual arts. For when I construct lines and colour combinations on a flat surface, it is with the aim of portraying *universal beauty* as consciously as possible. Nature (or that which I see) inspires me, provides me – as it does every painter – with the emotion by which I am moved to create something, but I want to approach the truth as closely as possible, abstracting everything until I come to the foundation – still only an outward foundation! – of things. It is for me a clear truth that when one does not want to say something *specific*, it is then that one says what is most specific: the truth (which is of great universality). I believe that it is possible by means of horizontal and vertical lines, constructed *consciously* but not *calculatingly*, guided by a higher intuition and brought to harmony and rhythm – I believe that these fundamental esthetic shapes – where necessary supplemented by lines in other directions or curved lines, make it possible to arrive at a work of art which is as strong as it is true. For anyone who sees more deeply, there is nothing vague about this: it is only vague for the superficial observer of nature. And *chance* must be as far removed as *calculation*. And for the rest it seems to me that it is necessary to keep breaking off the horizontal or vertical line: for if these directions were not countered by others, they would themselves come to signify something 'specific', and thus human. And it is precisely my view that in art one should not strive to produce something human. By not trying to say or recount something that is human, by a total disregard of oneself, a work of art emerges which is a monument to Beauty: something which surpasses all that is human; and yet is intensely human in its depth and universality![94]

There follows then the passage cited earlier, in which Mondrian evaluates Futurism and Cubism with respect to their modernity. At the close of the letter he touches on his own position:

And finally I must tell you that I was influenced by seeing the work of Picasso, whom I *greatly* admire. I am not ashamed to speak of this influence, for I believe that it is better to be receptive to correction than to be satisfied with one's own imperfection, and to think that one is O so original! Just as so many painters think – And besides, I am surely totally different from Picasso, as one is generally wont to say.

This letter, which is of great significance, is in many respects similar to the letter of 1909 to Querido referred to earlier. In both cases Mondrian was seeing to it that a writer who already entertained a certain sympathy for his work was well informed concerning his views and motives. In the letter to Bremmer certain subjects and concepts reappear, but now as seen in the light of Mondrian's standpoint in 1914. What remains is the solidarity with the visible world as the source of inspiration for a work of art; and the conviction that the modernity of the artist is reflected not only in the subject-matter but also in a specific technique and manner of expression. In the past it was pointillism, now it is the construction of mainly horizontal and vertical lines borrowed from Cubism. And Mondrian, who, as in the past, realizes that he is different from the other modern artists, hopes and expects to find understanding among those of the public who 'see more deeply'. But the real significance of the letter to Bremmer lies in his remarks on the expression of universal beauty, which aims to impart 'nothing specific' and 'nothing human'. This echoes remarks in the letter to Querido, to the effect that he was striving to ban all human action and movement. But here the concept has been extended: the destruction of the entire material world must be given shape in the work of art. This is the stage at which Mondrian's theory found itself towards the end of his first stay in Paris.

2

Natural Reality and Abstract Reality: 1914–19

In the summer of 1914 Mondrian returned to the Netherlands for a combined business and family visit. He wanted to see his father, who was seriously ill, look up friends in Domburg and elsewhere, and perhaps also pay a visit to the exhibition of his recent work – his first one-man show – that Bremmer had been instrumental in obtaining at the Walrecht gallery in The Hague. While he was there the Great War broke out, and what was intended as a visit of a few weeks turned into a stay of five years. It was not until June 1919 that Mondrian was able to return to Paris. This time it was a final leavetaking, for he was never to see the Netherlands again.

Mondrian's homeland remained neutral throughout the Great War. The battles were fought beyond its borders, and the main effect within the country was a flood of refugees from German-occupied Belgium seeking a safe haven. Otherwise, life continued much as before. In a political sense the country was stable, although towards the end of the War there was some unrest as a result of the Revolution of 1917 in Russia, and the worsening situation in Germany. Except for the difficulty in obtaining goods and raw materials from overseas, the economic situation was considerably more favourable than in neighbouring countries; in certain sectors of industry the War actually provided a boost for business.

It is not clear why Mondrian did not return to Paris in 1914 or 1915. The journey was not easy, but it was certainly not impossible. One could travel by way of England or through Germany and Switzerland, and in letters to friends he indicated that there was nothing he would rather do. Indeed, he continued to pay rent on the studio in Paris throughout the War years. I believe that he may have been prevented from leaving for purely practical reasons. In Paris he had not sold anything for several years, and with France at war, the Parisian avant-garde had been virtually disbanded; the existence of a modern artist from abroad would be more precarious than ever.[1] In the Netherlands, however, Mondrian's prospects were finally becoming somewhat brighter. No doubt to his own surprise, the 1914 exhibition in The Hague had resulted in the sale of several works to important collectors. The Revd. H. van Assendelft, a minister of the Remonstrant Brethren at Gouda, bought three works to add to his already impressive collection of modern art, which included paintings by Kandinsky and Franz Marc.[2] Another painting was purchased by Bremmer. It must have been clear to Mondrian that for the time being he would do better to remain in the neighbourhood of potential buyers, rather than to return to Paris, where the situation was so uncertain.

The Great War brought with it nearly total isolation from all that was happening abroad, not just for Mondrian, but for the entire Dutch art world. This was in sharp contrast to the preceding years, when there had been a lively exchange of information with artists and collectors abroad. Dutch artists travelled extensively in order to keep abreast of current developments, or worked for long or short periods abroad. The work of foreign artists was regularly exhibited, at the initiative

of the Moderne Kunst Kring and De Onafhankelijken in Amsterdam, the Rotterdamsche Kunstkring in Rotterdam, and several galleries. In the period 1911–14 such exhibitions introduced Dutch art-lovers not only to the French Cubists and other painters who lived and worked in Paris, but also to the Italian Futurists and the German Expressionists of the Blaue Reiter group. Kandinsky had one-man exhibitions in several Dutch cities in the course of 1912, and translations of his writings and those of the Futurists appeared in Dutch art journals. Among the private collectors who gave the latest international art an enthusiastic welcome were van Assendelft, Kröller-Müller, Beffie and Tak van Poortvliet. In short, there was an atmosphere of lively interest, reflected in continuing discussions in journals and newspapers regarding the merits or otherwise of modern art.[3] All this ended abruptly when the War broke out. There was only a trickle of information: the journal *Der Sturm* was available, Herwardt Walden occasionally entered work by his Sturm artists at exhibitions in the Netherlands, and some French news reached the country by way of journals. On the whole, however, this provided no more than a vague idea of what was being produced abroad, and what the current topics of discussion were in artistic circles. In the same way, very little Dutch news reached the outside world, and even this was limited to written material and the occasional illustration. It proved next to impossible for Dutch artists to exhibit abroad.

The transition from Paris back to the Netherlands cannot have been easy for Mondrian. He was convinced that the French capital was the only place on earth where a truly modern culture had any chance of developing and flourishing. He had done his best to assume the air of a man of the world, and had even Frenchified his name by omitting one 'a'. Now here he was, back in the old environment from which he had tried so hard to escape, among his old artist friends and the younger men who had joined their ranks. Bereft of its international contacts, the Dutch art world must have struck him as provincial indeed. However, for the time being this was to remain his frame of reference and his sounding-board. To exhibit his paintings he had to depend on invitations. Following the one-man show at the Walrecht gallery in the summer of 1914, he succeeded in exhibiting work at the Rotterdamsche Kunstkring in January 1915, together with Peter Alma and the French painter Le Fauconnier, who lived in the Netherlands during the War. In October of that year Mondrian's work was on show at the Stedelijk Museum in Amsterdam, with the other leading lights of the modern movement in the Netherlands: Gestel, Schelfhout, Sluyters and Le Fauconnier. It was not until the latter exhibition, over a year after his return, that he entered a number of new works, alongside several paintings done in Paris.

Mondrian appears to have been knocked off his stride by the enforced change of scene. His productivity declined dramatically. In the two and a half years or so that he had spent in Paris, he had done no fewer than forty paintings, as well as a number of large drawings and countless smaller ones in sketchbooks. In the two and a half years between the summer of 1914 and the end of 1916, he finished only two paintings, and a few large drawings. There may have been practical reasons for this meagre output: for one thing, his work had entered a period of radical change, which required not only experimentation but also serious and protracted reflection. To keep his head above water he was again painting portraits, copies of Old Masters, and miscellaneous works along the lines of his earlier

landscapes and flower pieces, while continuing to put his ideas on art into writing.[4] All this was reason enough for the decline in productivity, but I believe the most important reason was the simple fact that he was much less stimulated by his surroundings than had been the case in Paris. There was little in the Dutch art world to interest him. He was almost the only artist pursuing the Cubist line on into abstraction; other painters who had previously come under the spell of Cubism were now branching out – under the influence of Le Fauconnier – into something that has been characterized as 'Cubo-Expressionism'. Among the younger converts to modernism, there were many who gave vent to their esoteric interests in expressive abstractions à la Kandinsky, for which Mondrian could muster scant enthusiasm.[5] Furthermore, there were nasty little controversies going on within the society he had helped to found, the Moderne Kunst Kring, which took away any desire he might have had to play an active part in the art life of his homeland.

Fortunately, after meeting with colleagues, people like Theo van Doesburg and Bart van der Leck, Mondrian gradually managed to dispel this sense of disorientation. Here were artists with whom he could develop a relationship of mutual trust, basking in their admiration for his work, his ideas, and not least for the experience he had gained abroad: he had, after all, been a member of the illustrious Paris avant-garde. It was these exceptional circumstances – a position of isolation in a neutral country surrounded by warring neighbours – that made it possible for an individualist like Mondrian to emerge as the artistic and spiritual leader of a new movement. That movement was given form in 1917 with the launch of a journal, *De Stijl*. For more than a decade, the journal and the group revolving around it propagated an art and architecture with a more rigorously abstract and basic language of form than any other European avant-garde movement.

Paintings and drawings, 1914–16

Mondrian's artistic production, which got off to such a slow start following his return to the Netherlands in 1914, differed quite significantly from the themes he had employed in Paris. Turning again to the familiar 'Dutch' motifs from the past, he made a limited selection from that repertory. He may well have drawn inspiration from a stay in Domburg during the summer of 1914, for between then and late 1916 his work was focused almost exclusively on the sea and the facade of the Domburg church. This subject-matter is considerably less 'modern' than the facades of stately Paris residences. One wonders why, if he attached so much importance to this aspect, Mondrian did not search for suitable modern subjects such as could have been found in the larger cities of the Netherlands. I suspect that for Mondrian the essence of the country of his birth was totally different from that of a true metropolis like Paris, and that he felt the need to express this difference in his choice of subject-matter. At this stage in his development, the visual impression of the environment was apparently still of importance.

The choice of subject-matter is typical Mondrian, not least because ultimately it is confined to just two highly contrasting givens: one, the sea, is a product of nature, in itself formless, with a horizontal orientation; the other is a product of culture, an architecture formed by human hands and vertically oriented. As of old, he saw in these motifs the expression of the masculine and the feminine

principle. But now, in contrast to the period 1908–12, it was no longer his intention to present the two principles separately. Rather he intended to visualize them within a single work, emphasizing their complementary nature. As he noted in one of his sketchbooks: 'Woman, with the horizont. line as element, sees herself in the recumbent lines of the sea, and her complement in the vert. lines of the forest.'[6] In his later treatment of the motifs of the sea and the tower he took great pains to avoid an excessively one-sided orientation.

Where the sea motif is concerned, horizontality still dominates in several large drawings from 1914. *The Sea* (illus. 61), for example, harks back – via the single painting with that motif dating from 1912 (illus. 53) – to Domburg paintings such as the *Sea after Sunset* of 1909 (illus. 38). There are differences, of course: in the 1914 drawing the sensation of depth is largely suppressed, because the image has been detached from its rectangular 'window'; the oval shape suggests both a contracting and an expanding movement within the plane itself. Moreover, the long horizontal lines of the waves have been chopped into shorter segments, and numerous vertical strokes have been added for punctuation and contrast. Mondrian then undertook to reinforce the vertical element. It is interesting that he did not opt for a contrived solution, as in the citation of the woods and the sea (the combination of woods bordering on the sea does not exist in the Netherlands!), but rather a solution based on observable reality: he incorporated a pier into the sea scene. It was not the first time that he had portrayed a pier or a breakwater, but in his earlier seascapes these were viewed from one side, as a more or less horizontal line (illus. 38). The crucial step here was the decision to place the object in a perpendicular position, as if seen from the front and from a high vantage point.

There are no naturalist drawings of the pier-and-ocean motif. We have only drawings that display a radical abstraction: two small ones in a sketchbook, and a number of splendid larger pieces, which reflect quite an interesting evolution, culminating in 1915 in the painting *Composition* (illus. 64). A common feature of these works is the placement of the vertical pier in the centre of the work, where it serves as an axis for the constellation of lines to the left and right. On closer examination, however, there are subtle differences in the length of the lines and their position with respect to one another, which break the symmetry. The earlier drawings of the series (illus. 62) display a limited number of powerful lines, some of them slanting or curved. To counter the heavily accented vertical lines of the pier below, Mondrian placed at the top of the drawing a number of long, horizontal lines, which may indicate the horizon; but there is no satisfactory explanation for the unusual elevation in the centre. In the later drawings (illus. 63) the line segments are shorter and more numerous. The contrast between the verticality of the pier and the horizontality of the upper sections of the work has been retained; now we see the outlines of several squarish shapes. In the definitive 1915 painting, apparently the result of a great deal of searching and deliberation, the asymmetry is somewhat stronger, while the pier and the horizontal section at the top are no longer represented as separate elements, but are just visible as part of a rhythmic pattern distributed more or less uniformly within the oval.

The pier-and-ocean drawings and paintings have been linked by some art historians to the visual given of the breakwaters, which extend into the sea at Domburg.[7] Personally, I prefer the older association with the pier at Scheveningen

63
Pier and Ocean, 1914–15, charcoal
on paper, 51 x 63. Haags
Gemeentemuseum, The Hague.

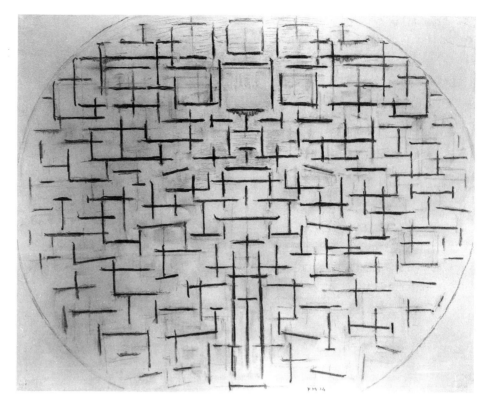

64
Composition, 1915, oil on canvas,
85 x 108. Rijksmuseum
Kröller-Müller, Otterlo.

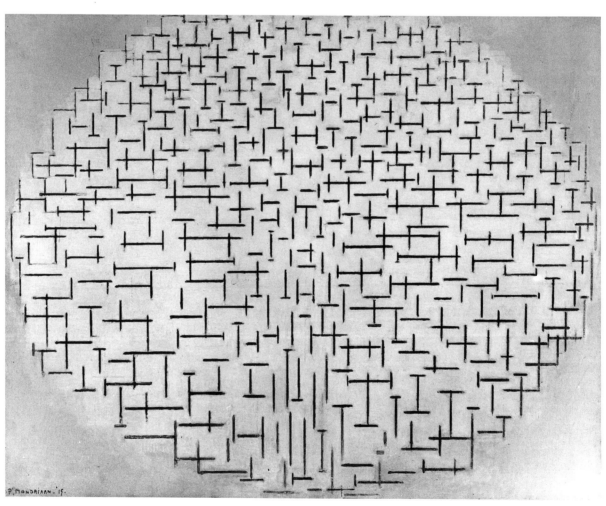

mentioned in books by Alfred Barr and also by László Moholy-Nagy, who had it on the authority of Mondrian himself. (Moholy-Nagy goes one further, and tells us that Mondrian worked from the fourth floor of a Scheveningen hotel.[8]) Supplementing the literature, there are indications in the drawings themselves – if not in all, then at least in some of them – that the pier in Scheveningen was indeed the visual point of departure. One sketchbook drawing and several of the large drawings contain elements such as the heavy contours of the rectangular elevation of top centre, which more or less coincides with the pavilion as it appears in old photographs (illus. 65 and 66). This attention to such a minor detail may appear somewhat exaggerated, but what is of particular interest here is the fact that if Mondrian did indeed portray the Scheveningen Pier, rather than a breakwater in Domburg, then that must mean that he was countering a motif from nature – the sea – with a modern cultural element. The pier, built in 1903, was an example of advanced industrial architecture. Seen in this light, the pier-and-ocean drawings and the painting may be considered variations on the series of architecture pieces he had developed while in Paris. At the same time, it must be said that in the later drawings in this series, and in the definitive painting, Mondrian erased all traces of the topography. In fact, he did away with all distinctions between the original components of the representation: the sea, the pier and the sky. All now appear to be made of the same ethereal substance, dispersed as they are in a network of thin, dark-grey lines against a white background.

Composition and one drawing, probably one of the larger studies of the facade of the Domburg church, were on show at Amsterdam's Stedelijk Museum in October 1915. These were the first new works Mondrian exhibited following his return to the Netherlands over a year before. We know that he did not consider the painting completely finished. In a letter to Bremmer, who purchased the work on the first day of the exhibition, he wrote: 'I originally intended to do it in colour, but there was no time, and I felt that it said what it was meant to say.'[9] This remark, in all its disarming honesty, is enlightening. In the first place, we may conclude that a version in colour, as intended, would have been more in keeping with the paintings of Paris facades done in 1913–14 and the *Composition* from 1916 (illus. 67). Moreover, the remark tells us something important about Mondrian's methods. Apparently he was in the habit of starting with the linear construction of the painting; only when that was to his satisfaction did he add the colour. We know that he used this procedure in later years, when his Neo-Plasticism had reached full maturity, but this seems to indicate that the practice dates back to 1915, and perhaps even to 1912, which saw the first of his paintings with thick black lines, such as *Sea* (illus. 53).

The fact that *Composition* never got beyond the black and white stage – or to be more precise, dark grey and white, with the section outside the oval done in a very light grey – and that it is, in effect, a drawing executed in oils on linen, makes it quite exceptional among Mondrian's paintings. Of the customary triad of background, line and colour, it contains only the first two components. This is the first – but not the last – such work, for in later years Mondrian regularly did paintings that were exclusively in black and white. Moreover, the 1915 painting provides a clear indication of the special importance of the background colour in his paintings. It is not a neutral, inert backdrop for the other elements of the work,

65
Pier at Scheveningen, 1914, pencil on paper, 16 x 11.5. Private collection.

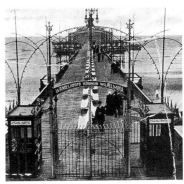

66
Postcard showing the pier at Scheveningen, *c.* 1910.

but rather an 'equal partner' with line and colour.

The second painting from this period, *Composition* (illus. 67), done in 1916, is based on the motif of the church tower of Domburg. Seen next to its predecessor, it seems at first glance to represent a retrograde step. This is largely the effect of the colour, the nature and distribution of which are far more 'Parisian', a difference that would of course have been nullified if the 1915 *Composition* had also been done in colour. There is a clear relationship between the two works. In fact, the 1916 *Composition* originated over quite a long period of time, developing via drawings made in 1914 and 1915. Mondrian also spent a long time working on the painting itself, as the thickness of the paint layers and the many corrections still visible declare.

Let us examine the sketches in the books and the large drawings of the church tower in the likely order in which they were produced. Here, as in the case of the sea motif, there is a gradual deletion of all the details. In a superb charcoal drawing (illus. 68), probably done in 1915, that process has largely been completed. There are no more than intimations of the pointed arches of the two small windows halfway up the tower, and the large window beneath them; other details, such as the slanting roof of the church and the graduated buttresses, have disappeared. The summit and base of the tower have both gone, lopped off by the edge of the paper. In the painting, finally, the last traces of the typical Gothic shapes that appeared in the drawing have been erased. The pointed arches of window and door openings have been 'straightened', and now form an asymmetrical pattern of short horizontal and vertical lines. These are surrounded by merging fields of blue, pink and ochre, which underscore the diffuse nature of the representation. The tower has lost its volume, its matter. It was precisely this effect that Mondrian had been striving for in the pointillist church-tower paintings of 1908–09, and in the transparent painting *Church in Domburg* done in 1911 (illus. 39). There is now no visible distinction between the tower and its surroundings, only a slight domination by the vertical, in both the direction of the lines and the format of the painting, and a gradual lightening of the colour in the upper regions.

Composition is Mondrian's only serious painting dating from 1916 that has been preserved. Undoubtedly there were others. We know, for example, that at the exhibition of the Hollandsche Kunstenaarskring that spring, where he sold *Composition* to H. van Assendelft, there were three other recent paintings on show. Judging from the brief descriptions that appeared in the reviews, one of these must have resembled the large *Composition*. The critic N. H. Wolf referred to 'small "stone" paintings [. . .] in pink, blue and yellow'. Two other works were done in a much more limited palette, 'in delicate nuances of grey and yellow against a transparent-grey background'.[10] This reminds us of *Woman* (illus. 49), painted back in 1913, and other Cubist works from the same period. Paintings in grey and yellow or ochre would remain part of Mondrian's repertory well into 1919, alongside works with a more pronounced palette. It was as if he was trying his hand at an ethereal and a more earthy colour scheme at one and the same time.

We know very little about the other three paintings from 1916, which have disappeared without a trace. No photographs of them exist, nor are they mentioned in any of the available letters. We do, however, have reason to believe that Mondrian was not satisfied with them, and that he either destroyed or painted over

67 (opposite)
Composition, 1916, oil on canvas with wood strip at bottom edge, 118.5 x 75. Solomon R. Guggenheim Museum, New York.

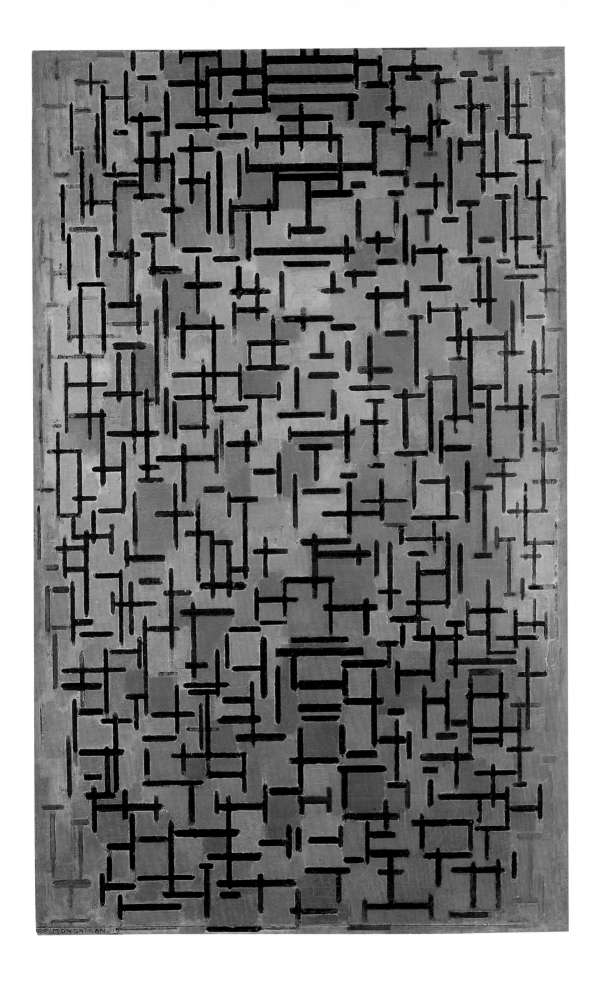

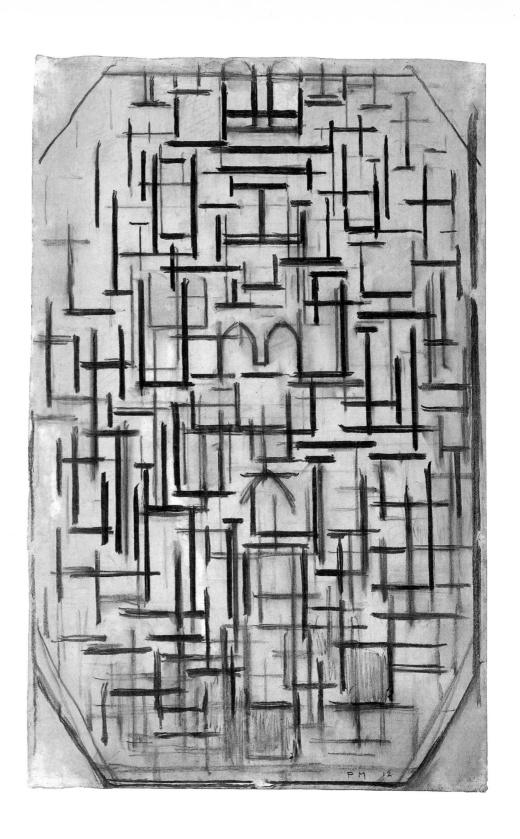

68
Composition, 1915, charcoal on
paper, 99 x 63.5. Museum of
Modern Art, New York.

them. It was directly after the exhibition that a contract between Bremmer and Mondrian went into effect, whereby he would receive a monthly allowance of fifty guilders in return for four small paintings per year.[11] Mondrian was delighted with the arrangement, since it meant that he could spend less time on portraits and the other work that he took on mainly for the money. Given his meagre sales and low level of productivity at this time, it would have been logical for him to give Bremmer the smaller works that were on show at his 1916 exhibition. He did not do so. No works were forthcoming during 1916 and the first few months of 1917, and in a letter of 7 March 1917 he gives as the main reason the fact that 'This year I have worked hard, and done much searching. A great deal of the old was due for a change. I was searching for a purer representation, which is why I wasn't satisfied with anything.'[12] Only then did he announce that he had completed one small painting, which he exhibited together with another canvas of the same proportions in May 1917, and subsequently handed over to Bremmer as part of their contract. These two works, *Composition in Colour A* and *B* (illus. 69, and 76 on left and right) probably conceal the two paintings in grey and yellow that he had exhibited the previous year. Traces of them are visible on the reverse of one of the works (illus. 70).

During this period it was not unusual for Mondrian to rework paintings he had originally considered finished, often radically altering them. This is what happened in the case of *Composition in Line* (illus. 75), to which he referred in his letter of 7 March to Bremmer: 'The large black and white one has also been totally reworked, which I now regret; it would have been better to leave it as it was, and make a new one. But when one is searching, one does not know in advance just how to go about it.'[13] Back in July 1916 he had sent Bremmer a photograph of the work in question in its original state (illus. 74), and we may conclude from his words that at that time Mondrian was satisfied with the painting. Otherwise he would not have had a photograph made and distributed among his friends. (We know that, in addition to Bremmer, Theo van Doesburg also received one.[14]) Later, we will return to Mondrian's decision to thoroughly rework a number of completed works dating from 1916, but for the present we can say that his output of paintings in that year, while extremely modest, was at any rate greater than the single work known to us today. In addition to *Composition*, there must have been another painting with the same general colour scheme, as well as two in grey and yellow and one in black and white, all of them displaying the characteristic structure of short horizontal and vertical lines, merging to form various configurations.

Abstraction

The *Compositions* from 1915 and 1916 are the last paintings by Mondrian that are demonstrably abstractions of a specific motif. The sketchbooks and larger drawings that have been preserved display the various phases of the process of abstraction. In the case of his later paintings, we have no such drawings. This is unfortunate, as they would have had considerable documentary value. And yet we do know from Mondrian's letters and the occasional reference in other sources, that until 1919 he was still using visible reality as the point of departure for his paintings, although perhaps not for all of them. The fact that we have no figurative drawings preliminary to these works may mean that Mondrian had by then adopted a

69
Composition in Colour B, 1917, oil on canvas, 50 x 44. Rijksmuseum Kröller-Müller, Otterlo.

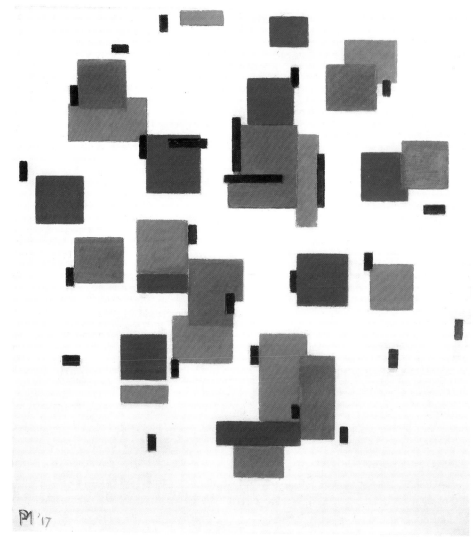

70
Verso of illus. 69.

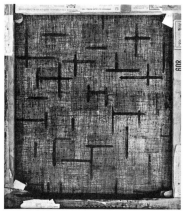

71
Composition, 1916, charcoal on paper, 50 x 44.5. Private collection.

different procedure. It is possible that once he had arrived at a certain standardization of his formal repertory, he no longer needed drawings to bridge the gap between reality and the painting, and completed the process of abstraction on the canvas itself. But this does not seem likely. There is another hypothetical explanation, namely, that Mondrian did use preparatory drawings, but in a purely functional way. Once a drawing had served its purpose, he may simply have thrown it away, because he did not consider it capable of standing on its own merits. The painting, as a complete and independent statement, was all that counted. This supposition is reinforced by a single drawing, probably from 1916, which has by chance been preserved (illus. 71). I believe it is a composition sketch for *Composition in Colour A* and *B* in its early state; the drawing has almost the same format. However, it clearly lacks the power and the boldness that were so much a part of the drawings from a slightly earlier period (illus. 61 and 68). It is also telling that after 1915 Mondrian no longer exhibited his preliminary drawings and studies, as he had done regularly up to then. The number of drawings from 1916 until his death that have survived is extremely small.[15]

Questions of this nature concerning the existence, function and presentation of preliminary studies may be seen as part of the more complex problem of abstrac-

tion, which was touched upon at the end of the previous chapter. If we ask ourselves when Mondrian ceased to base his work on some element of the visible reality around him, then we must conclude that it was probably during the second half of 1919. In the 'official' history of abstract art, this may be seen as fairly late. But there is no strict line of demarcation between a figurative and an abstract work of art, whether we are referring to Mondrian or to Kandinsky, to Malevich, Kupka, Arp or any of the countless other pioneers of abstraction. There is, however, a more interesting question concerned with the relevance of abstraction for Mondrian himself: How much significance did he attach to the motifs he employed in the course of this gradual transition, and how important did he consider the recognition and understanding of those motifs on the part of the viewer?

It would appear that for a number of years Mondrian was not entirely consistent when it came to the formulation of his standpoint on this issue. On the one hand, he distanced himself quite early on from the traditional solution of using the title to reveal to viewers the visual sources of his paintings. From the autumn of 1913 on, his entries were consistently designated *Tableau* or, in German-speaking countries, *Gemälde*, with or without an accompanying number. After 1914 he used the title *Composition*, combined with a letter or a number; in many cases he made use of a different letter or number for each exhibition, to the despair of later art historians. In 1917 he began giving each *Composition* a more specific designation (*Composition in Line*, *Composition in Colour*, and so on). He continued to use this method, although later the titles became more specific when he included mention of the colours employed (for example, the *Composition with Blue and Yellow*). It was not until well into the 1920s, and again in the 1940s, that certain works were given more suggestive titles (*Foxtrot*, *Trafalgar Square*, *Victory Boogie Woogie*, etc.). Due to the fact that from 1913 on Mondrian no longer used titles containing references to observable reality, the critics ceased to discuss the motifs that he had undoubtedly made use of. At most, they mentioned their own associations evoked by a particular painting: leaded glass windows, a butterfly's wings (suggested by the delicate colours), brick walls, or floor plans of buildings. Occasionally they attempted to characterize the mood of the works as serene or spiritual, musical or ornamental. Many of these associations and characterizations were deliberately negative or derisive, the implication being that such works were not worthy of being referred to as paintings. In any case, the critics were almost unanimous in assuming that the works he produced after 1913 were non-figurative.

On the other hand, for many years thereafter Mondrian repeatedly referred in his correspondence to specific motifs that he had used in his paintings, or discussed in more general terms the sources of his inspiration. In the letter to Bremmer of 29 January 1914 he wrote: 'Nature (or that which I see) inspires me, provides me – as it does every painter – with the emotion by which I am moved to create something.'[16] And in the same letter he compares Futurism and Cubism with regard to their 'contents', by which he seems to mean the choice of subject-matter. In this respect the Futurists were modern, but the Cubists were not, although he notes that they did take 'a giant step in the direction of abstraction', and were therefore modern with respect to language of form and effect. The entire passage is a clear indication that at this point Mondrian still attached importance to the choice of subject, and was striving for a kind of art that was modern in both form and content, as I maintained above with respect to his paintings of Paris facades

and the pier-and-ocean motif. At the same time, however, he made little effort to clarify the contents of his paintings for the benefit of the public, for example, by means of titles.

This apparent paradox can only be explained by the fact that at some time around 1914 Mondrian had succeeded in superseding the specific and had turned all his attention to expressing the general, to such an extent that the subject-matter of his paintings had become virtually interchangeable. It was in this sense that he agreed with Bremmer, who had said during a lecture in December 1915 that *Composition* (illus. 64), based on the pier-and-ocean motif, 'lived and breathed the clear, pure atmosphere of Christmas Eve'. Bremmer's audience had taken exception to this interpretation, but in a letter Mondrian supported him:

> For I would have felt like saying to them that it did not really matter what it portrayed, in the usual sense of representation, and that you were quite right in saying that something by me was a Christmas Eve atmosphere [. . .]. If you portray the idea of Christmas in a truly abstract way, then you're expressing stillness, equilibrium, the domination of the spiritual, etc., and that is undoubtedly what you intended to say.[17]

At this stage in his development Mondrian was seeking the general in the specific which was still present in his subject-matter. Referring to several photographs he had sent Bremmer in July 1916, he wrote of a drawing with the church-tower motif (a variant of illus. 68) that, in his view, there was 'too much of a specific direction, a specific "exaltation", so to speak, expressed in it'. Another photograph showed his most recent painting (illus. 74): this is almost perfectly square, with a more or less equal distribution of horizontal and vertical lines. He described it as 'more advanced, more general in its representation, than the others'.[18] That general representation, in which all the opposing forces were brought into harmony with one another, was his ultimate goal.

Abstraction, it seems, did not mean the same thing to Mondrian as it did to that other great pioneer, Kandinsky. For Kandinsky it was a matter of liberating the expressive form: he dreamt of a new, articulated system of signs whereby it would be possible to express feelings, or other communications of an individual nature, without any reference to visible reality. Mondrian, by contrast, abstracted the visible phenomena until he felt that he had found the common denominators that formed the essence of reality, the true reality behind the illusions that make up the visible world. It was for this reason that he referred to his own art as abstract-realistic painting. The process of abstraction took him many years, but he never rushed himself, apparently convinced that evolution in art, as in the universe, was an extremely slow process.

Contact with van Doesburg and van der Leck

After returning to the Netherlands from Paris, Mondrian had need of exhibitions if he was to show his work and, hopefully, sell it. But he did not seek any close association with fellow artists, at least not with those at whose side he had once achieved such a breakthrough for modernism in the Netherlands – men like Toorop, Sluyters and Gestel. In 1914–15 he distanced himself from the personal feuds going on in the Moderne Kunst Kring. Nor did he seek to associate himself with new groupings, such as De Anderen and De Branding, although he had several friends among the founder-members. He may have considered these

associations too heterogeneous, or perhaps somewhat lacking in calibre. Or perhaps it was for quite a different reason: among the artists who exhibited with De Anderen and De Branding were men like Janus de Winter, Johan Tielens, Laurens van Kuik and Gerlwh, who, like Mondrian, were interested in things esoteric, but who expressed their interest by means of outlandish abstract fantasies and representations of auras, somewhat in the vein of Kandinsky, a type of art to which he did not aspire.[19] In late 1915 and early 1916, however, he met two artists with whom he did develop far more than a passing acquaintance. In fact, it would be true to say that these two contributed more than anyone else to the crystallization of Mondrian's art and theory: Theo van Doesburg and Bart van der Leck.

Mondrian first met van Doesburg, who was almost ten years his junior, in his capacity as art critic of the esoterically oriented weekly *Eenheid*. In November 1915 van Doesburg published an exhibition review in which he praised Mondrian's newest work, *Composition* (illus. 64), which he said aroused in him a sensation of 'pure spirituality: The impression is one of Calm; the stillness of the soul.'[20] The unqualified admiration that was expressed in this review, and in a previous letter by van Doesburg, must have been music to Mondrian's ears; such praise did not often come his way, especially during this period. Moreover, he was no doubt gratified by van Doesburg's insight into his intentions. He himself had expressed those intentions with regard to *Composition* in similar terms in the above mentioned letter to Bremmer: 'If you portray the idea of Christmas in a truly abstract way, then you're expressing stillness, equilibrium, the domination of the spiritual, etc.'[21] Mondrian's written answer to van Doesburg is lost, but apparently it contained a favourable reaction, confirming van Doesburg's interpretation. The latter then wrote to his friend, the poet Anthony Kok, on 26 October, announcing 'I was right about the spiritual in Mondrian's work'. He also mentions that he dedicated a poem to Mondrian entitled 'Cathedral I', probably inspired by the drawing that Mondrian had exhibited in October 1915 together with *Composition*.

This initial exchange led to an intensive correspondence between Mondrian and van Doesburg; almost all the former's letters survive, so that we have a fairly clear – albeit one-sided – idea of their exchange of ideas. We know from the letters that they met only sporadically during the period prior to Mondrian's return to Paris in 1919. These meetings were almost always at Mondrian's home in Laren; van Doesburg himself lived successively in Utrecht, Haarlem and Leiden. As van Doesburg seldom exhibited, we may assume that Mondrian initially had only a vague idea of what kind of an artist he was. This was perhaps as well. I suspect that he would have found van Doesburg's work amateurish, and his genre one with which he himself had very little affinity. In 1915 van Doesburg was doing fairly nondescript work of an abstract expressionist nature: his paintings, depicting auras or thought-forms, betray the influence of Janus de Winter and Kandinsky. In the course of 1916, he opted for a Cubist discipline, but it was not until the middle of 1917 that the outward manifestation of his work began to display a definite relationship to that of Mondrian and van der Leck.[22]

Mondrian's regard for van Doesburg was undoubtedly based on his phenomenal abilities as an organizer and stimulator, as well as a writer and theorist. Van Doesburg was a man of inexhaustible energy, who made friends as easily as enemies; he had an agile mind, and was quite well-read in different areas of

science and the arts. The manner in which he familiarized himself with Mondrian's ideas, supplementing them with new elements, must have given Mondrian the pleasurable feeling that he was no longer a voice crying in the wilderness: the ideas on art that had taken him years to develop were finally beginning to bear fruit.

Mondrian's relationship with Bart van der Leck was of a different order. They had met before but they became good friends shortly after van der Leck moved from The Hague to Laren in April 1916. Their meeting had probably been engineered by Bremmer, who on behalf of the wealthy collector Mrs Kröller-Müller paid van der Leck a stipend and purchased work from him, as he did from Mondrian. In any case, Mondrian wrote to Bremmer on 1 August 1916 to inform him that he was pleased to have found in van der Leck 'a man who was striving in the same direction'.[23] During a period of about two years they saw quite a lot of each other; then their relationship cooled. We have no record of their exchanges, for they lived fairly closely to one another and had no need to correspond. There is some indirect information available, such as that contained in their letters to others, and it is clear from these letters that the contact between them was mutually fruitful at a crucial phase of their artistic lives – fruitful not only for their work, but also for their ideas. At the time they became friends, both were mature artists: Mondrian was forty-four, van der Leck five years younger. Both had gone through a long and gradual development – with occasional fits and starts – and both had thought a great deal about their work, albeit from quite different perspectives. In his youth van der Leck had trained in a workshop producing stained glass, and until 1904 he was a student at the Rijksschool voor Kunstnijverheid (State School for the Applied Arts) in Amsterdam, attending evening classes at the Academy. In keeping with his training, van der Leck's interest was directed mainly toward monumental art, which in the 1890s had begun to flourish anew, due to the Symbolist Antoon Derkinderen. Van der Leck attempted to re-create Derkinderen's ideal of community art in a new form, but discarded the latter's neo-medieval stylization and lofty subject-matter, preferring to concentrate on realistic, everyday themes. He adopted a quasi-naive style, here and there reminiscent of Nabis such as Bonnard and Felix Vallotton, and elsewhere of the early van Gogh, or Belgian social realists like Charles Meunier or Eugène Laermans.

From 1913, van der Leck schematized his figures and objects until they were almost like logos, their outlines filled in with a few strong, unmodulated colours against a white background. This highly personal style was worked out mainly in paintings which resembled a kind of framed mural, but then in a smaller format. He occasionally received commissions for monumental work, mainly from Bremmer on behalf of Mrs Kröller-Müller. On one occasion she arranged for him to collaborate with the prominent architect H. P. Berlage, a project that fell through in 1915–16 and engendered in van der Leck a heartfelt mistrust of architects.[24] In the spring of 1916, just about the time he met Mondrian, van der Leck completed two ambitious paintings, *The Storm* and *Port Labour*. Both works feature the three primary colours combined with black and white; they are unmixed and used full strength, with no trace of any chiaroscuro effect. In *Port Labour* (illus. 72) the human figures are still distinguishable from the background of a horse and cart and ships; however, due to the stylized rendering, the figurative elements have been absorbed into a rhythmic pattern of coloured shapes stretching across the

72
Bart van der Leck, *Port Labour*,
1916, oil on canvas, 89 x 240.
Rijksmuseum Kröller-Müller,
Otterlo. © DACS 1994.

73
Bart van der Leck, *Composition No.
4 (Mine Triptych)*, 1916, oil on
canvas, 113 x 56, 113 x 110.5,
113 x 56. Haags Gemeentemuseum,
The Hague. © DACS 1994.

full width of the frieze-like painting. It is easy to picture this work adorning the office wall of a shipping company.

Van der Leck's work must have given Mondrian ample food for thought. Here was art that owed almost nothing to the new international movements, whether Cubism, Futurism or Expressionism. It had no connection with Dutch modernism and was never seen at exhibitions where such work was on view. And yet it was unmistakably modern: in the rigorous simplification of form and intensification of colour, in the highly unpainterly application of paint, and in the unsentimental treatment of the subject. In comparison with *Port Labour*, Mondrian's *Composition* (illus. 67), likewise completed in early 1916, was admittedly much more abstract and thus more in line with the avant-garde art of the day. And yet there was a tonality in the colour and a sensitivity in the artistic signature that were, in effect, remnants of nineteenth-century movements, such as Impressionism. He could learn a great deal from van der Leck.[25]

What Mondrian and van der Leck together accomplished was a radicalization in the formal language of their paintings; they encouraged one another in the elimination of those characteristics that were too reminiscent of 'old' art. The influence of Mondrian is immediately evident in the four paintings that came after van der Leck's *Port Labour*, and to which the latter gave the telling title *Composition*, followed by a number. Each of these works was based on a series of studies in which a realistic drawing (a portrait of his wife, a girl with a cow, and so on) is systematically blocked out with white paint until all that remains is a series of isolated bars of colour against a white background. With a few minor changes,

this image was then transferred to the final painting.

Van der Leck's *Composition No. 4*, also known as the *Mine* triptych (illus. 73), is the indisputable high-point of this first group of semi-abstract works. It is based on sketches done in 1914 during a trip to North Africa and Spain, in preparation for a monumental leaded-glass window for the office of a firm owned by Hélène Kröller-Müller and her husband. The triptych is a sequel to that window, undertaken by van der Leck on his own initiative. The central panel shows the entrance to a mine, set in a hilly landscape; on each of the side panels we see a miner depicted in a subterranean passage – this explains the deep black of the background – bearing a tool or a sack on his shoulders. We have reason to believe that van der Leck intended this triptych to portray the arduous life inside the mines as a modern Calvary, as Meunier had done. The mine entrance in the central panel is indicated by means of a horizontal and a vertical beam, like a T-cross.[26] As in Mondrian's work from this period, the representation has been dissected into so many separate linear segments that it would be nearly impossible to reconstruct it without the benefit of the preliminary studies. The change that has taken place in the few short months since *Port Labour* is striking. Shortly after the delivery of the *Mine* triptych, van der Leck wrote to Hélène Kröller-Müller, who had bought it, to say that 'much of what is bound up with the old world has been let go', and that once he had eliminated the details of the subjects of his paintings, 'beauty [. . .] has been brought into pure relationship'. [27] The choice of terms is clearly traceable to his discussions with Mondrian.

The influence of van der Leck is equally visible in Mondrian's work, first and foremost in his reworking of some of the paintings that, in the summer of 1916, he had considered were finished. As he wrote in the letter to Bremmer of 7 March 1917, he had totally reworked 'the large black and white one', although he admitted that he would have done better had he left it in its original state and started afresh. He also reported that he had completed one of the two smaller paintings, either *Composition in Colour A* or *B*.[28]

Composition in Line in its original 1916 state (illus. 74) was quite different from the painting we now know by that name (illus. 75). It displayed a dense network of horizontal and vertical lines, most of them intersecting. These lines were fine and were rounded at the ends, showing the imprint of the brush. The image was largely concentrated in a circle or an octogon, the corners of the canvas left open, as in *Composition* done in 1915 (illus. 64). In the final version of the painting, the lines are much heavier and are cut off straight at the ends, so that they are actually more like blocks. Moreover, many of them are shorter and do not intersect in as many places. Each of the separate line segments and constellations of lines has acquired an identity of its own. The white, which runs smoothly from edge to edge, has been activated, as it were, becoming a full and equal element of the work: the brush strokes in the white section are just as heavy as those in black, and in effect serve to circumscribe the black. The liberation of the linear elements and the activation of the white background are characteristics that hark back to van der Leck's four compositions from 1916. The influence of van der Leck can also be seen in both *Composition in Colour A* and *B*, which form a pair, like those which he was already doing in 1916. In these two paintings, completed early in 1917, a third element – colour – has been added to background and line. For the first time in Mondrian's work we see colours confined in sharply bounded rec-

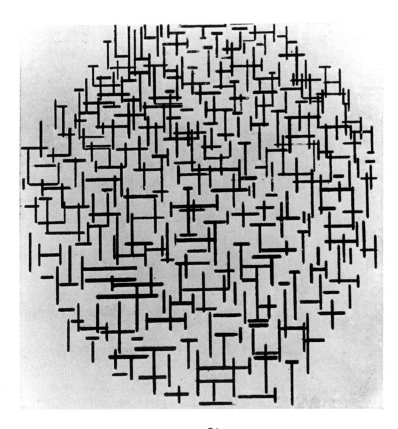

74
Composition in Line, original state of illus. 75, 1916, oil on canvas, 108 x 108.

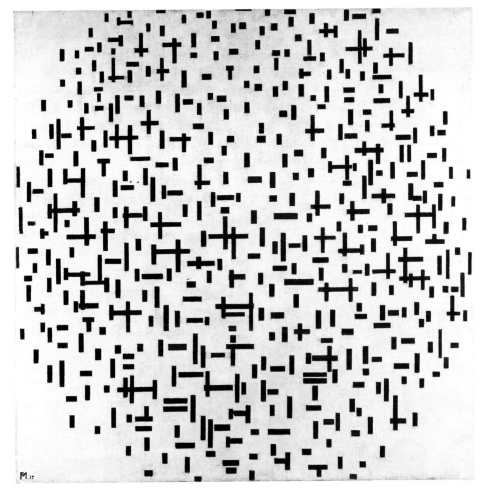

75
Composition in Line, 1917, oil on canvas, 108 x 108. Rijksmuseum Kröller-Müller, Otterlo.

tangles against white; no longer do they blend into one another, as in his paintings hitherto. But the subdued and diluted version of the primary colours used here betrays Mondrian's hand: a deep purple red, ochre, and dark blue, rather than van der Leck's strident red, yellow and blue. In another Mondrian touch, the blocks of colour are joined by various means, including one or more black line segments; some are simply juxtaposed, while others overlap, without any clear system or method, so that ochre, say, is not always on top or dark blue beneath. As a result, the spatial effect that invariably accompanies overlapping is here rather ambiguous. The constellation, the separate blocks of colour, and the separate segments of line all seem to be floating in indefinable space, or rather on an indefinable surface. Again, the white is not a neutral background, but a living, vibrant component of the painting: in some areas the white is as much form as the coloured shapes or the lines.

Alongside the various formal and technical considerations, there is another parallel between the work of Mondrian and van der Leck during the period 1916–17 that is of a totally different order. Mondrian had *Composition in Line* and *Composition in Colour A* and *B* hung as a kind of triptych when he exhibited them for the first time at the Hollandsche Kunstenaarskring show, held at the Stedelijk Museum in May 1917. The three paintings were hung some distance from one another, at different heights, but the placement was perfectly symmetrical, with the large work in the centre, well above eye-level. This unusual installation is recorded in a photograph in the van Doesburg archives (illus. 76).[29] On the basis of this photo, it is open to question, first, whether Mondrian did indeed see the three paintings as an entity, and second, whether he attached a special significance to the triptych-like presentation. I believe that the first question must be answered in the negative. Whenever he mentions the paintings in his letters, he refers to them as separate works; moreover, in the catalogue they are titled and numbered separately. However, in answer to the second question, it must be said that the triptych-like presentation was not without significance. This is clear from an interesting passage in a letter from Mondrian to van Doesburg of 7 July, shortly after the exhibition had taken place. He enclosed the glass negative of the installation photograph, which was to be printed in *De Stijl*:

Here is the plate of the 3 things [. . .]. I believe that the photograph is an excellent reflection of the work (that I exhibited). In the things to come I want to do something different, and yet this work expresses so well the religious, etc., etc. The placement of the three works together is likewise extremely expressive of certain things – don't you agree? [. . .] See how this negative works out – I think a reproduction might be just the thing for the first issue, and will complement the one by van der Leck.

For technical reasons the photograph was not published in *De Stijl*, but it is abundantly clear from this letter why Mondrian considered it to be an important document. He felt that not only in the works themselves, but also in the fusion of the three paintings to form a kind of triptych, the philosophical basis of his art had found expression, as it had six years before in his triptych *Evolution* (illus. 40). We have no figurative drawings for the three paintings, which might have provided some indication of the theme. However, we do know from other sources that in the one in the middle, *Composition in Line*, Mondrian returned to the motif of the sea – here without the pier – portrayed under a starry sky. *Composition in Colour A* and *B* were probably abstractions of trees, a motif that eyewitnesses tell

76
Installation photograph of three paintings by Mondrian at the 'Hollandsche Kunstenaarskring' exhibition, Amsterdam, 1917: *Composition in Colour B* (illus. 69), *Composition in Line* (illus. 75) and *Composition in Colour A*, also of 1917.

us he was still involved with in 1917. Indeed, in the preliminary drawing (illus. 71) the few slanted lines may be interpreted as the branches of a tree. Jan Maronier, who that year visited Mondrian in Laren, recalls that the painter was working on studies of espaliered apple trees (that is, trees trained against a wall), an interesting example of nature mastered by Man.[30] Because of the colour, these paintings are more earthy and material, contrasting with the somewhat ethereal and spiritual qualities of the centre panel, painted in black and white. We see here something of contrast, or perhaps evolution, in the centre panel, which is reminiscent of *Evolution*, but now without narrative, and without imposed theosophical symbolism.

Sadly, there was very little response to this carefully conceived visualization of Mondrian's deepest convictions. The majority of the reviews devoted to the exhibition of 1917, where the triptych was on show, either ridiculed his work or ignored it. One of the few to write a sympathetic review of his work was a good friend, the writer and critic Jan Greshoff. In an extensive discussion in the daily paper *De Telegraaf*, he spoke of the great devotion that emanated from Mondrian's work: the artist was searching for 'a form [. . .] for the eternal and unchanging laws which govern the world and life itself'.[31] There is no doubt that Greshoff had grasped the meaning of Mondrian's art. And yet the meaning of the manner in which the three works were hung had apparently escaped him. He did not mention it, nor was it referred to in any of the other reviews. In retrospect, Mondrian was forced to conclude that the installation of the three works as a triptych was less 'expressive of certain things' than he had hoped and expected.

It seems unlikely to have been a coincidence that Mondrian used the triptych form to express his metaphysical aspirations only months after van der Leck had produced his *Mine* triptych. Mondrian's installation may be seen as a personal statement, defining his standpoint with respect to van der Leck. The latter's triptych, no matter how abstract it appeared, was rooted in a specific motif from everyday life: the arduous labour of mineworkers. Their suffering was equated with that of Jesus on the Cross, which since the late Middle Ages had been the subject of countless altarpieces in triptych form. By contrast, Mondrian's own triptych, equally abstract in design, was based on universal, ageless motifs from nature that illustrated the process of cosmic evolution.

Compositions with colour planes, 1917–18

The interaction between Mondrian and van der Leck was not limited to the paintings discussed above. It was even intensified in the works that took shape in the course of 1917 and 1918, whereby van Doesburg and the Hungarian painter Vilmos Huszár gradually joined in the discussion. During a visit to the Kröller-Müller collection in December 1916 they had seen the four new compositions by van der Leck, including the *Mine* triptych, and they were deeply impressed, as van Doesburg made clear in an admiring letter to the artist. Shortly thereafter the work of both men displayed clear evidence of van der Leck's influence in the manner in which they dissected a motif into rectangles placed against a white background, and in their use of bright, though not exclusively primary, colours.

We know from Mondrian's letters to van Doesburg and other correspondence that the four painters wrestled with related problems, and that their exchange of views often gave rise to differences of opinion. The discussions centred on a variety of burning questions. Was it necessary to apply colour as bright and unmixed as van der Leck did? Could other colours besides the primary ones be used? Must the line be made explicit, or was it sufficient to indicate it implicitly in the contour and direction of the area of colour? Were directions other than horizontal and vertical permissible for the position of the various elements? How could the unity of line, colour and picture plane best be achieved? Should the image be concentrated within the surface of the picture, or was it better to suggest that it extended beyond the outer edges? Were the shape and placement of lines and areas of colour a question of intuition, or should they be governed by mathematical principles? And finally, there was the question of whether a painting should in some way be based on visible reality, or should take shape separately from that reality. These may appear to be purely formal questions, but for the artists concerned such issues were inextricably bound up with the ideological basis of their abstractions.[32]

In their common striving for a form of painting that employed its own basic means of expression – line and colour – as honestly as possible, proclaiming its two-dimensionality, the four painters gradually arrived at quite individual answers to these questions, honing their convictions on those of the others. Thus van Doesburg, after seeing Mondrian's *Composition in Colour A* and *B* at the 1917 exhibition, wrote to the artist, expressing his objections to the choice of dark, toned-down colours. In a letter of 16 May, Mondrian defended himself by maintaining that the light in the Stedelijk Museum was poor, so that the colour values were not as they were in the studio.[33] However, the criticism struck home, for in his next work, *Composition with Colour Planes* (illus. 77), the colours are noticeably more vigorous, approaching – for the first time – the unmixed primary colours of van der Leck. There is another interesting characteristic that reflects van der Leck's influence: all the linear elements have been left out, leaving only areas of colour of more or less equal size and visual weight, at more or less the same distance from one another, against a white background. This, too, is new for Mondrian. And finally, there are no longer any overlapping areas, such as we saw in *Composition in Colour A* and *B*; in only three places do the coloured blocks touch one another at their corners.

Composition with Colour Planes is not an ordinary oil painting. It is executed in

gouache on paper, a technique Mondrian seldom employed, but which van der Leck used for his studies – another link, then, between the two artists. Indeed, of all his works this is the one most reminiscent of van der Leck. Mondrian himself saw nothing strange in this. He was, in fact, quite pleased with the outcome, according to a letter to van Assendelft of 5 September 1917. He also had a black-and-white photograph taken of the gouache, which he sent to several friends, and which was published in *De Stijl* in January 1918. On the reverse of the photo sent to the painter and actor Louis Saalborn he wrote 'The blue is too dark, the yellow too light.'[34] The same observation appears in a letter to van Doesburg. He was obviously referring to the fact that black-and-white photographs were somewhat unreliable in the rendering of colour hues. In the reproduction in *De Stijl* this shortcoming is even more apparent: the yellow is pale grey, and the red and blue areas are very dark grey, which makes them almost indistinguishable from one another. It is possible that the photograph, or the poor quality of the reproduction, rekindled Mondrian's self-criticism; photographs sometimes had this effect on him. In any case, he returned to the gouache, making a number of changes. A blue plane to the left was completely removed, and a small yellow section at lower centre shortened; on the right, he also slightly altered the shape and relative position of the three blue planes that were positioned one below the other. These and other smaller corrections testify to a near obsessive attention to detail, which was to become even more marked in his later Neo-Plastic work. The rationale of the changes in the gouache is largely lost on an outsider. At most, one could say that the removal of the blue plane 'opens up' the work on the left and results in a greater concentration in the composition as a whole. The blue was the only plane to extend beyond the edge of the gouache on the sides, which leaves only a red plane at the top and a yellow one at the bottom still cut off by the edge. As a result of these changes, the white is more like a continuous field; this effect was always more pronounced in the work of van der Leck, who left more space between his coloured areas, and rarely allowed them to extend to the edge of the work.

For Mondrian, however, this gouache was a one-off experiment. In the course of 1917 he did four paintings that demonstrate that he was gradually distancing himself from van der Leck's idiom. The primary colours have been mixed with quantities of white to form pastel tints, and the interrelation between the colour planes, as well as their relationship to the background, differ from those of van der Leck. These paintings, all roughly the same format, again form pairs, as in the case of *Composition in Colour A* and *B*. In the first pair, the *Composition with Colour Planes*, now separated in museums in Rotterdam (illus. 78) and The Hague, the colour planes are positioned somewhat more evenly than in the gouache: they seem to form horizontal and vertical rows, albeit with deviations that disturb the apparent regularity. Moreover, there are fewer such areas, and they are larger and closer together. As a result the white background sometimes resembles a grid rather than a field; thus the vertical spaces in between the areas of colour look like white lines, counterbalanced by the staggered, horizontal white bands, that widen into open spaces. The white lends the works a tense, almost syncopated, rhythm.

In the next pair titled *Composition with Colour Planes*, both in private collections (illus. 79), Mondrian experimented with new visual effects. With the colour planes sliced off on all four sides, the expansive effect of the image has been extended

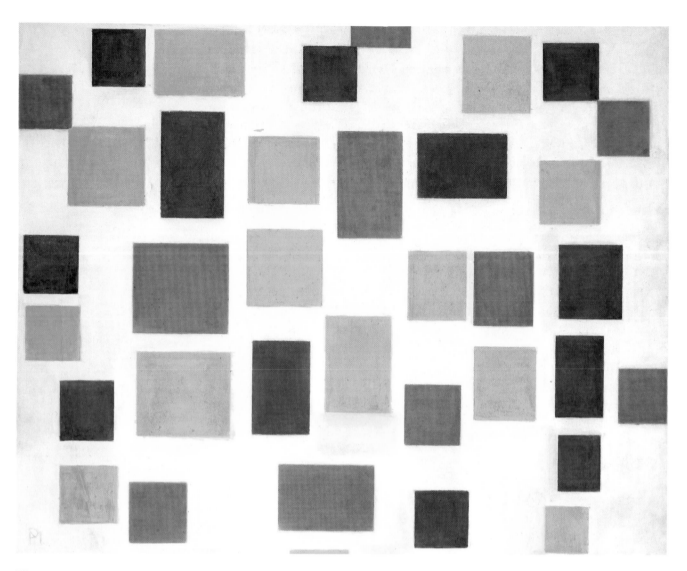

77
Composition with Colour Planes, 1917,
gouache on paper, 47 x 59.5.
Private collection.

in all directions. And while in the first pair the areas of colour touch slightly at only one point on the canvas, here they are contiguous in three or four places, while elsewhere they are positioned much further apart. But the greatest change is the fact that the unity of the white background has been relinquished: the background has itself been divided up into rectangular sections, and the white relieved by additions of grey. Writing to Bremmer on 27 February 1918, Mondrian elucidated that these works 'represent a development which I believe offers a better solution for colour planes against a background. As I painted, it gradually became clear to me that for my work colour planes set against a solid field do not form an entity. They do for van der Leck, but his method is different.'[35] I am not entirely sure that 'entity' is the correct term for these two paintings. It is rather as if Mondrian chose further to enhance the spatial ambiguity of the coloured areas. A far more radical decision was needed to bring about the intended unity, a decision which he took in late 1917 or early 1918. It was the obvious step dictated by the appearance of the white grid effect in the first pair of *Compositions with Colour Planes*, and the division of the background into sections in the second pair: he began to make paintings in which both the coloured areas and the white or grey areas were caught within a network of dark grey lines. In this way, he killed

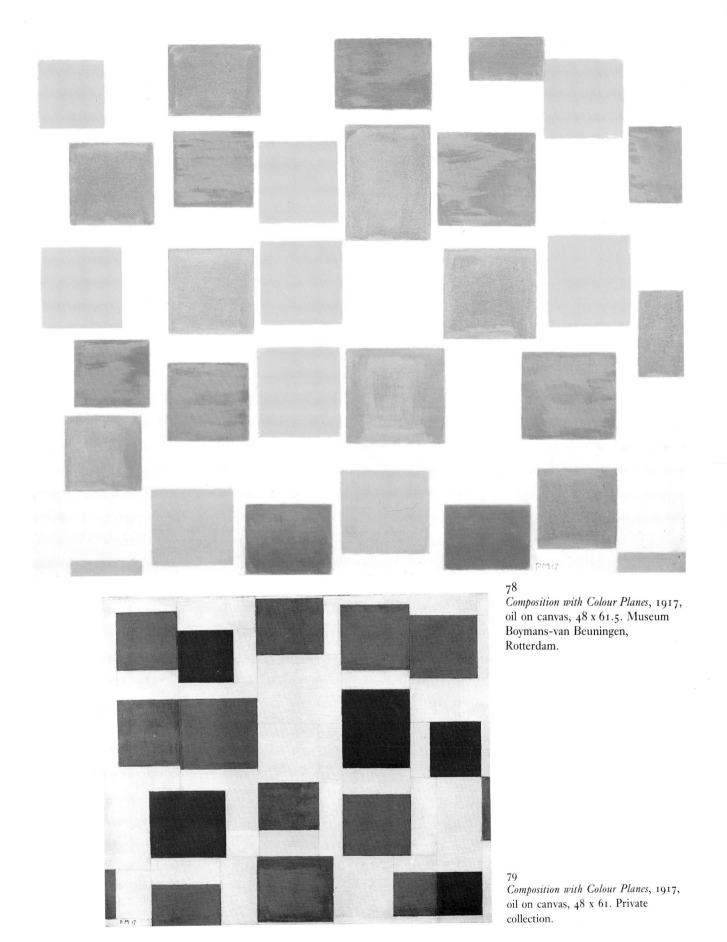

78
Composition with Colour Planes, 1917,
oil on canvas, 48 x 61.5. Museum
Boymans-van Beuningen,
Rotterdam.

79
Composition with Colour Planes, 1917,
oil on canvas, 48 x 61. Private
collection.

two birds with one stone, by distancing himself still further from van der Leck, and reinstating the line, which had featured so prominently in his paintings from his Cubist period onward.

In *Composition with Colour Planes and Grey Lines* (illus. 80), dating from 1918 and now in the collection of the Swiss painter Max Bill, we see the results of that momentous decision. The primary colours, less pastel and richer in contrast than in the previous works, but still not very strong, are both linked and separated by the lattice of dark lines, which creates a better balance between them. The white or light grey that previously functioned as background, and was always subordinate to the coloured sections, now has a form and identity of its own, and consequently a greater visual weight. The lattice not only connects but also stabilizes the idiosyncratic effects of colours and shapes: the yellows and reds advance less forcefully than they did against a white surface, and the blue, darker by nature, does not form a 'hole' in the surface. It is clear that this painting plays a crucial transitional role in Mondrian's *œuvre*. It refers back to earlier work, to the facade paintings he did in Paris, and in particular to the *Composition* of 1916 (illus. 67), but through his confrontation with the work of van der Leck, his own work has gained considerably in clarity and focus. At the same time this painting looks forward to the work that would take shape from late 1919 on. In effect, *Composition with Colour Planes and Grey Lines* may justifiably be seen as the first Neo-Plastic painting.

Originally, this transitional role was shared with at least three other works from 1918, which featured a similar irregular grid of dark lines that enclose both the coloured planes and the white or light-grey fields. Photographs of two of these paintings have been preserved: one, which turned up in the estate of Vilmos Huszár, shows a painting which, in view of the wide variation in gradations of grey, must have had more or less the same colour values and nuances of grey and white as the painting in the Max Bill collection;[36] the two works may even have formed a pair. The other photograph was published in *De Stijl* in March 1919 (illus. 81). We know from letters to van Doesburg that this was a composition in grey and yellow – the sober palette of his Cubist paintings – and that it was larger than the others. Mondrian mentions that it had been purchased by Bremmer; from there the work soon found its way into the Kröller-Müller collection, like so many of Mondrian's other paintings. In the printed catalogue that describes the collection as of 1 January 1921, Bremmer lists it as no. 420: 'Composition. Rectangles in tones of grey, yellow, greenish grey, grey, and mat white, separated by grey bands.' The dimensions were 67 × 81.5 cm. Under no. 421 Bremmer describes a similar painting dating from 1918; it is smaller, the size of the work in the Bill collection: 'Composition. Rectangles in red, yellow, blue and white, separated by black bands.'[37] During the 1920s, and on later occasions, Hélène Kröller-Müller removed a number of abstract Mondrians from her collection, because she felt that the painter had become bogged down in an overly rigid system. Most of these works can be traced to their present locations. Not so the two works dating from 1918. These have disappeared, not because Mondrian himself painted them over, as in the case of several works dating from 1916, but because, mysteriously, they cannot be traced following their removal from the Kröller-Müller collection.

The theory of Neo-Plasticism

Mondrian's close contact with van der Leck and van Doesburg during this period was not only fruitful for his art, it also enabled him to hone his artistic theories on theirs. In October 1917 he presented himself for the first time as an art theorist, with the appearance of the journal that van Doesburg hoped would unite the most prominent Dutch modernists – *De Stijl*, a review for the modern visual arts. On page two of the first issue, following an introductory piece by van Doesburg, there is an article entitled 'Nieuwe Beelding in de Schilderkunst' (Neo-Plasticism in Painting) by Piet Mondrian. This was the introduction to a series of monthly articles in *De Stijl* until October 1918, followed by an Appendix in the December issue.

If the impression created by the series was one of unity, it was a false impression. Its genesis was a lengthy and complex process, which went back to the very beginning of the Great War. Mondrian was apparently not discouraged by the rejection of his article for *Theosophia* in early 1914. In the summer of that year he was again in Domburg, where he continued to write down 'many things', as he confided to van Assendelft.[38] Over the next year or two he took off from painting a great deal of time in order to draft what he modestly referred to in a letter to Bremmer as 'some scribblings', but for the benefit of van Assendelft called 'my book'. On 7 September 1915 he announced that 'My book is almost finished. It is much more complete than I expected.'[39] The finishing of the work would ultimately take up a great deal more of his time. It is not clear whether Mondrian took steps to have his book published, as one might expect. In any case, the necessity to take some initiative in this direction was removed when he became acquainted with van Doesburg, who had plans for an art journal in which he hoped to involve both Mondrian and van der Leck. The realization of these plans took some time and, as we have seen, the first issue did not appear until October 1917. In the meantime, Mondrian undoubtedly made a great many changes to his book, many of them prompted by suggestions and criticism from van Doesburg, van der Leck, and probably van Assendelft and others as well. On 26 January 1917 he informed van Assendelft that 'I will soon be sending you the new introduction, and I would like to know whether you consider it an improvement. There's no hurry in returning it, as I am still working on the book itself, in collaboration with van der Leck.'[40] As late as May of that year van der Leck provided 'a few improvements'.

The text, as published in *De Stijl*, actually consists of different parts. The introduction was probably not written until late 1916, and was revised in 1917. In the letter of 26 January, Mondrian confided to van Assendelft that he had read his Introduction at a lodge meeting of the Theosophical Society, but that apparently 'those people were not yet ready, so to speak, for "the absolute"'.[41] The greater part of 'Neo-Plasticism in Painting' consists of the revised version of the book that he had worked on between 1914 and early 1917. When this section was published in *De Stijl* between November 1917 and May of the following year, there was no reference to a continuation. However, the June 1918 issue contained a new instalment under the same title, and others continued to appear up to and including the October issue. This 'new article', as Mondrian himself referred to

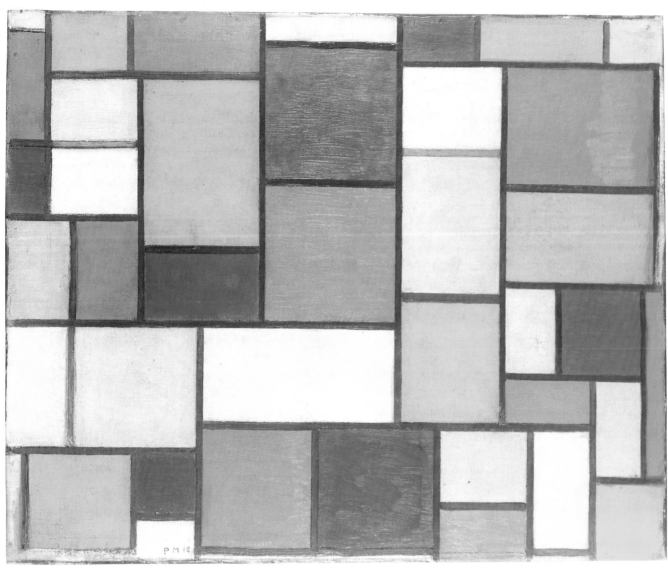

80
*Composition with Colour Planes and
Grey Lines*, 1918, oil on canvas,
49 x 60.5. Max Bill collection,
Zumikon, Switzerland.

81
*Composition with Planes in Grey and
Ochre*, 1918, oil on canvas, 67 x 81.5.
Formerly Kröller-Müller collection,
now lost; reproduced from *De Stijl*
II/5, 1919.

it in letters to van Doesburg, was not begun until April 1918. The December 1918 issue contained the Appendix, which Mondrian wrote in November of that year. The fact that the series was written over a fairly long period of time may account for certain discrepancies between the various instalments.[42]

'Neo-Plasticism in Painting' is a highly abstract text. Also wordy, it does not easily disclose its meaning, even after several readings. Mondrian was clearly not an experienced writer. The main section, the 'book' dating from the period 1914–17, is divided into three chapters with separate titles: 1. Neo-Plasticism as Style; 2. Neo-Plasticism as Abstract-Realistic Painting: Expressive Means and Composition; 3. The Rationality of Neo-Plasticism. The work is closely related to the notes in Sketchbook II, although here all attention is focused on the art of painting as the apotheosis of the new culture. References to the various religions have been deleted, probably because in writing for *De Stijl* Mondrian was addressing himself not to theosophists, but rather to a readership of fellow artists and art-lovers. And yet in the first chapter he says of style exactly what previously he had said about religion, namely, that there is a single universal content, which is shrouded in forms that are the product of their own particular age. Thus style encompasses both the universal and the individual.

The urge to achieve the universal, which all artists have in common, forces them to seek a mode of expression that most closely approaches this ideal. Earlier generations (and Mondrian himself, in an earlier stage of his development), traditionally made use of the cross, for example, but there were too many symbolic and religious connotations attached to this motif. The new art adopted the rectangle as the universal vehicle of expression, one which features both colour and – through the contours – line. Mondrian makes almost no reference to the line as a separate means of expression, probably because in 1917, under the influence of van der Leck, this had been temporarily banned from his work. Just as the line appears in its most essential form in the contours of the rectangle (two straight lines that meet in a right angle), colour is reduced to its essence in the primary colours. In a note Mondrian adds that they can be mixed with black or white without ceasing to be primary colours; this, too, is reflected in his actual work during this period, in which it differs from that of van der Leck.

As noted above, it is important to realize that Mondrian did not see these purified means of expression as symbols in the traditional sense of the word. With the exception of a few incidental remarks concerning the meanings other authors attribute to certain lines and colours (namely the nineteenth-century theorist D. P. G. Humbert de Superville and the philosopher M. H. J. Schoenmaekers), he avoids attaching any individual significance to the direction of a line or a particular colour: what matters is their concurrent appearance, their interaction. A work of art is not a symbol or a complex of symbols, nor is it an illustration accompanying some philosophical argument, but rather an expression – rooted in reality – of what he saw as the ultimate destination of the evolution of all creation. All opposites will be united in harmonious union, opposites which in this text are continually presented in different conceptual pairs (the universal and the individual, the inward and the outward, spirit and matter). Characteristically, the duality of masculine/feminine is barely mentioned, presumably because by this time he found it too specific.

Thus in 'Neo-Plasticism in Painting' Mondrian reserved a crucial role for the

art of painting, the most advanced form of which is his own work. Admittedly, even Mondrian's painting is not entirely free from the restrictions imposed by time and place. However, through the purification which it has undergone, the art of painting has become a shining example for all the other arts, indeed, for culture itself. Painting provides a glimpse, a foretaste, of the future of that culture; it is the concretization of all the tendencies becoming apparent in religion, science and other areas of life: the veiled proclamation of wisdom is increasingly giving way to the 'wisdom of pure reason'.

It is significant that here – and only here – Mondrian refers explicitly to Theosophy. In a note he says that in his book *Uber das geistige in der Kunst* (On the Spiritual in Art), 'Kandinsky points out that Theosophy (in its true sense; not as it generally appears) is yet another expression of the same spiritual movement which we are now seeing in painting.'[43] This comparison can only mean that Mondrian considered his art to be the 'outward sign' of theosophical thinking. It also implies that initially he expected theosophists to have the proper spiritual attitude, whereby they would be receptive to that art; his parenthetical aside makes it clear that he is pessimistic about Theosophy in actual practice. This pessimism was engendered both by the rejection of his article for *Theosophia* in 1914, and the realization, following his reading of part of his book at a lodge meeting of the Theosophical Society in early 1917, that 'those people were not yet ready'. Armed with the insight provided by these experiences, and the almost universal lack of understanding with which his paintings were met when they were exhibited, Mondrian posited, towards the end of the text, that the 'new contemporary consciousness' tended to manifest itself in small groups only that form around individuals. While he did not mention artists' groups here, the suggestion is that he saw himself as an individual surrounded by such a group, i.e., the artists of De Stijl, supplemented with a number of sympathetic followers like van Assendelft. Even in the elite company that he had in mind here, there is no perfect unity 'because of differences in the activities and inclination of individuals', but this unity may as yet come about through 'the development of the visual powers, in other words, the ability to see in a pure, i.e., abstract, plastic and conscious manner.'[44] Mondrian was confident that ultimately the new consciousness would expand until it included all mankind.

One reason why 'Neo-Plasticism in Painting' is such a difficult text is that Mondrian was simply trying to say too much at once. He was attempting to clarify and rationalize what he had achieved by purely intuitive means in his art, in an effort to generate sympathy and understanding for that art. At the same time, he wanted to proclaim his vision of culture and the relationship between art and life. On the one hand, the text is an essentialist theory of art (with Neoplatonic features), in the tradition of the late nineteenth-century theories of Gauguin and other artists. But it is also a philosophical piece in which the dialectic of Hegel has been superimposed on theosophical theories of evolution. This led him to claim that his art was eminently suited to make possible the disinterested vision propagated in the previous century by Schopenhauer.

In this text Mondrian repeatedly refers to other authors, and even when he does not mention them by name, the influence of others can be detected. One of them is M. H. J. Schoenmaekers, a former Catholic priest who, as he once confessed, devoted himself to the proclamation of 'a new, theology-free religion'.[45] It

was Michel Seuphor who first mentioned Schoenmaekers in connection with Mondrian, in an article in 1937, and the similarity between their theories is dealt with in great detail by H. L. C. Jaffé in his pioneering 1956 study of De Stijl.[46] In his article 'Mondrian and Theosophy' (1971), basing himself in part on the Paris sketchbooks from 1912–14, Welsh convincingly argues that Mondrian's ideas had taken form before he met Schoenmaekers, and before the appearance in 1915 and 1916 of the latter's most important books, *Het Nieuwe Wereldbeeld* (The New World Image) and *Beginselen der Beeldende Wiskunde* (Principles of Plastic Mathematics). Welsh believes that Mondrian and Schoenmaekers quite independently drew on related theosophical and philosophical sources.[47] This is in itself a plausible explanation, although we know from other sources that Mondrian must have been acquainted with earlier writings by Schoenmaekers. From its inception in 1910, Mondrian had subscribed to the esoteric weekly *Eenheid*, which in its first year serialized Schoenmaekers's *Christosophie* prior to its publication in book form. However, there is nothing to indicate that Mondrian was at that time influenced by Schoenmaekers's thinking. This was probably not the case until late 1914 or early 1915, when he became personally acquainted with Schoenmaekers through the composer Jakob van Domselaer. The three saw quite a lot of each other during 1915 and 1916, and after Theo van Doesburg had visited Mondrian for the first time in January 1916, he wrote to his friend Anthony Kok that Mondrian and van Domselaer were both 'obsessed by the theories of Dr Schoenmaekers'.[48] This was no exaggeration. Mondrian was a novice at writing, and he allowed himself to be led by concepts formulated by Schoenmaekers; the term 'Nieuwe Beelding', for example, appears to have been borrowed from Schoenmaekers's *Beeldende Wiskunde*.

But there were clear differences between their theories, especially with respect to art, while there also appears to have been something of a personality clash between them. Although Mondrian originally recommended Schoenmaekers to van Doesburg as a potential contributor to *De Stijl*, he withdrew his recommendation before anything could come of it, referring to him as an 'awful man'. And when van Doesburg suggested in a letter to Mondrian that he had been influenced by Schoenmaekers's work in the writing of 'Neo-Plasticism in Painting', this was denied most emphatically: '*I* got everything from the Secret Doctrine (Blavatsky), not from Schoenm. Even if he does say the same things', Mondrian wrote back in May 1918. And although prompted in part by pique, this answer was probably not far from the truth. In his article Mondrian presented the new purified version of his art, pared down to its essence, as the visual revelation of fundamental theosophical concepts that he had entertained for many years.

The regular grid

In March 1918 Mondrian entered eight recent works for the exhibition of the Hollandsche Kunstenaarskring at Amsterdam's Stedelijk Museum. These included the gouache, probably both pairs of *Compositions with Colour Planes*, and a number of paintings featuring the grid, including the large grey and yellow work purchased by Bremmer. When Mondrian asserted, in the letter to Bremmer of 27 February 1918, that he had found a better solution 'for colour planes against a background', he was no doubt referring to works on show at this exhibition.

The network of lines does indeed serve to increase the cohesion, not only between the colour planes themselves, but also between the coloured and uncoloured portions of the work. Some months later, around May, he wrote to van Doesburg that he had continued to work on the paintings that had been exhibited in Amsterdam, indicating that certain aspects of these compositions were still presenting problems.

One problem that Mondrian was unable to solve, initially at any rate, was the capriciousness of the dimensions of the various sections, and the unsettled quality of the grid itself. This is illustrated by the one existing painting and the photos of the two others: the lines run along two, three or four coloured planes, either making a slight shift or stopping at a crosswise line (illus. 80 and 81). The paintings also seem to consist of separate parts, almost like collages. In the work owned by Max Bill, for example, the upper-left quarter of the work, enclosed by straight lines, seems to be a painting within a painting, while other clusters of planes also appear somewhat isolated. And finally, there is something indecisive in the way the planes are cut off at the edges, indicating that Mondrian was still wrestling with the old dilemma of whether the painting should be seen as self-contained, or something that was part of a larger entity.

The work that Mondrian started on in the spring of 1918 was intended to address precisely these problems. During a period of about a year, he completed no fewer than nine paintings based on a completely regular grid. In all these paintings, regardless of the format – vertical, horizontal, or square – the surface is divided into 16 × 16 modules, so that each module has exactly the same shape as the painting itself. Within this regular pattern, larger planes take shape, which form an irregular composition. However, the underlying system is always immediately recognizable, and it is this that dictates the dimensions of the planes. Thus their ratio to one another and to the surface of the paintings as a whole is simple, and capable of being expressed in whole numbers. There is something unexpected about Mondrian's decision to make the size and arrangement of the planes subject to a mathematically determined grid. In view of certain pronouncements of his, he seemed to have more faith in intuition and powers of observation sharpened by experience, than in the measuring rod. As he had written to Bremmer some years before, 'chance must be as far removed as calculation'.

Of course, with the knowledge of art history and aesthetics that he had gained during his years at the Academy, it was not lost on Mondrian that down through the ages modular and proportional systems had played a major role in both art and architecture; and often a special significance was attributed to such systems, expressing as they did the perfect harmony and order of the universe. Towards the end of the nineteenth century such concepts had gained new topicality in the Netherlands in the theories and design practice of architects and practitioners of the applied arts, notably De Bazel, Lauweriks and Walenkamp, who traced their 'design by system' back to theosophical principles. The 1890s and the first two decades of this century saw the appearance of a great many publications devoted to the subject. Among the best-known and most influential were books by J. H. de Groot, such as *Driehoeken bij het ontwerpen van ornament* (Triangles in Ornament Design), published in 1896, and his *Vormharmonie* (The Harmony of Form) of 1912. There was also a handy little book by Herman Hana, dating from 1917, entitled *Ornament-ontwerpen voor iedereen: Het stempelboekje* (Ornament Design for

Everyone: The Stamp Book) in which he demonstrated the use of regular patterns produced by means of geometrical stamps.

We have no proof that Mondrian was familiar with this literature or that it inspired him during the period that he was concentrating on 'systematic' paintings, but it is not inconceivable that this was the case. *Vormharmonie* contains a number of short chapters on 'uniformity', 'uniformity of size and scale', 'uniformity of distribution' and 'balance', which had considerable relevance for his work.[49] He was undoubtedly familiar with Hana's *Ornament-ontwerpen*, as Hana lived nearby, in Blaricum, and the two saw a great deal of each other during this period.

The literature referred to above found application primarily in architecture, monumental art and the applied arts.[50] There was some incidental use of mathematical principles in the composition of paintings, notably by van Konijnenburg and Toorop, but these remained isolated examples.[51] For Mondrian it was presumably the traditional link between organizational systems and the applied arts that was initially a problem. As we know, he had always seen 'free' painting as strictly separate from the applied arts, and was opposed to any association of his abstract work with ornamentation or decoration, as had been suggested by certain critics. He felt that this implied a lack of recognition for the deeper significance of his work. And yet there are signs that around 1917–18 he was gradually adopting a more positive attitude toward 'the decorative', as he called it, and beginning to think about the relationship of his work to the architectural environment. These new insights were no doubt instigated by van der Leck, van Doesburg and Vilmos Huszár, who had been studying the subject for some time, designing, and in some cases executing, monumental art. They sometimes made use of modular systems, if only because the material called for them, as in the case of van Doesburg's tile floors and ornamental friezes made of glazed brick of 1917–18 for De Vonk, a seaside home for girls designed by the architect J. J. P. Oud (illus. 83).

Mondrian's vision of the relationship between painting and architecture will be dealt with in detail in the following chapter. Here it will suffice to note that modular systems figured in the discussions on that question; in a sense, these discussions provided an incentive to examine their applicability for free painting. This was quite clearly the case for Huszár, who during the first half of 1918 began to produce paintings based on a modular system (illus. 82); he attempted, moreover, to systematize the colour with the aid of the colour theory developed by the German physicist Wilhelm Ostwald.[52] It was at this time that Mondrian – independently of Huszár – began on his paintings using a linear grid. In a letter to van Doesburg of 13 June 1918 he recounted how a visit from Huszár six days earlier brought to light the similarities between their methods:

82
Vilmos Huszár, *Composition in Grey*, 1918. Lost; reproduced from *De Stijl* II/4, 1919.

I had just started on something which I showed to Huszár, and which he liked. It was done on the basis of a regular subdivision – without my knowing anything about his work. But *I* rework the subdivision a lot further, and I think it will look quite different from Huszár's work. I guess everything will depend on *how H. goes on*, but in *my* opinion, it is quite possible.

And in a postscript Mondrian added: 'I agree that there is no danger in the system itself, only in obstinate adherence to the system.' Almost the whole of the letter is devoted to this work 'on a mathematical foundation', as he put it, but what he viewed as most essential was the 'reworking' of the mathematical subdivision, the 'realization'. It was here that the intuition of the artist came into play, raising the

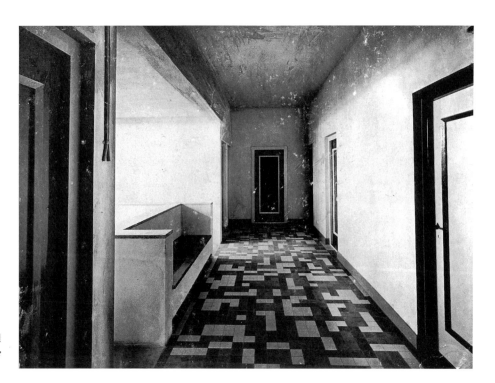

83
Theo van Doesburg's tile floor for the upper corridor in De Vonk, the seaside home in Noordwijk designed by J. J. P. Oud; reproduced from *De Stijl* II/1, 1918.

work above the mechanical and meaningless level of an ornament.

Mondrian's first paintings to be based on a modular system were probably two elongated works in a vertical format, which evoke the *Composition* of 1916 (illus. 67), and which may represent a further abstraction of the church-tower motif. The first is another *Composition in Grey and Ochre* (illus. 84). The other, larger work is unfinished. The underlying modular system has been drawn on the canvas in charcoal, and this is covered by dark grey lines in oil paint, enclosing areas of varying sizes. Both works have obvious advantages over the previous compositions featuring irregular subdivisions. The continuous lines lend the composition clarity, while the opposition of horizontally and vertically linked modules is more marked. However, it proved difficult to overcome the dominance of the vertical, and it may have been Mondrian's dissatisfaction with this visual effect that led him to lay aside the second work. Instead, he started a number of paintings with the more neutral square format, which he had used – to his complete satisfaction – in 1917 for *Composition in Line* (illus. 75).

The first diamond-shape paintings

By far the most interesting, as well as the most problematical, of the series of works based on a modular system are the four diamond-shape compositions dating from 1918 and early 1919; they are the first of his paintings to be done in this special format, consisting of a square set on point. To facilitate the discussion of these four works, I have numbered them as follows:

1. *Composition with Grey Lines*, dated 1918 (illus. 85)
2. *Composition with Black Lines*, dated 1919 (illus. 86)
3. *Composition with Planes in Ochre and Grey*, dated 1919 (illus. 87)
4. *Composition with Colour Planes*, dated 1919 (illus. 89)

84 (opposite)
Composition in Grey and Ochre, 1918, oil on canvas, 80.5 x 49.5. Museum of Fine Arts, Houston.

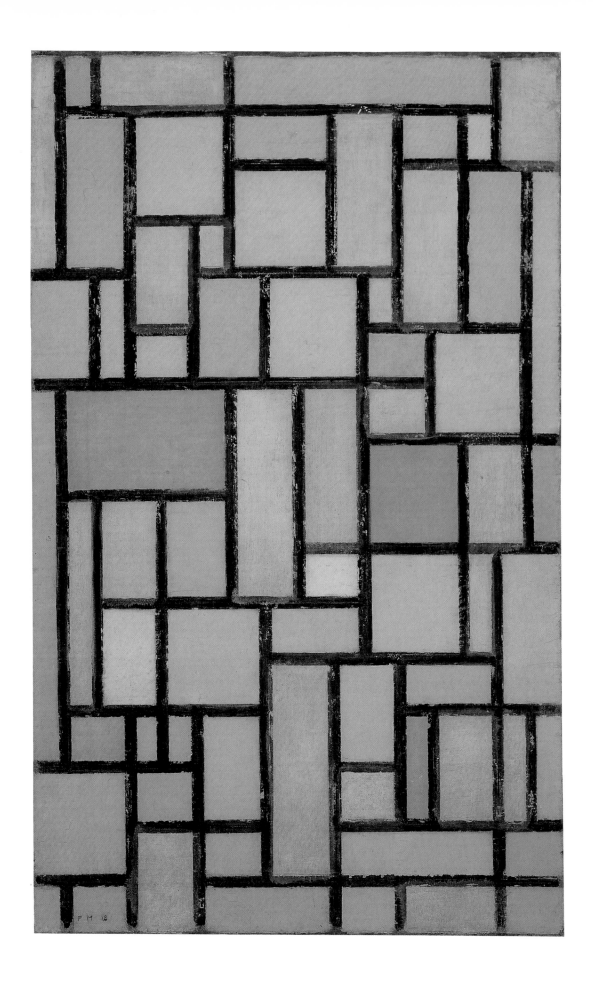

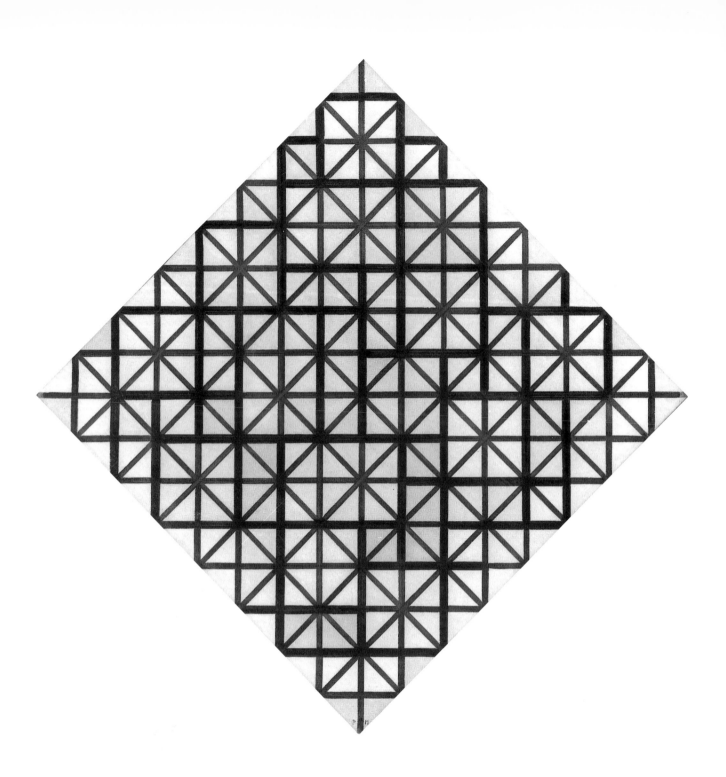

85
Composition with Grey Lines, 1918, oil
on canvas, diagonal 121. Haags
Gemeentemuseum, The Hague.

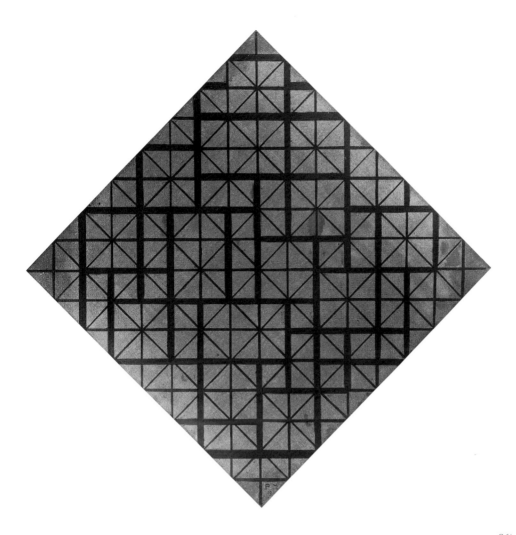

86
Composition with Black Lines, 1919,
oil on canvas, diagonal 84.5.
Philadelphia Museum of Art.

In the literature dealing with Mondrian's work, various explanations have been put forward for his use of the diamond format. According to some authors it can be traced to the diamond-shape coats of arms that appear in seventeenth-century paintings of church interiors by Pieter Saenredam and others. According to another interpretation, the diamond is the logical consequence of the centralized composition of picture elements, whereby the corners were left free, which Mondrian used in his mature Cubist paintings with ovals and, in particular, in *Composition in Line* and *Composition in Colour A* and *B* (illus. 76).[53] In my view, neither of these interpretations is satisfactory. In all probability these diamond-shape paintings originated in a different, more prosaic manner, whereby a crucial role was reserved not only for the compositional problems presented by the regular grid, but also for the protracted and heated debate that raged in 1918 among De Stijl artists concerning the admissibility of the diagonal line.

Of the four paintings, 1 and 2 are unique in Mondrian's later work, because they employ not only horizontal and vertical lines, but also diagonals. It is as if two regular grids have been placed at an angle of 45° with respect to one another, one consisting of 8 × 8 modules, the other of 16 × 16 modules. In 3 the same pattern of lines is just visible under the surface; only in 4 are the diagonal lines missing. The diamond-shape format of the paintings themselves is likewise proof of Mondrian's preoccupation with the problem of the diagonal. While his Cubist

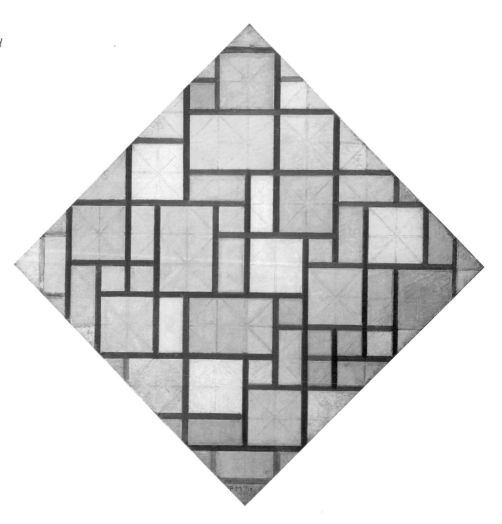

88
Bart van der Leck, *Composition no. 5*, 1918, oil on canvas, 70 x 70. Hannema-de Stuers Fundatie, Heino. © DACS 1994.

paintings did display incidental examples of slanted and curved lines, since 1915 Mondrian had confined himself to rectangular colour planes and straight lines. But there was no hard and fast rule governing the horizontal and vertical position of the lines and planes. We know from his texts dating from this period, both published material and correspondence, that it was the *right angle*, where the lines or the outlines of the planes met, which he considered crucial because it expressed the equilibrium between contrary forces.

In an undated letter to Theo van Doesburg written in February 1918, Mondrian referred to a difference of opinion with Bart van der Leck on precisely this question. Mondrian wrote that he advocated 'a right-angled enclosure of the colour', while van der Leck considered a rectilinear enclosure sufficient. In other words, in van der Leck's view, colour fields with acute and obtuse angles were perfectly acceptable. Accordingly, having temporarily bowed to Mondrian's views in 1917, he went on to introduce parallelograms and even triangles, pentagons and hexagons into his work (illus. 88).

Mondrian's dissatisfaction with such liberal views was shared by van Doesburg, who like many another convert, was inclined to be more Catholic than the Pope. In a letter of 22 March 1918, van der Leck asked if new work by the painter Peter Alma (a friend, and at that time a follower of his) could be reproduced in *De Stijl*. Van Doesburg wrote back that he had certain objections to what he called Alma's

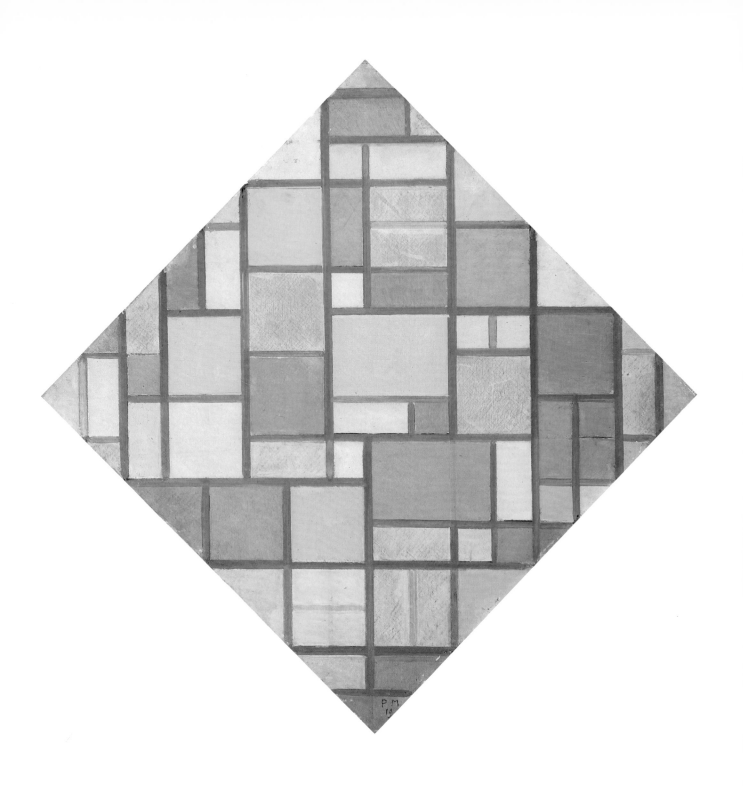

89
Composition with Colour Planes, 1919,
oil on canvas, diagonal 67.
Rijksmuseum Kröller-Müller,
Otterlo.

'diagonal destruction'.[54] Alma's paintings contained diagonal lines that were not sufficiently counterbalanced within the composition. As a result, van Doesburg contended that they produced the same spatial effect as traditional perspective: they suggested space *in* the picture plane, or depth, while the whole idea behind the new way of painting was to portray space *on* the plane. In the letter to van der Leck, van Doesburg concluded his criticism with a stern judgement:

In my opinion, the work of Alma, as visual art, cannot be justified. I have already written to Mondrian concerning this question, and in view of your suggestion to reproduce his [Alma's] work in 'De Stijl', I intend to discuss it with him in more detail. Perhaps we will be able to gain a better understanding of each other's standpoint.

Not surprisingly, van der Leck disagreed, as is clear from his reply:

Not only the universal construction, or stability, is of importance in the plastic expression of painting, but also universal motion. In painting, it is precisely the free and the diagonal which make this possible. Furthermore, it is my conviction that a mathematical figure such as the diamond or parallelogram, as well as figures or directions derived from them, should not be confused with perspective.[55]

Van Doesburg heightened the controversy shortly after this, when he reproduced and critically reviewed in *De Stijl* a work by Alma, *The Saw and the Goldfish Bowl* (illus. 90). Van Doesburg summarized his criticism by affirming that 'this diagonal destruction, especially when combined with the horizontal and the vertical, wherever it appears, in a painting or outside it, is a rudiment [of the Baroque].'[56] Needless to say, in van Doesburg's eyes, 'Baroque' was almost a term of abuse.

Mondrian considered it a good article, and expressed his approval in a letter to van Doesburg on 9 July. But even before the piece appeared, the two artists had already discussed at length the problem of the diagonal line. In an undated letter, which on the basis of other information must have been written in May of that year, Mondrian wrote:

With regard to the diagonal, too, I am in complete agreement with you. As soon as it appears together with straight [horizontal and vertical] lines, I believe it should be condemned. Where van der Leck is concerned, I'm not sure: his things do not really look individual. I think that's because he doesn't work the same way as we do.

The next paragraph in this letter is of particular significance:

A while back I started a thing entirely in diamonds, like this: [accompanied by a sketch consisting of several small diamond shapes, illus. 91]. I have to find out if it's possible: intellectually I'm inclined to say it is. There's something to be said for the idea, because perpendicular and flat lines can be seen everywhere in nature; by using a diagonal line I would be cancelling that out. But I'm inclined to say that this cannot be combined with perpendicular and flat lines or with different kinds of slanting lines.

This last remark refers to lines in a position other than absolutely diagonal.

A number of art historians have taken this as proof of the fact that Mondrian

90
Peter Alma, *The Saw and the Goldfish Bowl*, 1918, oil on canvas, 65.5 x 102. Amsterdams Historisch Museum. © DACS 1994.

91
Sketch of diamond-shape planes in a letter from Mondrian to Theo van Doesburg, undated (May 1918). Rijksbureau voor Kunsthistorische Documentatie, The Hague.

92
The *Composition with Grey Lines*
(illus. 85) in its presumed original
position.

93
The *Composition with Planes in Ochre
and Grey* (illus. 87) in its presumed
original position.

had then already embarked on the first of his diamond-shape paintings.[57] However, they base their conclusion on the paintings as we know them today, while in his letter Mondrian refers not to a diamond-shape painting, but rather to a 'thing in diamonds'. This formulation and his subsequent remarks concerning the significance of the diagonal, together with the sketch, can lead to only one conclusion, namely, that Mondrian was experimenting with a composition consisting solely of diagonally oriented planes and/or lines. This was obviously a kind of answer to, and improvement on, the work of van der Leck, who combined these shapes with planes that were bounded horizontally and vertically. Neither the text of the letter nor the sketch tells us whether Mondrian's painting was itself of a diamond shape, but this does not appear likely. He would certainly have mentioned such an important deviation from his normal practice; indeed, he did so some time later.

Thus there are two possibilities: the painting in question has been lost, or it is still in existence, but in an altered form. On the basis of arguments to be examined below, the second possibility would appear to be the most likely. I believe that the 'thing entirely in diamonds' was the first state of one of the four diamond-shape paintings done in 1918–19, but then in the 'normal' square position. No other painting by Mondrian dating from this period meets the description. It is difficult to say which of the four paintings it is, but 1, the *Composition with Grey Lines*, or 3, the *Composition with Planes in Ochre and Grey*, would seem to have the best credentials. Unlike the other two, these works both have quite a thick layer of paint. By all accounts, the artist must have worked on them over a fairly long period, and carried out a great many corrections.

If these two paintings are placed upright (illus. 92 and 93), then we see in 1 a clear pattern of diagonals together with horizontals and verticals, and in 3 a less distinct version of that same pattern. This is contrary to what Mondrian says in the letter to van Doesburg cited above, concerning the incompatibility of lines which differ in their orientation. However, a closer examination of the intersections

of these lines reveals that the diagonal lines (when the painting is placed upright) were painted first. Not until the paint was completely dry was a new grid applied, at an angle of 45°. Thus these two works, and possibly the other two as well, were originally compositions consisting exclusively of diamond-shape planes, set in a grid of diagonal lines.

It is possible that in creating these paintings Mondrian was inspired not only by the dialogue with van Doesburg and van der Leck concerning the diagonal, but also by certain publications devoted to the application of systems in the visual arts. Herman Hana's *Ornament-ontwerpen* of 1917 contains an illustration of a grid of diagonals with added cross-shapes (illus. 94) that bears an amazing resemblance to the paintings in their presumed original state.[58] However, the illustration in Hana's book was an ornament, a design that owed its decorative qualities to repetition. For Mondrian, by contrast, regular grids only served as a basis. As he explained to van Doesburg, he reworked the subdivision 'a lot further', into an asymmetrical composition of planes, which were in equilibrium with respect to size and position. To that end, he widened certain sections of the lines and, in the case of 3, painted over most of the underlying grid.

Mondrian continued to work on the paintings throughout the second half of 1918 and the beginning of 1919. He was presumably referring to 1 and 2 when he informed van Assendelft on 6 January 1919:

Right now I am working on a series of twelve, including some in black and white, but of course different from what you saw. I haven't done any more of those, since I'm always changing – in spite of myself [. . .] I will be exhibiting a couple of smaller canvases at the end of February in Amsterdam, but they're for Bremmer and have already been paid for.[59]

But the most radical change was yet to come. It came about quite suddenly, as witness a revealing letter that Mondrian wrote to van Doesburg in early February 1919:

Furthermore, as regards my work, I wanted to let you know that I am now hanging various things like *this* ◇; so that the composition looks like *this* +; whereas hung like *this* □ the composition looks like *this* × (à la van der Leck, for instance). What do you think of the idea? Let me know, when you've seen them. Regards in haste, Piet.

There are three conclusions to be drawn from the above: first, that at least two, but probably all four, of the paintings now known as Mondrian's first diamond-shape paintings were originally intended as normal squares with a diagonal composition. Second, that it was not until a few weeks before the exhibition in question, which opened on 22 February 1919, that he decided to hang the works as diamonds, so that he probably had very little time for radical alterations. And third, that his decision was dictated in part by his desire to contrast his own work with that of van der Leck. Van Doesburg's response to the decision to hang the works in this manner was favourable, although he had not yet seen the exhibition, as we know from Mondrian's next letter, dated 3 March 1919:

Dear Does, thank you for your letter [. . .]. I was glad to know that in principle you are in favour of the diamond hanging, and I think that in practice you will approve of this method for some of my things. You look at the thing itself, and not only the outward appearance, as Mrs Steenhoff [wife of the critic W. J. Steenhoff] appears to do: she wrote that they looked exactly like hanging handkerchiefs!

At the above mentioned exhibition in February and March of 1919, organized by the Hollandsche Kunstenaarskring at the Stedelijk Museum in Amsterdam,

94
Herman Hana, illustration from *Ornament-ontwerpen voor iedereen: Het stempelboekje*, Amsterdam, 1917.

95
Composition (Checkerboard, Dark Colours), 1919, oil on canvas, 84 x 102. Haags Gemeentemuseum, The Hague.

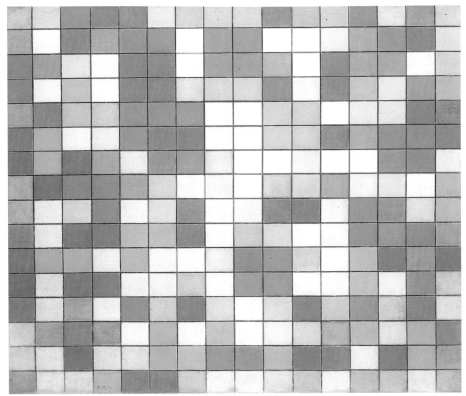

96
Composition (Checkerboard, Light Colours), 1919, oil on canvas, 86 x 106. Haags Gemeentemuseum, The Hague.

Mondrian was represented by five *Compositions*, identified by the letters A, B, C, D and E. None of the paintings was for sale, because, as he wrote to van Assendelft, they were intended for Bremmer. It is clear from reviews that among the works exhibited here were the diamond-shape canvases 3 and 4. In all probability 1 and 2, both of which consisted exclusively of grey or black lines on a white field, were not shown here.[60] In fact, so far as we know, Mondrian never exhibited them. Moreover, unlike the other two, which appeared in *De Stijl* in 1919, they were never reproduced in his lifetime. And strangest of all, they were never handed over to Bremmer, despite the fact that, due to his low output, Mondrian was then well behind schedule in supplying paintings in return for his monthly allowance. Bremmer did receive 3 and 4, and through him these works found their way into the collection of Mrs Kröller-Müller.

Thus 1 and 2 occupy a somewhat uncertain place within Mondrian's *œuvre*. It is not clear whether he himself was satisfied with them, or at any rate felt that they were finished. He did not publicize them, probably because he feared that the combined grids of horizontal/vertical lines and diagonals would betray the problems he was having in dealing with the diagonal. On the other hand, the two works were not cast aside. Photographs taken in the mid-1920s show them hanging in his Paris studio (illus. 111). After 1926 he gave 1 to his old friend A. P. van den Briel, while 2 was sold to the American collector Walter Arensberg in 1937.

Criticism from van Doesburg

The introduction of the diamond-shape format for his paintings marks a significant milestone in Mondrian's artistic career, a point at which he apparently felt the urge to define more clearly his position in relation to his closest colleagues. Later on, this format would reappear with a certain regularity and, to that same end, almost in a polemic role. This was the case around 1925, when it came to a fundamental difference of opinion with van Doesburg, a controversy that will be discussed in chapter Four.

Although in 1918–19 van Doesburg sided with Mondrian in rejecting certain developments in the work of van der Leck (who for various reasons soon withdrew from De Stijl), he was by no means a blind follower of Mondrian. While he approved of the use of the diamond-shape format, he apparently had some reservations when it came to Mondrian's cautious and inconsistent use of colour. Following the 1917 gouache (illus. 77), with its striking near-primary colours, Mondrian had continued to dilute his colours through the addition of white or grey, and in some paintings even confined himself to grey and ochre tones. The diamond-shape compositions 3 and 4 (illus. 87 and 89) display the same tonality: one features a cubistic, semi-monochromatic palette; in the other, the red, yellow and blue have been toned down so that they are now subtle pastels, which alternate with equally subtle medium-grey and white. This enabled Mondrian to obtain the desired unity, but it was not the unity of contrasting forces that he propagated in his writings. When van Doesburg pointed this out, Mondrian used a remarkable argument to counter this criticism, one that again underlines the degree to which his views on art were saturated with theosophical theory. In a letter of 13 February 1919, he claimed that most people had not yet evolved far enough to cope with primary colours employed at optimum strength, 'and furthermore that for the time

being I am using those subdued colours, thereby adapting myself to the present environment and the world. This does not alter the fact that I myself would prefer a pure colour.'[61]

A second point of criticism that van Doesburg launched at this time was concerned with Mondrian's use of the regular grid. He was not opposed to it on principle, but he did feel that too much of 'the system' was visible in Mondrian's work; this resulted in repetition, which weakened the contrast both between the lines and between the planes. Mondrian was not convinced. Replying to van Doesburg on 18 April, he said of one of the diamond-shape paintings recently exhibited (3 or 4): 'Perhaps there could be more contrast in the size of the various planes, but I cannot say that it bothers me here.'[62] In the same letter Mondrian mentioned that he was working on a painting that is now known under the apocryphal title *Checkerboard, Dark Colours* (illus. 95). In this composition, and its companion piece *Checkerboard, Light Colours* (illus. 96), the regularity of the grid is even more emphatic than in the diamond-shape paintings: fine lines divide the picture plane into small 16 × 16 rectangular units. Actually, the paintings resemble van Doesburg's tile floors for De Vonk (illus. 83). This regularity is only disturbed by the colour. Mondrian has coloured in the planes in such a way that they are constantly combining to create new formations. In the light painting, for example, the colour pink appears in several separate units, in combinations of two units next to or on top of one another, in groups of three units that make up an angle or combine to form a zigzag line, in blocks of four, and once in an irregular grouping of six. The same variation can be seen in the case of the blue and the yellow sections. Still other groupings appear when one connects, say, the dark-grey planes with the blue, which are almost as dark, or the medium-grey with the pink, or the white with the yellow planes. There is no rest for the eye, which is constantly enticed to wander over the surface of the painting. It is as if Mondrian is inviting the viewer to create his own composition, making a selection from among the units of colour on offer. Judging by the many corrections, this casual effect was only achieved after much effort: many planes have been painted over in a different colour and lines have been lightened or darkened in order to facilitate or hamper the link between two units.

With respect to the colour hues, these two paintings still reflect the 'subdued' effect that Mondrian had defended in his letter to van Doesburg as 'for the time being' and 'adapted to the present environment and the world'. In the light canvas, the primary colours appear as muted, pastel-like tints, together with off-white and subtle greys. In the dark version, the red is almost purple, and the yellow a kind of orange-brown, so that in effect there is nothing remaining of the primary colours; white and grey are totally absent here. The two paintings are mood pieces, emanating an almost rural atmosphere, which is further enhanced by the horizontal format. It comes as no great surprise that, as Mondrian informed van Doesburg in the 18 April letter, *Checkerboard, Dark Colours* was based on a motif from nature. He mentioned this in an intriguing reflection on abstraction versus the representation of nature, an opposition that he was apparently striving to put into perspective:

And then about whether or not to work from a given in nature. In my view, you define this in a rather narrow sense. In the main, I do agree with you that the destruction of the natural, and its reconstruction, must be accomplished according to a spiritual image, but I believe that we

should take a broad view here. What is natural does not have to be a representation of something. I'm now working on a thing that is a reconstruction of a starry sky, and yet I'm making it without a given from nature. Someone who says he uses a theme from nature can be right, but also someone who says he uses nothing at all![63]

This echoes Mondrian's view, as previously expressed to Bremmer, that he was striving to express the general, not the specific.

If *Checkerboard, Dark Colours* is a reconstruction of a starry sky, then *Checkerboard, Light Colours* may be seen as a reconstruction of a morning or afternoon sky.[64] Again, there is a link between two moments in a cyclic or evolutionary process in nature, just like those Mondrian depicted earlier in his career, in series of two or three paintings. These are also the last works known to have had their origin in observations from nature. By now Mondrian had completed the gradual and protracted process of the destruction of nature.

The two works referred to as *Checkerboard*, made in the first half of 1919, are fascinating paintings, and it is not hard to imagine Mondrian embarking on a totally different course than the one he actually chose. He could have gone on working on the basis of a modular grid, or continued to cling to his refined and sensitive palette. He chose not to do so. This developmental line was severed about the time he returned to Paris in June 1919. There he went back to paintings based on an irregular grid, such as those dating from 1918 (illus. 80), radicalizing both the composition and the colour. This was a decision influenced by his environment – that of the city, but also that of the studio. There is clearly a relationship between the Paris paintings and the arrangement and decoration of his studio according to Neo-Plastic principles, which he embarked upon towards the end of 1919.

Mondrian's decision to lay aside the modular grid was no doubt a response, albeit delayed, to the criticism voiced by van Doesburg, who never ceased to express – to the artist, but also to others – his concern about Mondrian's recent work. On 24 June 1919, for example, only a few days after Mondrian had left the Netherlands, van Doesburg wrote to Oud concerning the *Checkerboard* paintings:

Perhaps it was his return to Paris that was needed to provide him with fresh new possibilities in his work. Invigoration. His most recent work is without composition. The division of the picture plane is modular. That means ordinary rectangles, all the same size. The only contrast is in the colour. In my view, this runs counter to his theory concerning the abolition of position and dimension. This is in effect equality of position and dimension.[65]

Shortly thereafter, in August 1919, a reproduction of Mondrian's diamond-shape *Composition with Planes in Ochre and Grey* appeared in *De Stijl* (the publication of illustrations of his work lagged behind his production). In this reproduction the tone of the planes was so uniformly grey that Mondrian was finally forced to concede that van Doesburg might have been right when he said that there was too little contrast in the composition and in the colours. Mondrian frankly admitted this in a letter written from Paris on 6 September, in which he also announced that he had changed his manner of working: 'I now believe what you wrote at the time, that there is still an element of "repetition" in that work; this was much less the case in the original, probably as a result of the colour values. But I am now trying to avoid that in my new things.' This is the second time (as Els Hoek has rightly observed) that a photographic reproduction of his work made Mondrian

aware of certain shortcomings in his paintings, and induced him to alter his manner of working.[66]

During the years from 1914 to 1919, which Mondrian spent in the Netherlands, the interaction between him and several of his colleagues was more intensive and more fruitful than at any time before or after. The theories he had developed and entrusted to paper during the Paris years before 1914 were refined and perfected by his discussion with van der Leck and van Doesburg and by certain suggestions that they had made. Their interaction was even more intensive when it came to his actual work, as can be surmised from the paintings done in 1916–19. Mondrian's Neo-Plastic art was able to ripen in the isolation in which he and a few like-minded colleagues found themselves during the Great War. When he left the Netherlands for good in 1919, all that changed. His relationship with van der Leck had begun to deteriorate during 1918; he remained in touch with van Doesburg, mainly through correspondence, and these contacts were mutually beneficial. But back in Paris he had to fend for himself. He encountered there an artistic situation that was totally different from the Paris he had known before the War. There was no shortage of impulses for his work, but they were largely negative impulses, which forced him to define his position in the face of all the new phenomena on the Paris art scene, including the 'retour à l'ordre' of classicistic realism, as well as Dada and Surrealism.

3

The Content of all Art is One:
Neo-Plasticist Painting and the Other Arts

Mondrian's first full art-theoretical tract, 'Neo-Plasticism in Painting', published in 1917–18, is in effect one great celebration of painting. After a long and venerable history, painting has reached the point where a consistent abstraction of form and colour has finally revealed the universal means of expression (the straight line and primary colour). These are the instruments that make it possible to depict 'pure relationship' and 'the absolute harmony of contrasts', concepts pointing at the essence of life itself. As he says in the Introduction: 'The whole of modern life, which continues to gain in depth, is mirrored in the painting.'[1]

In the rather sketchy art-theoretical musings recorded in his letters and sketchbooks from earlier periods, Mondrian had already cast painting in the role of model. But there the notion was put forward somewhat diffidently, and he did not express himself on the subject of the other arts. By 1917–18, however, when the series of articles appeared in *De Stijl*, these tentative views had developed into a rock-solid conviction. Of all the arts, painting is the purest, the least fettered, the most liberated in its portrayal of 'pure relationship', and thus the one most suited to serve as an example for all mankind. The art of painting is also held up as a frame of reference for the other arts, each of which is called on to strive for that same degree of purity, within the bounds of its own possibilities. This is discussed briefly in the Introduction. There is a suggestion of scepticism in the words:

The free placement of the means of expression is a privilege enjoyed exclusively by painting. The sister arts, sculpture and architecture, are more restricted in this respect. The other arts enjoy even less scope in their employment of the means of expression: music is always restricted by the sound, no matter how abstracted into 'tone'; the dramatic arts have their natural form, and require sound – even words; and literature, finally, expresses itself in words, which emphasize individual aspects.[2]

With a great display of confidence, Mondrian placed painting at the top of the hierarchy of the arts. In so doing he was implicitly running against the prevailing views, according to which – depending on the aesthetic tradition to which one adhered – this hierarchy was headed either by architecture, the mother of all the arts, or by music, poetry, or rhetoric (considered the most abstract and least material of the arts). It is clear from this text that Mondrian was becoming increasingly interested in the relationship between the arts. Now that his theory had crystallized, he wondered aloud how it might be given legitimacy in the other arts. A major portion of his theoretical writings from then on would be devoted to this problem, notably in the years up to 1927. Thereafter it is only touched on, or discussed in general terms.

It is no accident that Mondrian's upsurge of interest in the relationship between the arts occurred in a period when he was actively involved with *De Stijl*. At the journal's inception in 1917, the contributors included not only the painters van

Doesburg, Huszár, van der Leck and Mondrian, but also the architects J. J. P. Oud and Jan Wils, and the poet Anthony Kok; they were soon joined by the sculptor and painter Georges Vantongerloo, the architect Robert van 't Hoff, and the cabinet-maker and architect Gerrit Rietveld. The magazine was originally subtitled 'Monthly Review for the Modern Visual Arts', but what van Doesburg envisioned was a broad cultural journal, patterned roughly on *Der Sturm* in Germany: 'If things go well, I can extend it enormously, including music, literature, and so forth', he wrote to Kok even before the publication of the first issue.[3] And van Doesburg saw this ambition realized in later years when the subtitle was changed to read 'Monthly Review for New Art, Science and Culture', admittedly a somewhat inflated description for such a slim publication.

The wide-ranging nature of the review was a reflection of the many and varied interests of van Doesburg himself. He was an 'anti-specialist' who needed a podium from which to proclaim his active and passive involvement with painting, but also with monumental art, architecture, typography, literature, theatre, film and music. To van Doesburg these were not isolated, independent fields: he was passionately interested in the integration of the arts, in accordance with the nineteenth-century ideal of the *Gesamtkunstwerk*. The first manifestation of this ideal that could conceivably be concretized right away was the architectural *Gesamtkunstwerk*, which involved the various plastic arts, and the majority of the painters and architects associated with *De Stijl* dedicated themselves to this goal. The numerous collaborative projects that followed, regardless of whether they were actually carried out, were among the most important contributions of De Stijl to the avant-garde between the wars.[4]

Mondrian, by virtue of his age, experience and status the undisputed spiritual leader of De Stijl, was challenged to define his standpoint with respect to the other arts and the principle of collaboration between representatives of the various disciplines. To be sure, he was a painter in heart and soul, and he never retracted his lofty views on painting. He also had strong reservations about the enthusiasm with which van Doesburg and some of the others threw themselves into collaborative projects. But what he saw happening around him did encourage him to write about the relationship between the arts, and even inspired him to undertake experiments in the area of architectural and theatrical design, and also literature. The effect of these confrontations with other disciplines was enriching, and undoubtedly they had a considerable influence on both his theories and his art.

If we were to ask ourselves whether Mondrian entertained any genuine interest in the other arts and the problems surrounding their merging before he joined the group centred on *De Stijl*, we would have to admit that there is very little evidence of this. Over the years he had met a great many practitioners of the other arts, and had become friendly with a number of them. He probably knew the architect De Bazel from their years at the Academy, and may also have been acquainted with De Bazel's theosophical friends and colleagues Lauweriks and Walenkamp. (The latter owned a painting by him.) Around 1908 he met Til Brugman, who later became a writer, and shortly thereafter he became acquainted with the violinist Aletta de Jongh and the actor and painter Louis Saalborn, who took painting lessons from him. In the Paris years, between 1912 and 1914, he was friendly with the poet Dop Bles and the composer Jakob van Domselaer, and during his stay in the Netherlands between 1914 and 1919 he lived for a time

with van Domselaer and his wife. In the flourishing artistic milieu of Laren he also met the composer and music critic Paul Sanders, the architects Piet Kramer and H. A. van Anrooy, and the poets Adriaan Roland Holst and Martinus Nijhoff. But with the exception of the representatives of the music world, these contacts did not go any deeper than the kind of socializing customary in artistic circles.

In the letters and sketchbooks dating from before 1917 there are only a few scattered references to the other arts. However, these remarks, which are concerned with architecture and music, are significant. As we saw in chapter One, Mondrian had always reserved a prominent role for architecture as a motif in his figurative work. From 1900 on, he used buildings to lend structure to a work, while at the same time making use of their symbolic connotations, as in the case of the church towers (illus. 10 and 12). These two aspects are combined in the Domburg paintings made between 1908 and 1911 (illus. 39), in the Cubist paintings of facades that date from his Paris years (illus. 57 and 58), and in the crucial works completed in 1915 and 1916, *Composition* (illus. 64) and *Composition* (illus. 67). It is noteworthy that in the letter to Bremmer of 29 January 1914 Mondrian interrupts his own discourse on his efforts to express 'universal beauty' with the remark 'For me, the architecture of Antiquity is the greatest art form'.[5] Apparently he recognized in classical architecture, in the abstract expression of pressure and weight seen in Greek temples, for instance, the equivalent of what he himself was striving for in his paintings by means of horizontal and vertical lines. In the same letter to Bremmer, he brought up the subject of music: 'The people find my work somewhat vague: at best they say that it is quite suggestive of music. Well, as far as that goes, I have no objection, except if they continue along that line and then conclude that my work is outside the domain of the visual arts.' It is clear from this passage that Mondrian did not give way to the temptation to justify his art by means of the analogy with music – also a so-called abstract art form – as many artists were eager to do during the early years of abstract art.[6]

As we have seen, at the time he wrote the Introduction to 'Neo-Plasticism in Painting' Mondrian had his doubts about whether music and the other arts could really be as free in the employment of the 'means of expression' as his beloved painting. But from 1917 on, encouraged by his experiences with van Domselaer and certain exchanges with van Doesburg, van der Leck and other artists close to *De Stijl*, Mondrian undertook an intensive study of the applicability of his theory of Neo-Plasticism to the other arts, with special reference to literature, architecture and music.

Neo-Plasticism and literature

In August 1918 Theo van Doesburg published a lengthy and detailed book review in *Het Getij* (not in *De Stijl*, which at that time was still devoted exclusively to the visual arts). The book he chose to discuss was an unimportant novel, but the review itself is of considerable interest from the point of view of literary theory, as it contains opinions that are directly traceable to Mondrian's theory of Neo-Plasticism. Van Doesburg maintained that the author had not succeeded in 're-creating' his theme, in transforming it into 'elementary values, and then exteriorizing these by linguistic means'.[7] He then concluded his critical evaluation with the following desideratum for a new literature:

What we need, what will transform literature into a plasticism of words, is relationship, notably the relationship between words and the relationship between sentences. Not chatter, not talk about something, not a description of something, and above all not pseudo-psychological analysis, but rather the plastic expression of reality through the relationships between words and between sentences. The linguistic plastic expression of action.

And van Doesburg refers to illustrious examples from abroad: Ezra Pound, August Stramm and Filippo Tommaso Marinetti, as well as 'the anti-philosopher, Giovanni Papini, the futurist'.

We do not know whether Mondrian was acquainted with this application of his theory to literary criticism; in any case there is no mention of it in his letters. But he was interested in Papini. Some six months later, on 3 March 1919, he wrote to van Doesburg: 'I've just read a magnificent book by Papini, "The blind pilot" – have you ever heard of it?' The book he refers to, *Il pilota cieco*, was written in 1907, before Papini's Futuristic period, and was translated into Dutch in 1908. It is a collection of philosophical fairy tales that explore the experience of time, and the changes in one's self over time. The first story, 'Two Images in a Pond', settles up with the past: the 'Self of the past' is murdered by the 'Self of the present'. Another story in the collection is 'One Life Shared by Two People', an account of two individuals who are so close that everything that is a source of happiness to one of them brings pain to the other, and vice versa. The tale ends with the suicide of one of them. What undoubtedly appealed to Mondrian in Papini's book was the intriguing use of polarities and the rigorous manner in which they cancel one another out.

Papini continued to preoccupy Mondrian. Shortly after his return to Paris in 1919, on 22 November he wrote to van Doesburg prompting him to ask Marinetti to join *De Stijl*, although he couldn't remember the Italian artist's name:

Wouldn't it be a good idea to publish that article by . . . I can't remember his name (the leader of the Futurists, I guess you could call him). I read it [. . .] this summer – are you familiar with it? – it's about the new form of literature and typography, etc. I found it extremely interesting [. . .]. This as form seemed to me to be along the right lines; as far as the content is concerned, I think The Blind Pilot by Papini is the best new book.

And he continued with an intriguing confidence: 'I have myself found something related to form in writing, and later on I will see whether it works. But first I must finish this series.' It would appear that at this time Mondrian had literary ambitions of his own, and wanted the advice of van Doesburg, whose experience in such matters was much more extensive.

The 'series' Mondrian mentioned in this letter was the 'trialogue' entitled 'Natural and Abstract Reality', which was serialized in *De Stijl* from June 1919 to August 1920. His 'Dialogue on Neo-Plasticism' had already appeared in the February and March issues of 1919. Following the complex and philosophical essay 'Neo-Plasticism in Painting' with which he had made his debut in *De Stijl*, the dialogue and trialogue strike the reader as refreshingly accessible, clear explanations of his theory, cast in the form of playlets. The dialogue comprises a discussion between a singer and a painter, each of them reasoning from the standpoint of his own professional background. In the trialogue the participants are an old-fashioned painter, a modern painter and an art-loving layman. In the eighteenth and nineteenth centuries it was not uncommon for the dramatic form to be used to expound some theory concerned with art or literature. The tradition went back much

further, of course, to Plato's dialogues. But we may assume that Mondrian found his inspiration closer to home: in 1913 van Doesburg had published a dramatic dialogue in the esoteric weekly *Eenheid*, which Mondrian was in the habit of reading. The piece was entitled 'Resurrection, a Historical Drama of Ideas on Beauty and Love'.[8] A rather pompous little play, it pits an old-fashioned artist against a modern one. With a bit of effort, Mondrian's dialogue and trialogue may likewise be seen as literary pieces, or at any rate theoretical essays cast in an albeit quite traditional literary form. In the meantime, as is clear from letters to van Doesburg, Mondrian was speculating on the feasibility of a completely new literature; for the form, he would be guided by Marinetti, and for the content, the work of Papini.

In February and March of 1920 van Doesburg spent several weeks with Mondrian in Paris, and although this means there is a gap in their correspondence, there are other sources indicating that during this period the two men were very much occupied with literature, and that in their discussions Dada and Futurism served as catalysts. On 9 February, shortly before van Doesburg's arrival, Mondrian promised to 'show you a piece about "le mouvement Dada"'. The fact that van Doesburg used his stay in Paris to augment the little he knew of the movement is reflected in his article 'Dada', which appeared in the weekly *De Nieuwe Amsterdammer* on 8 May. The influence of Futurism and Dada shines through the literary manifesto that appeared in *De Stijl* that same month.[9] Its authors were van Doesburg, Mondrian and Anthony Kok. In all probability Kok's contribution did not go beyond some suggestions, as the bulk of the article undoubtedly took shape during van Doesburg's recent visit to Mondrian in Paris. Unlike the first manifesto of De Stijl published in November 1918, the moderate tone of which was designed to win readers over, this literary manifesto echoes the aggression that often characterized Dada and Futurist propaganda. The literary canon – naturalistic, individualistic and psychological – was declared dead. In its place, a new literature was envisaged, in which 'the word will be re-created, as regards both meaning and sound'. The signers of the manifesto aim 'with all the means at our disposal – syntax, prosody, typography, arithmetic, orthography – to give the word new meaning and new expressive power'. Several passages in the manifesto betray van Doesburg's characteristic preoccupation with space and time, and the many technical literary terms were undoubtedly his contribution as well. But it is abundantly clear from the aims cited above that it was in fact Mondrian's theory of Neo-Plasticism that the authors were applying to literature.

Mondrian as Man of Letters

So much for the theory; now the theory had to be realized in literature. Van Doesburg chose to do so by means of poems. In May 1920 he published a number of 'X-Images' in *De Stijl*, followed a year later by a series of 'Letter – Sound – Images' (illus. 97), a radical version of the Dadaist sound poem as created by Hugo Ball and Raoul Hausmann.[10] Van Doesburg's 'Letter – Sound – Images' consisted entirely of separate letters, mainly consonants, placed one beneath the other; the size of the letter and other typographical means were used to indicate how the letters were to be pronounced. For these publications, van Doesburg assumed the pseudonym 'I. K. Bonset', a deception that other contributors to *De*

Stijl, such as Oud, Kok and Huszár, saw through, but which was successful where Mondrian was concerned.

Mondrian likewise attempted to put his literary theory into practice. His resolve to produce a literary piece himself, which he had mentioned in the letter of the previous November to van Doesburg, was realized during the latter's stay in Paris. On 24 February van Doesburg informed Oud that 'Piet is sitting across from me, hard at work on a boulevard column. It took all my powers of persuasion to get him to do it . . .'. The 'column' in question appeared not in *De Stijl* but in two parts in *De Nieuwe Amsterdammer* (21 and 28 March 1920). Van Doesburg, who was a contributor to the paper, no doubt helped to get it published. The title is 'The Grand Boulevards', and like the paintings he had done in the period 1913–14, the subject is the metropolis, the place where all the more advanced representations of culture are on display. 'The Grand Boulevards' is something of a hybrid, and it cannot actually be said to meet the criteria laid down in the manifesto in *De Stijl*. For one thing, it is quite traditional with respect to syntax, typography and spelling, and to a degree descriptive. On the other hand, it displays a number of decidedly modern features. The opening lines and several intermediate sections consist of onomatopoeic sequences representing motor cars and carts in the street, a somewhat naive imitation of Futurist practice. Futurism also inspired the simultaneous rendering of the impressions received through the various senses. Futhermore, regular shifts are employed in the narrative perspective. As a result of all this, there is something kaleidoscopic about the text. Intentionally or otherwise, in places it is also quite comical. This is how it opens:

97
'I. K. Bonset' (Theo van Doesburg), *Letter – Sound – Images IV (in Dissonants)*, published in *De Stijl*, IV/11, 1921.

Ru-h-ru-h-ru-h-h-h-h. Pooh-ooh-ooh. Tick-tick-tick-tick. Pre. R-r-r-r-r-uh-h. Huh! Bang. Su-su-su-ur. Booh-a-ah. R-r-r-r. Pooh . . . multitude of sounds, all mixed together. Motorcars, buses, carts, carriages, people, lamp-posts, trees . . . all mixed together; in front of cafés, shops, offices, posters, shop windows: multitude of things. Motion and standstill: different movement. Movement in space and movement in time. Multitude of images and all sorts of ideas.

Images are veiled truths. All different truths form what is true. What is individual does not display all in a single image. Parisian women: refined sensuality. Internalized outward appearance. Naturalness pared down. Did Greetchen show that? And yet Greetchen went to heaven. But was it because of her appearance?

Ru-ru-ru-u-u. Pre. Images are boundaries. Multitude of images and all sorts of boundaries. Elimination of images and boundaries through all sorts of images. Boundaries cloud what is true. Rebus: where is what is true? Boundaries are just as relative as images, as time and space.[11]

As we can see from this, the first paragraph, the observations of Mondrian the painter are interspersed with the more reflective passages of Mondrian the theorist. The contrasting elements that he observes in the metropolis around him are linked and brought into balance with one another. This is, however, not a 'natural' given, but rather a creative act on the part of the artist. About halfway through the article there are a few lines, almost hidden away, that are a telling illustration of Mondrian's view of the role of art and the artist in relation to visible reality: 'The artist makes things move, and is moved. He is policeman, motor car, everything at once. He who makes things move also creates rest. That which aesthetically is brought to rest is art.'

Mondrian's literary debut did not go unnoticed. The most noteworthy reaction came from Lodewijk van Deyssel, one of the most prominent writers of the Eighties generation. In the issue of the literary journal *De Nieuwe Gids* for May 1920, van Deyssel discussed Mondrian's piece in great detail.[12] He had certain points of

criticism, but there was also a great deal of praise. For one thing, he considered it the work of a true artist, saying that it had called up in him impressions which even the liveliest form of journalism did not evoke: 'I saw in one spot, a confusion of sparkling colours all crowded together, without emotion, without representation.' Such recognition from this literary lion must have done Mondrian's heart good. On the advice of his Dutch friends in Paris, the Stieltjes, he wrote to van Deyssel on 28 June, enclosing another example of his literary work, entitled 'Small Restaurant – Palm Sunday'. In his letter he also mentioned that he was working on 'a regular essayistic exposition of my ideas concerning "the new" – in particular in literature – just as I write about painting in De Stijl', and he asked van Deyssel if he was interested in publishing the piece in *De Nieuwe Gids*. Apparently the answer was yes, but van Deyssel cautioned Mondrian that it may take two years before the article could be published – perhaps a polite form of rejection, after all. Mondrian's reply was not without humour: 'In Holland people seem to count in centuries: two years from now, I'll write differently.' He asked van Deyssel to return the manuscript, which remained unpublished during Mondrian's lifetime.[13]

In the meantime, Mondrian was hard at work on the 'essayistic exposition' referred to in the letter to van Deyssel, clearly a theoretical piece. In a letter of 30 June he asked van Doesburg for his advice, and this provides a good insight into the further development of Mondrian's ideas with respect to literature, a field that was still somewhat foreign to him:

May I first send you the manuscript to look over, since we both have and support the same ideas, and I might have made a mistake somewhere. I believe that I have found a solution for literature as N.B. [Neo-Plasticism], and I am most anxious to hear your verdict. Again, it has been a lot of work. I see now that I was quite close with my two pieces ['The Grand Boulevards' and 'Small Restaurant – Palm Sunday'], but that it must be carried even further. What it amounts to is that I believe that the word or the sentence can only be made more profound by placing it right next to its opposite. What do you think? Keep this to yourself for the time being. Only nouns have opposites, is that right? And do they *all* have opposites? My idea is that this can be extended, something like:

man – woman
boy – girl
soldier – camp follower
etc., etc.
Are these all opposites?

About representing the concept of Man: Actually it's only male and female that are opposites, isn't it? But it doesn't make a lot of difference, because I arrive at the same result.

 Maybe you could find time to write back right away, just a note, so that I'll have a better idea of how to proceed. In the article I do give some indications, but only briefly, and I talk about the difference with the Cub. [Cubists] and Dada. I have asked myself how N.B. [Neo-Plasticism] is possible in literature and the other arts; I then immediately reply to all the points put forward by van Deyssel. I'm beginning to see more and more what great work we are doing and have already done, my dear Does! [. . .] Your friend, Piet-Dada.

The article that Mondrian was working on must have expanded considerably in the process. The second half of 1920 was taken up with writing and subsequently translating the piece into French, with the help of the Dutch physician R. Ritsema van Eck, an old friend of Mondrian's. It was published in book form in late January 1921 by Léonce Rosenberg's Editions de l'Effort Moderne (illus. 98). *Le Néo-Plasticisme*, dedicated 'to future men', is one of Mondrian's main theoretical works.[14] With the aid of highly philosophical terminology and using a great many

passages from his earlier articles – but formulated somewhat more lucidly – he sketched out a future phase in the development of culture and humanity. This new era was to put an end to the tragedy of bias and imbalance, and the domination of one thing over the other. In this utopia, all contrasting elements were to be brought into perfect harmony.

Mondrian ascribes a pioneering role to the arts, and he discusses them one by one. In his view, the common goal of all the arts is an aesthetic re-creation of the harmony between individual and universal, subjective and objective, nature and spirit. He repeats what he stated in 1917, that while the arts are all equal, they do differ with respect to the means which they employ. He maintains that throughout history there have been entire cultural periods in which the striving for balance was disturbed by the use of the wrong means: one art made use of the means reserved for the other. Today, he says, there is increased consciousness of the specific characteristics and potential of each individual art. All the arts are now involved in a process of purification, although it must be acknowledged that some have a longer road ahead of them than others, before the goal is attained.

As Mondrian had announced in various letters, ample attention was given to literature, which in his view would be much slower to free itself from its own restrictions than painting. The destruction of the form (all that has been formed, and is therefore limited, whether depiction or description) would be achieved directly in painting, through the creation of abstract works of art. In the case of literature, the necessary destruction could only take place indirectly. A short-term possibility might be the notion that he had put to van Doesburg: words could be juxtaposed with other words with a contrasting content. In a more distant future it may be possible to re-create the word, and to produce words without form: i.e., a completely new 'sound', or 'sign'. Apparently Mondrian did not yet consider the time ripe for poems consisting solely of sounds, or purely typographical poetry; presumably he feared they might smack too much of music or visual art, and thus would not be truly literary. And yet he did attach importance to the experiments he saw originating around him. Referring to the future, Mondrian wrote that the man of letters 'will make use of, and even improve on, the excellent qualities which the Futurists, the Cubists and the Dadaists have brought to syntax, typography, etc.'. The writer, however, must draw on a more wide-ranging arsenal: 'He will make use of all that comes to him from life itself, from science, and from beauty.'[15]

Towards the end of his discussion of literature, Mondrian turned to van Deyssel's views on the creative process, though without actually mentioning him by name. In his discussion of Mondrian's literary debut, van Deyssel had written that a literary piece should be a 'construction of thoughts'. This view was rejected by Mondrian, because it presupposed a cerebral and therefore individual and one-sided action, which would necessarily be at the expense of the intuitive or unconscious action that he prized so highly in the arts. But he was equally opposed to the domination of the unconscious that he noticed in several new French writers. Apparently this was a reference to writers from Dada and proto-Surrealist circles, since he quotes from an article by André Gide devoted to them.[16] A key passage in Mondrian's veiled polemic against van Deyssel and these French writers is the following:

98
Front cover of Mondrian's book *Le Néo-Plasticisme*, Paris, 1921.

A particular thought is not the same as a concentrated, creative thought, which is actually a feeling of inward-looking calm. The former produces a descriptive and morpho-plastic art, the latter a purely plastic manifestation. It is a question of the universal versus the individual.[17]

It is interesting to see how Mondrian, who had only just arrived back in Paris, was already involved in the latest artistic discussion on the still somewhat unfamiliar terrain of literature. It is, however, doubtful whether *Le Néo-Plasticisme* was distributed so widely that it was seen by those literary persons who might have taken personally the views expressed in it. The response in France was minimal, and that in the Netherlands not much better. There were a few reviews, some of them quite appreciative, but – with one exception – the booklet was ignored in Dutch literary circles. That exception was Lodewijk van Deyssel, to whom Mondrian sent a copy on 1 February, a few days after *Le Néo-Plasticisme* had appeared. Van Deyssel apparently replied, giving his impressions and comments, together with a number of questions. Mondrian, in turn, wrote back in great detail on the 10th. That letter clarifies certain passages in the book that are perhaps not as lucid as they might have been, and it also offers a splendid credo:

I believe that the new art must differ totally in its manifestation from art as we know it, and people may be very reluctant to accept this. It is perhaps true to say, as someone did of Cubism, that 'To sum up: since art is a need to create rather than imitate, the "cubists", rousing themselves from the sentimentality born of the picturesque aspect of some natural spectacle or other, disengage the fleeting aspects from those which are constant and absolute, and with the aid of these two elements, construct a reality equivalent to that which they see before them.' Thus it is a question of finding the true equivalence (that offered by Cubism is still not true equivalence), and this can only be 'that which is not nature at all, and is nonetheless one with nature' (as in Neo-Plasticism).[18]

This time Mondrian's efforts to clarify his intentions were lost on van Deyssel. The review that the latter devoted to the book in *De Nieuwe Gids* in April was lukewarm and uninspired: while not unsympathetic to Mondrian, it lacked the understanding one might have expected, in the light of the previous article on 'The Grand Boulevards'.[19] Certain of his remarks must have pained Mondrian, for example it was not clear to van Deyssel why the world needed a new art, and he suggested that the core of Mondrian's argument was that nature excels art. (The opposite, in fact, was true.) Mondrian replied in a short, cool note: 'I'm sorry that you have not understood me in all respects, and that we are so far apart – otherwise I might have been able to discuss certain things with you in person.' From then on, their correspondence was restricted to polite little notes – on the occasion of Mondrian's sixtieth birthday in 1932, and on van Deyssel's seventieth two years later.

Mondrian's discussion with van Doesburg on the subject of literature likewise died a natural death. This may seem surprising, but we must remember that at the time van Doesburg's literary activities were played out behind his pseudonyms (in addition to 'I. K. Bonset', he also used 'Aldo Camini'), and he probably felt that it precluded involvement in discussions of this nature with Mondrian. There is almost no further mention of the subject in their correspondence, and there was little opportunity for an exchange of views in person, since van Doesburg's stay in Paris in 1920 was followed only by a brief visit in March and April 1921, before he moved to Paris in 1923. By that time Mondrian's own interest in the subject had waned. For a year or two he had entertained hopes of seeing Neo-Plasticism realized in literature, encouraged by the example of Futurist and Dada

poetry, but this optimism finally dissolved. It could not be denied that language was tightly bound up with everyday usage, and that in an art form making use of language it was extremely difficult to separate the word from its conventional meaning or its individual emotional charge. A tone of resignation is overt in an interview that appeared in a Dutch newspaper in March 1922, to mark Mondrian's fiftieth birthday.[20] Here he says that according to his art dealer Léonce Rosenberg, he had been born too soon, and

I believe that this is especially true for writers-in-my-spirit. As for myself, I published my 'boulevard impressions' in the (now defunct) *Nieuwe Groene*. That was somewhat futuristic. This type of literature is intended for later generations. The musical and pictural form language can be 'broken'. Words cannot, although the Futurists made an effort to do so.

Thereafter Mondrian made almost no further mention of literature. It was only in his personal contacts with Michel Seuphor, in the latter half of the 1920s, that his involvement with this art had a temporary revival, albeit in a rather strange form. Seuphor had written *L'Ephémère est éternel* – 'not really a play, but more of a critical piece on drama, very good', as Mondrian wrote to Oud on 20 December 1926 – and Mondrian offered to design the stage scenery for it (illus. 118).[21] Later on, we will return to this design. Mondrian was opposed to the appearance of human figures on stage, as he had previously made clear in a passage on the theatre in *Le Néo-Plasticisme*, and the actors were to speak their lines from the wings. Two years later he produced a 'tableau-poème', a composition in Neo-Plastic style and incorporating a text by Seuphor, which was intended as a joint entry for an exhibition (illus. 104). It is characteristic that in both cases Mondrian was guilty of no small intervention in a literary work, using the means reserved for painting, the art that in his view was most fully evolved and best suited to give shape to Neo-Plasticism.

Neo-Plasticism in architecture

As one of the visual arts, architecture was a far more crucial issue for the artists grouped around *De Stijl* than literature could have been.[22] For all his reservations, this also held true for Mondrian. Initially, as we have seen, architecture was for him no more than a supplier of suitable subject-matter for his paintings, notably in the period of his Cubist and semi-abstract compositions. He had always considered painting to be an autonomous art form, and refused to accept that it could gain an artistic or social significance by allying itself with architecture, a notion that since the 1890s had enjoyed a certain popularity in the Netherlands. The term *gemeenschapskunst* or 'community art', by which the phenomenon came to be known, refers both to the German notion of *Gesamtkunst* and to the community for which this monumental art was in effect intended.[23] Mondrian, however, believed that any such link would equate painting with decoration, which initially had negative connotations for him. It would be no more than a handmaiden of architecture, a position totally at odds with the exalted status that the art of painting had earned for itself, not least by virtue of recent developments.

The fact that Mondrian did ultimately become more interested in architecture, particularly in the problem of the relationship between painting and architecture, can be traced largely to the influence of Bart van der Leck and Theo van Doesburg. As we saw in chapter Two, van der Leck was trained in monumental art, and had

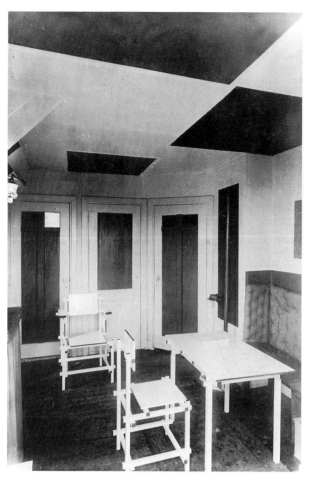

99
Theo van Doesburg, a colour
composition of 1919, in an interior
with furniture by Gerrit Rietveld,
reproduced from *De Stijl* III/12,
1920.

practical experience in the field. However, on those few occasions that his chief
patron Hélène Kröller-Müller offered him the opportunity of working with the
architect H. P. Berlage, the collaboration proved disappointing. Van der Leck
demanded that painting be accorded the same status as architecture, and formu-
lated his views on the merger of these disciplines in two high-principled pieces
that appeared in the first volume of *De Stijl*.[24] The major proposition he put
forward was that, by its very nature, the art of painting was meant to destroy
visually the structural and material nature of any building in which it was employed,
a view not calculated to endear him to architects.

Van Doesburg, who in 1916–17 had received his first minor architectural com-
missions (mainly leaded-glass windows), came under the compelling influence of
van der Leck's radical theories. More pragmatic than van der Leck, and less
inclined to stand on principle, he immediately embarked on a number of projects
in collaboration with the architects Oud and Wils (illus. 99), attempting, with
varying degrees of success, to increase his grip on architecture.[25] It was thanks to
van Doesburg's contacts that *De Stijl* did not become a journal exclusively for
painters; from its inception it included architects among its regular contributors,
not entirely to the satisfaction of van der Leck and Mondrian.

Flanked by van der Leck, now disillusioned, and van Doesburg, dynamic and
enthusiastic as always, Mondrian was more or less compelled to define his own
position on the topic that was being discussed with so much vigour in the pages of
De Stijl: the integration of painting and architecture. He did so with characteristic

circumspection. Mondrian shared van der Leck's scepticism, and he was convinced that it would be some time before architecture reached the same stage of development as painting. In letters to van Doesburg he repeatedly warned that for the time being any collaboration with architects was highly premature. He found his worst fears reconfirmed each time van Doesburg reported his latest disappointing experience, and chronicled the conflicts that had arisen. On one such occasion Mondrian, in a letter dated 9 July 1918, wrote:

And now about architects in general – I have to say it, Does, when De Stijl was founded I left it up to you, but I never did agree with you when you ranked the architects alongside us, alongside our N.B. [Neo-Plasticism]. I knew then that it would lead to conflict. [. . .] I cannot write about architecture because I'm not an architect. I mean, I cannot write about it the way I write about painting. Later on, though, I will put forward a few ideas.

And some months later his judgement had become even harsher: 'Whatever the content of the new, most of it has had to come from the painters, don't you agree? I have yet to see principled and consistent results from the Messrs. architects.'[26] Mondrian himself always took pains to keep somewhat at a distance from the architects associated with *De Stijl*, and during the early years of the journal he was not even personally acquainted with them. It was not until 1920 that he had any contact at all with Oud, and then only by letter.

And yet in the course of his exchange of views with van der Leck and van Doesburg, Mondrian became persuaded that in the end painting could manifest itself better and more forcefully the more intimately it was involved with a specific architectural setting. This idea was launched, cautiously at first, in his article 'Neo-Plasticism in Painting', in the January 1918 issue of *De Stijl*. Here he claimed that ideally the painter should determine his colours on the actual site, under the conditions of light and space in which the public will see the work of art: 'Only then will the colours and relationships produce the proper effect, bound up as they are with the architecture as a whole. The architecture, in turn, must be in complete harmony with the painting.'[27] But he hastened to add that the moment has not yet come for a complete integration of painting and architecture. For the time being at least, Neo-Plasticism would have to be realized in painting. It is precisely because of the purity and integrity of painting that it was thought capable of awakening the observer to the tradition-bound and inadequate nature of the built environment by which it was surrounded. The wording is noteworthy: it testified to Mondrian's self-confidence as a painter, and implied a highly critical attitude towards architecture as it then existed.

This intriguing passage, in which Mondrian recommended that a painting be executed on the site where it was ultimately to be seen by the observer – no easy task, given the mobility of paintings – was triggered by an actual instance. In May 1917 in a letter van Doesburg had taken Mondrian to task for his subdued use of colour in the paintings exhibited in Amsterdam in May 1917 (illus. 76). In his reply of 16 May, Mondrian complained of the poor light in the galleries of the Stedelijk Museum, claiming that the colours were not the same as in the studio. 'This is a purely technical question, for I feel strongly that my work must be executed in relation to a particular site, and must be carried out on that site. I also see my work as the new decorative art, in which the pictural and the decorative are fused.'[28] As this letter and 'Neo-Plasticism in Painting' indicate, then, in the course of 1917 Mondrian took his first decisive steps along the path trodden

before him by van der Leck and van Doesburg. Painting, the tradition from which he sprang, was no less important to him than before, but from now on it was to be seen as provisional. Painting existed 'for want of something better', and would one day become superfluous, once the harmony of relationships it expressed was realized in the total environment. This view, which seems to me to be a translation into concrete terms of the theosophical theory of evolution, was to be developed by Mondrian in his subsequent writings, and given shape in the furnishing of his studio.

The studio on the rue de Coulmiers

Crucial to this development was Mondrian's text in dramatic form that was published in instalments in *De Stijl* from June 1919 to the following August under the title 'Natuurlijke en abstracte realiteit' (Natural and Abstract Reality). The main character in the piece is 'Z', a modern painter, who tries to convince 'Y', an art-loving friend, of the intrinsic necessity of the artistic development that Z has undergone. A third character, the painter 'X', voices the conventional, naturalistic standpoint. This trialogue is highly autobiographical: the locale for most of the discussions corresponds to places depicted in Mondrian's earlier paintings, and the views expressed by Z are clearly those of Mondrian himself. It is no accident that this discussion comprises seven scenes. Not only is seven a sacred number in the Judeo-Christian tradition, it also plays an important role in Theosophy, which distinguishes seven stages in the cosmic evolution from matter to spirit. Mondrian has his participants undertake a symbolic stroll from the countryside to the city, passing from rugged, uncultivated nature bathed in natural light into a world shaped by human hands and lit by artificial means. The seventh scene is set in the studio of the modern painter. Here the art-lover comes to the realization that Neo-Plasticism, as propagated by the painter Z, is the logical outcome of art, indeed of all human culture. He sees, in the manner in which the studio is designed and furnished, that the modern painter's initial – painterly – view has become reality. This leads Y to conclude that 'Here, in this room, the abstract has become real for me.'[29]

It is generally assumed that 'the room' referred to here was Mondrian's own studio. Although it has been suggested that he may have furnished his studio in Laren in some special way, the visitors to it in Mondrian's day that I have spoken to categorically deny that this was the case.[30] Actually, the crucial final scene was written not in the Netherlands, where the trialogue was begun, but in Paris, to which Mondrian had returned in June 1919. Thus 'Natural and Abstract Reality' is the reflection of a process of evolution on more than one level. The three, X, Y and Z, represent successive stages in human development and insight (comparable perhaps to the three figures of the triptych *Evolution*). And the seven locations, from the nocturnal moonlit countryside in the Netherlands to the studio in the French capital, stand for the evolution of the material world in which Mondrian lived, and which is represented in his work.

After spending several months at a studio at 26 rue du Départ, Mondrian moved to a studio at 5 rue de Coulmiers, which was to be the scene of a new venture. Here for the first time he applied the principles of Neo-Plasticism to his own studio, not only through the use of coloured planes on the walls, but also by a

considered distribution of objects.[31] The direct relationship between this experiment and the final scene of the play emerges in a letter Mondrian wrote to van Doesburg on 4 December:

My new instalment is about decoration, occasioned by my studio here, where I've set up a sort of display. I couldn't work directly on the walls, so I had to make do with pieces of painted cardboard. But in any case, I am now convinced that in this way it is possible to realize Neo-Plasticism in the interior. Of course, I had to paint the furniture as well. It was worth the effort, as it has a favourable influence on my work.

Mondrian had no photographs taken of this first provisional arrangement; apparently he felt that it was enough that it 'worked' for him and for his visitors, and indirectly for the readers of his trialogue. Only one informal little snapshot has been preserved, showing Theo and Nelly van Doesburg in the studio during a visit in the spring of 1921 (illus. 100). Unfortunately, it shows nothing of the transformation of the interior except for a curtain and a single wicker-chair, painted white. However, we may assume that the description given in the trialogue provides an accurate picture of Mondrian's studio following its metamorphosis. It was apparently a rectangular room, endowed by the architect with a certain amount of 'architectural structure'; Mondrian mentioned that this is typical of French interiors, in contrast to their Dutch counterparts, which were generally not much more than a 'space bounded by six planes'. The layout, as determined by the original architect, and improved on by Mondrian through the use of form and colour, is the subject of the following amusing excerpt from the conversation between the art-lover Y and the modern painter Z:

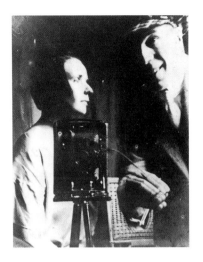

100
A photograph by Theo van Doesburg of himself and Nelly van Doesburg in Mondrian's studio, 5 rue de Coulmiers, Paris, in spring 1921.

Y. You said that the structure of the room itself also contributes to your placement of colour?
Z. To a degree, yes. A natural division of the interior space and its planes is provided by the projecting fireplace, the closet and the *souspend* [usually a kind of balcony used for storage, which juts into the room]. These planes are articulated architecturally by the large skylight in the ceiling, by the studio window in the front wall, divided into sections and then subdivided into small panes, by the door and the *souspend* on the rear wall, by the fireplace and the window on one side wall, and by the large closet on the other wall. This structural articulation formed the point of departure for the painterly articulation of the walls, the placement of the furniture and utensils, and so forth.
Y. Yes. I see how all these things help to articulate the room, as do the ivory-coloured curtains that are now drawn aside.
Z. The curtains form a rectangular plane that divides the wall next to the window. To continue the division, I added those red, grey and white planes on the wall. The white shelf with the grey box and the white cylindrical jar also make their contribution to the arrangement.
Y. And the jar takes on the appearance of a rectangular plane!
Z. The grey tool-cabinet in the corner is also significant.
Y. And the little orange-red paint cupboard under the curtain . . .
Z. . . . against the grey and white plane behind it.
Y. The ivory chair is perfect against that background.
Z. Note the greyish-white work-table, with the jar in cool white at one end and the pale red box at the other, set against the black and white planes on the wall below the window. And next to the table, the bench with the black throw, against the large, dark red plane on the wall next to the window.
Y. The yellow stool is just right in front of the black bench.
Z. We could go on and on, right around the entire studio, and yet I must point out that there is still no unity.
Y. If the wall near where you work were also decorated in different colours, wouldn't that bother you?
Z. The easel stands in front of that large closet, which projects into the room. Here in this studio, it should be painted a neutral colour like grey. That would solve the problem . . . But an even better solution would be to stop making separate paintings altogether![32]

This description gives us a fairly good impression of Mondrian's first interior design. As there are no contemporary photographs available, it is impossible to create an exact reconstruction of the studio like the scale models of his studio in Paris in 1926 (where the only uncertainty concerns the precise colours used) and in New York in 1944.[33] However, an approximate reconstruction is possible, on the basis of the text of 'Natural and Abstract Reality' and the structural details and dimensions of the rue de Coulmiers studio itself, which today remains more or less intact.

The studio is situated on the second, top, floor of the building at the back of the courtyard (illus. 102); it can be reached via a staircase and a corridor leading to a small room (2.11 × 2.27m), which Mondrian used as a bedroom. A side-door in the corridor opens into the studio, a fairly large room with a floor area of 5.38 × 6.57m. Due to the fact that half of the ceiling slopes somewhat, the height of the room ranges from 3.77 to 4.3m. The *souspend*, mentioned in the text, is not a balcony jutting into the room, but rather the space above the corridor. This storage space, which can be reached by means of a ladder, is 1.64m high, with a railing reaching about halfway up (illus. 101). The studio is bathed in light from windows on three sides: set into the sloping section of the ceiling is a large skylight, one of the side walls has French windows, and in the front wall there is a large window, the middle section of which can be opened. Originally, this was joined to a little door below, which made it possible to remove large paintings from the studio by means of a hoist. This door is now sealed off, but the outline is still visible on the outer wall. Other structural alterations later carried out included the removal of the closet that protruded into the room on one side and the fireplace in the opposite wall. In the exploded box drawing (illus. 103) these are indicated by hatching. The present railing, with its decorative pattern of spades, is probably of a later date; the original is thought to have been closed off, so that it formed part of the wall below.[34]

In the trialogue Mondrian refers briefly to certain structural details of the walls and ceiling, but then turns his attention to the front wall. The exceptionally large window is 'divided into sections, and then subdivided into small panes', calling to mind the paintings based on regular lattices done in the preceding years, in particular, the two *Checkerboard* paintings dating from the first half of 1919, themselves highly reminiscent of leaded-glass windows (illus. 95 and 96). Here, however, the window was incorporated into a larger composition that took up the entire wall. This effect was promoted by the fact that the glass was matte rather than transparent, and blocked out the view. Thus the window forms a complex of pale grey planes, the symmetry of which is offset to some extent by the curtain and the surrounding planes of colour (illus. 107).

The window poses no difficulties in the reconstruction, but the dimensions and placement of the other elements that Mondrian mentions in his description are hypothetical. This is particularly the case for the pieces of coloured cardboard mounted on the wall. There is somewhat more certainty concerning the furniture and other objects. A number of the pieces that are visible in photographs of a few years later (illus. 110–114) were, in fact, already part of Mondrian's interior in the rue de Coulmiers. This is true of the white wicker-chair – it can be seen in the photo of Nelly and Theo van Doesburg – and a large, square wicker-chair that is mentioned in an interview of 1920.[35] We can assume that the tool-cabinet,

101
Interior of Mondrian's studio, top floor, 5 rue de Coulmiers, Paris, in 1994.

102
Mondrian's studio, top floor, 5 rue
de Coulmiers, Paris, in 1994.

103
Exploded box-plan of Mondrian's
studio, top floor, 5 rue de
Coulmiers, Paris; a reconstruction
by the author, 1994.

143

the paint cupboard, the work-table, the bench draped with a black throw, and the stool that feature in 'Natural and Abstract Reality' are the same as those we are familiar with from photographs of the later studio in the rue du Départ.

The front wall of the rue de Coulmiers studio must have given the impression of a carefully balanced composition, the dominant colours white and grey, with accents of red, black and yellow; there is no mention of the colour blue. It is interesting to note that red, as well as the non-colours white and grey, appear in various shades: cool white, ivory, greyish-white, orange-red, and light and dark reds. This same variation can be seen in the paintings done from 1920 on, the first of his more mature Neo-Plastic works. Another interesting aspect of the description of the studio is Mondrian's explicit use of the term 'plane', even when he is referring to objects. He was apparently striving to play down the three-dimensional and material nature of the objects, in order to stress their function as planes in the overall colour composition. This was also the impression the interior made on van Doesburg during his visits in 1920 and 1921. On 12 September of the latter year he informed Oud that 'What Mondrian has done in his studio, with his colourful pieces of cardboard, is restricted to a single plane (window wall), which makes it a painting in two dimensions.'

The remaining walls were probably given a less detailed treatment, and they are not described at any length in the trialogue. We know only that the side walls were divided up by means of the closet and fireplace. It is clear from other sources that there was a large mirror against the back wall – this was the mirror that van Doesburg used to take the photo of himself with Nelly – and that one of the diamond-shape compositions with lines from 1918–19 hung above the entrance to the studio; this latter detail was mentioned in the 1920 interview.[36] In the meantime, Mondrian steadfastly maintained that the furnishing of his studio was provisional. The underlying structure could not be altered, and he was not able to work directly on the walls, presumably because the premises were rented on a short-term contract. The large built-in closet, which he would like to have painted grey, had to remain in its original state, probably dark brown wood. Mondrian stressed that the interior was no more than an indication of what the possibilities were in that respect, and what he considered desirable.

This future scenario is touched on in the final scene of the trialogue, when the modern painter Z brings the conversation around to the exterior, and to the design of the built environment as a whole. Mondrian admits that this is something over which we have as yet very little control, in comparison with our own living space, and it will be some time before cities and streets are dominated by 'the new'. But in the end, the new cities and streets will be a reality; then painting will be one with the environment. This will, however, require a new 'technical' grasp of colour: 'Exact expression requires exact tools, and what is more exact than machine-made material? The new art will need skilled technicians, and the new age has already begun the search: we have coloured concrete and coloured tiles, and yet there is still nothing suitable for us in Neo-Plasticism.'[37]

Above all, if this ideal is to be realized, there must first be a complete purification of architecture, just as in painting. Only when architecture has transcended all the technical and practical restrictions to which it is now subject will it be ready to merge with painting, and to give universal expression to that most exalted of human states: a perfect equilibrium of relationships in all areas. In a sense, we

104 (opposite)
Piet Mondrian and Michel Seuphor, *Picture-Poem*, 1928, gouache and ink on paper, 65 x 50. Private collection.

TEXTUELL

îlot physique Seuphor sous l'aile de Mondrian
sous les drapeaux sérieux du Néo-Plasticisme
battant le pavillon très pur

échappée belle de l'art
enfin mesure d'hygiène
ralliez-vous tous au pavillon du grand secours
du grand sérieux quand nous serons mieux éclai- [rés
et disparaisse la flore sous le regard néo
et cessent les éboulements

l'îlot physique sort des cavernes
il ose construire dans le clair
il lève la tête
où il n'y a que le grand bleu
et le grand gris et le grand blanc
et le grand noir et le soleil tout feu
suivi des synonymes bonheur sagesse connais- [sance
et de la joie...
qu'il ne faut pas confondre encore

mais il fallait y penser si j'ose dire
être déjà et non choisir et choisir bien quand-même
mais il fallait prendre contact
marcher longtemps et sous le juste signe

M. Seuphor

16 mai 1928

P.M

145

can say that Mondrian placed the integration of painting and architecture in a teleological perspective.

Disagreement with Oud and van Doesburg

When Mondrian formulated his standpoint concerning the relationship between painting and architecture, he fully expected to be able to count on the understanding and support of the nucleus of De Stijl, in particular Oud and van Doesburg. In the spring of 1921 there was talk of a commission for a residence-cum-gallery that Léonce Rosenberg in Paris was thinking of giving to the artists of De Stijl.[38] Mondrian wrote to Oud to say that if it was to be a paid commission, he might consider providing designs for the decoration. This is the first recorded instance of Mondrian declaring that he was prepared, albeit conditionally, to collaborate with an architect on a joint project – quite a step, considering his views on architects and architecture. As it happened, his willingness was not actually put to the test, as the commission never materialized. In any case, it soon became clear that there were deep-seated differences of opinion on the subject of integration between Mondrian and Oud (and, later, van Doesburg as well). These are fought out between the lines in publications and, because hidden from the outside world, more frankly in their correspondence.

The seemingly innocent incident that triggered this controversy was the publication of a lecture in June 1921 that Oud had given in Rotterdam shortly before, 'Building in the Future and its Architectonic Potential'.[39] In it Oud advocated a functional architecture, based at once on social circumstances and on the new techniques made possible by the use of iron, concrete and glass. This would open the way for a clear and austere form, free of any ornament or accessory. In Mondrian's view, this statement did not go nearly far enough. He was also piqued that Oud had not even bothered to mention Neo-Plasticism as the true road to the architecture of the future, and he responded with 'The Realization of Neo-Plasticism in the Distant Future and in Present-day Architecture', which appeared in De Stijl in two instalments, in March and May of 1922.[40] In it Mondrian explained what he felt to be wrong with architecture, even the work of modern architects of good will (such as Oud, although he was not mentioned by name). They allowed themselves to be excessively influenced by practical considerations connected with construction, and they were in too much of a hurry. They assumed that they could execute immediately that which can only be achieved after endless searching and experimentation, as he himself had experienced in his painting. They clung to buildings as material objects, structures made up of forms rather than structures of planes and open space.

Oud's personal written response to this left no room for doubt: he told Mondrian quite frankly that he had no faith in the application of Neo-Plasticism to space: it was appropriate for painting, but not for architecture. The clash of opinions in their correspondence reached such a pitch that Mondrian finally terminated the friendship. Relations between the two men were later restored (this was primarily in Mondrian's interest, since Oud helped him by buying his paintings and recommending his work to others), but each held firmly to his own standpoint. Mondrian resigned himself to the rift, convinced as he was that architects were simply not as advanced as true artists, as witness an angry outburst in one of his

letters to van Doesburg, where he referred to them as 'damned architecture-slaves of money and the public'.[41]

But of greater seriousness was the conflict that arose in 1923–4 with van Doesburg, who was, after all, a fellow painter, and the only member of the group whom he had always considered a kindred spirit. As in the case of Oud, the rupture between them, which ultimately led to Mondrian's decision to withdraw from De Stijl, originated in a fundamental difference of opinion on architecture. It was not, as is often maintained, the result of a dogmatic battle over the rationale of the diagonal line in painting.

Van Doesburg, who by then had also broken with Oud after quarrels over an architectural project on which they had collaborated in Rotterdam, worked closely with the young architect Cornelis van Eesteren on the design of several houses (illus. 105). The drawings and scale models were exhibited in 1923 at the group show of De Stijl architecture held at Léonce Rosenberg's gallery in Paris (illus. 106).[42] Needless to say, Mondrian was not represented. Not only did he have his doubts about the models themselves, and about van Doesburg's seemingly irresistible urge to consort with architects, he was also deeply disturbed about the architectural theory that surfaced in van Doesburg's articles and manifestos. Central to this theory was the view (undoubtedly influenced by El Lissitzky) that the new 'colour architecture' was the concrete manifestation of the time–space continuum, in which the concept of the fourth dimension played a major role. Van Doesburg related this concept to the actual experience that the observer undergoes as he moves through the built environment.

Mondrian strongly disagreed. He had already made it clear where he stood on this issue in 'The Realization of Neo-Plasticism in the Distant Future and in Present-Day Architecture'. He stated that architecture had always made use of forms and volumes, which were seen by the observer in a traditional manner, in perspective. Architecture based on Neo-Plastic principles, by contrast, consisted

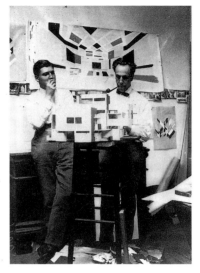

105
Cornelis van Eesteren (*left*) and Theo van Doesburg, working on a model of a house in van Doesburg's studio, Paris, 1923.

106
An exhibition of De Stijl architecture at Léonce Rosenberg's Galerie de L'Effort Moderne, Paris, 1923.

147

107
The front wall of Mondrian's studio,
5 rue de Coulmiers, Paris, in a
provisional reconstruction by the
author, 1994.

of planes. Thus, according to Mondrian, the observer experienced the built environment in a totally different manner: wherever he looked, he found himself face to face with a flat image:

The new vision [...] does not proceed from a fixed point. Its viewpoint is everywhere, and not limited to any one position. Nor is it bound by space or time (in accordance with the theory of relativity). In practice, the viewpoint is in front of the plane [...]. Thus this new vision sees architecture as a multiplicity of planes: again flat. This multiplicity composes itself (in an abstract sense) into a flat image.[43]

Interestingly enough, Mondrian based his argument in part on Einstein's theory of Relativity (just as van Doesburg did, although in a different manner, in his concept of architecture as a time–space continuum, the expression of the fourth dimension). In Mondrian's case, however, I believe this to have been a scientific 'front' for a purely esoteric view. This is confirmed by an undated letter to van Doesburg written in May or June 1922. In it Mondrian says that in three-dimensional art – and therefore in architecture, 'time must be set aside, in order to arrive at a purely abstract image (I mean an inner seeing)'. In other words, the built environment must be transformed in such a way as to foster this 'inner seeing', a state in which the observer is exalted over matter, and there is no consciousness of either time or space. This is not so much an alteration as an extension of the view of visible reality that Mondrian had arrived at many years before under the influence of Theosophy.

It is obvious where the two men came to a parting of the ways: van Doesburg interpreted colour architecture as concrete and dynamic, and believed it could be realized in the present; Mondrian saw colour architecture as an abstract concept, an object of meditation devoid of time and dimension, and projected his ideal into the future. Once this fundamental difference in their view of man and his world became clear, and was expressed in their articles, there was no longer any basis for their collaboration within De Stijl.

The studio as a model home for future Man

At the time of these conflicts Mondrian was again living and working at 26 rue du Départ, where he had found a studio in October 1921 (illus. 108).[44] As in rue de Coulmiers, he furnished his studio, albeit somewhat provisionally, according to Neo-Plastic principles, through the use of rectangular pieces of coloured cardboard on the walls, and a judicious distribution of everyday objects. There is only one brief description, given in an interview, of the studio as it was in the early years.[45] There are no photographs, except for a portrait that offers a glimpse of the interior (illus. 109). In 1924–5, however, he gave the studio a complete facelift, and even painted directly on the walls. As he wrote in a letter to Oud: 'You wouldn't recognize it, now that I've repainted everything, etc. It was really necessary, since so many people are coming to visit me, a lot of them from abroad.'[46] Not that this represented the final 'version', for he continued to make changes. Thus, following an interview with Mondrian in 1926, the Paris correspondent for the newspaper *De Telegraaf* wrote:

At each visit the interior has undergone an evolution [. . .]. Now all the walls have been divided rhythmically by means of horizontal and vertical rectangles, whereby the positives red, blue and yellow are magically held in balance by the negatives white, grey, and black. The large mirror, which in the past fairly swallowed one up in its depths, has now been divided by the magician into small segments, whose dull gleam here and there highlights the composition. The divan with its colourful cushions and the rectangular rugs on the floor likewise reflect the major theories of the Neo-Plastic gospel.[47]

It was also in 1926 that Mondrian first permitted photographs of his studio to be published. This was, in my opinion, no coincidence. Following his disappointing experiences with Oud and, more recently, with van Doesburg, Mondrian apparently felt the need to publicize – not only in words, but also visually – his conviction that for the time being Neo-Plasticism in architecture could only be realized where the painter is in complete control, namely in his own studio. In so doing, he took a polemical stand against his former allies within De Stijl, in particular van Doesburg, whose architectural projects were then creating something of a stir in art journals and at exhibitions, both in France and elsewhere.

It is also conceivable that Mondrian wanted to set his views off against various developments then taking shape that were of relevance to the fusion of painting and architecture. In Germany there was the Bauhaus and the work of Lissitzky and Baumeister, and in Paris itself the group associated with the journal *L'Esprit Nouveau*. Léger, who did murals for Le Corbusier's L'Esprit Nouveau pavilion at the Exposition des Arts Décoratifs and also for a building by Mallet-Stevens, made a sharp distinction between autonomous painting and murals, and showed himself more than willing to place his art in the service of architecture. This was of course anathema to Mondrian. Furthermore, he rejected altogether the Functionalist movement then gaining prominence in international architecture, and its conviction that the visual manifestation of a building ought to be determined by social and technical considerations. *His* manifesto on architecture was contained in the published photographs of his own studio, and the articles he published in art reviews and journals in various countries.

The photograph from the 1920s that was most often reproduced, and which was probably Mondrian's own favourite (assuming that he himself had a say in

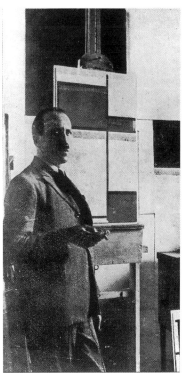

108 (top)
A photograph by Alfred Roth of Mondrian's studio on the top floor of 26 rue du Départ, Paris, 1928.

109
Mondrian in his studio at 26 rue du Départ, *c.* 1923, reproduced from *De Stijl* no. VI/6–7, 1924.

Mondrian's studio at 26 rue du
Départ in 1926.

which illustrations accompanied his articles) dates from 1926, and shows the studio
at its most austere (illus. 110).[48] It is a frontal view of the back wall; most of the
wall is painted, but certain portions are covered with pieces of cardboard. The
composition of the wall calls to mind a type of painting that Mondrian had been
working on since 1921. It consisted of a large, almost square plane surrounded
on three or four sides by smaller planes. The interesting thing about the wall is
that these areas are not bounded by black lines, and that the large plane is darker
than the surrounding area. According to some descriptions, it was grey. The
impression of austerity is created not only by the composition on the wall, but also
by the careful distribution of the simple, painted furniture and the few utensils.
Nothing was left to chance, not even the placement of a bowl or a rug, as we
know from contemporary reports. The dark easel against the back wall occupied
a central position. During this period Mondrian was no longer painting on an
easel, preferring instead to lay his canvases flat on a table. He only used the easel
when he wanted to subject a painting to a critical examination, or to show it to
visitors. But the easel in the picture was not even used to display a painting; it
functioned solely as a network of horizontal and vertical lines, against the back-

HET ATELIER VAN PIET MONDRIAAN TE PARIJS.

De schilder in zijn interieur van rhythmisch ingedeelde muren.

111
Photomontage of Mondrian in his studio at 26 rue de Départ, *c.* 1926, as published in *De Telegraaf*, 12 September 1926.

ground of the planes on the wall. To dispel the impression of domination by the verticals, an additional horizontal slat was laid across the box-shape, movable section of the easel.

There are a number of other, less formal, photographs dating from 1926 that show a corner of the studio, and some of these, too, were occasionally published (illus. 111).[49] High on the walls we see a number of paintings, including the diamond-shape *Composition with Grey Lines* from 1918 (illus. 85). Below, a number of coloured planes have been added, and pieces of mirror: one to the left of the door, and at least two to the right. This contributes an unexpected element of mobility to the otherwise rigidly static interior. In general, however, Mondrian preferred those photos that presented a frontal view of the back wall. This preference was clearly related to something he had previously said – to counter van Doesburg's dynamic view of architecture – concerning the visual experience of the Neo-Plastic architecture of the future: in 'the new vision' the observer is confronted with a plane which has neither time nor dimension. It was this kind of experience that Mondrian was trying to make possible – in a temporary and as yet imperfect form – in his studio and, above all, in the photographs of his studio.

It is significant that, as Nancy Troy observes, Mondrian went to considerable
lengths to disguise the fact that his studio was not rectangular, but actually had
an irregular, five-sided floor plan (illus. 112).[50]

The next photograph that, on the basis of its early publication date, has gained
something of an official status is the most unusual of all the studio photos (illus.
113).[51] It was probably taken in the summer of 1927, and the primary difference
with respect to the previous year is that the large planes on the wall are now
partially covered by smaller, rectangular pieces of cardboard, painted in various
unspecified colours or tones of grey. At a time when the planes in his paintings
were becoming ever larger, he was opting for increasing fragmentation in the
decoration of his studio. Stranger yet is the treatment that the easel has undergone
(assuming that it is indeed the same one as in the previous photo). A clamp in
the form of a small square is mounted at the top of the easel, and there is a small
slat at the bottom right, presumably intended only as a horizontal accent. The
asymmetrical effect is carried through quite rigorously in the painting of the easel,
with some parts in black, others in white. In order to stress its a-functional, purely
visual nature, a piece of cardboard with rectangles painted in various sizes and
colours has been mounted precisely where one would expect to find a painting.

A particularly fine photograph of the studio was taken in 1930 by Michel
Seuphor (illus. 114).[52] Mondrian obviously continued to carry out modifications
and adjustments to the wall composition, which is now almost completely covered

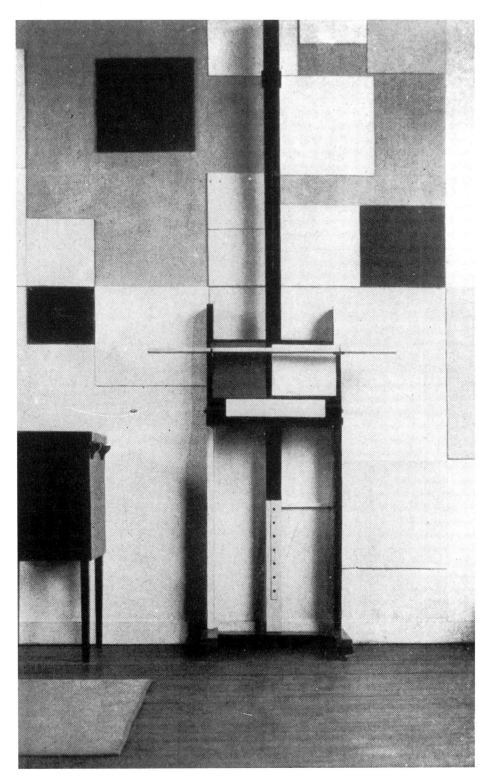

113
Mondrian's studio at 26 rue du
Départ, *c.* 1927.

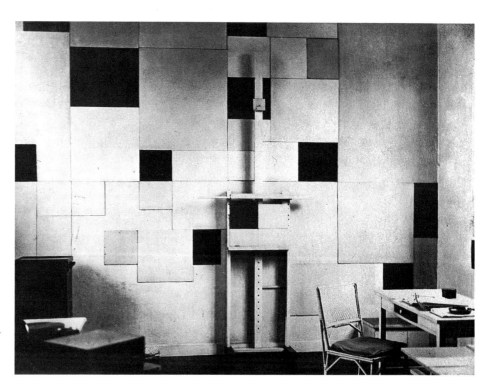

114
A photograph by Michel Seuphor of Mondrian's studio at 26 rue du Départ, *c.* 1930.

in small planes. The photograph also shows that the easel has undergone another transformation: the asymmetrical black and white sections have been painted over in white, and the cardboard on the box replaced by a new version, which has four rectangular planes. In a publication that appeared in 1932 this detail was mistakenly reproduced as a separate painting, which it clearly cannot be, as the fine lines and the nearly symmetrical division into four parts are inconsistent with his painting practice.[53] Later photos, showing a painting on the easel, leave no doubt that it is actually part of the easel itself. It is also obvious from Seuphor's photograph that the legs of the easel have been sawn off.[54] Mondrian may have done this on an earlier occasion, but the photos dating from before 1928 are not clear in this respect. Sawing off the legs made the easel totally useless, since it was then liable to fall over. What Mondrian accomplished, on the other hand, was that it was now possible to place the easel flat against the wall, in effect integrating it into the composition; or rather it forms the transition between the flatness of the wall and the three-dimensionality of the architecture, without, however, calling up any notion of perspective. One would be justified in seeing the easel as a relief element, and the same might be said of the pieces of cardboard and the rectangular sections of mirror mounted on the walls of the studio (illus. 111). We have reason to believe that Mondrian saw the relief as the next logical step in the evolution of painting in the direction of architecture, and on that basis welcomed the experiments in this direction carried out by his disciples Jean Gorin and César Domela. Gorin later wrote in his memoirs that Mondrian had encouraged him to make reliefs.[55]

During the 1920s Mondrian occasionally designed interiors for others. We have, for example, the detailed plans for a project that was never executed and which is known in the literature as the 'Salon de Mme B'.[56] This Mme B. was the collector Ida Bienert of Dresden. In 1925 she and her son Friedrich bought a

number of paintings from Mondrian, and shortly thereafter she asked him – through the offices of Sophie Lissitzky-Küppers – if he would design a room for her. Early in 1926 Mondrian sent her three handsome gouaches, two containing an isometric representation of the Salon (illus. 116), and one in which the walls could be folded out (illus. 115). At her request he included several pieces of furniture – an oval table with a lamp, a cabinet and a divan – but otherwise the Salon was designed using only painterly means. His ideas were interpreted more rigorously here than in his own studio, which was a combined living area and work-space and thus contained more household utensils. The four walls, the floor and the ceiling of the Salon have the air of having been conceived independently of one another, so much so that they might all be paintings in their own right. Nowhere does one composition continue on into the next. When Lissitzky's wife sent Lissitzky photographs of the designs he was somewhat disappointed, referring to the Salon as 'just one more spatial still-life, to be viewed through the keyhole'.[57] This was, however, precisely what Mondrian was aiming for: a total repression of the temporal and spatial aspects of architecture. As he had stressed in previous writings, the observer was to take up a position directly in front of a plane. In his own 1926 design for the Kabinett der Abstrakten in the Landesmuseum, Hanover, Lissitzky came up with an arrangement for the walls that immediately calls to mind Mondrian's compositions (illus. 117). However, he ingeniously made use of strips mounted in front of the wall, so that when the observer altered his position he was treated to a dynamic, constantly changing impression of the interior. The contrast with the views held by Mondrian could not be more obvious.

In 1926 Mondrian undertook a second spatial project, when he designed scenery consisting of three interchangeable decors for Michel Seuphor's play *L'Ephémère est éternel*.[58] The scenery was originally to have been designed by the Italian artist Enrico Prampolini, but for some reason it was decided to replace him. The play was to be performed in Lyon, and at one point there was some talk of Mondrian himself taking part as a member of the chorus. In the end, however, the entire project fell through. The scale model for the scenery has unfortunately not survived, but in the original photographs it presents a very strange sight indeed (illus. 118).[59] The proscenium arch is painted on linen and appears to have been made from a mounted canvas, probably a rejected painting, from which the stage entrance has been cut. The floor and shallow wings were probably made of cardboard and wood, as were the interchangeable backdrops. Several strips seem to have been pasted on and there is a section in the upper left-hand framework of the proscenium arch that was tacked on later. Mondrian apparently devoted a great deal of time and effort to getting the composition exactly as he envisioned it, just as he did in his paintings, although there the corrections were generally more carefully camouflaged. It is noteworthy that in this design there is some inconsistency in Mondrian's treatment of the line. All the various planes on the decors are surrounded by black lines: they are like details from his paintings. In the case of the proscenium arch and the wings, however, some of the planes are outlined in black, others are not, and still others are enclosed on only one side, all apparently quite arbitrarily. As we have seen, these contour lines are entirely lacking in the designs for the Bienert Salon and, for that matter, in his own studio as well. It may be that Mondrian considered a network of thick black lines too dominant for a wall. Or perhaps he felt that as the line was a fundamental element of painting, it should

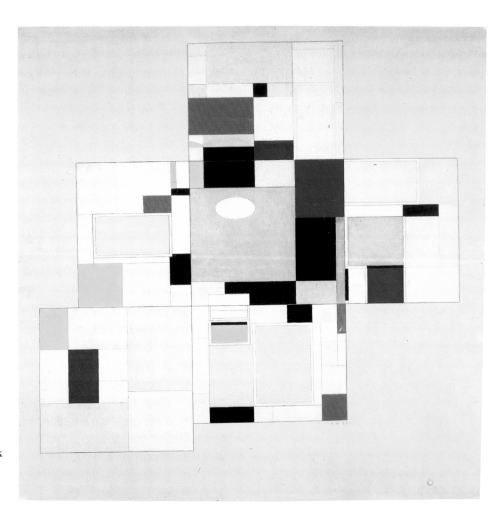

115
Exploded box-plan of the Salon for
Ida Bienert, 1926. Gouache and ink
on paper, 75 x 75.
Kupferstichkabinett, Staatliche
Kunstsammlungen, Dresden.

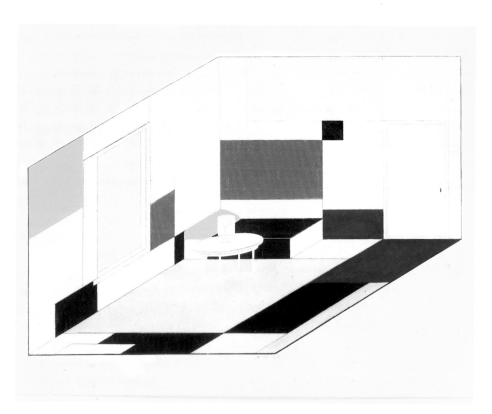

116
Isometric perspective of the Salon
for Ida Bienert, 1926. Gouache and
ink on paper, 37.5 x 57.
Kupferstichkabinett, Staatliche
Kunstsammlungen, Dresden.

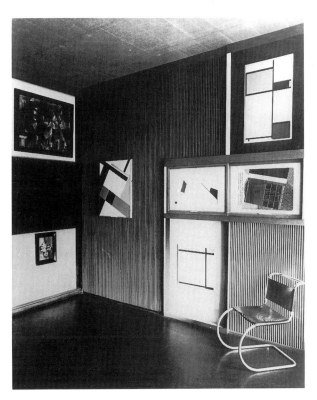

117
El Lissitzky, *Kabinett der Abstrakten*, 1926, Landesmuseum, Hanover; photograph of *c.* 1930 showing, on the right, two paintings by Mondrian, 1923 (*upper*), 1929 (*lower*).

118
Mondrian's stage-set for Michel Seuphor's *L'Ephémère est éternel*, 1926, paint on canvas, cardboard and wood. Lost.

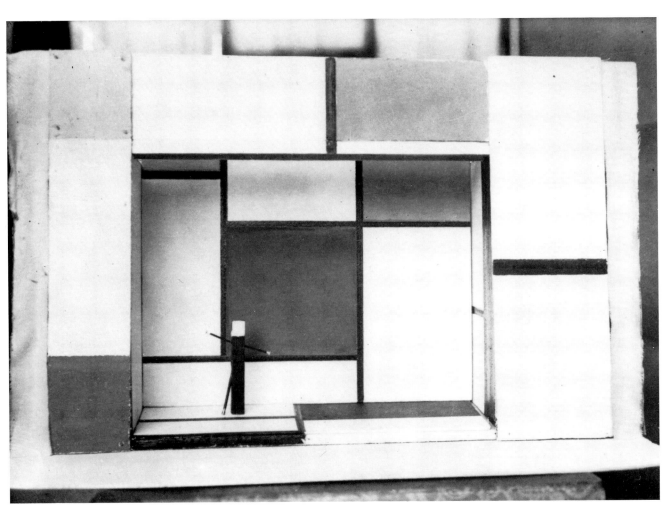

by definition be reserved for use in paintings. For all its visual merits, there is a hybrid quality to the model.

'Without the preliminary work on my own studio, I could never have done it.' This is what Mondrian wrote to Oud early in 1926, in reference to his design for the Salon. His own interior was of paramount importance, and it remained the only design actually to be executed. Mondrian lived in his studio in rue du Départ until 1936, when the building was demolished. His subsequent studios – in Paris until 1938, in London until 1940, and then in New York at two addresses – were furnished in the now familiar sober style, using furniture he had adapted to his purposes or even made himself from orange crates. The white walls were again covered with coloured cardboard, and which, judging by the photos, were regularly rearranged. In New York we see a more immediate link between the constellations of coloured planes on the wall (illus. 119) and the sparkling compositions in the paintings done during his final years.

To the end of his life Mondrian felt a need to transform each of his studios into a kind of model home of spiritual Man, a foreshadowing of what he hoped would be the future environment of all mankind. He continued to cherish this metaphysical ideal, despite the deteriorating political and social situation. The eyewitness accounts of visitors, as well as the large number of photographs that have survived, provide a well-documented picture of the various studios and the alterations and improvements that Mondrian was constantly carrying out. However, these photographs were no longer published along with his articles. I cannot escape the impression that in later years his ambitions with respect to the studio interior were less far-reaching than they had been in the 1920s. During the earlier period he presented his studio quite emphatically to the outside world (by means of what I have termed the 'official' photographs), as a concrete example of an ideal that would ultimately be realized in the environment as a whole. In later years, however, the studio was reserved for visitors, as a place where they could look around them and say, with the new insight of the art-lover in the trialogue: 'Here, in this room, the abstract has become real for me.' However, Mondrian himself had deferred the realization of Neo-Plasticism in architecture to a distant future.

Neo-Plasticism in music

As we saw at the beginning of this chapter, Mondrian was sceptical of attempts to compare abstract art such as his to music; he was in any case unwilling to use music simply as a means of providing legitimacy, as many artists and critics were doing. Mondrian believed firmly in the autonomy and the uniqueness of each art, and abstract art was not 'visual music'. But he had undoubtedly thought about the analogy between music and the visual arts on a more fundamental level, and in his publications he returned to the subject on several occasions. While he had mixed feelings about the new literature and architecture, he set great store by certain aspects of contemporary music, and in practice they provided inspiration for his work. In the final analysis music was, for Mondrian, probably the most important of the other arts, together with dance, which in his view could not be detached from it.[60]

As far as we know, music did not play a significant role in Mondrian's upbringing. It would not have been surprising if it had, for the Calvinists considered music

– in certain forms – the most acceptable of all the arts. Later he more than made up for this, and often frequented musical circles. Early evidence of this is the drawing he made in 1900 of R. Ritsema van Eck at the piano. A lifelong friend, van Eck gave up his original ambitions as a composer, and became a doctor.[61]

A major stimulus for Mondrian's interest in modern music was without doubt his friendship with Jakob van Domselaer, whom he met in 1912 and with whom he shared a house in Laren in 1915–16. At this time van Domselaer was writing a number of compositions to which he later gave the telling title *Proeven van Stijlkunst* (Examples of Style). As van Domselaer's widow recalls in her memoirs, Mondrian proclaimed the first of these pieces 'an audible confirmation [. . .] of the emergence and "portrayal" of the upright and the reclining (the vertical and the horizontal) element'.[62] In his letters Mondrian more than once confided to friends that the pieces were created under the influence of the plus–minus compositions that he did around 1915 (illus. 64).[63]

The first of these 'examples of style' was performed by van Domselaer on 5 February 1915 during a recital in the Concertgebouw in Amsterdam. A somewhat ironic report of the proceedings is to be found in Henriëtte Mooy's novel *Maalstroom*, in which Mondrian also makes a brief appearance: 'The room was full of painters [. . .]. The works had no name, only a number [. . .]. Unfortunately, there was nothing very "stylish" about the "style movements". . . .'[64] On that occasion Mondrian intervened in the discussion with a fervent defence of the work of his friend. In the course of 1916 it came to a rift between the composer and the painter. According to his wife, van Domselaer had come to see 'not abstract sound, but chaotic sound' as the challenge which music must address.[65]

Other musical contacts took the place of this friendship. In 1916 Mondrian made the acquaintance of Frits van Hengelaar, a psychology student and amateur composer, and shortly thereafter the composer and music critic Paul Sanders. The latter recalled conversations he had with Mondrian then and later in Paris during the 1920s in which the main topic was modern music.[66] In his correspondence with friends Mondrian regularly returned to the subject, as in a letter of 21 February 1918 to a young woman named Willy Wentholt. He was apparently greatly attracted to Wentholt, a French teacher from Amsterdam, and they often went dancing together. In this particular letter Mondrian commented on the reviews of a concert she had sent him: 'I read them with approval, and yet I cannot help feeling that De Bussy still portrays "style in the manner of nature". Of course this is good, too, but it means that natural emotion plays too dominant a role (see Stijl art. 2). Later French musicians – their names escape me – have gone further.'

As is clear from the reference to *De Stijl* (the recently published instalment of his series 'Neo-Plasticism in Painting'), Mondrian assessed the evolution of music, indeed of all the arts, on the basis of what had already been achieved in painting, not least by his own efforts. In the subsequent articles which appeared in *De Stijl* and elsewhere, he returned again and again to the question of how Neo-Plasticism could best be realized in the other arts as well. Modern music had already made progress by relinquishing melody, which he saw as the equivalent of the natural, rounded line in painting, with which he had now broken. Melody could be replaced by rhythm. In rhythm, the regular repetition of musical elements – like that of the visual elements in a painting – was to be avoided at all costs. Harmony and balance were the result of linking elements that, while of equal value, were not identical.

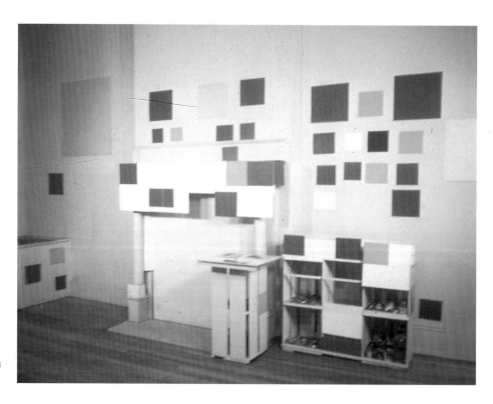

Mondrian's last studio, 15 East 59th
Street, New York, 1944.

It is not entirely clear what type of modern music Mondrian had in mind, as
he seldom mentioned actual composers (just as he almost never referred to archi-
tects or writers by name). Sanders recalled that in 1917 he had spoken to Mondrian
in glowing terms of the work of Schoenberg and Busoni. In *Le Néo-Plasticisme*,
published in January 1921, Mondrian is critical of the use of the traditional 'natural'
tonal scale (which he likened to the natural colour scale of a prism), without,
however, referring to the obvious alternative: atonality and Schoenberg's twelve-
tone system. Instead, he still characterized his old friend from the Netherlands as
the representative of the New Music:

> Do we not see even now in the New Music that the descriptive, the old melody, is losing its
> power? Has 'a different colour' not appeared in the New Music, a less natural colour, and a
> new, more abstract rhythm? Are there not signs of a neutralizing contrast (for example in some
> of the 'examples of style' by the Dutch composer van Domselaer)?[67]

While Mondrian looked with favour upon certain developments in the music
of the concert-hall, the ultimate innovation was to be found elsewhere, namely,
in jazz and mechanical music. Both forms of music are mentioned for the first
time in texts dating from 1920, not long after his return to Paris. While he devoted
a number of articles to these phenomena during the 1920s, he seems to have lost
interest in the 'traditional' concert repertory.

There is a brief passage on mechanical music in the trialogue 'Natural and
Abstract Reality', in the instalment that appeared in *De Stijl* in June 1920. Interest-
ingly enough, this passage is part of a more wide-ranging and fundamental dis-
cussion between the three participants – the traditional painter X, the art-lover Y
and the modern painter Z – on the value of the individual in a work of art. Z
claims that the new painting requires a new and more exact technique, for which
machine-made material will have to be developed. Once that material is available,
it will even be possible for the artist to leave the actual execution of the work to

others, as is customary in architecture. The traditional painter contends that this cannot hold true for painting: 'But is the hand of the artist not all-important?' The modern painter admonishes him: 'You are thinking of the old art. There, indeed, the hand of the painter was all-important, precisely because the old art accorded such a major role to the individual.' In the new art, the individual is relegated to the background, in favour of the universal. In the same way, the individual and sentimental that in music is attached to the playing of traditional instruments must be abolished. 'We must find other instruments, or . . . machines! [. . .] Would it not be glorious, and indeed much more certain, if someone invented a machine to which the composer, the actual artist, could entrust the work?'[68]

Later on in 1920, while working on *Le Néo-Plasticisme*, Mondrian discussed these speculations on the new music in somewhat more concrete terms. To give expression to the new spirit, the old scale and the traditional set of instruments would have to be cast aside. Tones would have to be clearly defined, flat, and pure, free from the natural timbre of ordinary instruments:

> String, wind, and brass instruments, etc., must be replaced by a battery of hard objects. The material and the construction of the new instruments will be of the utmost importance. Thus the 'hollow' and the 'round' will make way for the 'plane' and the 'flat', for timbre depends on the shape and the material used. All this will require a great deal of research. When it comes to the production of sound, there will be a preference for electricity, and magnetic and mechanical devices, for they come closest to excluding the intervention of the individual.[69]

Mondrian's hopes and expectations with respect to music as outlined in these 1920 texts were partially fulfilled by the musical experiments of the Futurist painter-composer Luigi Russolo. We may assume that Mondrian had heard or read of Russolo before, and was acquainted with the Futurists' interest in music. The very first musical manifesto launched by the Futurists, dating from 1910, was the work of Balilla Pratella, and this was followed in 1913 by Russolo's more fundamental text 'Arterumori'. But, as always, sensory experience was more important to Mondrian than theory. His introduction to Futurist music itself did not come until June 1921, when he attended a concert at the Théatre des Champs-Elysées in Paris, where Russolo demonstrated his sound machines – *intonarumori* or *bruiteurs* (illus. 120). This immediately prompted Mondrian to write several articles devoted entirely to music. In August and September 1921 *De Stijl* published 'The "bruiteurs futuristes italiens" and the New in Music'.[70] In January and February 1922 an extensive follow-up article appeared in the same journal.[71] Both pieces were also published in 1922 in the magazine *La Vie des lettres et des arts*, translated into French by Mondrian and his friend Ritsema van Eck.

Mondrian's evaluation of Russolo's *bruiteurs* was at once enthusiastic and critical. Without a doubt, it represented a considerable step in the right direction: the concept of tone in music had been extended to include noise, and the machines produced a totally different timbre than traditional instruments. Indeed, this signified the end of the old music, just as photography had signified the end of the old painting. But in Mondrian's view the tones of Russolo's machines were still much too imitative: 'It is abundantly clear from names such as shriekers, buzzers, cracklers, squeaiers, gobblers, blowers, howlers, and croakers that the sound produced by the bruiteurs is suspiciously reminiscent of the natural reality of music.'[72] A second, no less important, objection was the fact that in the ordering and linking

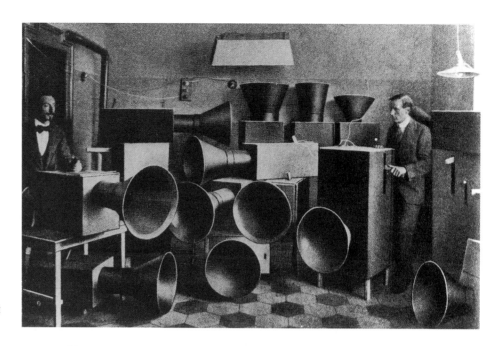

120
Luigi Russolo (*left*) and an assistant with 'bruiteurs', *c.* 1920.

of sounds Russolo had set about his task in the manner of a traditional composer. Mondrian quotes the Italian with undisguised disapproval: 'Luigi Russolo says: "Using my bruiteurs it is possible to execute diatonic and chromatic melodies, in all the tones of the scale and in all rhythms." In this way, the old has not been destroyed, and that is what is required by "the" new.'[73]

The halfway measures adopted by the Futurists when it came to the actual practice of music prompted Mondrian to set down on paper exactly what steps he thought ought to be taken to create a new kind of music. Guided by his own experiences in the creation of his Neo-Plastic painting, he seized every opportunity to stress the analogies between sound art and visual art. In order to realize Neo-Plasticism in music, it was of the utmost importance to develop instruments that were capable of producing a fixed and flat tone, with a constant wave-length and vibration, a tone that could also be broken off suddenly. Vibrato and aftertones were undesirable because they expressed 'undulation, and rounding'. Second, in the ordering of the arsenal of sounds, 'contrasts must be created which neutralize one another'. Certain composers – and here he does mention Schoenberg and his piano pieces – strive to accomplish this through a specific linking of sound and rest. But in Mondrian's view this was a remnant of traditional music: rest was a 'void', which 'the listener would immediately fill with his own individuality'. His alternative was the duality of 'sound (tone) and noise (non-tone) – both defined in their purest and most elemental form'.[74]

This rather cryptic wording was elaborated in the article that appeared in *De Stijl* in 1922. The piece was triggered at least in part by a response to his first article from Nelly van Moorsel (the future Mrs van Doesburg), a pianist who specialized in the modern repertory. On 23 December 1921 Mondrian wrote to van Doesburg: 'I was pleased with Nelly's letter from Vienna, in which she reiterated that it is the rest that is "the opposite" in music. This set me writing again, in an effort to show her wrong. I am not able to work out my N.P. [Neo-Plastic] music in full, as the instrument is not yet available, but I will set out the course it will take.' Mondrian begins his article with a long theoretical discussion in which

he airs his views on certain aspects of Neo-Plasticism, before embarking on a closer examination of the musical means to be employed, notably the concept of 'non-tone'. This non-tone must be made up of noise. This is an internalized sound and is contrasted with tone, which has 'colour' and constitutes the external element. Tone and non-tone are the equivalents of colour and non-colour in Neo-Plastic painting. There, too, the non-colour – white, grey, or black – is not a void, nor does it represent inertia or vagueness. Although this danger had not been entirely absent from his 1917 paintings, with their colour fields against a white background, from 1918 on the non-colour has been defined in the rectangular field, without losing any of its oppositional effect with respect to the colour.

Mondrian extends the analogy with painting by suggesting that Neo-Plastic music may require no more than three tones and three non-tones, although he leaves the way open for other solutions: 'The number will ultimately be determined in practice.'[75] Strangely enough, he does not motivate these views by calling on arguments from physical science or other 'given' laws, as he was wont to do in the case of the three primary colours. This decision to allow only three tones was apparently inspired by a desire to present Neo-Plastic music as clearly and simply as possible. Mondrian stresses that this does not mean that the new music would be monotonous. Everything depends on what the composer does with it, just as the success of a Neo-Plastic painting depends on the inspired intuition of the maker. The duration and volume of the tones and non-tones will vary, and 'by such means as allowing certain sounds to be heard again but in a new relationship to one another, or where appropriate, by repeating a particular image, etc., the limited number of sounds will be capable of portraying the richness and fullness of the Neo-Plastic painting, with its pure colours.'[76] Mondrian clearly believed that a musical composition that relied on such sober means for its effect could be as 'rich' as one of his own paintings.

At the close of this article Mondrian extended his speculations on Neo-Plastic music to include the venue where such music might best be performed and heard. This was to be far removed from the traditional site: 'not a theatre or church, but a bright and open space with a roof, which would meet all the new criteria of beauty and utility, matter and spirit'.[77] It was to be a space where people could come and go at will; the musical compositions, produced by an electrically operated 'musical machine' positioned in such a way that it was invisible to the spectators, could be repeated *ad infinitum*, with no loss of quality, like a film in a cinema. The surroundings would cater not only to the ear, but also to the eye: in appropriate spots throughout this space Neo-Plastic paintings could be exhibited, and if the necessary technical facilities could be arranged, might even be projected onto a wall. Continuing along these lines, Mondrian suggested the creation of a new kind of visual art that, like music, would manifest itself within a certain interval of time: 'A series of exclusively rectangular fields in colour and non-colour could be projected, one at a time, in the form of a colour slide.'[78]

It is interesting to note that Mondrian did not refer to film, although a few months earlier an issue of *De Stijl* had included an enthusiastic article by van Doesburg on the first abstract films, produced by Viking Eggeling and Hans Richter. Moreover, in Paris Mondrian was friendly with Leopold Survage, who had been experimenting along these same lines. But, as we know from the brief description given here, Mondrian was interested not in the visualization of motion

or processes of change, but in a succession of static images. What he was aiming for was a meditative, timeless experience of harmony, rather than a dynamic temporal experience. In this passage Mondrian somewhat uncharacteristically delves quite deeply in sketching the future meld of music, art and architecture, which could culminate in a kind of theatrical *Gesamtkunstwerk*. In general, he felt that all the arts would first have to undergo a thorough 'purge' before there could be any question of collaboration between artists from different disciplines. But he did not return to this subject, and his theories concerning Neo-Plastic music were never worked out. He made no effort to put his ideas on music into practice, as he had done for literature with his prose pieces. In all probability he did not have the basic knowledge of music that would have been necessary.

Unfortunately, there is no indication in his correspondence or other sources as to whether these theories were picked up by composer friends such as Paul Sanders, or the Dutchman Daniël Ruyneman, whom he knew in Paris during the 1920s. In any case, there is no sign of this in their work. The main problem was obviously that there were as yet no instruments for the execution of Neo-Plastic music. The development of suitable sound machines would involve a considerable outlay of time, effort and money, and Mondrian was apparently content to leave all that to 'the future'. There was, however, at that time a musical phenomenon that was of great interest to Mondrian, and from which he expected a good deal more than from the music of the concert-hall. I am of course referring to jazz, and modern dance music in general, of which Mondrian had quite a collection of gramophone records (illus. 121). This interest is even reflected in the titles of his paintings. While other early abstract artists made use of terms borrowed from classical music, christening their works *Nocturne*, *Scherzo* or *Symphony*, Mondrian used titles like *Foxtrot*. (He gave this name to two paintings done in 1929, but apparently he was toying with the idea as early as 1920.)[79] In fact, the last two paintings he ever did were entitled *Broadway Boogie Woogie* and *Victory Boogie Woogie*. His admiration for this genre is abundantly clear from his first music article, published in 1921, in which he claimed that 'modern dance music displays more inwardness than all the well-known psalms'.[80]

Mondrian had long been a keen dancer, and during the Great War he had taken lessons at a dancing school in Amsterdam, together with Willy Wentholt. The two also went dancing in Laren, at the Hamdorff Hotel, and at the home of the collector Sal Slijper. Following the move to Paris, he wrote to Willy about the latest developments on the dance front. In the autumn of 1919, for example, he describes the excellent private instruction which he enjoyed at Ritsema van Eck's apartment, lessons which his friend also paid for. The woman who taught them was 'no longer young, but the epitome of refinement. Not only in outward appearance – she has made up her ears with rouge, which is actually quite fetching – and movement, but in her whole person – very beautiful.' Here he learned the tango, as it was performed in Paris, 'much more graceful and refined than the way we were taught'. Two years later he sang the praises of the shimmy in another letter to Willy Wentholt: 'for me [it is] the most enjoyable dance there is. The music is a fast foxtrot, which you're probably familiar with. This is a real revelation.'[81] There was only one problem, which is touched on in his correspondence with other friends, and that was the fact that admission to dance-halls was expensive, at any rate for someone in his circumstances, while he was also expected to stand

Mondrian, with Gwen Lux, playing jazz records on the gramophone in his studio at 26 rue du Départ, Paris, in 1935.

his youthful dancing partners to refreshments.

Mondrian saw in ballroom dancing a reflection of the modern outlook on life, and that is why the dance so often appears in his theoretical writings. He was, however, quite critical of modern theatre dance: performers like Isadora Duncan and Gertrud Leistikov represented a traditional, individual and natural view of art. In the dances that were all the rage in the dance-halls he saw movement that was taut, angular, fast and full of contrasts: 'Take the shimmy, for example – where the contrasting duality is heel-toe.' It wasn't yet the real thing, but it was a big step in the right direction, and the same went for the musical accompaniment: 'Listening to a jazz band, we sometimes hear sounds that more or less clash with the "harmonious" tone in their timbre and touch, proof enough that it is possible to construct a "non-tone"'.[82]

Jazz was the great discovery that Mondrian made when he returned to Paris after the War. In fact, it was so new to him that the first time he used the word in a published text he spelt it wrong. In the instalment of 'Natural and Abstract

Reality' that appeared in *De Stijl* in June 1920, he has the modern painter Z say: 'I don't know much about classical music and violins and all that, but the music of the jas band appeals to me more. For one thing, the old harmony has been broken off. That's a beginning at least.'[83] From then on, references to jazz recur in many of his writings, notably in the article 'Jazz and the Neo-Plastic', published in December 1927 in the avant-garde journal *i10*.[84] The contents of the article do not entirely fulfil the promise of the title. It is a somewhat involved philosophical discussion, following from his earlier pieces, that focuses on the changing form and the unchanging core of all the constituent parts of culture, including beauty, morality and psychology. But once he has concretized his argument, Mondrian does indeed maintain that jazz and Neo-Plastic painting are at present the only manifestations of 'the new life', in the midst of a culture of form in decline. Both are 'highly revolutionary phenomena: they are destructively constructive. They do not destroy the actual content of form, but rather deepen form only in order to elevate it to a new order. They break the bonds of "form as individuality", in order to make possible a universal unity.'[85]

We may find it surprising that Mondrian should place jazz more or less on the same level as his own painting. No other art was accorded the same treatment, at any rate, not in their present state. It is significant that the article culminates in a eulogy on the bar, a place where people enjoy a drink, dance the charleston, and tap their feet to the rhythms of jazz. He even compares the bar to a cathedral, and the bottles on the bar to candles on an altar, which calls to mind his remark of a few years before to the effect that dance music has more depth than the Psalms. He saw the bar as the place where the new life was celebrated, and he accorded it a place beside his own studio as the environment in which the 'new Man' would feel at home. There is also another text by Mondrian that is of interest in this connection. It was written in 1931 for a questionnaire circulated among selected artists and architects on the idea of a new international museum for modern art. Mondrian welcomed the initiative, and in his reply he described a number of museum rooms that would show the evolution of modern art, from Naturalism to abstract art, culminating – naturally – in Neo-Plasticism, which appears as the end of painting. But that was not all. Such a museum would also illustrate the dissolution of art into real life:

To show that this end is only a beginning, it is essential that [. . .] the series of galleries be followed by a room in which painting and sculpture will be realized by the interior itself [. . .], demonstrating that what is lost for art is gained for life. This room could therefore be designed for use as a lecture room, a restaurant . . . as a bar with an American jazz band.[86]

The countless articles that Mondrian wrote from *c.* 1920 on were in effect intended to develop Neo-Plasticism into a theory that would have validity for all the arts. In some cases, as we have seen, he provided a detailed analysis of the steps that would have to be taken by the other arts in order to complete the purge of their own resources and achieve a well-balanced composition of contrasting elements, as had been done in painting. In other cases, he was less specific, which no doubt had to do with the level of his knowledge and affinity with a particular form of art. In general, he was content to leave the elaboration of his ideas to the specialist.

It is interesting that in his discussion of the other arts Mondrian exhibited a somewhat ambivalent attitude toward the role of the artists themselves. In keeping

with both Romanticism and Symbolism he saw the artist – in theory, at any rate – as a leader of society, at once king, priest and prophet. Not only does the true artist possess the gift of intuition, which enables him to pick up the 'signals' of the future development of humankind, he also has the capacity to shape those developments in a concrete sensory and experiential form. In practice, however, Mondrian was of the opinion that precisely because of their alliance with the tradition of their particular art form, their penchant for individual expression, and their 'artisticity', most artists did not display the desired openness towards new developments. It was for this reason that in writing on architecture he was inclined to think more highly of the work of engineers than that of architects. In the same way, he considered jazz more promising than classical music, and preferred amateur ballroom dancing to theatrical dance executed by professionals. In 'Natural and Abstract Reality' Mondrian allows the art-lover Y to contribute more to the discussion than the traditional painter X. In the final analysis, an individual's understanding of the new culture that Mondrian envisioned was more a question of attitude than an automatic attribute of the artist. And in his view, the proper attitude was still to be found only in a small elite, comprising himself, a few kindred artists and several non-artists capable of assessing his work at its true value.

4

Centres of Magnetism – Paris, London, New York: 1919–44

Mondrian's return to Paris in 1919 was the fulfilment of a dream that he had cherished throughout the War years. He arrived back in the third week of June, in time for Bastille Day on 14 July. France's recent victory meant that the celebrations were even more exuberant than usual. During the train journey through Belgium and Northern France, Mondrian could not have avoided seeing devastated cities and the war-ravaged countryside. And yet in the letters that have been preserved, to such intimate friends as van Doesburg, Slijper and Wentholt, there is not a single word about the damage or the celebrations marking the end of the conflict. Mondrian's attention appears to have been focused entirely on the future; his sole aim was to again carve out a place for himself in the city that was so dear to his heart. In certain respects, the situation was favourable. He found all his belongings as he had left them in 1914 – this was particularly important, as he had promised to sell Slijper, a faithful collector of his work, a large number of pre-war Cubist paintings. That was to be his 'nest-egg' on his return to Paris. He was able to move back into the studio in rue du Départ, which he had sub-let from Conrad Kickert and on which he had continued to pay rent during the War. The rent had not gone up, which greatly surprised him, as the cost of living had risen enormously.

During the first few months Mondrian did very little painting. He spent a great deal of time working on 'Natural and Abstract Reality', the first instalments of which had already appeared in *De Stijl*, and exploring the lay of the artistic land. He went to see old friends, among them the Mexican painter Diego Rivera, who had given up his Cubist style and to Mondrian's intense disappointment was now producing 'paintings that would be not out of place in the Louvre. Although very well done, they are anything but modern.'[1] He took pains to look up several artists who had been in contact with *De Stijl* from Paris, like the sculptor Alexander Archipenko and his girlfriend, Tour Donas. And he went to exhibitions. Writing to van Doesburg on 1 August, he mentioned that he had just been to see the Picasso exhibition at the Léonce Rosenberg gallery, where both old and new Cubist paintings were on display. He found the recent work less serious, less convincing (illus. 122). He had not yet seen the parallel exhibition of Picasso's work at the gallery of Léonce's brother, Paul, but he had heard that the work exhibited there was quite different, and included portraits in a realistic or classicist style: 'They say that he's doing different work now, not for the money, but because he wants to be versatile!! It's true: his work cannot possibly be convincing then, can it?' Nevertheless, there were encouraging signs that Cubism had survived the War years. There was the work of Picasso, and the existence of a specialized gallery like that of Léonce Rosenberg, where he had seen quite a good painting by Léger. 'In short, the new progresses, and we go on working, and waiting.'[2]

Within a few months, however, Mondrian's view of the situation in Paris was

122
Pablo Picasso, *The Italian Woman*, 1917, oil on canvas, 149.5 x 101.5. E. G. Bührle Collection, Zürich © DACS 1994.

somewhat less positive. Traditionalism proved to be very strong, even among those who had formerly been part of the avant-garde, such as Severini, who from 1917 on had contributed several articles to *De Stijl*, and had represented almost the only line of communication with Paris during the War. Now, like Picasso, he was doing quite heterogeneous work, both Cubist and classicist-realist (illus. 123). Mondrian found him 'a bit of this, and a bit of that'.[3] In general, there was a tendency to seek affiliation with the great and glorious past, preferably that of one's own country. Nationalism played a prominent role, not only during the War, but also in the years that followed. The French (as well as some of the foreign artists working in Paris), considered Fouquet, Poussin, the Le Nain brothers, Ingres, Corot and Courbet as exponents of that sense of order and moderation that they felt was characteristic of their nation.[4] The reopening of the Louvre in the course of 1919 provided an added stimulus to this historicist tendency. Mondrian took a look, but found he had little sympathy for the almost hysterical admiration of some of his fellow artists for the masters of the past: 'I also went to see the famous "atelier of Courbet" – Kickert goes there almost every day! He thinks it extraordinarily good!!!! Of course, it is good, but just as a Rembrandt is good. All in all, there is really nothing here.'[5] And on closer examination, Mondrian failed to be impressed by what he saw at the Léonce Rosenberg gallery, where he himself was trying to get his foot in the door. Even Léger's latest work was disappointing. The artists who had remained faithful to Cubism and its new disciples were closest 'to us', as he told van Doesburg, but Mondrian became more and more convinced that the art being produced in Paris lagged far behind that which he and the other De Stijl artists were doing. The War had led to stagnation and regression.[6]

123
Gino Severini, *Motherhood, 1916*, oil on canvas, 92 x 65. Museo dell'Academia Etrusca, Cortona.

Thus it seemed that there was considerable missionary work to be done on behalf of De Stijl. No doubt van Doesburg hoped that Mondrian, with his old contacts in the French capital, would make a good missionary, and Mondrian himself may have had certain illusions in that respect. But he was quick to realize that he did not possess the social skills demanded of a propagandist. On 6 September he confided to Willy Wentholt in a letter that he had found it difficult to accept that the solitary life he had led in the Netherlands was destined to be continued in Paris. 'Perhaps you can understand how much I initially wanted to be part of it all, in many different ways. But I just don't seem to be cut out for it.' And on 4 December he wrote 'I have thrown myself into my work and my writing ... because I had to. Out of pure necessity.' In a long letter to van Doesburg written that same day, his tone was resigned: 'I don't really see anyone any more, and I guess it's better that way, for the time being at least.' It took only two visits to Paris by van Doesburg – in February and March of 1920 and in March and April 1921, both lasting no more than a few weeks – to put De Stijl on the artistic map. He met dozens of Cubist, Futurist and Dada artists, magazine editors, gallery owners and other leading lights of the Paris art world. These meetings resulted in an exhibition of works by members of the Cubist group La Section d'Or in the Netherlands; the collaboration of numerous Paris artists and writers in *De Stijl*; Rosenberg's provisional commission for De Stijl artists to design a residence cum art gallery; and the promise of an exhibition in his own prestigious gallery. The extrovert van Doesburg, with his contagious enthusiasm, accomplished more in a few weeks than Mondrian had in two years.

It was in writing and painting that Mondrian was determined to establish himself, and his environment offered an abundance of new impulses for both activities. In the latest instalments of 'Natural and Abstract Reality' he gave vent to the same annoyance he had expressed in his letters at 'the terribly conventional way people cling to all that is old and established', although here his arguments were presented somewhat less vehemently. The traditional painter X becomes more doltish and conservative, while the art-lover Y gradually sees the error of his ways, and acknowledges the wisdom of the arguments put forward by the modern painter Z. Far more important, however, was the stimulus that the environment gave to Mondrian's painting, which he took up again with renewed energy and enthusiasm during the summer of 1919. In his letters Mondrian himself attributed the momentous changes his work underwent in the next few months to the influence of his environment.

If we compare the last paintings Mondrian did in the Netherlands, *Checkerboard, Light Colours* and *Checkerboard, Dark Colours* (illus. 95 and 96), with the works produced soon after in Paris, the first thing that strikes us is the contrast in atmosphere. As I have argued, the *Checkerboard* paintings reconstruct a starry sky and a cloudy sky seen by day. The muted and evenly distributed colour, the facture and the horizontal format combine to evoke a mood quite in keeping with the rural area around the Dutch village of Laren, where the two works originated. In the paintings that followed, the colours suddenly take on heightened clarity; the distribution of colour is richer in contrast and the lines are more pronounced, while the format is square or vertical. Even though they are not abstracted renderings of specific locations, as were the Paris townscapes of 1913–14 painted in Cubist style, these works seem to echo Mondrian's excitement at seeing Paris again, with its hectic traffic, tall buildings, facades covered with colourful posters, and electric signs against the night sky. They are synthetic 'portraits' of the metropolis.

On another level the environment was also of crucial importance. In November 1919 Mondrian moved from the studio in rue du Départ to the one at 5 rue de Coulmiers, which was discussed in the previous chapter. 'I am – I believe – happy with the change', he told van Doesburg:

The old studio was gloomy, no matter what I did to brighten it up. Kickert had it filled with antique furniture – you remember, the man from the moderne K.K.! [Modern Kunst Kring], which seemed to fit the general cheerlessness. People like that have no gravity of their own, which is probably why they are partial to a – would be – grave environment![7]

The new studio was lighter and more pleasant, thanks to the extra daylight from above, and Mondrian was free to furnish it according to his own insights. Within a few weeks, he had transformed it into a provisional Neo-Plastic interior. This transformation had a highly invigorating effect on his painting, as he confided to a number of his correspondents in the Netherlands.

The emphasis that Mondrian placed on the importance of the environment, in both the narrow and the wider sense, was not simply the customary glorification of all that was modern, in which avant-garde artists since Baudelaire had indulged. It was closely linked to his own vision of the evolution of human culture, in which the city created by man represented a higher stage of development than fickle nature.[8] As we saw in chapter One during the discussion of the work dating from his first Paris period, Mondrian was highly susceptible to the 'psyche' of a city and its buildings; he probably perceived the metropolis, in the words of Leadbeater,

as a 'centre du magnétisme'. Now that he had once more nestled into conducive surroundings, his paintings were inevitably different from those he had done in the Netherlands, different and on a more exalted plane. As we shall see, Mondrian did not distance himself from his old articles of faith; on the contrary, his Neo-Plastic work, which came to full fruition in Paris, may be seen as the ripe fruit of his theosophical thinking.

Compositions 1919–21

'I am searching for the proper harmony of rhythm and unchanging proportion, as I wrote in the article. And I cannot tell you how difficult it is!' This was the lament voiced in a letter to van Doesburg, written on 16 September 1919. Ten days before, Mondrian had penned a somewhat belated response to van Doesburg's fundamental criticism of the domination of the regular grid in the last paintings done in the Netherlands, the diamond-shape canvases and the two *Checkerboard* paintings. Seeing the reproduction of the diamond-shape *Composition with Planes in Ochre and Grey* in the August issue of *De Stijl*, Mondrian was forced to admit that there was indeed a strong element of repetition, and very little evidence of the contrasts he had propagated in his theory. In his new work, he strived to correct these shortcomings.[9]

Mondrian's first Paris paintings had been slowly incubating. Started in the summer of 1919, they were not completed until the first half of 1920. There were about five of them, all but one square, and quite large – roughly 100 × 100 cm. Three of these new works were presented to the public at the Section d'Or exhibition that opened on 20 June 1920 in Rotterdam, and was later presented in other Dutch cities. In a sense, Mondrian was reverting to the compositions done early in 1918, like the one in the Max Bill collection (illus. 80), while at the same time endeavouring to retain certain structural qualities that characterized the paintings with a regular grid from 1918–19. In the paintings made in Paris in 1919–20, such as *Composition with Red, Yellow, Blue and Black* (illus. 124), which was probably the first of the series, the lines no longer form a perfectly regular grid, so that the planes are of unequal size. This alleviates somewhat the repetitive effect. Moreover, the compositional image is much clearer, perhaps because the planes are quite large and virtually all the lines extend across the whole surface, while in the Max Bill painting and the majority of the works with a regular grid, the planes were small and the lines often truncated and staggered, which gave the works a slightly unsettled look. Finally, the colours are now stronger than before. Covering a larger area here, a smaller one there, and occasionally joining two adjacent planes, the colour adds extra weight to the contrastive effect created by their variable size and shape. In this way Mondrian was striving – by trial and error and cautiously as yet – to create rhythm within the 'unchanging proportion', as he put it. The advantage of this in comparison with previous work is easy to see. The new paintings seem to 'breathe', while compositionally, they are at once more lucid and more vigorous, less atmospheric, more contrastive and dynamic in the relationships of colour and form. These works are the manifestation of a new beginning in a new environment. And yet these five paintings represent a transitional phase in Mondrian's work. They contain countless problematic issues that Mondrian apparently felt had not yet been solved.

124
Composition with Red, Yellow, Blue and
Black, 1919, oil on canvas, 90 x 91.
Galleria Nazionale d'Arte Moderna,
Rome.

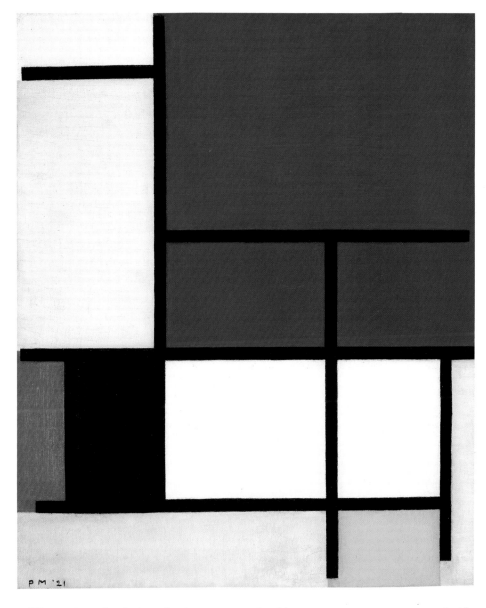

P M '21

125
Composition with Large Blue Plane,
1921, oil on canvas, 60.5 x 50. Dallas
Museum of Art Foundation of the
Arts.

The series of paintings he began around mid-1920 were an attempt to clarify
for himself a number of these issues. One was the problem of colour. For years
he had advocated the use of the primaries, the purest form of colour. In practice,
however, he had invariably tempered his reds, yellows and blues by adding white
or grey, or mixing them with other colours. (The only exception was the 1917
gouache: illus. 77.) He had parried van Doesburg's criticism with the curious
argument that he was adapting himself to his Dutch environment, and that the
public was not yet ready for pure, primary colour. In the early Paris works his
colours are stronger, although nowhere near as totally primary as those which van
der Leck had been using for years. The reds vary in intensity, while sometimes
inclining towards purple or bright orange; his yellows range from a greenish shade
to a warm yellow, while the blues tend towards ultramarine in one work and light
cobalt blue in another. We are reminded here of the description of the Neo-Plastic
atelier given by the painter Z in the trialogue, where there is also mention of
orange-red, light red and dark red. In the works painted from the middle of 1920
on, these wide variations in colour gradually disappeared, although he never went

so far as to completely standardize his reds, blues and yellows. Apparently he needed the freedom to make slight adjustments, in order to achieve the effect he envisioned for each colour within a particular work.

The distribution of the colours over the surface of the work was another object of lengthy contemplation. In the first Paris paintings (illus. 124 and 126), there are invariably several fields of red, yellow and blue, distributed more or less evenly over the surface. This is also the case in some of the works dating from the second half of 1920 and from 1921, although more and more often we see that each colour covers only one field or, in exceptional cases, several adjoining fields, as in *Composition with Large Blue Plane* (illus. 125). The colours are placed far apart and have an area of their own. This makes it more difficult to create an overall harmonic image than in the case of an even distribution of colour.

Not only colour, but also non-colour was crucial to the ultimate effect of the painting. As far back as 1917 Mondrian had decided that a uniform white background such as van der Leck used was not appropriate for his own work. He countered the danger of inertia inherent in such a background by introducing into his non-colour a distinct range of grey tones, reserving for them equally specific positions within the network of lines, as he did for his colours. This is illustrated by the *Composition* (1918) from the Bill collection, as well as the diamond-shape *Composition with Colour Planes* and *Checkerboard, Light Colours* dating from 1919 (illus. 89 and 96). In Paris he continued to work along these same lines. In the first group of paintings the non-colour occupies close to half the individual planes; here, however, there are not only a variety of grey tones but also, for the first time, black. Moreover, some of the greys are slightly tinted, through the addition of a minute quantity of pigment. Due to their size and grey values, these non-colour fields have a tendency to link up visually with the colour planes: black with blue, medium-grey with red, light grey with yellow. In the paintings that followed the contrast between colour and non-colour becomes gradually more pronounced: the non-colour now often covers over half the total surface area, separating the fields of colour. The grey tints have lightened and there is less contrast between them; they form a unity of their own, without, however, being reduced to a solid background. The greys are like a subtle counter-melody that serves to highlight the chords of the coloured planes, allowing the black to 'sing' itself free of both. Later, we will look at the role of the black in more detail.

And finally, during the initial years in Paris, the line underwent something of a metamorphosis. At first Mondrian continued to give the lines in his paintings varying degrees of emphasis, by making some of them a lighter or darker grey. He had used the same method in the Bill *Composition* and the two *Checkerboard* pictures. In *Composition with Red, Yellow and Blue* (illus. 126), dating from 1920, for example, the line between the two adjoining yellow fields has been painted over in a much lighter grey, and the other yellow fields are bounded on at least one side by a light grey line. Moreover, the lines are still quite thin, especially in relation to the format of the paintings. As a result, the lines appear to soften, receding discreetly behind the colour and non-colour planes. This effect is reinforced at the ends of the lines: where they approach the edges they are painted over in an extra light tint, so that they seem to fade. The lines in the paintings dating from the second half of 1920 are less discreet. Of a substantial width, and executed in a deep, shiny black, they cut grooves in the body of the painting.

However, it is unusual for a line to continue 'outside the painting': as a rule they are sliced off close to the edge. From now on, the complex of lines was to be given as much weight as the colour and non-colour planes, and plays an equally crucial role in shaping the identity of each painting.

These more or less parallel developments in Mondrian's painting technique, or rather radicalizations of his means of expression – for that is what they were – served to reinforce and highlight the special nature of colour, non-colour and line, which in the end had to be integrated within each painting. Mondrian undertook this difficult task with verve and dedication. From the middle of 1920 on, his production soared. By early 1921 he was able to report to van Doesburg that he had completed between twenty and thirty new paintings. He was perhaps using the term 'completed' somewhat loosely, as a number of those works were not actually finished until 1922, or even 1925. In various ways Mondrian used this quite sizeable group of works to test the potential of his radicalized and purified expressive means. It is possible to divide these works into different types of compositions – indeed, it has already been done by Robert Welsh, Cor Blok and Els Hoek, among others.[10] Without attempting to be exhaustive, I would like to take a closer look at three of these, illustrating them by means of a single example.

Composition with Red, Yellow and Blue (illus. 127), completed in 1920, is an excellent example of the first type, which I will call the 'all-over composition'. It is linked to the paintings of the first Paris group (illus. 124 and 126) to the extent that the picture plane is still filled more or less uniformly, through the placement of the lines as well as the distribution of the fields of colour and non-colour. Yellow and black (a matte black, which contrasts with the glossy black of the lines) appear twice, in non-adjoining fields. And yet the painting differs from its predecessors in the use of thick black lines – which are no longer the slightest bit vague or indefinable – and of colours that are almost pure primaries. The tension between line and colour has been intensified. Never before in Mondrian's work had there been a yellow as radiant as the one in this painting, thanks to the black lines surrounding it. Such tensions are difficult to control, and it was perhaps this experience that led Mondrian to transfer the colour to the periphery, allowing the non-colour to function as the stabilizing factor, not only in the centre but across the entire picture plane. This was to become a more or less standard feature in the paintings to come.

In the second type of painting the picture plane is transected by two dominant lines, one horizontal, the other vertical, which cross somewhere near the middle of the painting: the most pronounced example is the large, almost square *Composition with Red, Yellow and Blue* completed in 1921 (illus. 129). Exceptionally, the lighter sections of this work are blue rather than grey, almost as if Mondrian's hand had slipped while he was adding the pigment. None the less, it is a handsome work, one with considerable openness, not least because of the extremely large area of non-colour. The intersecting lines partition the picture plane into four, roughly equal, compartments, but each of these is subdivided in a different way, while at the bottom and to the right, the links between the compartments also differ. There is something in the composition of lines that is reminiscent of a swastika, which back in 1921 was free from any political connotations. It gives the painting a kind of rotational dynamics, but this is stabilized by the position of the single blue plane and the two small black planes.

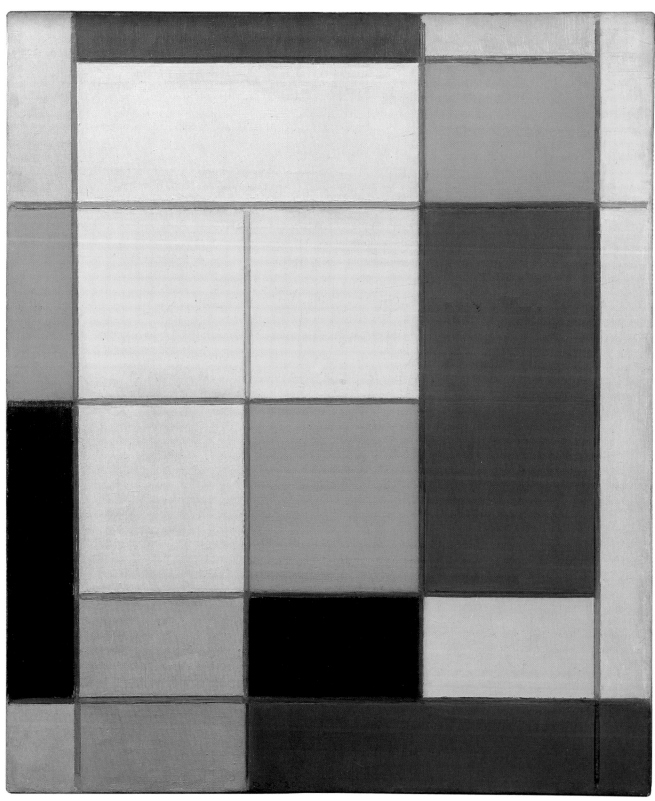

126
Composition with Red, Yellow and Blue,
1920, oil on canvas, 67 x 57.5.
Wilhelm-Hack-Museum,
Ludwigshafen.

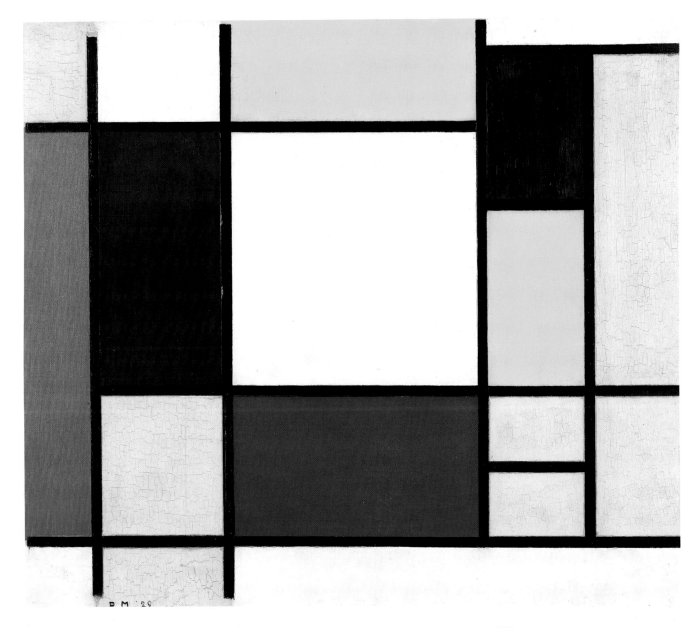

127
Composition with Red, Yellow and Blue, 1920, oil on canvas, 51.5 x 61. Stedelijk Museum, Amsterdam.

The third group of paintings that can be distinguished here has been christened by Els Hoek 'the peripheral type'. In these works the greater part of the picture plane is taken up by a square, or near-square, field in non-colour, which is bounded on three or four sides by lines and narrow elongated planes. There is an exciting interaction between the main form and those surrounding it, especially when the work itself is nearly square, like *Composition with Red, Yellow and Blue*, for example, completed in 1922 (illus. 130). In a composition such as this, the central field is not a void, for it is filled with the correlations, so to speak, between the lines and colours on the periphery. According to every rule of artistic logic, the elements stacked against the upper edge should make the painting top-heavy. But the elongated red plane at the base and the black plane that reinforces the line on the left together succeed in balancing the fragile structure. Another interesting feature of this painting is the fact that Mondrian has pushed two of the three colours almost beyond the edge of the picture plane, so that the area which they occupy is no wider than the black lines themselves. In several other works the white or

light grey areas at the edge of the picture plane are equally narrow. Thus the paintings dating from 1922 and thereafter illustrate how the simple distinction between line and plane has become more complicated. Just as black may also appear as a plane, colour or non-colour may become a line. While in this painting these phenomena are side effects, they foreshadow Mondrian's later technique of widening his lines until they become near-planes and executing them in colour.

The diamond-shape *Composition with Red, Yellow and Blue* of 1921 (illus. 131), now in Chicago, stands somewhat apart from the above types of work. While it displays two continuous lines that intersect, reinforced by an adjacent dark field (here black), it is completely different from the large, bluish *Composition* in The Hague (illus. 129), which served as the prototype of the 'cross type' paintings. That difference is due in part to the nature of the colour planes. In the large square painting these rotate along the periphery of the picture plane, while in the diamond-shape painting they point conspicuously in the direction of the centre. This was to be Mondrian's last diamond shape painting for the time being, a fact that may have been related to certain difficulties he had encountered with the edges. In the paintings made at this time, the black lines almost always stop short of the edge. This detail, which is not without significance, is often lost in reproduction, as a result of carelessness in trimming the edges. Mondrian, apparently, was afraid that if these lines were extended the effect might be too expansive, suggesting that his paintings were some kind of 'cut-outs' lifted from a larger work. In the diamond-shape painting these truncated lines, in combination with the diagonal edges of the picture plane, produce a somewhat strange effect. The whole complex of lines resembles a branch, or the root system of a tree that has somehow worked its way through the frame of the painting.

With this new surge in production in 1920–21 Mondrian was making a statement, taking a stand against the regressive tendencies he observed in the Paris art world and beyond. But the problem was that there was little or no response to the message that he launched in his own name, and on behalf of De Stijl. During his first two years back in Paris his work was exhibited only in the Netherlands and on one occasion in England, in an exhibition of Dutch painting. The Parisians had to visit his studio if they wished to see his paintings. The few people who did so, mainly fellow artists, were shocked by Mondrian's rigorous abstraction. In June 1920 he told van Doesburg that he had had a visit from Leopold Survage, a moderate Cubist painter, who found his newest paintings highly unharmonious, particularly his distribution of colour: 'When I explained to him that we were searching for a different harmony, he said that there was only one.' In the face of such criticism, from Survage but also from his De Stijl colleague Georges Vantongerloo, Mondrian again set to work, further developing his theories on what he called 'the new harmony', which he contrasted with the old, 'natural' harmony.[11] In the new order of things, contrasts were not neutralized and made harmless, but rather presented in a heightened form, and dissonances were permitted. In his paintings this principle was exercised in the eccentric placement of the pictural elements on the plane, and the rather extreme discrepancies in the weight of the colours.

One ray of sunlight in the almost total darkness that surrounded Mondrian in Paris was the response he received from Léonce Rosenberg at the beginning of 1920, the art dealer whose support he had hoped for ever since his arrival in Paris. In the course of that year they reached agreement on the publication of *Le Néo–*

Plasticisme, which appeared in January 1921 in Rosenberg's Editions de l'Effort Moderne. It was Mondrian's first theoretical text to appear in a language accessible to foreign readers. Moreover, Rosenberg offered to stage a one-man show at his gallery in April of that year; this scheme ultimately took the form of an entry consisting of five paintings for a group show. Mondrian's work was shown with that of Léger, Herbin and others under the title 'Maîtres du Cubisme' (illus. 128). It was a modest beginning, but it marked Mondrian's first public appearance in the Paris art world since his return.

Setbacks

Despite the fondness for the pleasures of the sophisticated French capital that imbued his new work, Mondrian remained true to his theosophical vision. Nor did he see anything contradictory in this, for he saw Theosophy as a doctrine uniquely in tune with modern life. This conviction was confirmed and reinforced by current developments in science and in art – primarily, of course, in his own art. Although Mondrian's later writings contain virtually no direct references to Theosophy and no explicit mention of its authors, such as Madame Blavatsky, they are no less steeped in theosophical doctrine than those dating from his years in the Netherlands. There was also the odd reference to Theosophy outside of his writings. For example, the Paris correspondent for the *Nieuwe Rotterdamsche Courant* who came to interview Mondrian on the occasion of his fiftieth birthday (7 March 1922), recounted how the painter had referred to *The Secret Doctrine*, Blavatsky's best-known book: 'The visitor recalls in this connection [a particular painting] that Mondrian mentioned in passing the "secret" doctrine which he had gradually made his own.'[12]

It is worth noting here that Léonce Rosenberg was also a theosophist, a fact not without importance for the relationship between Mondrian and his dealer. In

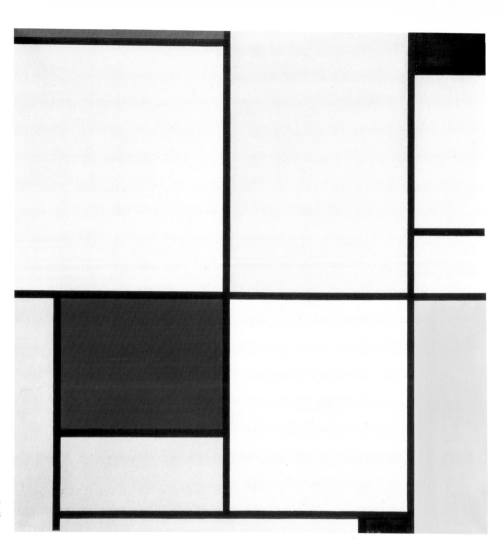

129
Composition with Red, Yellow and Blue,
1921, oil on canvas, 103 x 100. Haags
Gemeentemuseum, The Hague.

130
Composition with Red, Yellow and Blue,
1922, oil on canvas, 53 x 54.
Staatsgalerie, Stuttgart.

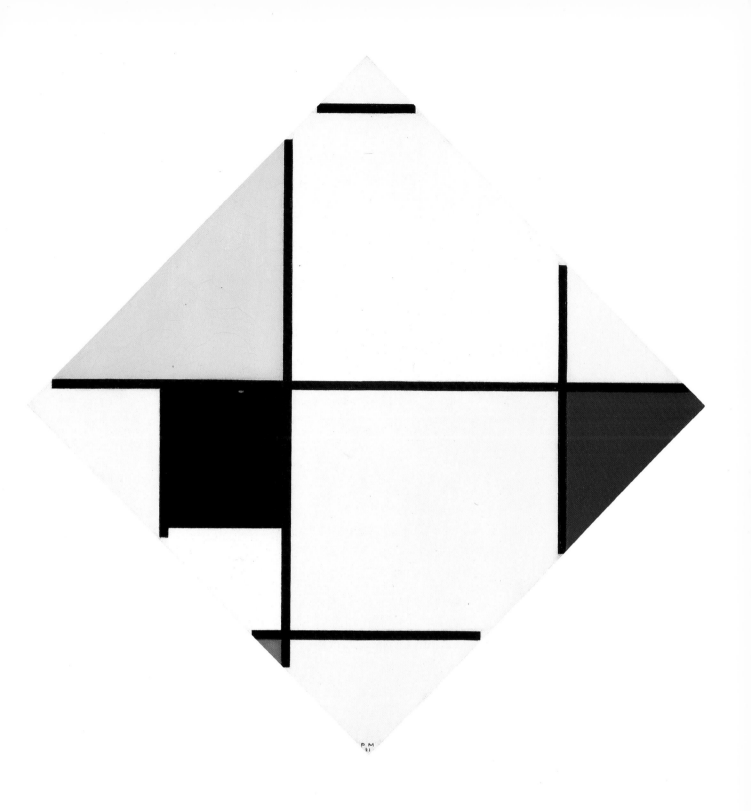

131
Composition with Red, Yellow and Blue,
1921, oil on canvas, diagonal 84.5.
Art Institute of Chicago.

an interview published in 1927 in *Feuilles Volantes*, Rosenberg confided that he found a release for his physical strength in boxing and fencing, 'just as my moral strength is expended in the defence of painting and Theosophy'.[13] The ethical and philosophical issues touched on in his writings on art (some of which were published in *De Stijl* in 1920–21), betray Rosenberg's theosophical background. And while Mondrian undoubtedly differed with him on more than one question, there was a basis for understanding between the two men. Like Mondrian, Rosenberg abhorred the domination of art by everything that was individual and particular, and maintained that art without a universal tenor was no more than entertainment. He saw in Cubism a renascence of the spiritual, a road leading to Knowledge, the domain of the true initiates, *les initiés*. This latter concept, although fairly common in everyday speech, here probably refers to *Les Grands Initiés* by the French theosophist Edouard Schuré, a book that Mondrian had also read with approval.[14] In fact, on the same page Rosenberg maintains that Moses, Pythagoras, Plato and Jesus were all inspired by ancient Egypt, an inspiration that will also 'illuminate the prophets of the future' – a phrasing that is directly culled from Schuré and Blavatsky.[15]

The relationship between Mondrian and Rosenberg, although obviously based on commercial considerations as well, provides circumstantial evidence for Mondrian's tenacious belief in the close connection between Theosophy and art. The clearest proof is to be found in the fact that in 1921 he sought the support of Rudolf Steiner, the former leader of the German section of the Theosophical Society, who left the society in 1913 to found Anthroposophy. Apparently, the break was no problem for Mondrian. When Steiner went on a lecture tour throughout the Netherlands in February and March of 1921 (followed a month later by a course in which he lectured on the visual arts), Mondrian sent him a copy of his recently published *Le Néo-Plasticisme*, together with a brief note (illus. 132):

Having read several of your books, I wonder if you could find the time to read my brochure Le Néo-Plasticisme, which I am enclosing. I believe that Neo-Plasticism is the art of the foreseeable future for all true anthroposophists and theosophists. Neo-Plasticism creates harmony through the equivalence of the two extremes: the universal and the individual. The former by *revelation*, the latter by *deduction*. Art gives visual expression to the evolution of life: the evolution of the spirit and – in the reverse direction – that of matter. It was impossible to bring about an equilibrium of relationships other than by destroying *the form*, and replacing it by a new, *universal* expressive means. I would be pleased to hear your opinion on this subject, if you would like to respond. Please forgive me for writing to you in French; my command of German is insufficient.[16]

This note to Steiner remained unanswered, as can be deduced from Mondrian's letter to van Doesburg written about a year later. Van Doesburg had apparently made a number of critical remarks about anthroposophical art and art theory, enclosing an illustration to support his criticism. In his reply, written on 7 February 1922, Mondrian did not mince his words:

As far as your remarks on the Steinerians are concerned, I couldn't agree more. And perhaps – I see in the illustration that it is so – this even goes for Steiner himself. Just like Schoenmakers and Bolland:[17] one-sided and opinionated. When Steiner was in Holland last summer [here Mondrian is mistaken about the time of the visit], I wrote him a letter and enclosed a copy of my brochure! He didn't even bother to reply! I'll teach them a lesson or two, but that can wait. It is the N.B. [Neo-Plasticism] that exemplifies theosophical art (in the true sense of the word). Those people who are now so fond of calling themselves theos. or anthroposophists are all half-baked. Steiner has written some good books, though (as long as he keeps away from art).

132
Letter from Mondrian to Rudolf Steiner, dated 25 February 1921.

The heated tone of the letter betrays the disappointment occasioned by yet another demonstration of indifference and lack of understanding on the part of a group to which he felt, in principle, such spiritual kinship, and now displayed by one of the leaders he most admired. (Among the small store of books Mondrian felt were worth keeping all his life was one by Steiner.)

In the early 1920s there were other disappointing experiences that sorely taxed Mondrian's sense of purpose with respect to his art and his theory. His material circumstances often left a great deal to be desired. In the beginning of 1920 Bremmer had already cancelled the monthly sum he was accustomed to send him in return for paintings, because he had no faith in the course on which Mondrian had embarked. The latter was so depressed that on 9 February 1920 he informed van Doesburg that he wanted to have just one more exhibition, after which he would give up painting. He was contemplating moving in with his friend Ritsema van Eck in the south of France, and trying to find some kind of agricultural work. Once he had cut himself off from the inspiring environment of Paris, he expected that 'I probably won't have any desire to continue work on my paintings'. The idea seems to have remained in the back of his mind in the following years, and occasionally crops up in his correspondence – 'Maybe I'd better just go pick olives down south' (letter to van Doesburg, 7 February 1922). The association with Rosenberg, which initially held such promise, did not provide the hoped-for solution to his financial problems. The only sale that resulted from the 1921 exhibition in the Rosenberg gallery involved a Dutch buyer: to Mondrian's surprise, this was Bremmer. After that, Rosenberg's own fortunes declined to such an extent that he was forced to auction off a large portion of his stock, including several works by Mondrian.[18] Mondrian himself also sold some work, mainly to old friends in the Netherlands, but such sales were few and far between. Moreover, the cost of living had soared, while he was now getting less for his work than before.

Driven by necessity, he resorted to a solution that had served him well in the past. In 1922 he began to concentrate on easily marketable work, largely in the style of his earlier years. In Laren he had painted variations on his early landscapes, as well as commissioned portraits. In Paris he also did the occasional portrait, but most of his work consisted of watercolours of flowers.[19] Over the years he must have done dozens of such works, which were bought for about twenty-five guilders apiece by Dutch friends. In these works Mondrian was harking back to his drawings and watercolours of flowers from around 1909 (illus. 30). But the Paris watercolours depicting lilies, roses, chrysanthemums and other species have a individuality all their own, and there is no danger of mistaking them for earlier work, despite the fact that most of them are undated. The palette is soft, even slightly sugary, the colours one might expect to find in an advertisement for perfume or toilet soap (illus. 133). These watercolours are now popular items among collectors. Against the background of the current reassessment of the modernist tradition in the art literature and the exhibition world, the Paris watercolours of flowers have been excessively upgraded to the level of serious works of art.[20] Compared with Mondrian's earlier flower pieces, however, most are fairly mediocre. What an artist thinks of his own work is not always a good measure of its true worth, but in this case I am inclined to agree with Mondrian. He considered the watercolours, born of necessity, to be a product of his skill, rather than his art. As if to stress the fact

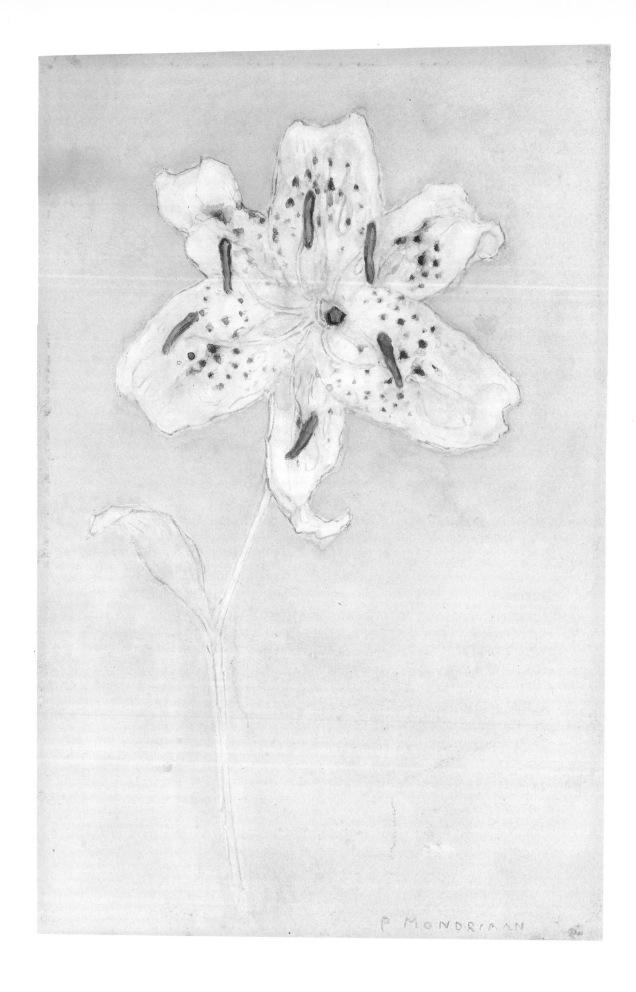

P. MONDRIAAN

184

that they were not representative of his current work, he was in the habit of signing them P. Mondriaan – with the double 'a' – whereas in his Paris years he otherwise always spelt Mondrian with just one.

No doubt the production of these potboilers kept him fairly busy. Moreover, during this period Mondrian wrote a number of articles on Neo-Plasticism and the manner in which it was to be realized in music and architecture: this, too, took up a great deal of his time, since writing did not come easily to him. But there must be other explanations for the fact that following on the fruitful years 1920–22, this period produced so little in the way of serious paintings. Only two works bear the date 1923, and we know of none at all from 1924. He appears to have found himself in an impasse; he felt that he had completed his task – from time to time this is even expressed outright in the correspondence with his more intimate friends – and was uncertain about which road he should now take.[21] The disappointing sales of his work, the lack of response from those he considered kindred spirits, and the problems and differences of opinion within De Stijl, including those between Mondrian and Oud discussed in chapter Three, probably contributed to this. It may also have been a question of age. Mondrian had turned fifty in 1922, and if his letters are anything to go by, he did not consider this fact, or the modest festivities it occasioned (an exhibition in Amsterdam and several interviews in Dutch newspapers), a cause for rejoicing. In short, he appears to have been in the throes of a kind of mid-life crisis.

The debate with van Doesburg

In the course of 1924 and 1925 some light began to appear at the end of the tunnel. This, at any rate, is the conclusion to be drawn from the fact that during this period his production of abstract paintings again reached a respectable level and continued to increase. He also redecorated his studio at this time, a project that kept him occupied for several months. As he confided to Oud, the renovation was not only useful but necessary, not least because so many people were now coming to see him in his studio, most of them from abroad.[22] The growing recognition in certain small but influential circles no doubt encouraged him to take up his work again with renewed energy and enthusiasm. From about the mid-1920s on, he was regularly characterized as one of the pioneers and leading lights of abstract art. This increased appreciation was not without its material rewards. In 1924 Alexander Dorner bought one of Mondrian's compositions of 1923 for his Landesmuseum in Hanover, which thereby became the first museum to actually purchase an abstract work by the artist. This painting and several other works by him were later awarded a place in the Kabinett der Abstrakten that El Lissitzky designed for the Landesmuseum (illus. 117). A second token of recognition in Germany came in 1925, when a selection of articles in translation appeared in the Bauhaus books series under the title *Die Neue Gestaltung* – the German for Neo-Plasticism.[23] In the same year Mondrian had a show at a gallery in Dresden. It was about this time that the collector Ida Bienert and her son Friedrich purchased some paintings from Mondrian, while somewhat later interest in his work was also evinced by collectors in Switzerland and the USA, among them Katherine Dreier. As a result of all these developments Mondrian was no longer dependent solely on the little circle of loyal, but far from wealthy, friends back in the Netherlands.

133 (opposite)
Blue Lily, c. 1924, watercolour and gouache on paper, 26.5 x 17.5. Private collection.

Even in the Paris art world, which a few years before had appeared so discouragingly reactionary, changes were afoot. The architecture exhibition of De Stijl held at Léonce Rosenberg's gallery in 1923 (and which had a sequel the following year in Nancy and again in Paris) served to focus attention on the Dutch avant-garde movement. And while there was no concensus regarding the overall quality of the exhibition, it did serve to point up the fact that Mondrian had been the founder of that radical movement. Due in part to his articles in various French journals, Mondrian was gradually becoming an artist to be reckoned with in the international art circles of Paris. As such, he featured in the big exhibition 'L'Art d'aujourd'hui' held in 1925, a veritable pageant of contemporary art.

This growing respect and appreciation was undoubtedly welcome, but Mondrian was spurred to greater activity above all by the current artistic discussion and the confrontation with views that differed from his own. In the early years of De Stijl he had also undergone the stimulating effect of confrontation, but in 1924–25 the confrontation was particularly acute. Within his own circle he now found himself in conflict with van Doesburg, whom he had always seen as his major – indeed, at times his only – friend and ally.

Van Doesburg spent the greater part of 1923 in Paris, in connection with preparations for the architecture exhibition of De Stijl at the Rosenberg gallery, and left the capital only for several brief journeys abroad. Towards the end of the year, when he was forced to leave his rented apartment-cum-studio, he and his girlfriend, Nelly, even stayed with Mondrian for several weeks, before finding new accommodation on the Avenue Schneider in the suburb of Clamart. This was the first time that the two leading lights of De Stijl had ever lived in the same city, and the first time that they were able to follow closely one another's work, and engage in informal exchanges on artistic matters. As long as that exchange had been limited to written correspondence, there was little evidence of opposing ideas, and if any difference did arise Mondrian was inclined to dismiss it as a point of detail. Van Doesburg was more aware of the fact that their views were growing further apart, and in correspondence with others he sometimes mentioned this. But, no doubt out of respect and for tactical reasons, he did not press the matter with Mondrian. Initially, their close association appeared to have only a positive, stimulating effect on them both, above all on their painting. Like Mondrian, van Doesburg had not executed any paintings to speak of for some time, putting all his effort into architectural projects and international activities designed to promote De Stijl. In the course of 1923 he again took up his brush, and once the architecture exhibition at Rosenberg's was over he was able to launch into painting again. Mondrian was swept along on the tide of his enthusiasm, judging by the letters from van Doesburg and Nelly to their friend Anthony Kok back in the Netherlands. In May 1924 Nelly wrote that van Doesburg was 'trying to work out the problems of Neo-Plasticism in painting, taking it a stage further. Greater simplicity and more expression. Mondrian has also started work on a new canvas.' Later in the month the correspondence even made mention of 'collaboration' between the two artists, although it is not clear just what this entailed.

It is difficult to determine the exact sequence of the paintings that van Doesburg made during this period. The titles and numbers of his *Compositions* and *Contra-Compositions* are quite confusing. There are also certain discrepancies between the dates of a study and the actual work: in some cases, we know that a considerable

time elapsed between design and execution. Mondrian's work presents us with similar problems. He often worked on his paintings for an extremely long time, and as long as they remained in his studio he would go back to them, sometimes years later, making both major and minor alterations. Thus it is entirely plausible that some of the works dated 1925 or 1926 were actually initiated in 1924, at the time of the intensive and mutually inspiring contact between him and van Doesburg. Evert van Straaten has recently approached this subject in a most enlightening fashion, and I have drawn most of the information in the next few pages from his findings.[24]

The estate of van Doesburg contains a small book, characterized by van Straaten as a kind of *liber veritatis*. It consists of some twenty gouaches in a miniature format, most of which correspond to paintings done between 1924 and 1927. The words 'not made' appear on certain pages. What is probably the earliest work, designated 'I', is a curious example (illus. 134). There is no known painting corresponding to the gouache, which is a diamond-shape, with a regular grid of horizontal, vertical and diagonal lines. This grid is exactly the same as that on which Mondrian based his four diamond-shape paintings dating from 1918–19. Van Doesburg must have been familiar with these works, as two of them had appeared in *De Stijl* (illus. 87 and 89), and the two others, consisting solely of lines (illus. 85 and 86) hung in Mondrian's Paris studio. On this grid van Doesburg imposed a rhythmic composition of lines enclosing planes that is likewise highly reminiscent of Mondrian's first diamond-shape paintings. Here, however, the lines are very thick and executed in jet black, which produces quite a marked visual change. An even greater difference lies in the fact that in van Doesburg's version the composition of lines is deliberately kept within the picture plane; only the corners of the planes touch the edges of the painting, while in other places lines are cut off perpendicularly or even set at an angle. The strange tension that the horizontal/vertical composition evokes within the diamond-shape painting, especially where the lines approach the edges of the work, cannot but have been familiar to van Doesburg from Mondrian's diamond-shape *Composition with Red, Yellow and Blue* done in 1921 (illus. 131), which in all probability was still in his atelier. In his own version, van Doesburg considerably heightened the tension through his use of such bold black lines.

Judging from other gouaches in the book, and paintings that we know were done, or at least started, in 1924, it would appear that van Doesburg also made use of other compositional schemas that Mondrian had developed in the preceding years, enlarging and accentuating them until they were almost like caricatures. He used this method on works with a rectangular as well as a diamond-shape format (illus. 135). Occasionally he allowed himself the liberty of juxtaposing planes of colour and non-colour, with no intervening black lines of demarcation (illus. 141), a practice he had employed for some of his previous work. As a result of these interventions, van Doesburg's paintings are much less visionary and inward-looking than Mondrian's work dating from this period, as well as more material and harsher in their use of colour and form contrasts. This effect was intensified by van Doesburg's direct, almost mechanical, handling of the paint.

Mondrian was not indifferent to van Doesburg's vigorous new approach to the Neo-Plastic idiom. As Nelly wrote to Kok on 6 August 1924, 'Having seen Does' latest work, he called his own next-to-last work "old-fashioned"!' It is quite prob-

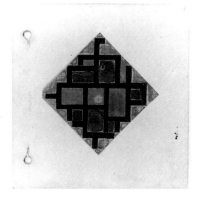

134
Theo van Doesburg, Sketch for diamond-shape composition, 1924, gouache on paper, 12 x 12. Rijksdienst Beeldende Kunst, The Hague.

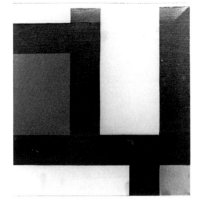

135
Theo van Doesburg, *Contra-Composition IV*, 1924, oil on canvas, 51.5 x 50.5. Private collection.

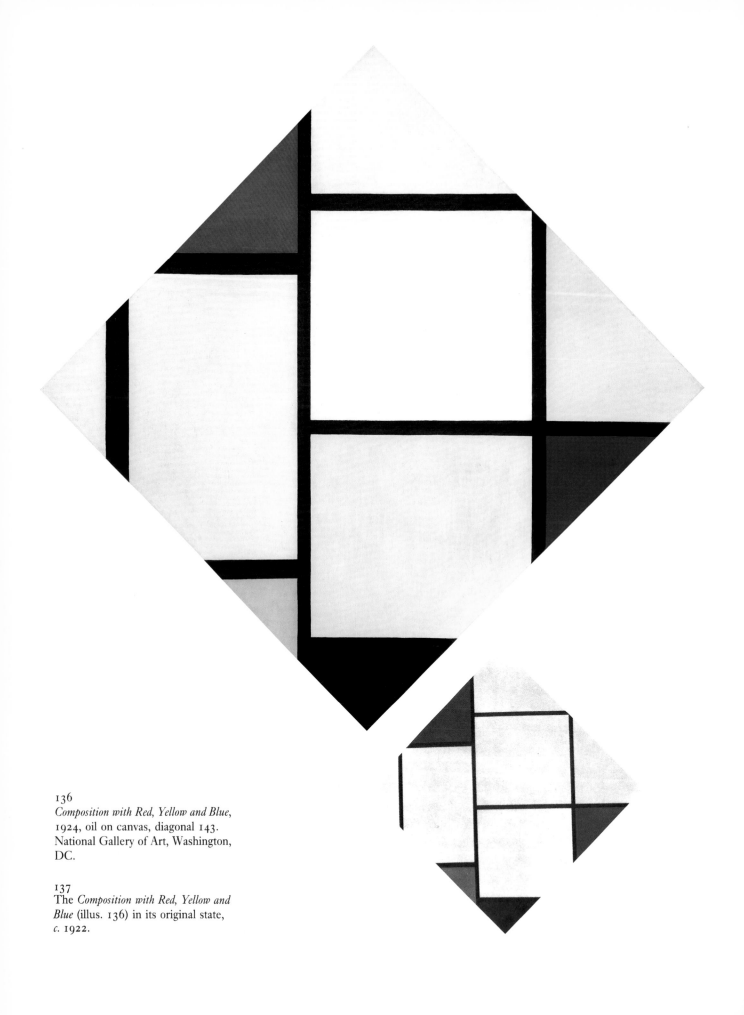

136
Composition with Red, Yellow and Blue,
1924, oil on canvas, diagonal 143.
National Gallery of Art, Washington,
DC.

137
The *Composition with Red, Yellow and
Blue* (illus. 136) in its original state,
c. 1922.

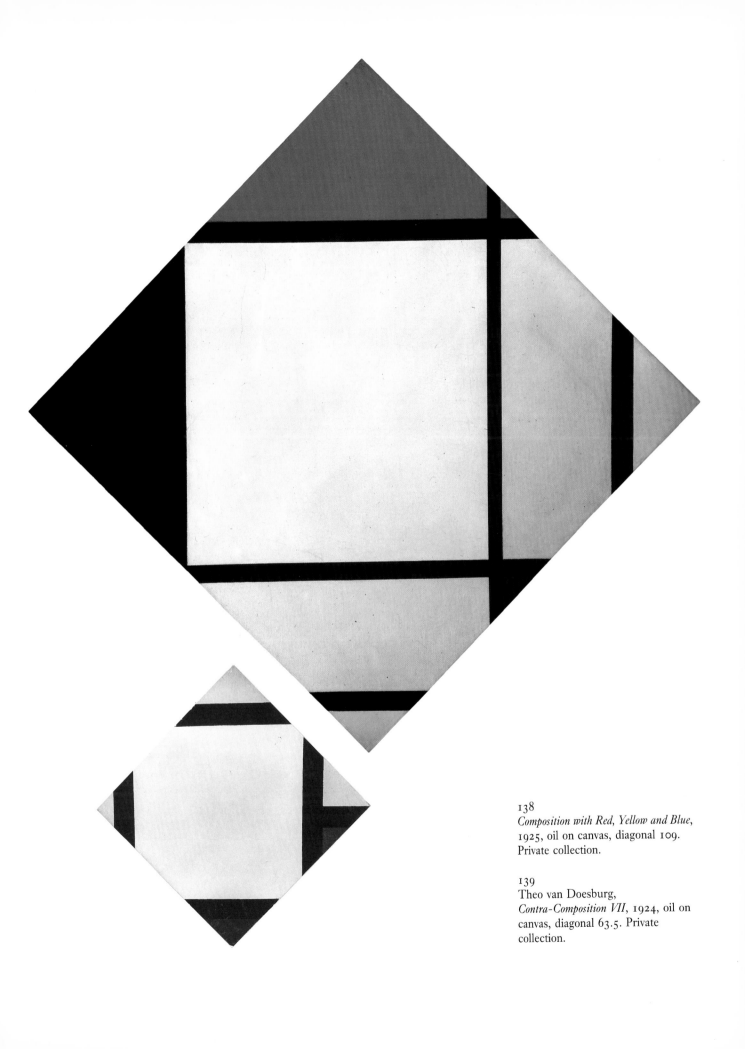

138
Composition with Red, Yellow and Blue,
1925, oil on canvas, diagonal 109.
Private collection.

139
Theo van Doesburg,
Contra-Composition VII, 1924, oil on
canvas, diagonal 63.5. Private
collection.

able, as van Straaten maintains, that Mondrian's first response to the challenge of van Doesburg's new work was embodied in two undated, diamond-shape paintings, generally reckoned to have been executed around 1925. In 1926, reproductions of both works accompanied an article by Georges Vantongerloo in which the composition was analysed in great detail; the original text itself is dated to July 1924, an indication that the paintings, if not yet completed, must then have been in an advanced stage.[25] One of them, *Composition with Red, Yellow and Blue* (illus. 136), is an interesting case in point.[26] It was probably started as far back as 1921 or 1922; compositionally, it is related to the work done in those years. There is a photograph showing the painting in an earlier state (illus. 137). During the revision, which probably took place in 1924, alterations were made in both the grey tones and the colour values, as we know from the technical analysis. There were, however, more fundamental changes, which are visible even in reproductions. The black lines have become almost twice as thick, and the short vertical line on the left almost three times as thick as in the original version.

The second diamond-shape composition (illus. 138) was probably begun in 1924 and finished sometime the following year.[27] This piece is still closer to van Doesburg's 1924 work. To begin with, the lines are thick and robust, particularly in relation to the format of the work (although still discreet compared with van Doesburg's 'beams'). Moreover, the impression created by the black triangle on the left and the large red triangle at the top is one of solidity and mass. And, while the composition, with its almost square white field in the centre, recalls Mondrian's own 'peripheral' paintings made in 1922 and thereafter (illus. 130), the effect in a diamond-shape work is quite different from that in an upright painting. In the present painting, the white square appears to be rotated 45° with respect to the diamond format, which creates an effect of virtual movement. Van Doesburg carried this principle even further in his *Contra-Composition VII*, painted in late 1924 (illus. 139): the white square is almost the same size as the picture plane, and its four corners seem to be straining to break through the perimeter of the painting.

As I mentioned, the origin of these paintings cannot be determined right down to the day, week or even month, and it is impossible to say who actually took the initiative in introducing this or that formal innovation. The most we can say is that there appears to have been a kind of two-way traffic between Mondrian and van Doesburg. Inspired by aspects of Mondrian's earlier work, van Doesburg took them a step further – or rather, several steps further. This spurred Mondrian, in turn, to take a fresh look at his own work, and to revise his approach.

Until the summer of 1924 the relationship between them appears to have been one of brotherly solidarity, at least if the letters to Kok are anything to judge by. Below this somewhat idyllic surface, however, there was a conflict brewing, one that was in part personal, and in part a matter of principle. Now that they lived in such close proximity to one another, and saw each other so often, Mondrian could not escape the conclusion that van Doesburg's flamboyant personality (and that of his girlfriend, Nelly) was ill-matched to his own introvert character and sober life-style. Not only that, but van Doesburg's habit of polarizing every artistic discussion he entered into was often a cause of friction with people whom Mondrian considered friends, such as the writer Til Brugman (illus. 140).[28] Van Doesburg demanded absolute solidarity, and this was something Mondrian was not

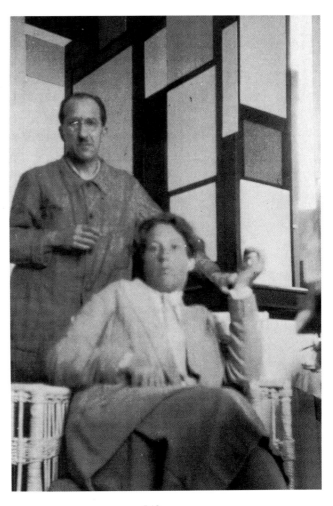

140
A photograph by Hannah Höch of
Mondrian and Til Brugman in
Mondrian's studio, 26 rue du
Départ, Paris, in 1927.

always able or willing to give. When it came to the company he chose, Mondrian
had his own particular preferences, and in some cases his own interests. The
situation finally came to a head. On 9 August 1924, apparently in response to an
exasperated letter from van Doesburg, Mondrian announced that he no longer
wished to receive him at home.

It has become clear that we are not suited to a daily contact with one another (the three of us,
I mean) [. . .]. As long as we corresponded with each other, it was all right. Let us agree to
write when we feel it is necessary, or perhaps send a card in order to arrange a meeting at the
[café] Dome.

Having mentioned a number of trivial incidents that served to underscore their
incompatibility, Mondrian also took this opportunity to stress certain disagreements
between them: 'But you speak of aesthetic matters as well. And much of what you
say is true.' Their views on art were at the heart of the matter, and one of the
major differences of opinion had to do with the significance of time and space in
relation to art. This bone of contention had come to the surface when van Does-
burg agreed to collaborate closely with the young architect van Eesteren, a collabor-
ation that culminated in the architectural models and drawings exhibited at the
Rosenberg gallery in late 1923. As we saw in chapter Three, Mondrian considered
such a co-operative effort premature, and was critical of the results. He himself
had a different, more contemplative vision of the application of Neo-Plasticism to
architecture and the interior; he saw the ideal experience of architecture as one

in which time and space were suspended. It was a source of grave concern to Mondrian that van Doesburg, and with him van Eesteren, continued to propagate his dynamic time–space views on architecture in his writings. Moreover, it must have been galling to Mondrian to find in his very own *De Stijl* (no. 6/7, 1924) a French-language manifesto by van Doesburg and van Eesteren in which they announced that 'painting which is separate from architectural construction (that is, easel painting) has no *raison d'être*'.[29] By the time this pronouncement appeared in print, van Doesburg – disarmingly inconsistent, as ever – was again blithely producing paintings. Mondrian must have taken the whole affair very badly. In his view painting was indeed destined to disappear in the future. It was, however, in today's world the only art form that was pure, and capable of providing an example to be followed. It is significant that the issue of *De Stijl* in which the manifesto by van Doesburg and van Eesteren appeared also contained Mondrian's last contribution to the journal, with the exception of an 'In Memoriam' for van Doesburg in 1932.[30]

Thus, in the summer of 1924, the problems between the two leading figures of De Stijl led to an estrangement, although not yet to a definitive break. They were in touch, but at a distance; and even this did not prevent new irritations from arising. From now on van Doesburg adopted an increasingly critical tone when discussing Mondrian's work, and his 'rigid' view of culture and the human spirit. Initially these sentiments were confined to remarks made in letters. On 11 November 1924, for example, he wrote to Oud that Mondrian 'is spiritually "in arrears", due to his theosophical restrictions'. In his later articles in *De Stijl* he made little effort to disguise the fact that he considered Neo-Plasticism *passé*.

As yet I have made no mention of the diagonal line in van Doesburg's work, which has traditionally been viewed as the decisive factor in the break between the two artists. As we have seen, however, there were other grounds for their falling out. In 1918–19 Mondrian had himself experimented with diagonally placed planes and diagonal lines (illus. 92 and 93), but had ultimately decided not to pursue these attempts. Van Doesburg incorporated diagonal compositions into several of the architectural designs he did in 1923 for the exhibition at the Rosenberg gallery, including one for the roof in the hall of a university building designed by van Eesteren (see background drawing in illus. 105). There is no evidence that Mondrian had any particular objections to such liberties. This is also confirmed by his article 'Neo-Plasticisme. De Woning – De Straat – De Stad' (Neo-Plasticism: Home – Street – City), which appeared in January 1927 in the first issue of *i10*. In a long passage, Mondrian examined for the first time the difference that had arisen between van Doesburg and himself with respect to their compositional practice: 'It may be noted that in Neo-Plastic art the crucial thing is the right angle, that is, the right-angle lines, and not whether the position of the lines is vertical or horizontal. [. . .] So it is possible to make very beautiful things while placing the lines in a diagonal position.'[31] Mondrian's objections were not directed towards van Doesburg's artistic practice, but rather his motivation – motivation 'after the fact', and one that was highly critical of Neo-Plasticism.

As far as we know, the paintings that van Doesburg undertook in 1924, at a time when the two men were seeing a great deal of one another, consisted exclusively of horizontal/vertical compositions. It was not *after* personal issues and artistic differences of opinion had driven a wedge between them that he began to make

compositions with diagonal lines. 'Make' is perhaps not the right term here, since in the very first of these works the effect was achieved by simply rotating diamond-shape paintings 45°, so that the composition was on the diagonal. Ironically, this was precisely the opposite of what Mondrian had done at the beginning of 1919. *Contra-Composition V*, painted in late 1924, which was originally intended as a diamond (illus. 141), was hung as a square, while the same fate awaited *Contra-Composition VI* of 1924–5. It was only in the course of 1925 that the first paintings and other works appeared that were conceived from the start as diagonal compositions. These included the design for a 'flower room' in the villa of the Comte de Noailles in Hyères, and a poster or catalogue cover for a New York exhibition. Perhaps the most intriguing of all these works is *Contra-Composition XIV*, dating from 1925 (illus. 142), because there a horizontal black bar serves literally as the base of the diagonal composition, almost as if to illustrate the views expressed in his writings, that his new work is at once a consequence of Neo-Plasticism and an adjustment to it.[32] In short, there is every reason to conclude that van Doesburg's use of diagonal lines in 1925 and the years to come was not the cause, but rather the effect – indeed the confirmation – of the rift between him and Mondrian.

The estrangement meant that the two men were no longer privy to the latest developments in one other's work, as they had been during the first half of 1924. In all probability they seldom if ever visited one another's studio, and for information had to rely on the occasional illustration in publications, and the one or two exhibitions that were mounted. The first time that van Doesburg exhibited his diagonal *Contra-Compositions* was when he entered four works at the 'L'Art d'aujourd'hui' show in Paris in late 1925, where Mondrian was also represented. From then on, illustrations regularly appeared in *De Stijl*, accompanied by extensive texts in which van Doesburg set out the theoretical framework on which this work was based. The dynamics of modern life, which was continually renewing itself, found its true expression in Elementarism, the term which he adopted for his own art.

Mondrian did not take this provocation lying down. He responded to van Does-

burg's increasingly public defection both in his writings and in his paintings. The creative rivalry that took shape in 1924 appears to have been fought out with a vengeance in the years that followed. It may be useful to examine more closely the work that Mondrian did during this period in relation to that of van Doesburg.

The first thing that strikes one is that 1925 saw the creation of Mondrian's first Neo-Plastic compositions in which the primary colours did not appear as a trio, but rather in pairs (blue and red, blue and yellow, but almost never red and yellow) or even on their own – although generally in combination with a black or a grey field. That year also saw the first of the non-colour compositions, done exclusively in white, grey and black (illus. 145, 146). This is clearly a reaction to paintings by van Doesburg completed in 1924 and 1925, in which he had done the same. A prime example of this latter type is the large, diamond-shape *Contra-Composition VIII* now in Chicago (illus. 143), which van Doesburg referred to in letters to friends, and in *De Stijl*, as the very last of his compositions based on horizontals and verticals, and thus the end of his 'classical-abstract period'.[33]

143
Theo van Doesburg,
Contra-Composition VIII, 1924, oil on canvas, diagonal 142.5. Art Institute of Chicago.

Another striking point here is the relatively large number of diamond-shape works that Mondrian painted at this time, as indeed did van Doesburg. The two works mentioned above (illus. 136, 138), which he was working on in 1924–5, were followed by three or four more. In addition, of the handful of sketches that have survived from the 1920s, the majority are related to precisely this group of diamond-shape paintings (illus. 144). Clearly Mondrian considered these paintings a major component of his *œuvre*, as indeed they were: not only because of their superior quality, but also because of their influence on his subsequent work, which extends well into the 1930s.

We have seen that the two diamond-shape paintings dating from 1924–5 grew out of a kind of interaction with the work that van Doesburg was doing at the time, and his shadow also hangs over the following works. The *Composition with Blue and Yellow* of 1925 (illus. 147), which once provided a welcome interval of rest in the dance studio of Gret Palucca, the daughter-in-law of the collector Ida Bienert,[34] and the *Composition* of 1926 (illus. 145), represent two new variations on the theme of a white square in the middle of a diamond, first used by van Doesburg for his *Contra-Composition VII* of 1924 (illus. 139). The square in the first of these paintings is not so much a square as an upright rectangle bordered on three sides in such a way that the fourth side is outside the picture plane, and is thus left to the imagination of the observer. In the case of the entirely black-and-white painting that now hangs in New York, the four sides of the square are indicated, but just as in the above-mentioned work by van Doesburg, they have been allowed to extend beyond the picture plane: three of the four corners pierce the edges of the painting, the one in the lower right most forcefully. This effectively destroys the closed shape of the square. The lines below and to the right allow for two different interpretations: they are at once the sides of the square and individual lines.

The most unusual of the diamond-shape paintings in this group is the *Composition with Blue*, which was completed in 1926 and now hangs in Philadelphia (illus. 148). It is a painting in which the opposition between horizontal and vertical is presented in a clear, simple and almost stark manner. I say 'almost' stark, for in the lower left-hand corner there is a small triangular field between the black lines that is painted in blue. Five years later he would repeat the composition, but

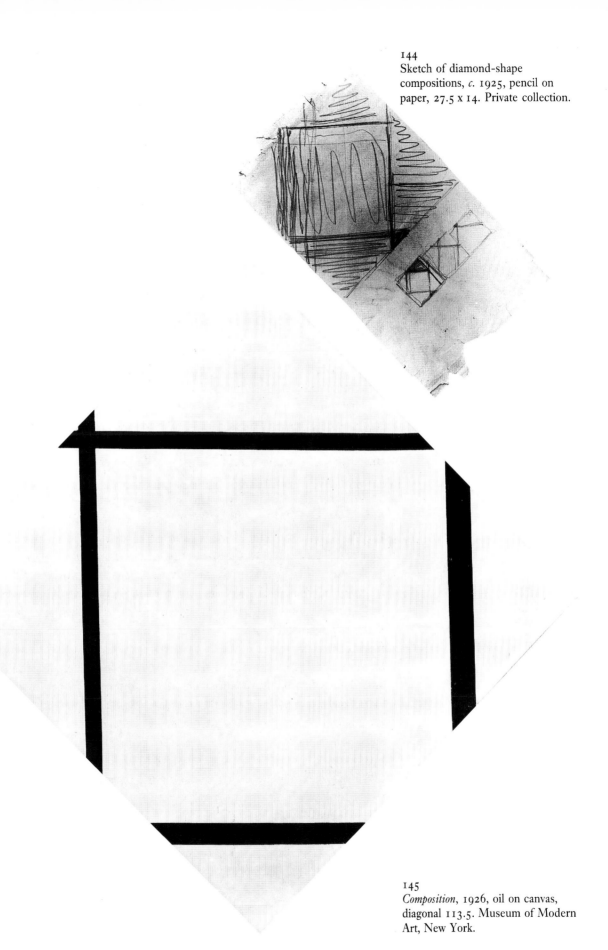

144
Sketch of diamond-shape
compositions, *c.* 1925, pencil on
paper, 27.5 x 14. Private collection.

145
Composition, 1926, oil on canvas,
diagonal 113.5. Museum of Modern
Art, New York.

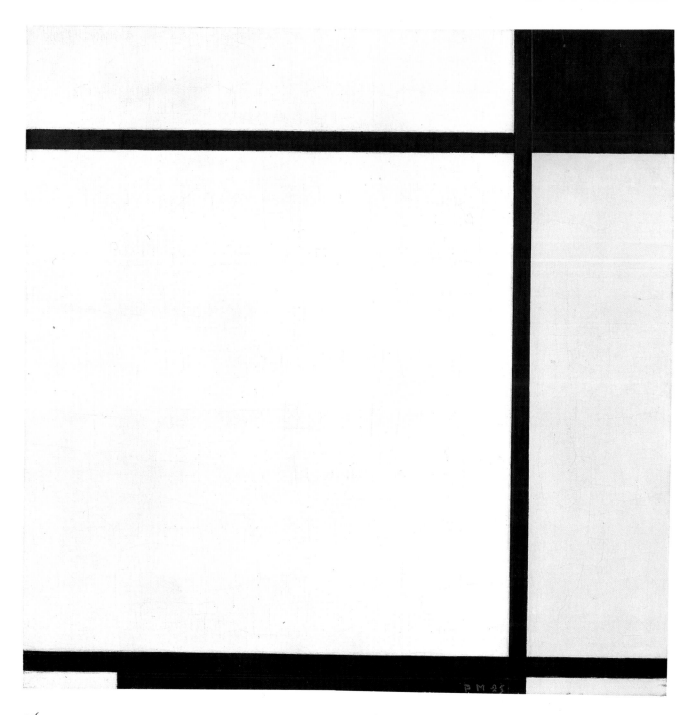

146
Composition with Grey and Black,
1925, oil on canvas, 50 x 50.
Kunstmuseum, Bern.

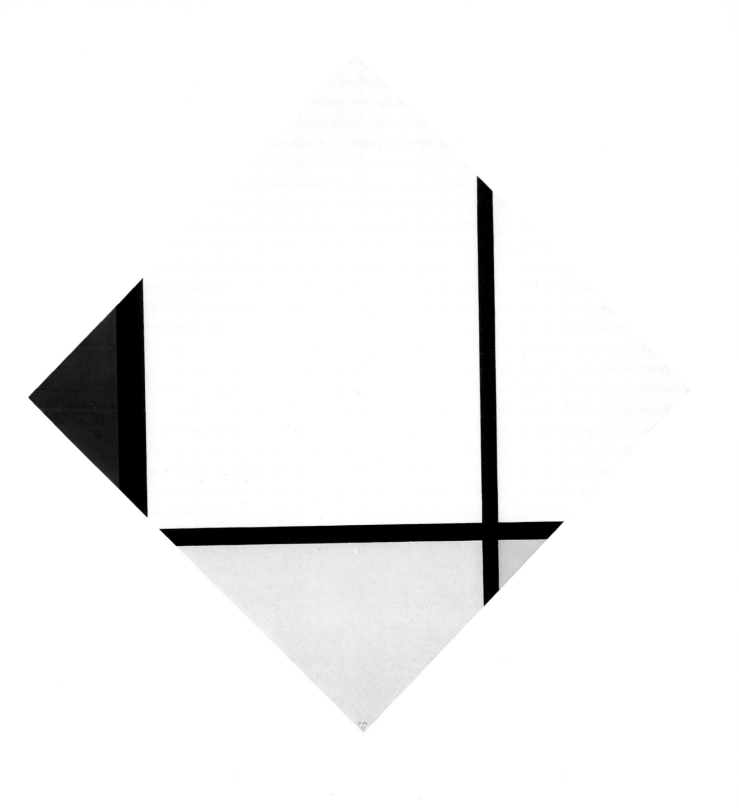

147
Composition with Blue and Yellow,
1925, oil on canvas, diagonal 112.
Kunsthaus, Zurich.

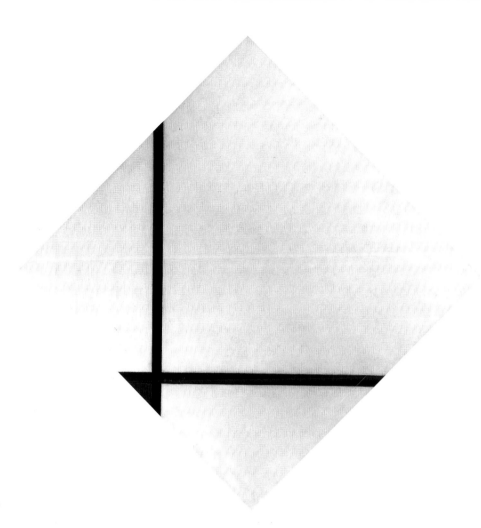

148
Composition with Blue, 1926, oil on
canvas, diagonal 84.5. Philadelphia
Museum of Art.

then without colour, in his *Composition with Two Lines*, now in Amsterdam (illus.
156). Both these works again point in the direction of van Doesburg, who in his
Contra-Composition VIII (illus. 143) had already visualized this simple opposition
of one horizontal and one vertical line, albeit in his own loud and boisterous style.

While van Doesburg was producing his Elementarist paintings, Mondrian's
diamond-shape paintings from 1925–6 continue to express his Neo-Plastic credo.
However, a new aspect was introduced that was clearly an answer to the new stand
taken by his comrade turned rival. It is as if Mondrian was trying to demonstrate
that compositions with horizontals and verticals could be just as dynamic as those
with diagonals, a view that he also promulgated in his writings. The diagonal sides
of the picture plane are in themselves a dynamic element, but what is now taking
place on that plane is even more interesting. The lines are no longer terminated
before they reach the edge, as in the 1921 painting (illus. 131); no longer do they
serve primarily to enclose areas in colour and non-colour. They have become
highly active elements in their own right, elements that are not so much *in* the
painting as hurtling through it, and expanding into the architectural environment
in which the painting is presented. Moreover, in the diamond-shape paintings
done in 1925–6 (illus. 145 147 and 148), in particular, the intersection of two
lines close to the middle of one side creates an implicit diagonal movement: the
lines are like the two blades of a pair of scissors that – when closed – form a line
running diagonally across the centre of the picture plane.[35]

This suggestion of diagonal movement is also to be found in many of Mondrian's 'ordinary' rectangular paintings from the mid-1920s onwards. In his *Composition with Grey and Black* dating from 1925 (illus. 146), for example, the ordering of the planes results in a diagonal that runs from the lower left to the black field at the upper right. An even stronger diagonal effect is obtained in a type of composition that Mondrian was quite partial to from about 1928 on, and which is exemplified by *Composition with Yellow*, painted in 1930 (illus. 149). We see the same scissors-like construction of lines positioned on the picture plane, but now with a diagonal effect from lower right to upper left. Thus the rivalry with van Doesburg provided Mondrian with a wealth of new impulses, impulses that would lead him to re-examine the work he had done up to then, and to explore the new possibilities offered by his visual language.

Mondrian's position around 1930

The foregoing might create the impression that around 1925 Mondrian's main pastime was shadow-boxing with his old comrade-in-arms from De Stijl. Nothing could be further from the truth. By that time he had so many contacts in the cosmopolitan Paris art world, and was acquainted with so many artists, collectors, writers and magazine editors abroad, that this compensated for the undeniably painful loss of *De Stijl* as a permanent podium on which to air his artistic views. There is a tone of calm acceptance, and faith in the future, in the text he published in July 1926 in *Cahiers d'art*. The article was a rebuttal of criticism by Christian Zervos of post-Cubist abstract art, in particular, Neo-Plasticism. Mondrian wrote: 'It is of small importance whether De Stijl still exists as "a group"; a new style was born, a new aesthetic created; it needs only to be understood – and cultivated.'[36] His efforts to win understanding for the new aesthetic were welcomed by journals such as *Bulletin de l'effort moderne*, *L'Architecture vivante* and *Vouloir* in France, and *i10* in the Netherlands, while in Germany, Switzerland and the countries of Eastern Europe both his new and his old texts were being published.

Mondrian's faith in the progress of Neo-Plasticism was also supported by the fact that traces of his influence were becoming increasingly evident in the work of others. Among the members of the old De Stijl, it was Vantongerloo who, after years in which he concentrated on sculpture and architecture alongside his writing, came to the fore in the late 1920s with paintings that displayed more than a suggestion of Mondrian's spare, centrifugal compositions. Admittedly, Vantongerloo's paintings were based on complicated mathematical calculations (which only he understood), in contrast to Mondrian's intuitive approach, and he did not confine himself to the primary colours. None the less, in its visual manifestation and underlying motivation, his work could be seen as a personal variation on Neo-Plasticism. In 1925–6 the Dutchman César Domela, a more recent member of the De Stijl group, was also doing paintings which bore a strong resemblance to Mondrian's, but he later followed in the wake of van Doesburg, basing his further compositions on the diagonal line.

Then there were several neophytes among the French artists. One of them was Felix del Marle, unfortunately an artist of quite mediocre talents, editor of the journal *Vouloir*, published in Lille. In 1926 he exchanged his Kupka pastiches for Mondrian pastiches, which even extended to the furnishing of his studio, but

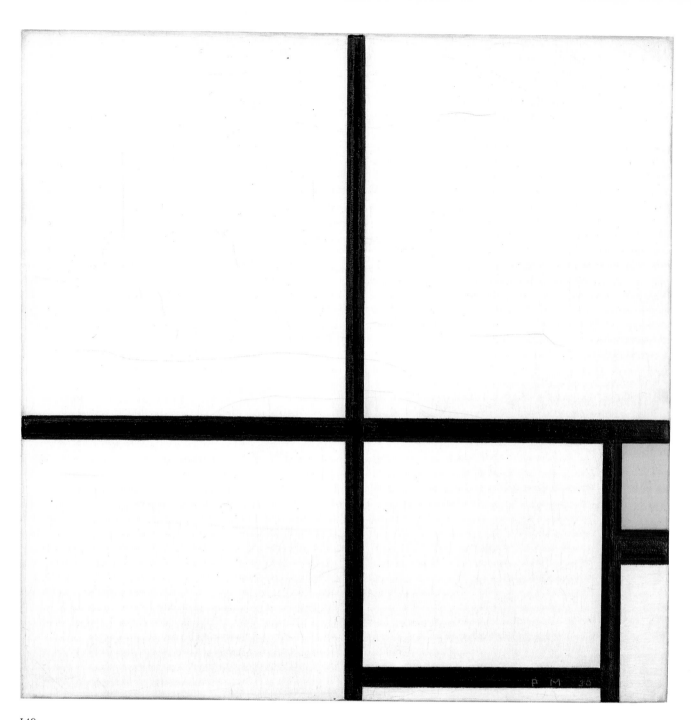

149
Composition with Yellow, 1930, oil on
canvas, 46 x 46.5. Kunstsammlung
Nordrhein-Westfalen, Düsseldorf.

these, in turn, were abandoned in 1930. A much more serious artist was the young Jean Gorin, who did his first Neo-Plastic paintings around the same time as del Marle, and then expanded his activities to include sculpture and architecture designs. His early work in this style, such as *Composition No. 10* (illus. 150) dating from 1926, display not only the influence of Mondrian's diamond-shape paintings from this same period (illus. 136 and 138), but also citations from van Doesburg, notably the very thick lines. Gorin's painting is a kind of amalgamation, executed in a fairly crude style. However, in the reliefs that he began doing in 1930 he added an accent of his own that captured Mondrian's interest, judging by his letters to Gorin. Mondrian considered the relief a step leading to the realization of Neo-Plasticism in the concrete physical world, as we saw in the discussion of his studio in chapter Three. We may assume that it was not mere politeness or tact that led him to say in a letter that Gorin was 'further' than he himself in his two-dimensional painting.[37] 'Further' was not a word that Mondrian often employed to describe the work of a colleague.

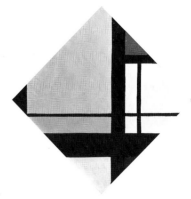

150
Jean Gorin, *Composition no. 10*, 1926, oil on cardboard, diagonal 70.5. Private collection.

The last of the disciples deserving of a mention here is the English painter Marlow Moss, who in 1930–31 became fascinated by Mondrian's work. Although there is no written evidence to that effect – none of their correspondence has survived – the fact that the artist in question was a woman must have been somewhat embarrassing for Mondrian. He had always held firm views on the place of women and female artists within the cosmic order of evolution, views that today would be seen as decidedly sexist. And yet, during the 1930s it was due in part to impulses emanating from the work of 'Miss Moss' that he was prompted to introduce into his paintings a number of major changes.

While his influence was most direct in the case of the above-mentioned artists, it also made itself felt, in an indirect and passing manner, among major Parisian masters, such as Léger, Joaquin Torrès-Garcia, Alexander Calder, and even Picasso. We are perhaps justified in seeing the rectilinear lattices enclosing organic, abstract forms and figures in some of Picasso's paintings from the late 1920s (illus. 151) as a playful reference to the compositions of the Dutchman.[38] And in a broader and more global sense, it would be true to say that Mondrian had an unmistakable, if indefinable, influence on Functionalist architecture, typography and the applied arts in the Netherlands, Germany, France and elsewhere. And yet it was not so much the dissemination of the Neo-Plastic idiom – which often became diluted in the process – to which he owed his burgeoning prestige, but rather it was the uncompromising art that he himself produced – an art that was greeted if not with passionate enthusiasm, then at least with great respect. Internationally, by 1930 Mondrian was being seen alongside Kandinsky as the major exponent of abstract art.

In the second half of the 1920s abstract art amassed a quite considerable following in Paris, in particular among the foreigners who were part of the artistic colony: Russians, Czechs, Hungarians, Swiss, Dutch and a group of Scandinavians centred around Léger.[39] However, they had very little leverage on the market, and were only really welcome in a few galleries and general Salons. The prestigious galleries were dominated by the true 'greats' like Matisse and Picasso and by the middle-of-the-road figurative art of the Ecole de Paris, while after 1925 Surrealism also rapidly gained ground. It was above all the popular success of the latter movement – under the brilliant leadership of André Breton – in presenting itself as a rival

151
Installation photograph of Picasso's
The Studio (1927–8), flanked by
paintings by Mondrian, Miró and
Hélion, at an exhibition of the
Renaissance Society of the
University of Chicago, 1935.

avant-garde movement, that spurred the abstract artists of various persuasions, who up until then had operated more or less individually, to undertake some kind of joint action.

In 1929 van Doesburg, with the help of the Uruguayan painter Torrès-Garcia, attempted to rally his fellow abstractionists. But due to a variety of complications, he could ultimately count on the support of only a few of the younger and less experienced artists, under the banner of the group L'Art Concret. The journal of the same name never got beyond the first issue, and the group itself did not survive the untimely death of van Doesburg in 1931. In the meantime, another group had been formed: in 1930 Torrès-Garcia and Michel Seuphor founded Cercle et Carré, which boasted a far more illustrious membership. Léger, Mondrian and Kandinsky were the central figures around whom several dozen artists and architects from various countries revolved, including Jean Arp and his wife Sophie Tæuber, Kurt Schwitters, Le Corbusier and Vantongerloo. After one exhibition and three issues of the magazine of the same name, Cercle et Carré was dissolved. However, this initiative and that of L'Art Concret paved the way for the new group Abstraction-Création, which was better organized and managed to survive from 1931 to 1936. It was larger and more broadly based than its predecessors, and included not only Arp but also a number of other artists whose abstractions featured organic and biomorphic shapes borrowed from Surrealism. The sharp contrasts between the two movements were gradually becoming blurred.

At first glance it may seem strange that Mondrian should become affiliated with such a large and disparate group, in the light of the views that he held – and aired in all his articles – concerning the true nature of modern painting, as exemplified in his own work. However, he now knew from experience that even within a group as small as De Stijl it had not been possible to arrive at a longlasting form of collaboration on the basis of common art-theoretical starting-points. In the late 1920s he had not given way to van Doesburg's renewed overtures, and in 1934 he similarly declined to take part in a planned exhibition that would have featured work by himself, César Domela, Jean Gorin, and the late van Doesburg. Rather than give the appearance of a unity of principles that he himself did not see, he preferred to exhibit his work at the shows of Cercle et Carré or Abstraction-

Création, whose criteria for membership were formulated in a fairly general way. In fact, the individuality of his own work was shown off to better advantage. And in his writings Mondrian made it clear, in his characteristically restrained manner, what he approved of and what he rejected in the artistic theories of his colleagues not only outside, but also inside these groups.

It is not true, as has often been claimed, that Mondrian totally rejected Surrealism. He may have felt that, within the cultural and political context of Paris, it was no bad thing that Cercle et Carré, and initially Abstraction-Création too, were intended to present a kind of united front against Surrealism. But he did not share the view of Michel Seuphor, for example, who claimed that Surrealism was 'a tiny piece of shit which each of us carries in his heart'.[40] In a long article that Mondrian wrote in 1930 for the second issue of the journal Cercle et Carré, he even spoke of 'the magnificent movements of modern art, Futurism, Cubism, Constructivism, Dadaism, Surrealism'. As it happened, however, his manuscript was drastically cut, and this line did not appear in the magazine article itself.[41] In any case, the year before he had taken part in the exhibition 'Abstrakte und Surrealistische Malerei und Plastik' held in Zürich, and we may assume that his participation was not based exclusively on commercial or opportunistic considerations. The confrontation with Surrealism led Mondrian to reconsider at length the similarities and differences between it and his own vision of art and life, and to formulate them with even more clarity and precision.

What undoubtedly did appeal to him was the fact that Surrealism – unlike Cubism and Fauvism, for example – was not a single-minded art movement, but rather an all-embracing view of life designed to revolutionize human existence and sweep away all the old structures. This utopian view was a dimension that Surrealism had in common with his own Neo-Plasticism. Surrealism, with its pronouncements on the primacy of the subconscious and its rejection of calculating reason, prompted Mondrian to again take up such questions as the source of knowledge and the nature of the creative process. Throughout the 1920s, starting with Le Néo-Plasticisme, his writings continued to stress the crucial importance of intuition as creative instrument, and its superiority to the intellect, and this notion received increasing emphasis, particularly in the articles dating from around 1930. It is almost as if Mondrian saw in the Surrealists an ally, the bond between them being their rejection of art based on mathematical laws, as in the work of Vantongerloo and, though in a somewhat different manner, in the latest work of van Doesburg.

The fact remains, however, that Mondrian's concept of intuition only partially coincides with psychic automatism, as advocated by the Surrealists. It has a personal connotation, coloured as it is by his theosophical view of life, and is linked to a 'detached', meditative state of mind. In the words of Rudolf Steiner, intuition follows on imagination and inspiration, representing the third and highest stage in Man's striving for inner knowledge.[42] This was probably a view shared by Mondrian, although he never ceased to stress that the artist must give outward expression to that intuition in the physical manifestation of the work of art.

Alongside the many positive aspects of Surrealism there were also negative features. These were most prominent in the figurative direction, which enjoyed so much popularity. Mondrian felt that there was a tendency for Surrealist artists to become preoccupied with the individual and the particular. He saw in the dream

world that they evoked no more than a 'rearrangement of nature and the events of life'. Thus they re-created the old reality, rather than succeeded in creating a new reality, as he wrote in 1936 in one of his most lucid pieces, 'Plastic Art and Pure Plastic Art'.[43] It is interesting to note that of all the artists who were part of the Surrealist movement, his greatest admiration was reserved for Arp, who was also associated with Cercle et Carré and Abstraction-Création. In a letter of 19 November 1931 to his friend the Swiss architect Alfred Roth, he wrote: 'I very much like Arp's things. I consider him the only "pure" artist after Neo-Plasticism.'[44] In later years Mondrian also spoke of his regard for Max Ernst and even for Jackson Pollock, the talented young artist who was making such a name for himself in Surrealist circles in New York.

Mondrian recognized not only the merits of Surrealism, but also the short-comings inherent in abstract art. He dealt with such negative aspects in the measured and well-considered tone that is so characteristic of his writings. As we have seen, he was critical of Vantongerloo's application of mathematical laws, as well as of the formalism of the Purists.[45] He saw both as fundamentally rooted in the nature of things, rather than as a free creation of human intuition. Mondrian also sensed in abstract art the very real danger represented by its decorative facets, which lent themselves so easily to the walls of buildings, and a wide variety of objects. Mondrian always maintained a certain critical distance between himself and fellow artists, even those with whom he associated and exhibited within the above-mentioned groups. And he remained equally critical of his own work, which was now undergoing significant changes.

Mondrian's paintings from around 1930

Between 1928 and 1932 Mondrian did at least twenty paintings with a square format, all of them based on the 'scissors-like' composition described above, with the powerful oblique dynamics created by the position of the lines and planes. Within this larger group there are two main types of work. They appear side by side in a handsome photograph of Mondrian's studio as it was *c.* 1929, showing a display of several paintings together with the scale model of the stage-set made some years previously (illus. 152). In the paintings on the floor to the left and right of the easel there is a large, almost square plane in the upper right that is bordered on two sides by highly eccentric lines. Between these lines and the nearby edges there are several small planes. The second type is exemplified by the small painting on the easel, on top of the larger painting. The composition is divided into four parts by two lines that meet almost in the centre; of these four, only the section in the lower right is further subdivided, forming almost a painting within a painting. Close to the intersection of the two main lines there is an almost square plane, which is the only one to be enclosed on all four sides by lines. Several small planes are grouped tightly along the edge of the painting.

Although there is a certain standardization to be seen in these paintings, they are far from uniform. There are subtle differences in the thickness of the lines and the proportions of the planes, and quite striking differences in the colour scheme employed. Both of the paintings standing on the floor have a white plane at the upper right and smaller colour fields placed against the edges, but there are two almost identical compositions dating from 1930 in which the large plane

152
Installation photograph of
Mondrian's studio, 26 rue du Départ,
Paris, 1929, including four paintings
and Mondrian's 1926 stage set for
Michel Seuphor's *L'Ephémère est
éternel*.

at the upper right is bright red; in fact, this colour covers almost half the total
surface area of the paintings (illus. 154). It is as if during this period Mondrian
was striving for extreme differences in expression, while remaining within the
same basic compositional form.

The trio red, yellow and blue had long represented colour reduced to its essence.
Mondrian did not attribute any individual symbolic value to these colours, at any
rate, not as far as we know. But he was not blind to the undeniable difference in
expressive effect, as we know from a letter dated of 7 September 1929 to Alfred
Roth, who wanted to buy one of his paintings: 'Let me know whether you prefer
blue and yellow, white and grey, or perhaps red, a bit of blue and yellow and
white and grey. The latter works with red in them are more "real", the others
more spiritual, more or less.'[46] Roth got what he requested, a painting containing
all three primary colours, but with a very dominant red (the painting that is illus.
154), a work that Mondrian apparently saw as 'more real', more earthy, than those
with little or no colour.

In these extremely prolific years Mondrian was not only exploring the possibilit-
ies for orchestrating colour. He was also devoting even more meticulous attention
to the technical execution of his paintings, and introducing certain alterations.

From the late 1920s on, most of his paintings no longer display any nuances in the non-colour planes. Gone are the various grey values, differing in tone and colour value; they have been replaced by a solid, or near solid, white that flows through the entire painting. Where the grey does appear, it is a clear pearly grey in a single field, as in *Composition with Grey and Red* from 1932 (illus. 155). Just as elsewhere in the case of the black fields, Mondrian has drawn the grey into the complex of colour relations, without entirely extinguishing its link with the non-colour.

There was a certain risk attached to this reduction of the non-colour to solid white. This might cause the paintings to break up into a foreground – the lines and colour planes – and a background, the white. Mondrian had wrestled with this dichotomy in 1917, at a time when his work was closely related to that of van der Leck (illus. 77 and 78). After some ten years' experience in working with his Neo-Plastic idiom, he was now better equipped to deal with the undesirable background effect that was liable to crop up. One of the devices he used to counteract this was to build up the white in multiple layers, which gave it more substance. The glossy black lines, on the other hand, are painted in a single thin layer – the structure of the canvas is still visible – so that they almost appear to have been countersunk into the white. Moreover, Mondrian varied the direction of his brush strokes. In some of the white fields the top layers have been done in a vertical direction, in others horizontally. Under good lighting conditions this is visible to the naked eye; the brush strokes catch the light in different ways, creating wonderfully subtle nuances in the white that are lost in reproduction.[47] The visual impression of the white also varies under the influence of the adjacent colour or black field. Thus a narrow strip of white bordered by black lines is just a shade brighter than the white of a large field. In this way Mondrian succeeded in enlivening and activating his non-colour; the effect is no less pronounced than before, when he tinted his whites and greys.

Another alteration that Mondrian decided on during this period concerned the lines. From now on, they always continue right out to the edge of the picture plane, or even beyond the edge and onto the side of the canvas, as do the coloured fields. Apparently Mondrian had ceased to worry that viewers might be inclined to see his paintings as arbitrary sections lifted from some infinitely large work. Their existence as independent aesthetic objects was evident, and he emphasized this by a new manner of framing his work. In 1920 he had begun to exhibit his paintings unframed (the sides of the canvas and the nails painted over in light grey), but it appeared that the edges were easily damaged. Since that time he had edged his canvases with narrow strips of wood painted white, which were set back from the painted surface of the canvas.[48] But now, in the late 1920s, he got into the habit of creating a kind of base for the work, made of wider strips, also painted white, on which the canvas, including the narrow strips, was mounted. The effect of this is that the painting is presented to the viewer in step-wise fashion, while the widened frame is sufficient to check the expansive drive of the lines (illus. 152).

All these experimental adjustments, no matter how minute and unimportant they might appear, bore fruit. Mondrian's paintings from the late 1920s have a stronger presence than the previous ones. The somewhat introvert images have become objects that, without imperiously demanding attention for their material

presence, none the less form a radiant force within their surroundings, their radiance directing itself forward, towards the viewer, but also to all sides across the wall on which they hang. It cannot have been easy for colleagues to have had their work placed next to his on the often crowded walls of an exhibition room. A painting by Mondrian demanded space, and it created that space around it, no matter what happened to be hanging next to it (illus. 153).[49]

The technique was one of the means he had at his disposal to minimize the difference between foreground and background. Another, no less important, means was the composition. It is as if Mondrian, when he sets about making the white as uniform as possible, is taking extra pains to devise compositions in which that white is delegated at least as important a role as the colour. By *c.* 1925 he had already produced several paintings done exclusively in the non-colours black, white and grey; these were followed around 1930 by several paintings in black and white only, which are fully as radical as the *Composition in Line* done in 1917 (illus. 75). Two of these are diamond-shape and form a fairly close link with the earlier diamond-shape paintings discussed above. *Composition with Two Lines* (illus. 156), for instance, echoes the constellation of lines in *Composition with Blue* (illus. 148), but here all colour has been deleted, and the statement lies in the stark opposition of horizontal and vertical, presented in the expansive and dynamic diamond format. The lines, however, are never dominant with respect to the white, and in that sense, the painting could equally well have been called a 'composition with white planes'.

Two other paintings in black and white dating from 1930 are in the ordinary rectangular format and display exactly the same composition of two intersecting lines, to which a single short horizontal line has been added (illus. 157), the only difference being the proportions of the planes and of the canvases themselves. This composition is in fact a somewhat simplified version of that of the two paintings which appear to the left and right in the photograph of the studio (illus. 152), but then turned 180°. Perhaps Mondrian started the black and white paintings in that position, and only altered the direction in the course of the work. In any case, thanks to the present position and the exclusion of all colour, they are totally new paintings, which display the meticulous care that has been taken in determining the exact width of each separate black line. The composition is now exactly as it should be. Turned upside down, it would simply cease to 'work'.

Although it is impossible to isolate the line from the other constituents of the

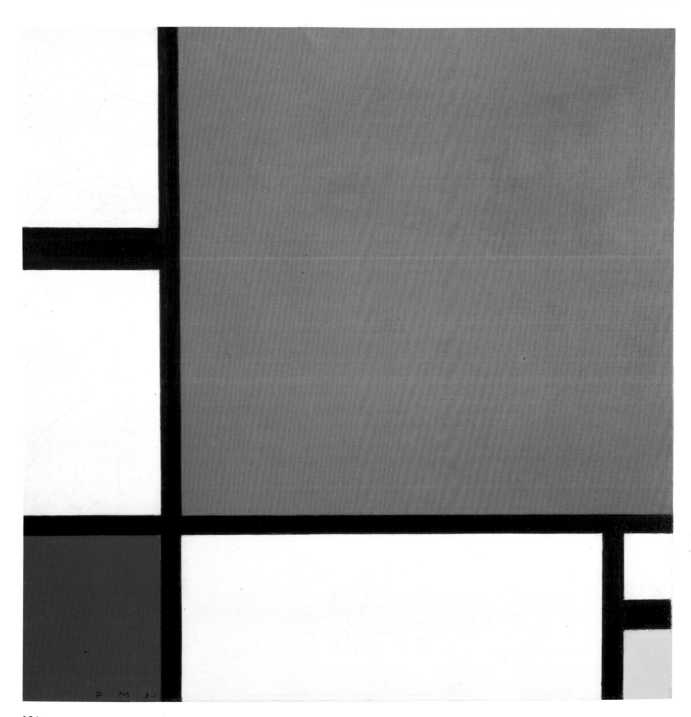

154
Composition with Red, Yellow and Blue,
1930, oil on canvas, 45 x 45.
Kunsthaus, Zurich.

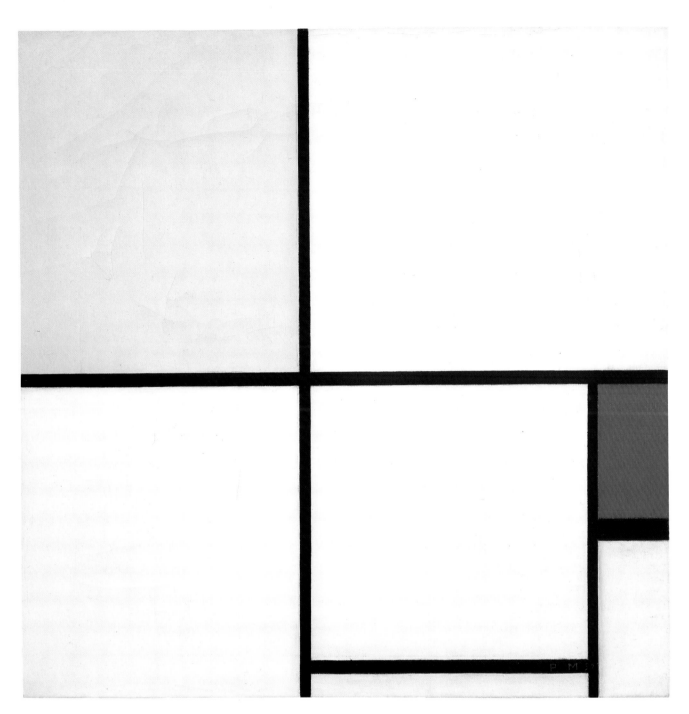

155
Composition with Grey and Red, 1932,
oil on canvas, 50 x 50. Private
collection.

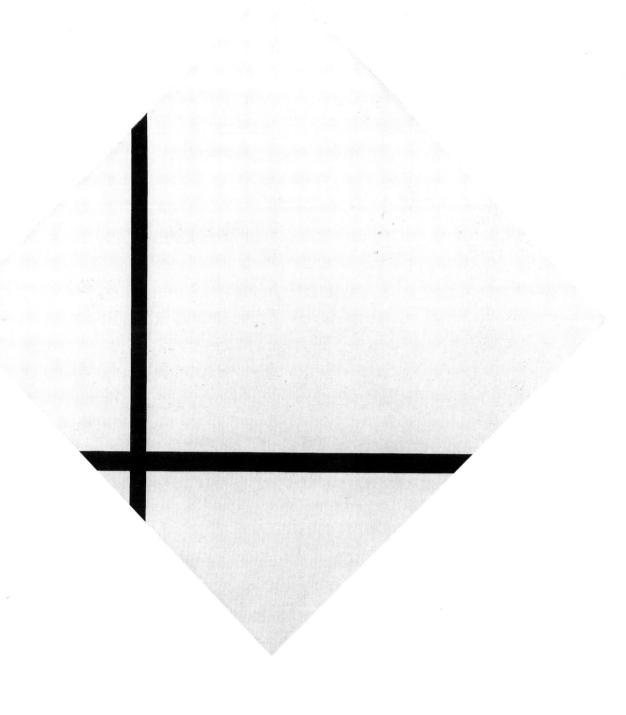

156
Composition with Two Lines, 1931, oil
on canvas, diagonal 114. Stedelijk
Museum, Amsterdam.

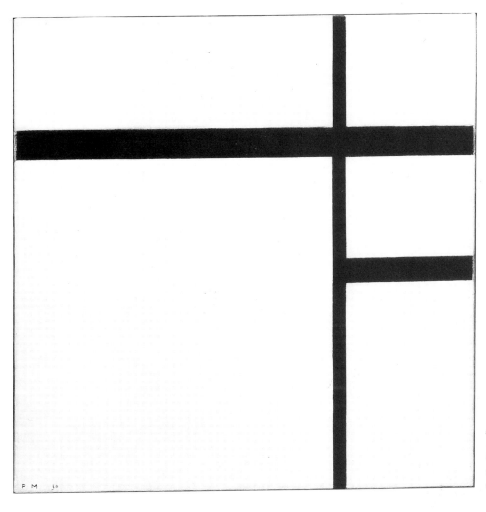

157
Composition with Black Lines, 1930,
oil on canvas, 50.5 x 50.5. Stedelijk
van Abbe Museum, Eindhoven.

composition, it will be clear that from about 1930 on this was a special object of concentration. The lines often play a decisive role in the innovations that Mondrian introduced into his work in the last fifteen years of his life. *Composition with Yellow Lines*, completed in 1933 (illus. 158), was that same year donated to the Gemeentemuseum in The Hague by a group of friends and admirers. It was a somewhat belated gesture to commemorate Mondrian's sixtieth birthday the previous year. Mondrian did not make the work especially for the occasion, but it is without doubt a very special painting. While it has many links to earlier work, it is at the same time a radical restatement of his artistic strategy. As regards composition, it is closest to the two paintings done in 1926 (illus. 145) and 1930, also consisting of four lines which form a square within the diamond-shape picture plane. Here, however, the square is almost as large as the diamond itself, so that it extends far beyond the edges of the painting. The lines are in fact so far apart that it is possible to see them not only as the outlines of a square, but also as separate sections of lines that cut off the corners of the painting. The lines relate to both the centre and the periphery, and the painting appears to be expanding and contracting at the same time. Moreover, there is another way in which the lines lend themselves to a two-fold interpretation: they are thicker than in any other painting by Mondrian, so that they can almost be seen as planes.

But the most unusual facet of this work is the appearance of colour as line. In his works from the 1920s, as we have seen, Mondrian often ran his colour areas

158
Composition with Yellow Lines, 1933,
oil on canvas, diagonal 113. Haags
Gemeentemuseum, The Hague.

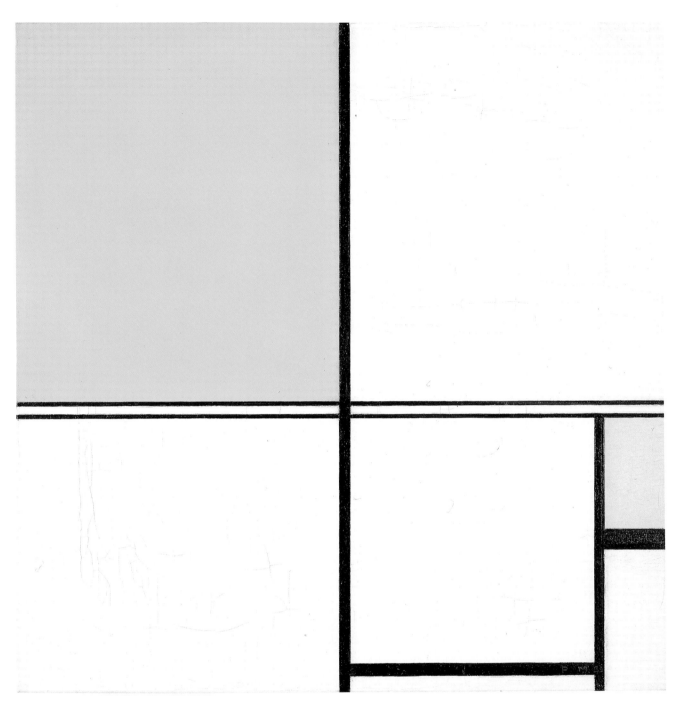

159
Composition with Yellow and Grey,
1932, oil on canvas, 50 x 50. Private
collection.

almost to the very edge of the painting; this left only narrow strips which could be interpreted as coloured lines. However, these were always enclosed on two or three sides by the black lines of the grid, which is not the case here. For the first time since the *Compositions with Colour Planes* of 1917 (illus. 77 and 78) Mondrian positioned his colours directly against the white, with no dark borders to 'tame' them, separate them, and keep them in equilibrium with the non-colours. By using yellow, intrinsically the lightest of the three primary colours, and by proportioning the lines meticulously, Mondrian none the less succeeded in achieving that equilibrium. The result is one of the highlights of his entire *œuvre*, a painting that radiates a serene beauty, not only through the composition and palette, but also through his subtle treatment of the paint layer. The white surface is of a silky smoothness, in which the discreet brush strokes are just barely discernible; in the yellow lines, the paint is ever so slightly more substantial.

The double line

Somewhat surprisingly, this painting long remained an isolated case. Not until the last years of his life did Mondrian again opt for coloured lines. At the time he was working on *Composition with Yellow Lines*, there was apparently another experiment taking up as much or more of his time. This was the doubling of the lines, which first appeared in *Composition with Yellow and Grey* of 1932 (illus. 159). The double line was almost certainly borrowed from one of his most faithful disciples, the above mentioned Marlow Moss.[50] They appear in her work for the first time in 1930, or at the latest 1931. Two of her paintings, including *Composition* (illus. 160), dating from 1931, were reproduced in 1932 in *Abstraction-Création art non-figuratif*, the yearbook of the group.[51] A striking feature of this work is the fact that the parallel lines, which are placed very close together, are not of equal thickness or length, so that they do not entirely merge to form a united whole. In 1932 and after, however, some of her paintings do display compositions with lines of equal width and length, which are very close to Mondrian's work. This is obvious from the two paintings reproduced in *Abstraction-Création art non-figuratif* in 1934 (illus. 161 and 162).[52] I assume, although there is no proof of this, that in this respect Mondrian in turn served as an example for Moss.

What we do know for certain is that he was intrigued by the first of her paintings in which the double line appeared. The letters to Jean Gorin bear witness to this. In a letter that probably dates from 31 January 1933 Mondrian broached an important question – one that occupied both Mondrian and Gorin – namely, how much leeway did Neo-Plasticism allow for the expression of the artistic personality, in other words, personal differences. He had written to Moss, asking her about the motivation behind the compositions with double lines; however, he was unable or unwilling to comprehend the explanation she gave.[53] It probably consisted of an explanation of the mathematical principles she used to determine the position of her lines. She is known to have used the golden section in a rather complicated manner, folding the planes at the edges of the painting towards the centre, as it were, so that some lines ended up close to one another.[54] In Mondrian's eyes, the use of such a system probably placed Moss closer to Vantongerloo than to himself. As he wrote to Gorin, he found her reply somewhat beside the point, as she gave no explanation for the use of double lines as aesthetic means. He put the question

to her again, but never received a written reply.

Nevertheless, Mondrian saw distinct possibilities in the use of double lines that Moss initiated. In 1932 he painted *Composition with Yellow and Grey* (illus. 159), which, while a variation on the second type of scissors-shape composition done previously (illus. 155), takes on a new aspect through the doubling of the continuous horizontal line. On 22 December of that year he wrote to the architect Oud that he was too busy for other things because 'I am doing some new research: canvases with double lines, which enables me to achieve a greater clarity'. In the years to come he repeatedly used the term 'new research' and 'evolution' in letters to Gorin and others, in connection with his recent work. This is proof enough that Mondrian himself felt that his painting was gaining momentum, presenting him with challenges that he addressed with a new *élan*. And it is undeniable that the work he did between 1932 and his death in 1944 displays far-reaching compositional changes that have everything to do with the new vigour of the line.

As in the past, Mondrian's writings shed very little light on the motivation behind the changes that characterized his later work. In his letters there is the occasional casual, almost throwaway, reference, but that is about all we have on which to base an interpretation. One such reference is the above mentioned remark in the letter to Oud: the double lines enabled him to achieve a greater clarity. Another reference, which is of greater significance here, appears in a letter to the architect Alfred Roth dated 31 October 1932: 'I am presently involved in new research into painting with double lines. Thus in a sense I do away with the black, which I find less and less pleasing.'[55] This remark about black may also clarify the replacement of black lines by coloured ones in *Composition with Yellow Lines*, on which he was still working at the time he wrote the letter. However, Mondrian himself linked it to the use of double lines; this, too, is apparently a means of repulsing the black, which had played such a dominant role in the work of the last few years. In *Composition with Yellow and Grey* of 1932 (illus. 159) it is almost as if a thick black line has been partially covered over with white. The white between the two thin lines is of a greater optic clarity than that in the large fields; it outshines the adjacent black, more or less nullifying it. There is little or nothing of this effect in the work of Marlow Moss painted in 1931, although it does occur in some of her later paintings.

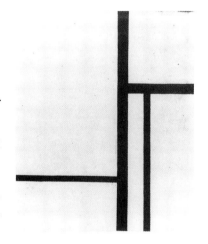

160
Marlow Moss, *Composition*, 1931, oil on canvas. Location unknown.

Mondrian viewed Gorin as his most important follower, and when it came to such questions as this, the Frenchman was apparently a good sparring partner. To a letter of 31 January 1934 Mondrian added a postscript in which he returned to Gorin's statement that the double line cannot but bring about symmetry, a principle of order that Mondrian eschewed. He disagreed with Gorin, for the double line 'is still one line, as in the case of your grooves' (by which he was referring to the wide, sunken lines in Gorin's reliefs). And he added, 'In my last things the double line widens to form a plane, and yet it remains a line. Be that as it may, I believe that this question is one of those which lie beyond the realm of theory, and which are of such subtlety that they are rooted in the mystery of "art". But all that is not yet clear in my mind!'[56] In the light of this last remark, we may assume that the visual effect nevertheless took precedence over the theory.

The double line widens to form a plane, while still remaining a line: in effect, quite a telling characterization of the phenomenon we see in *Composition with Black Lines* of 1933 (illus. 161). This work was reproduced the following year in

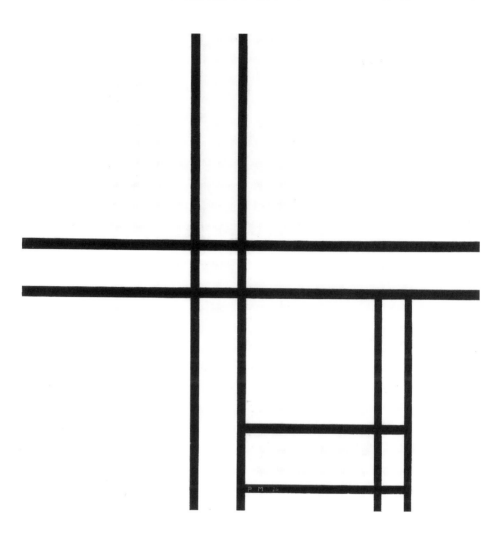

161
Composition with Black Lines, 1933,
oil on canvas, 60 x 60.5. Dallas
Museum of Art, anonymous loan.

162
Marlow Moss, *Composition*, 1933, oil
on canvas. Location unknown.

Abstraction-Création art non-figuratif, in the same issue that featured a similar paint-
ing by Marlow Moss (illus. 162). Mondrian was still using the familiar scissors-
shape composition (illus. 155 and 159), but here he has doubled all the lines and,
with great subtlety, made the horizontals just a fraction thicker than the verticals.
They are much further apart than in the 1932 painting, and yet the planes enclosed
by lines are indeed somewhat in the nature of lines: the white appears to be more
prominent, detaching itself ever so slightly from the other, larger white planes.
With some exaggeration, this work could be referred to as a 'composition with
white lines'. The fact that Mondrian agreed to have the painting reproduced a
short time after its completion must mean that he was pleased with the ultimate
effect. And yet I cannot escape the impression that in retrospect he realized that
there were also problematic aspects attached to the work. The short lines in the
lower right segment, for example, appear to be of secondary importance, almost
as if they are on a different plane than the highly dominant intersecting lines that
run across the entire field. The doubling of all the lines makes the composition
slightly repetitive, and this is not entirely compensated for by the alternating width
of the white between the lines. The painting is perhaps a bit too demonstrative
to be entirely successful.

In any case, in 1935–6, when Mondrian again made several paintings based on
the same composition, these display a greater variation. The horizontal that runs
across the plane has been tripled or even quadrupled, while other lines have

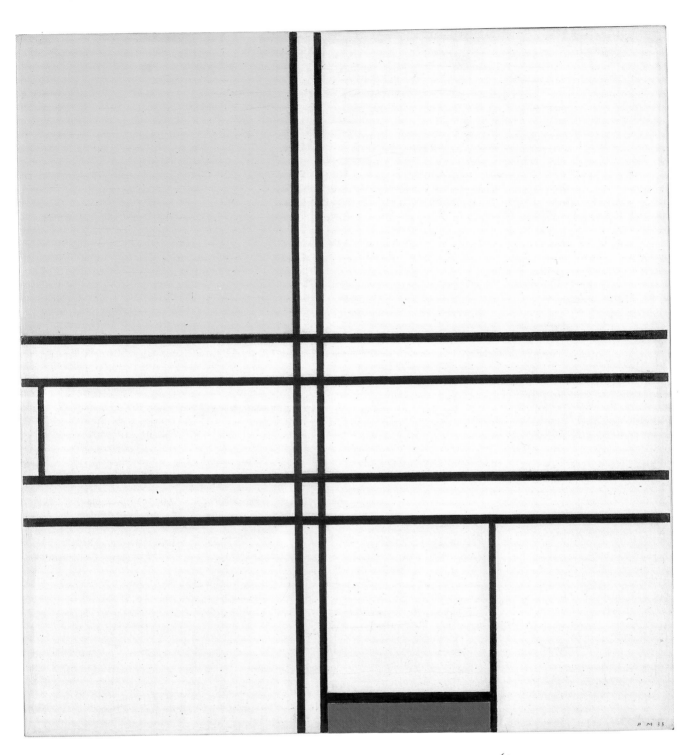

163
Composition with Blue and Yellow,
1935, oil on canvas, 72.5 x 69.
Hirshhorn Museum and Sculpture
Garden (Smithsonian Institution),
Washington, DC.

remained single. In the handsome *Composition with Blue and Yellow* of 1935 (illus. 163), the horizontal double line has itself been 'redoubled'; on the left a short vertical line has been added, while colour accords have reappeared.

Composition with Blue from 1937 (illus. 164) reveals the complexity to which this multiplication of the line ultimately led.[57] There is, in effect, no strict distinction possible between white-as-line and white-as-plane; rather Mondrian succeeded in creating a smooth transition between the two. All the white areas between the lines, seen in both a horizontal and a vertical direction, are of varying widths. Vertically, the narrowest is approximately the width of a black line, the next about double that; others are about four and five times as wide, and there is one on the left that has been increased six-fold. Only the widest field cannot be expressed in terms of multiples. Horizontally, a similar division can be discerned. There is, however, absolutely no question of the composition having been based on an arithmetical progression of any kind. The width of the various white areas was determined with the naked eye, creating a tense, syncopated rhythm, like that of the jazz that was so dear to Mondrian's heart. This effect is heightened by the subtle differences in the thickness of the black lines, whereby the horizontals, as so often, are somewhat thicker than the verticals. The length of the lines is another factor of importance in the creation of that rhythm. While all the vertical lines reach from edge to edge, there is only one horizontal line – just below the centre – that does so. The second line from the top is slightly shorter, not quite reaching the edge on either side. The other lines are even shorter and are arranged in equal pairs, as if they are each other's reflection in water. The composition has something of the all-over effect of the paintings done during the period 1918–20, but how much richer and more controlled is this work. The eye can freely follow the lines, making its own formations of planes, the small blue field serving as the eccentric centre of this transparent labyrinth.

In addition to complex, 'jazzy' paintings such as the one described above, Mondrian regularly came up with works that were almost the converse, displaying a minimum of elements and somewhat lyrical in character. The most extreme example is the *Composition with Blue* of 1936 (illus. 165). The highly elongated format – the work is more than twice as high as it is long – may again have been borrowed from Marlow Moss, or perhaps Jean Gorin; works by them in a similar format appear in *Abstraction-Création art non-figuratif* in 1935 and 1936 respectively (illus. 166).[58] But from a compositional point of view, Mondrian adopted a considerably more radical approach than his fellow artists: the verticality is not diluted by horizontals running from edge to edge, as in their works. On the contrary, Mondrian gave the format extra emphasis by placing a single, knife-edge of a line on the left, along which the white is free to run from top to bottom, like a city street. The only counterweight he provided is the small horizontally oriented blue field in the upper right, the black border underneath, and the line further down in the white area. That is all, and it is enough.

Although many of the paintings that date from the 1930s may be seen as variations on certain basic types, Mondrian's treatment of these schemas became freer and more versatile. The richness of his Neo-Plastic language of form increased with each new painting, and over and again he succeeded in creating new relationships between the familiar expressive means. The lines play a role of major importance in this process. Through their sheer number, there is much

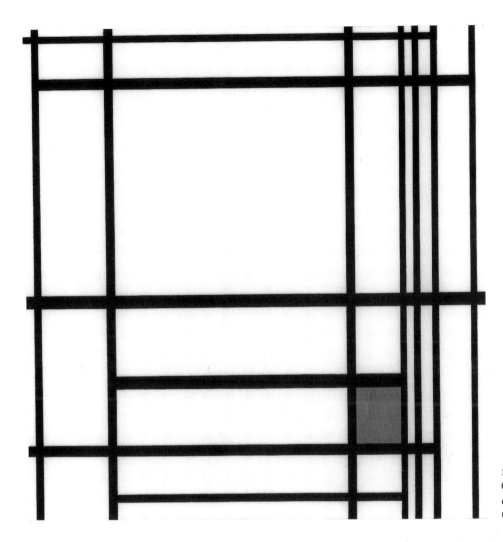

164
Composition with Blue, 1937, oil on
canvas, 80 x 77. Haags
Gemeentemuseum, The Hague.

more black in these paintings than there was in the pieces done during the 1920s,
a fact that would appear to contradict Mondrian's statement in his letter to Roth
that he was becoming less and less enamoured of black. But, as he implied in that
same letter, the doubling and multiplication of the lines led, paradoxically enough,
to a destruction of the black. It is, in fact, almost a literal destruction, since in the
case of a network of lines as dense as that in *Composition with Blue* from 1937
(illus. 164), the familiar optical illusion of light spots at the junction of black lines
is exceptionally strong: it makes the lines look as if they were cut up in many
sections. The multiple black lines also make the small, white in-between fields
brighter and more radiant. In the end, the staccato of the white fields is at least
as important in determining the nature of each separate composition as the network
of lines. Colour, by comparison, is often obliged to take a back seat.

Neo-Plasticism and society

It must have been about the time that Hitler came to power in Germany, in January
1933, that Mondrian finished what was perhaps the most serene painting of his
entire *œuvre*, *Composition with Yellow Lines* (illus. 158; see 167). This is perhaps
no more than a coincidence, but it leads us to ask whether Mondrian, with his
utopian views on art and life, had any real notion of what was going on in the

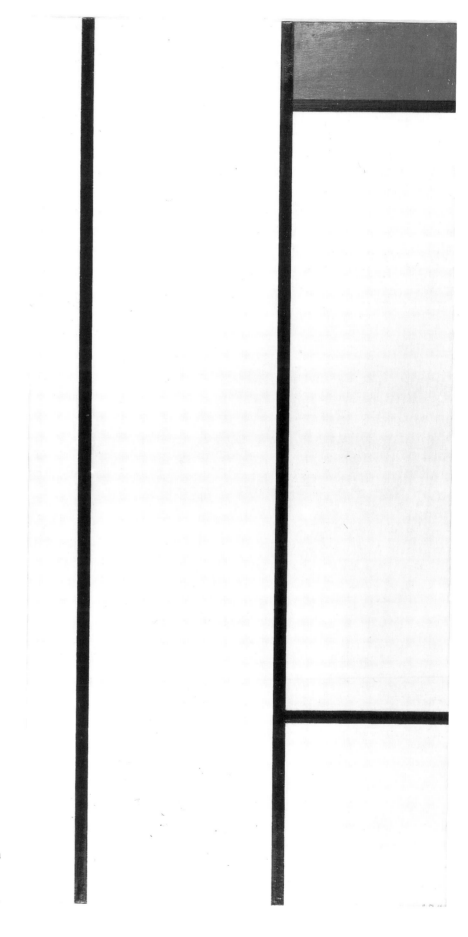

165
Composition with Blue, 1936, oil on
canvas, 121.5 x 59.
Kunstsammlung
Nordrhein-Westfalen, Düsseldorf.

world around him. It is clear from his correspondence that he did. Shocked by the events in Germany during the first few months that Hitler was in power – the burning of the Reichstag building, the Enabling Act, and the first measures aimed against Jews and communists – he wrote in a letter to Gorin on 1 April 1933: 'Although the events now taking place in Germany fill us with the utmost sorrow and disgust, they cannot go on much longer, and are bound to call up a tremendous counter effort. At any rate, all we can do is to continue our work.' His concern also extended to Russia: 'The reports reaching us here are far from encouraging. There is a tendency towards regression, as everywhere. But in any case art and humanity will continue to advance.'[59]

These few short sentences convey his undisguised aversion to Hitler and what Nazism was doing to Germany, as well as an insight into the situation in Russia under Stalin that very few Leftist artists and intellectuals in the West had yet developed. What is also clear from this passage is Mondrian's undiminished trust in the future, which made it worthwhile to go on making art. It is as if Mondrian drew from the deteriorating political situation during the 1930s the incentive in his writings to hold up to his contemporaries even more emphatically the hope of a better world, and to offer them a concrete example of that world in his paintings.

But Mondrian had never been unaware of life's political and social dimensions, and felt called on to express himself on the subject long before the rise of Nazi Germany. Indeed, he was already doing so during the 1920s. If we review the entire body of published and unpublished writings – and this can now be done, following the appearance in 1986 of the collected writings, edited by Harry Holtzman and Martin James – it is possible to divide them into roughly three chronological periods. In the period 1913–20 Mondrian was striving to integrate his theory of painting and his outlook on life, and to expand it into an operational instrument (Neo-Plasticism). Between 1920 and 1927 he was wrestling with the question of how Neo-Plasticism could be realized in arts other than painting. And finally, from 1927 on, he was engaged in writing, not only on Neo-Plastic painting, but also on the realization of Neo-Plasticism within society itself. These are, of course, shifts in emphasis rather than substantial changes in Mondrian's orientation.

The last shift in accent began to make itself felt when Mondrian distanced himself from *De Stijl* and found a new 'home' at *i10*. This journal, which was founded in 1927 by the young anarchist writer Arthur Lehning, attracted the support of an impressive company of artists and thinkers in a wide variety of fields. As early as 22 May 1926, when the group was still taking shape, Mondrian announced to Oud (whom he persuaded to take on the post of editor for art and architecture), 'As for myself, I am planning to write about Neo. Plast. in society, something I've been planning to do for some time. Human existence is one, and art (or no "Art") follows automatically – right?' About a year later, on 27 August, he wrote to Oud that he was working on 'Jazz and Neo-Plasticism', which was due to appear in *i10* in December, explaining that jazz was merely his point of departure: 'It hasn't really that much to do with music, and is not in the domain of Pijper' (the Dutch composer, who was the music editor for *i10*). The role of jazz music in the article is not as unimportant as Mondrian suggests, but the focus of the piece is indeed as much society as it is music.

Mondrian saw this article as the start of a new book, on which he worked from the summer of 1927 to the end of 1931, and to which he referred in his

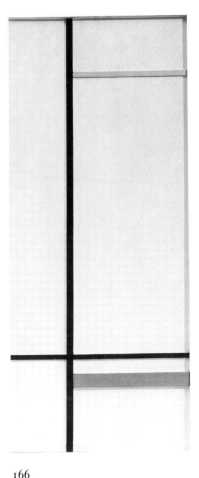

166
Jean Gorin, *Composition no. 28*, 1935, oil on canvas, 49 x 115. Private collection.

167
Mondrian in his studio, 26 rue du
Départ, Paris, in 1933.

correspondence alternately as 'L'Art et la vie' and 'L'Art nouveau – La vie nou-
velle'.[60] He tried to get the well-known Dutch publisher A. M. Stols, who did a
great deal of work in French, to take it on. With touching self-confidence, Mon-
drian wrote to him on 26 March 1932: 'I believe that at times such as these my
modest efforts may be useful to mankind. I have shown how the new art has
succeeded in bringing about pure relationships, and furthermore how these can
be created in day-to-day life.'[61] The response was negative, and Seuphor and
Roth were equally unsuccessful in their attempts to get the book published in
France or Switzerland. Mondrian then asked for the typescripts he had given to
various friends to be returned, so that, as he explained, he could make a number
of improvements to the text. Having left the piece untouched for years, he took
it up again in the late 1930s. However, it was never to be published in his lifetime.

'L'Art et la vie' is one of Mondrian's major works. Like almost all his writings,
it is of a general philosophical nature. Only in his letters does he occasionally
mention what prompted him to write about particular issues, the sources he used,
and which artists and writers he agreed or disagreed with. One important impetus
for his writing was undoubtedly his association with *i10*, where art was viewed
within a broad cultural and social context. Mondrian appears to have taken to
heart what Arthur Lehning had written there and elsewhere concerning socialism,

222

the distribution of work, and worker self-management, as well as the views on militarism aired by a mutual friend, the well-known pacifist Bart de Ligt.[62] He also quoted with approval the somewhat obscure thinker Dr H. Jaworsky (almost the only non-artist he mentions by name) on the rhythm of 'interiorization' and 'exteriorization', which is the life principle of all organisms.[63] In Mondrian's view, this was in perfect agreement with the ancient esoteric wisdom, with which he was familiar through Theosophy, and he saw in Jaworsky's theories the confirmation of his own concept of the harmony of opposites. But there are other passages in the book that are clearly directed against someone or something. One of these concerns the vision of society put forward by Louis Hoyack, a Dutch philosopher who lived near Paris and with whom Mondrian was on friendly terms. It gradually became clear, however, that the two men differed on a number of issues, including the social significance of the individual and the family, and the value of the machine. Thus on 24 June 1931 he wrote to Arthur Lehning the portentous words:

Hoyack has again published two books which I consider totally wrong. While he rightly proceeds from ancient wisdom [again a reference to Theosophy], he applies it to life in the wrong way, which brings him into conflict with the march of 'progress' (the machine, etc.). Indeed, he draws idiotic conclusions; in politics he advocates the monarchy, among other things! As for myself, I have not yet been able to take up my writing again. But I will come to it in time. It is diametrically opposed to Hoyack, and yet personally I like the man very much.[64]

Mondrian was also prompted to write by the – in his eyes – regrettable decision of his brother Carel in 1930 to enter the Roman Catholic church, following the conversion of the youngest brother, Louis, in 1922.

In Mondrian's book all these different impulses and influences are integrated within a calm but resolute argument, in which he maintains that society must be freed from its galling bonds, and recast according to the example provided by art. Just as the abolition of the enclosed form, and the harmonious balance of unequal but equivalent elements, had been given concrete shape in Neo-Plastic painting, so, too, society's traditional and individual forms (state, Church, family, etc.) must be done away with, and all attention given to achieving equilibrium. The comparison that Mondrian draws between social phenomena and the visual manifestations in his art is often surprisingly direct, as in the following passage:

The rectangular plane of varying dimensions and colours visibly demonstrates that internationalism does not mean chaos ruled by monotony but an ordered and clearly divided unity. In Neo-Plasticism, there are, in fact, very definite boundaries. But these boundaries are not really closed; the straight lines in rectangular opposition to one another constantly intersect, so that their rhythm continues throughout the whole work.[65]

In the future the same thing must happen to the boundaries between countries. 'These frontiers will be clearly defined but not "closed"; there will be no customs, no work permits. "Foreigners" will not be viewed as aliens.' There is the echo here of Mondrian's own experiences as a foreigner in France.

The central concept in this and other texts by Mondrian is 'relationship': the important thing in art and life is not the objects and the people themselves, but rather the relationships between them that must be thought through, worked out and brought into harmony, even the relationship between good and evil. His conviction that human development had already taken its first steps in the direction of that harmony strengthened his belief that evil and the regression he saw embodied in the rise of dictatorship ('the tyranny of the Middle Ages') could not

long continue. This faith which, as ever, was bound up with the role of art as model, was expressed not only in 'L'Art et la vie' but also in later writings. There is, for example, a text dating from 1940 (again, not published during his lifetime) that bore the – for Mondrian – explicit title 'Art Shows the Evil of Nazi and Soviet Oppressive Tendencies'.[66] However, his optimistic expectations for the future provided no safeguard against the pressure of present circumstances. In the letters written during the 1930s there is no mistaking his worry and concern. In 1935 he appears to have been in the throes of such a serious crisis – both physical and mental – that the painter Charley Toorop actually feared for his life. On 4 April of that year she wrote to Arthur Lehning: 'He is no longer able to do anything; he just lies in a chair, and everything makes him go all emotional. I'm afraid he's getting very close to the end.'[67] Mondrian was then sixty-three years of age. But the crisis passed, and after some time he was again able to take up his pen and his brush. In 1935 and the years that followed he would do some of his best work.

In 1937 Munich was the scene of the exhibition 'Entartete Kunst', the macabre apotheosis of the witch-hunt against modern art that had raged ever since Hitler had come to power in Germany. This exhibition of works from German museums was intended as a final reckoning with the recent cultural past of Germany itself, a fact that is often forgotten. It consisted mainly of the art of the German Expressionists, whose work was considered so pernicious. Among the handful of foreign artists, Mondrian was represented with two works (illus. 168), probably because of his association with the equally pernicious Bauhaus.[68] He and Metzinger were the only artists of the Paris avant-garde to be accorded this dubious honour. I know of no letter in which Mondrian speaks of the removal of his work from German museum collections, but it must have been a painful blow. No doubt it confirmed his fears that if war broke out and Paris were occupied, it would be impossible for him to exhibit his art, or indeed to continue working.

Towards the end of September 1938, when the situation in Europe had deteriorated still further following the Anschluss of Austria and the German occupation of Sudetenland, he left his beloved Paris and France, probably more to safeguard his art than out of any instinct for self-preservation. In London he was welcomed by several artist friends, notably Winifred Nicholson, Ben Nicholson and Barbara Hepworth, who also provided material assistance. Mondrian had in the past taken part in exhibitions organized by their group and during his Paris years he had contributed to the yearbook *Circle*.[69] Thus he was taken up by a group of artists who were familiar with his work and ideas, and sympathized with them, a group which also included Naum Gabo. Through the Nicholsons he found a studio and living accommodation in Hampstead, where he soon felt at home, judging by the postcards he dispatched to his brother Carel in the Netherlands. Borrowing a metaphor from the recent Disney film *Snow White* (which he found enchanting), he recounts in a manner both touching and comical how his friends (the dwarfs) and his landlord had helped him: 'The landlord has had the room cleaned by Snow White, and the squirrel has whitewashed the walls with his tail [. . .]. The evil witch "war" has departed, at least for the time being, hasn't she?'[70] As he had done in Paris, he used simple, white-painted furniture and pieces of coloured cardboard on the wall to transform his studio into the kind of environment in which he felt at home.

But London was not yet out of the clutches of the 'evil witch', war: during a

German air raid in the autumn of 1940 a bomb fell close to Mondrian's studio. Even before the move to London he had requested help from friends in the USA, and actually would have preferred to have gone there straight away. So, when Harry Holtzman offered to pay his passage and to act as his guarantor, Mondrian was quick to accept. On 1 October of that year he arrived by ship in New York. It was here, at two different addresses, that he spent the last years of his life, years that proved extraordinarily active and prolific. He painted and wrote, devoted a great deal of time to decorating his studio, and even had time for quite an active social life, at any rate in comparison with his years in Paris. He moved in circles associated with the American Abstract Artists, where he was much admired and attracted a number of followers, such as Burgoyne Diller, Fritz Glarner and Charmion van Wiegand. He was also part of that group of prominent exiles from the Paris avant-garde, the core of which was formed by Peggy Guggenheim with her gallery Art of this Century, André Breton, Marcel Duchamp and Max Ernst. In his new surroundings, the modern metropolis *par excellence*, Mondrian was in his element.[71]

Mondrian in New York

It is noteworthy that in New York Mondrian again made a habit of giving his paintings evocative titles. This was something he had not done since 1913, apart from the occasional *Foxtrot* amid several hundreds of *Compositions* with colour designations or an even more neutral number or letter. Starting with his first one-man show in New York, held at the Valentine Gallery in January and February of 1942, the catalogues display titles that recall locations in the various cities in which he had lived (*Place de la Concorde*, *Trafalgar Square*) or the metropolis in which he was living at that moment (*New York*, *New York City*), or which refer to a type of jazz music particularly dear to his heart, including *Broadway Boogie Woogie* and *Victory Boogie Woogie*.

It is true that in his writings Mondrian continued to stress that a modern

painter like himself was no less receptive to visual impressions emanating from his environment than a traditional painter. He was also fond of using visual aspects of modern city life as examples of the more mature culture that he envisioned. Thus in 'L'Art et la vie' he points to the regulation of traffic in the big cities as an example of exactness, imposed by necessity: 'the Place de l'Opéra gives a better image of the new life than many theories. Its rhythm of opposition, twice repeated in its two directions, realizes a living equilibrium through the exactness of its execution.'[72] But it is useless to scrutinize his paintings, even the later works, for resemblances to the visual reality of a certain location. He did not need the Place de l'Opéra in Paris to produce a painting with double lines, or a street map of Manhattan or diagram of the subway system to create the coloured grid of *New York City I*. He might just as well have christened 'Paris' all the paintings he produced between 1920 and 1938, but he did not choose to do so. Thus it is clear that the renewed use of referential titles in his New York paintings does not signal a move away from abstraction. It is more likely to have been intended as an expression of the bond between Neo-Plasticism and the culture of the metropolis, in particular New York. As such, these works are a tribute to the city that guaranteed him the freedom to develop and expand his art and theories.

Many of the paintings of Mondrian's final years bear two dates. This phenomenon is not entirely without precedent; several of his paintings are dated '1921–25', and we know that during the 1920s and 1930s he occasionally returned to certain paintings after they had been exhibited or reproduced. But in the last years of his life it became the rule rather than the exception for Mondrian to spend much longer than a year on a particular work.

When Mondrian had left Paris in 1938 he had with him a number of unfinished canvases, and in London he immediately started on several new works. And yet during the two years he spent there and his first year in New York he completed very few paintings. Only a handful of works are dated 1938 or 1939, and not a single one bears the date 1940. In 1940 he probably did very little painting, so appalled was he by the political situation in Europe. After the fall of Paris in July 1940 he confided to friends that he found himself unable to work. By contrast, there is a whole series of paintings that, judging by the double dates, were started in London or even in Paris, but not completed until 1942 or 1943. 'Completed' is perhaps not the correct word here. Initially Mondrian probably regarded most of them as finished, but in New York he felt a need to make certain – in some cases, radical – alterations, generally consisting of the addition of colour accents, before exhibiting them at the one-man shows he had in 1942 and 1943 at the Valentine Gallery. In referring to these works, Kermit Champa coined the apt term 'transatlantic paintings'.[73]

One of the few paintings that is dated 1939 and thus must have been completed during his stay in London is the handsome *Composition with Red* (illus. 171), which was bought by Peggy Guggenheim. The composition of the painting is intriguing, not so much because it sets one minuscule colour plane near the edge against a whole conglomeration of white planes bounded by black lines – this was often the case during the 1930s – but above all because of the way those lines conduct themselves. While in the *Composition with Blue* of 1937 (illus. 164) and similar works the lines lose their individuality, resulting in a kind of all-over pattern, in the *Composition with Red*, certain lines stand out in relation to others. There is,

169
Composition with Red, Yellow and Blue,
1935–42, oil on canvas, 108 x 58.5.
Private collection.

170
Composition with Red, Yellow and Blue,
1939–42, oil on canvas, 79.5 x 71.
Private collection.

for example, an unmistakable ladder-like construction, which built on the linear structure of the elongated vertical compositions begun in 1935 (illus. 165), two of which were not completed until after Mondrian arrived in New York (illus. 169). This figure is not isolated: the upper and lower rungs are elongated and there is a continuous horizontal line running across the ladder that serves to link it to the two verticals on the right. Nevertheless, the impression is that it is a separate entity, and it is possible to visualize it as either in front of or behind the horizontal line. To my mind, this represents a degree of spatial ambiguity.

This phenomenon was further explored by Mondrian in two paintings started in 1939 and completed in 1942 (illus. 170 and 172). In both works the so-called ladder motif reappears, although here it is identifiable only in the upper section, together with the two topmost rungs. In the lower section the ladder is more or less interwoven with the rest of the composition. And yet in these paintings, too, we sense something of that same spatial ambiguity.

There are, moreover, certain complications in the use of colour. In these works the colour is presented in three different ways: as planes bounded by black lines (upper left and lower right), as Mondrian had been doing for over twenty years, but also as separate blocks of colour bounded by black lines in one direction only

and bordering on white in the other direction, and even as coloured lines that are not bounded at all by black lines. *Composition with Red, Yellow and Blue* (illus. 172), for example, was largely completed in London in 1939. But, in 1942 Mondrian added a number of coloured planes at the left, at the bottom, and between the second and the third line from the right; more surprisingly, he inserted a short coloured segment of line across the three horizontal lines in the middle of the painting. In a sense, he was reverting to *Composition with Yellow Lines* of 1933 (illus. 158), and even the compositions with coloured blocks on white dating from 1917 (illus. 77 and 78). Other works completed in 1942 and 1943 display similar tiny accents of colour, almost always close to the edge of the picture plane. Some are clearly small planes, others are more like sections of line; often there is some-thing to be said for both readings. This again calls to mind *Composition with Yellow Lines*, which displays lines so thick that they are almost planes. It is clear that following a period of years during which the black line was dominant, Mondrian was about to allow colour to share the limelight.

Red, yellow and blue, in their most primary manifestation, differ in lightness and intensity, and thus in their spatial effect. When combined, the colours are never in the same optical plane. This is unavoidable. Mondrian, who had the sensitivity of an Old Master, must always have known that his ideal of flatness might be appoximated but could never actually be achieved. Bringing the primary colours into line by playing them down with white or grey, as he had done in 1917–19, had not proved an entirely satisfactory solution. In his paintings the aim was not uniformity and repetition, but rather equal weight for contrasting elements. Employing the strong primary colours that he had adopted in the early 1920s, he could use the dosage and position on the plane (generally with large areas of non-colour between the colour planes) to minimize the spatial discrepancies. But the most important role was reserved for the lines: within the black grid, colour and non-colour were joined together to form a unity that, if optically not entirely in one plane, was nevertheless more or less in a plane, i.e., the picture plane.

The most crucial change which took place in his work during the last years of his life is reflected in the fact that the colour is no longer checked by the black lines. This development may be seen in the light of the remark he made in his letter of 1932 to Alfred Roth, to the effect that he was becoming less and less fond of black. For almost ten years he had tried to suppress the black by doubling and multiplying the lines, in effect, by paradoxically increasing the total quantity of black. In his last works, however, he took the major step of relinquishing the black network altogether. This not only freed the colour from its bonds, but also allowed it to take over certain functions that for many years had been allocated to the lines, notably the determination of the rhythm of the painting.

In all honesty, it must be said that when Mondrian decided on this artistic change of course, he was lagging years behind a whole army of artists who at one time or another had been influenced by him. Coloured lines had appeared in Bart van der Leck's work as early as 1916, and later in the paintings of van Doesburg, Domela, Gorin, Jean Hélion, Moss and others. The same is true of the colour planes set against one another or against white, without benefit of black borders. Thus the phenomenon was new only for Mondrian himself. It represented a reconsideration of the role of colour in his art, in which he reflected in depth upon the possibilities for directing the behaviour of colour without falling back on

171
Composition with Red, 1939, oil on
canvas, 105 x 102.5. Museum of
Modern Art, Venice (Peggy
Guggenheim Collection).

172
Composition with Red, Yellow and Blue,
1939–42, oil on canvas, 79.5 x 74.
Phillips Collection, Washington,
DC.

the familiar black grid. The result he achieved was uniquely his own, and far
superior to that of his fellow artists.

The last works

The first painting that Mondrian both began and finished in the New World bears
the title *New York*: it is dated 1941–2 (illus. 174). There is a hybrid quality about the
painting, in the sense that it contains both black and coloured networks of lines.
However, this in no way detracts from the quality of the work. Here Mondrian
shows us that he does not shrink from discarding past achievements, or from
addressing – and solving – new problems. Along three of the four sides of the
painting we see the small blocks of colour or coloured sections of line that are
familiar from previous paintings, but now in greater numbers. However, the most
striking element is formed by the complex of three red lines that traverse the
entire picture plane horizontally and vertically, in unison with the black lines,
which seem to echo them. Surprisingly, at the intersections with the black lines,
Mondrian has consistently chosen to allow the red lines to take precedence, so
that in effect the red network is on top of the black network. Thus a colour that
is quite pronounced to begin with is brought forward even more. It is the task of

the little planes of colour to compensate for this effect; they serve to keep the lines under control.

It is not only in relation to one other that the black and the colour lines and planes take on different roles, but also in relation to the white. While the large rectangular plane in the centre may be seen as a spatially somewhat undefined area, the white planes surrounding it are considerably more specific. Where the small colour elements border directly on the white, especially along the lower edge, they activate it until it appears to represent a staccato rhythm of planes that refuse to accept the subordinate role of 'background'. Thus the painting displays a wide spectrum of forces that, pushing and pulling, attracting and repelling, succeed in keeping one another in balance and in their place, which is approximately the picture plane.

Yet another step that Mondrian took in 1941–2, can be seen in *New York City I* (illus. 175), one of the highlights of the work of his last years. The network of black lines has been completely replaced by a grid of coloured lines, or perhaps it would be more precise to say three grids, in different colours. The blue and red lattices appear to be enlargements of the yellow, which is much denser. The implicit perspectival effect and the receding or advancing movement of the colours that could have resulted have been effectively dealt with by the intertwining of the three grids. The yellow is on top almost everywhere, but at five strategic intersections it gives way to the red, and at one intersection to the blue.

In an in-depth article devoted to this painting, Yve-Alain Bois analyses the changes Mondrian made to the intersections during the creation of the work (revealed by a comparison with a studio photo showing the work in unfinished state).[74] Bois also points out the compositional significance of the precedence that Mondrian gives to either the horizontal or vertical lines when the intersections are executed in a single colour. While in the past the black lines were invariably painted in thin, glossy paint, with hardly a trace of brush strokes, the coloured lines in his late works are in general done in thick paint, which in itself lends more significance to the direction of the brush strokes at the intersection.

Not only are the lines of *New York City I* painted in a fairly robust manner, but also the white planes, in contrast to the 'velvet touch' that Mondrian employed in the past. Despite the fact that he probably worked on the painting over a period of months, giving it a number of layers, the top layer – both lines and white planes – must have been completed largely in a single session. This may be deduced from the fact that where colours touch or overlap they have sometimes become mixed (blue and yellow, for example), while at several places in the white planes there are traces of yellow or red paint, picked up by the brush from colour lines that were still wet. This wet-on-wet painting is a far cry from the meticulous methods of the 1920s and 1930s, the patient working out of lines and planes. In its material manifestation, this painting displays a masterly nonchalance.

At the time Mondrian was working on *New York City I* he was engaged on three other paintings of the same type; all of them remained unfinished, although fortunately they have survived. On top of these canvases are paper tapes in various colours, a product that Mondrian had discovered in New York and which he reportedly found extremely useful during the long process of working out the proper position of the lines, prior to executing them in paint. He probably used the same material earlier, during the making of *New York*, with its red and black

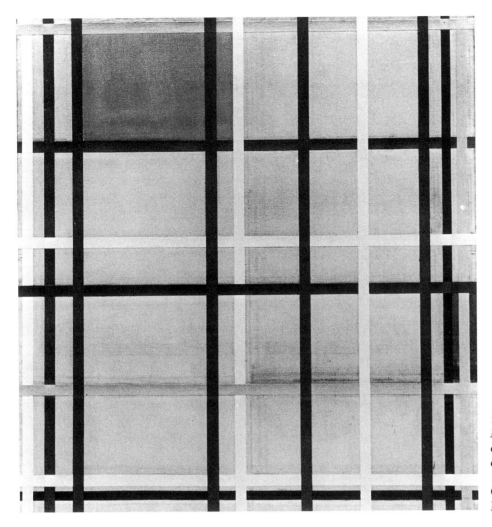

173
New York – New York City, 1941–2, oil and charcoal on canvas with coloured tape, 117 x 110.5, before a 1977 restoration. Fundación Colección Thyssen-Bornemisza, Madrid.

lines, and almost certainly for *New York City I*, which features lines in the three primary colours. In the above-mentioned 1941 studio photograph, it is just possible to see that most of the lines have been executed in paint, but that the third yellow line from the bottom is still in the form of tape, and is situated quite a bit higher in the plane than in the definitive painting.[75]

The earliest of the three unfinished works is known as *New York – New York City* (illus. 173). The title may have been bestowed on the work at a later date by Mondrian's heir Holtzman, but in any case it reflects the transitional position which the work occupies between *New York* and *New York City I*. In fact, it displays certain characteristics that go back even further: there are two coloured planes – a large yellow one at the upper left and a small elongated blue one along the right-hand edge – which are still enclosed and transected with lines, in keeping with Mondrian's earlier practice. By contrast, the networks of lines in the three primary colours point in the direction of *New York City I*.

In the unfinished painting *New York – New York City*, that triad of colour becomes more complex through the appearance of black and – more remarkable – white lines. These can be distinguished from the background thanks to the fact that the primed canvas is itself off-white, while there are also traces of the charcoal that Mondrian used for his initial sketch of the composition. Today the lines are in even starker contrast to the background than was previously the case. This is the

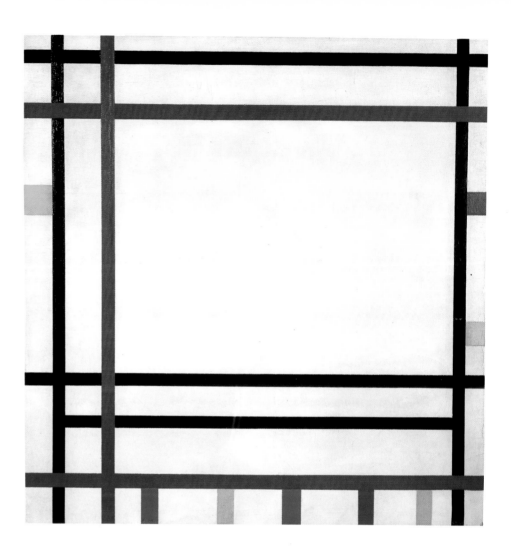

174
New York, 1941–2, oil on canvas,
95.5 x 92. Private collection.

result of a restoration carried out by Holtzman in 1977, quite an irresponsible one, more in the nature of a remake. Most of the original paper tapes were replaced by new ones, covered over with acrylic paint. One cannot help but wonder what Mondrian would have done with those white lines if he had completed the painting. If, as was his wont, he had built up the planes out of layer on layer of brilliant white, then the white lines would have been almost invisible, and thus superfluous. The most probable conjecture is that he would have made the lines light grey, thus reversing the tone values of the lines and planes on the unfinished canvas.

Grey lines do not appear in the painting *New York City I* nor in the unfinished *New York City II* (illus. 176), but we do find them in *New York City III* (illus. 177): one of the horizontal bands, the third from the top, is grey. But this work presents us with new riddles. Mondrian has used not only red, yellow, blue, black and grey, but also a cream-coloured masking-tape. We have no way of knowing whether he would indeed have used this colour in the actual painting, introducing an inter-mediate shade between white and yellow. At any rate, it is clear that during this period the equal treatment of the primary colours and the non-colours black, grey and white was a major preoccupation.

The commercially available coloured paper tapes were a genuine find, but they were not without their drawbacks. It had always been Mondrian's custom to make use of extremely subtle differences in the width of the lines in his paintings. As

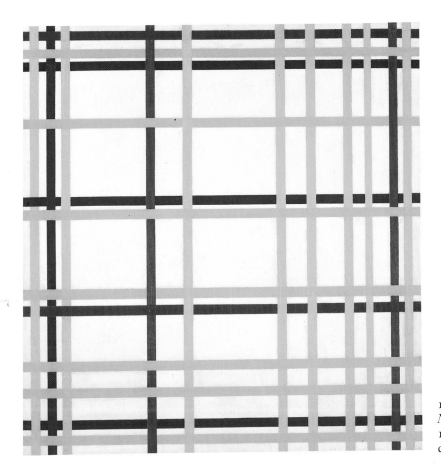

175
New York City I, 1942, oil on canvas,
119.5 x 114. Musée Nationale
d'Art Moderne, Paris.

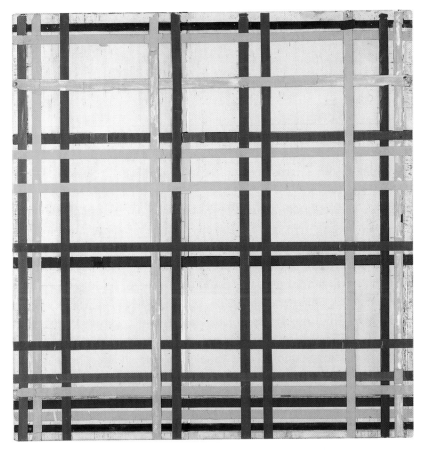

176
New York City II, 1941–2, oil on
canvas with coloured tape,
119.5 x 114.5. Kunstsammlung
Nordrhein-Westfalen, Düsseldorf.

235

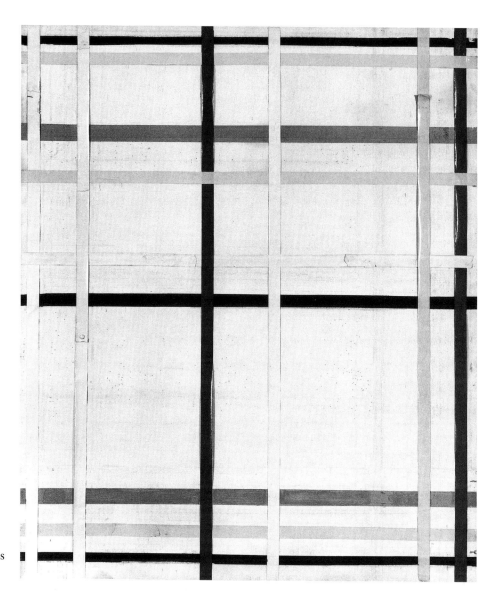

177
New York City III, 1942, oil on canvas
with coloured tape, 114.5 x 99.

a rule, the horizontals were somewhat heavier than the verticals, although this
does not mean that either all the horizontals or all the verticals were equal. The
width of each line had to be decided on separately, and this made the paper tape,
which came in a number of standard sizes, less than ideal. In the three unfinished
canvases we see that here and there Mondrian has used a different width, or has
cut 'down to size' one of the standard widths. In *New York City III*, for example,
the grey and the blue horizontals are somewhat heavier, and the black horizontals
a bit narrower than the uniform width of the other lines. In *New York City II* the
black horizontals are again narrower than the other lines, while one red and one
blue horizontal appear to be wider, in this case because they have been superim-
posed on a previous line that is still just visible. In order to assess the ultimate
effect, he adapted the available material to suit his needs.

We will never know how close the three paintings were to what Mondrian would
have considered a satisfactory result. But what he was trying to do is highly
intriguing. Here, and in the finished work *New York City I*, all the lines, both
horizontal and vertical, continue from one edge of the painting to the other,
traversing the entire picture plane. This was something almost completely new;

236

in the past, one or more lines had invariably been cut off somewhere on the plane. And here Mondrian was exploring, in all manner of ways, the spatial ambiguity that results from the overlapping of coloured lines, about which a decision had to be made at each separate intersection.

The various works differ considerable in their expressive qualities, depending on the treatment decided on. This becomes clear if we compare *New York City I* and *II*, works of approximately the same format. While *I*, the completed painting, has an almost elegiac quality, thanks to the quantitative and situational dominance of the yellow, the visual effect of *II* is vastly more dramatic, due to the aggressiveness of the dark lines, in particular the red, which seems to snake through the picture plane. A second important difference is the fact that in this work the accumulation of lines is such that in some places it threatens to overpower the white. At the lower edge of the work the tapes form a broad, multi-coloured band of alternating light and dark that at intervals is interrupted. This, too, is a new phenomenon in Mondrian's work.

Had they been completed, the three works, together with *New York* and *New York City I*, would have formed a masterly and cohesive group, with the dynamic interaction of coloured lines as the main motif. The fact that Mondrian did not take the time to complete these three paintings probably had to do with his preoccupation with new developments in his work, developments that are evident in his last two paintings, *Broadway Boogie Woogie* (illus. 179) and the unfinished *Victory Boogie Woogie* (illus. 178). The first displays a network of lines that is quite as dense as that in *New York City I*; however, the impression of a grid is less forceful because the lines – which are predominantly yellow – are interrupted at almost every intersection and at dozens of other places by red, blue and grey blocks. Here and there between the lines, or sometimes overlapping them, there are larger, coloured planes; these often have a smaller field in a contrasting colour on top of or next to them, giving the impression of tiny flags along the rigging of a ship decked out for a festive review.

In the diamond-shape painting *Victory Boogie Woogie*, which, according to a sketch done by Charmion von Wiegand, started life as a composition with coloured lines similar to *New York City I*, the grid of lines has receded right into the background, overpowered as it is by a swarming mass of larger and smaller colour planes that seem to dance over the surface of the painting, drawing the non-colours white, grey and black into their dance.[76] It is as if Mondrian was no longer concerned about whether, here and there, one colour plane appears to be lying on top of another, or whether the white planes seem to have been superimposed on the colour. These spatial effects cancel each other out by the sheer weight of their numbers.

In retrospect, the three years and four months that Mondrian spent in New York at the end of his life represent one of the most adventurous and remarkable periods in his entire artistic career. His production was in the nature of a 'triple jump': while he made alterations – some of them quite drastic – to at least a dozen older canvases, which made them truly 'transatlantic paintings', there are only three works that were started *and* completed in the USA: *New York*, *New York City I* and *Broadway Boogie Woogie*. The new works were vastly outnumbered by the unfinished paintings.

On several occasions during the last years of his life Mondrian discussed the

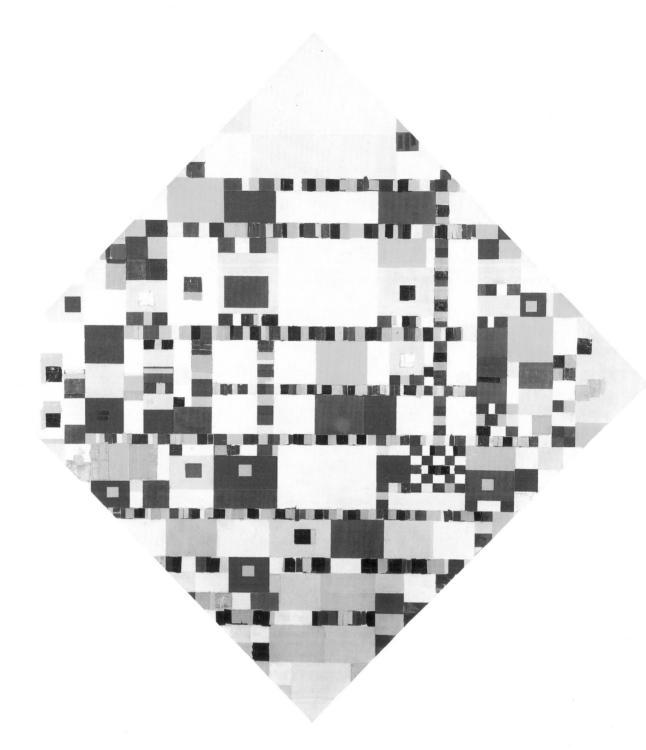

178
Victory Boogie Woogie, 1942–4, oil on
canvas with scotch tape, diagonal
178.5. Private collection.

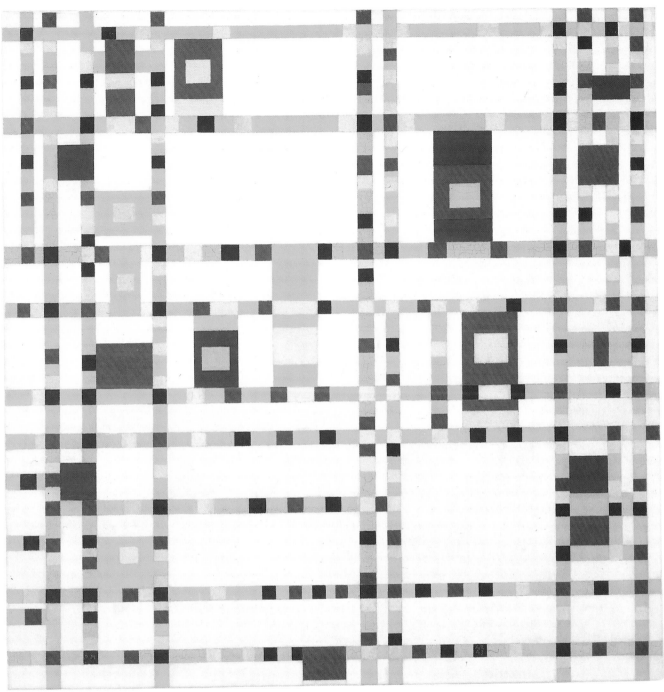

179
Broadway Boogie Woogie, 1942–3, oil
on canvas, 127 x 127. Museum of
Modern Art, New York.

spectacular changes that were taking place in his work with the critic and art historian James Johnson Sweeney, and these comments are extremely enlightening. Thus in late May 1943 he confided in a postcard note:

Only now ('43) I become conscious that my work in black, white and little color planes has been merely 'drawing' in oil color. In drawing, the lines are the principal means of expression; [. . .] In painting, however, the lines are absorbed by the color planes; but the limitations of the planes show themselves as lines and conserve their great value.[77]

This statement, with its almost disconcerting element of self-criticism, explains why in his New York period Mondrian undertook to eliminate the black lines as borders of the colour planes. In the last two paintings, however – and this change goes even deeper – he has also relinquished the line as the structuring principle of the composition. That function has been appropriated by the tiny dots of colour that lend rhythm to the surface of the painting.

A few days before Mondrian wrote his postcard note, he had sent Sweeney a letter (dated 24 May) containing detailed autobiographic information. In it he described his life's work as a series of destructive actions, the last of which he was at present engaged in: 'Now the only problem is to destroy these lines also through mutual opposition.' And in the margin of the letter he penned the telling understatement: 'I think that the destructive element is too much neglected in art.'[78] *Broadway Boogie Woogie* and *Victory Boogie Woogie* are the baffling result of that action.

The works that great artists produce towards the end of their lives, especially unfinished last works, are difficult to assess objectively, entangled as they are in sentiment and myth. Mondrian's work is no exception to this rule. His two *Boogie Woogie* paintings have been called the recapitulation and apotheosis of his life's work. Although I value *Broadway Boogie Woogie* highly, I prefer the assessment contained in the comments that the painter Stanton MacDonald-Wright sent to Michel Seuphor in 1956, shortly after the latter had published the first extensive monograph on Mondrian: 'I feel that the late works, the Boogie-Woogies, are transitions to something that God did not let him wait to accomplish + a step in advance but a step that was unsure and tentative.'[79] 'Unsure' is perhaps a less appropriate term here, but tentative is a description I endorse. Rather than representing the brilliant conclusion of his life work, *Victory Boogie Woogie* is proof of the vitality and the undiminished belief in a better future which the 71-year-old Mondrian still entertained when he was felled by pneumonia on 1 February 1944.

References

To avoid tiresome repetitiveness, I have refrained from mentioning in each individual case the location of unpublished correspondence. The following institutions share the letters cited in the text: Rijksbureau voor Kunsthistorische Documentatie (State Office of Art-historical Documentation), The Hague (van Doesburg Archives, Bequest of van Moorsel): all letters to van Doesburg, letters by Theo and Nelly van Doesburg to Anthony Kok. Haags Gemeentemuseum, The Hague: Mondrian's letters to Louis Hoyack, Sal Slijper, and Slijper Archives. Fondation Custodia, Paris: letters by Mondrian and van Doesburg to J. J. P. Oud. Stichting Mondriaanhuis, Amersfoort: Mondrian's letters to Willy Wentholt. Rijksmuseum Kröller-Müller, Otterlo: Mondrian's letters to Aletta de Jongh.

Introduction

1 – Piet Mondrian, 'The New Art – The New Life: The Culture of Pure Relationships', published posthumously in *The New Art – The New Life: The Collected Writings of Piet Mondrian*, ed. Harry Holtzman and Martin S. James (Boston, 1986), pp. 244–76; quotation on p. 275.

2 – Clement Greenberg, 'Modernist Painting', *Arts Yearbook*, IV (1961), p. 48.

3 – Kermit Swiler Champa, *Mondrian Studies* (Chicago and London, 1985), p. xiii.

4 – R. P. Welsh, 'Mondrian and Theosophy', in *Piet Mondrian 1872–1944: Centennial Exhibition*, exhibition catalogue: Solomon R. Guggenheim Museum (New York, 1971), pp. 35–51.

5 – Yve-Alain Bois, *Painting as Model* (Cambridge, Mass., and London, 1990), pp. 247–8; Champa, *op. cit.* (note 3), p. 17.

6 – Martin James, 'Mondrian and the Dutch Symbolists', *Art Journal*, XXXII (1963–4), pp. 103–11; Carlo L. Ragghianti, *Mondrian e l'arte del XX secolo* (Milan, 1962), pp. 66–76.

7 – Margit Rowell, 'Interview with Charmion von Wiegand', in *Piet Mondrian 1872–1944: Centennial Exhibition*, *op. cit.* (note 4), pp. 77–86; quotation on p. 77.

8 – This fragment of a letter by Mondrian written *c.* 1930, is taken from 'Enkele gedachten uit brieven van *Piet Mondriaan*' (Some Thoughts from Letters by Piet Mondrian), collected by Sal Slijper, probably with the intention of publishing them in the catalogue of the 1946 Mondrian exhibition in Amsterdam. The text (typescript, 4 pp., Slijper Archives, Haags Gemeentemuseum, The Hague) remained unpublished. I suppose that these highly interesting fragments are from Mondrian's letters to his old friend Albert van den Briel, virtually all of which were later destroyed. See also *'t Is alles een groote eenheid, Bert: Piet Mondriaan, Albert van den Briel en hun vriendschap*, ed. Herbert Henkels (Haarlem, 1988).

Chapter One

1 – Annotation, probably by the critic Albert Plasschaert, in a copy of the catalogue of the Arti Spring exhibition, Amsterdam, 1906; Rijksbureau voor Kunsthistorische Documentatie, The Hague (hereafter RKD, The Hague).

2 – Guillaume Apollinaire, *Chroniques d'art 1902–1918*, ed. L.-C. Breunig (Paris, 1960), p. 378.

3 – For Mondrian's Winterswijk years and his relationship with his

family, see Herbert Henkels, 'Mondrian in Winterswijk', in *Mondrian: From Figuration to Abstraction*, exhibition catalogue: Seibu Museum of Art, Tokyo; Miyagi Museum of Art; Museum of Modern Art, Shiga; Fukuoka Art Museum; Haags Gemeentemuseum, The Hague (Tokyo and The Hague, 1987–8), pp. 145–64.

4 – D. Jansen, 'Het spiritistisch genootschap Oromase', *De Negentiende Eeuw*, VI (1982), pp. 159–72. It would be worthwhile to investigate whether there is any connection between Mondrian's later interest in Theosophy and his uncle Dirk Ernst's spiritualist leanings. In an undated letter to Aletta de Jongh, probably of October 1910, Mondrian compares the occult science of Theosophy favourably with Spiritualism: he says he strongly believes in spirit phenomena, but advises her not to attend seances because they might be dangerous – admitting, at the same time, that he has never attended one.

5 – F. M. Lurasco, *Onze moderne meesters* (Amsterdam, 1907), n.p.

6 – Herbert Henkels, 'Mondrian in his Studio', in *Mondrian: Drawings, Watercolours, New York Paintings*, exhibition catalogue: Staatsgalerie, Stuttgart; Haags Gemeentemuseum, The Hague; Baltimore Museum of Art (Stuttgart, The Hague and Baltimore, 1980–81), pp. 219–81; quotation on p. 231. For Mondrian's studies at the Academy and its programme, see also Carel Blotkamp, *Mondriaan in Detail* (Utrecht and Antwerp, 1987), pp. 12–15.

7 – Charles Dumas, 'Art Dealers and Collectors', in *The Hague School: Dutch Masters of the Nineteenth Century*, exhibition catalogue: Galerie Nationale du Grand Palais, Paris; Royal Academy of Arts, London; Haags Gemeentemuseum, The Hague (London, 1983), pp. 125–36; Richard Bionda, 'The Market for Contemporary Art in the Netherlands', in *The Age of Van Gogh: Dutch Painting 1880–1895*, exhibition catalogue: Burrell Collection, Glasgow Museum & Art Galleries, Glasgow; Rijksmuseum Vincent van Gogh, Amsterdam (Zwolle, 1990), pp. 59–81.

8 – Mondrian's work dating from the period covered by this chapter is most extensively dealt with in A. B. Loosjes-Terpstra, *Moderne Kunst in Nederland 1900–1914* (Utrecht, 1959); Cor Blok, *Piet Mondriaan: Een catalogus van zijn werk in Nederlands openbaar bezit* (Amsterdam, 1974); Robert P. Welsh, *Mondrian's Early Career: The 'Naturalistic' Periods* (New York and London, 1977).

9 – Robert P. Welsh, 'The Portrait Art of Mondrian', in *Album Amicorum J. G. van Gelder*, ed. J. Bruyn *et al.* (The Hague, 1973), pp. 356–60.

10 – For all these activities, see Henkels, *op. cit.* (note 6) and Herbert Henkels, 'Mondrian: A Life in Pictures 1872–1944', in *Mondrian: From Figuration to Abstraction*, *op. cit.* (note 3), pp. 192–235, especially pp. 192–4. Most of the illustrations for *Medeërfgenamen van Christus* are reproduced in *Mondriaan/Aanwinsten/Acquisities/1979–1988*, exhibition catalogue by Herbert Henkels: Haags Gemeentemuseum (The Hague, 1988), pp. 32–3.

11 – H. L. C. Jaffé, 'Een gedateerde plafondschildering door Piet Mondriaan', *Oud Holland*, LXXXIII (1968), pp. 229–38; H. L. C. Jaffé, 'Een preekstoel naar ontwerp van Piet Mondriaan', *Nederlands Kunsthistorisch Jaarboek*, XXXI (1981), pp. 533–43.

12 – For a survey of late nineteenth-century Dutch painting, see Bettina Polak, *Het Fin-de-siècle in de Nederlandse schilderkunst: De symbolistische beweging 1890–1900* (The Hague, 1955); *Kunstenaren der Idee: Symbolistische tendenzen in Nederland ca. 1880–1930*, exhibition catalogue: Haags Gemeentemuseum, The Hague; Groninger Museum,

Groningen (The Hague, 1978); *The Age of Van Gogh, op. cit.* (note 7).

13 – For views on the artist's role voiced by the writers and painters of the Eighties movement, see Enno Endt, 'Our Beauty is the Flowering of Desire', in *The Age of Van Gogh, op. cit.* (note 7), pp. 23–35.

14 – Geurt Imanse and John Steen, 'Achtergronden van het Symbolisme', in *Kunstenaren der Idee, op. cit.* (note 12), pp. 21–35; Carel Blotkamp, 'Annunciation of the New Mysticism: Dutch Symbolism and Early Abstraction', in *The Spiritual in Art: Abstract Painting 1890–1985*, exhibition catalogue: Los Angeles County Museum of Art; Museum of Contemporary Art, Chicago; Haags Gemeentemuseum, The Hague (Los Angeles and New York, 1986), pp. 89–111.

15 – J. M. de Jong, 'Piet Mondriaan en de gereformeerde kerk van Amsterdam', *Jong Holland*, v/3 (1989), pp. 20–23.

16 – Reproduced in J.-B. de la Faille, *The Works of Vincent van Gogh: His Paintings and Drawings*, ed. A. M. Hammacher *et al.* (Amsterdam, 1970), p. 415 (F 1128).

17 – The catalogue from Plasschaert's estate is in the RKD, The Hague.

18 – Martin James, 'Mondrian and the Dutch Symbolists', *Art Journal*, xxxii/2 (1963–4), pp. 103–11; *Kunstenaren der Idee, op. cit.* (note 12), passim.

19 – Peter Gay, *Art and Act: On Causes in History – Manet, Gropius, Mondrian* (New York, 1976), pp. 175–226; see also Pieter J. van den Berg, 'Piet Mondrian: Splitting of Reality and Emotion', in *Dutch Art and Character*, ed. Joost Bancke *et al.* (Amsterdam and Lisse, 1993), pp. 109–32.

20 – For the development of Mondrian as a landscape painter, see Welsh, *op. cit.* (note 8), passim.

21 – Invitation card in the archives of the RKD, The Hague.

22 – C. Kickert, 'Piet Mondriaan, Jan Sluyters en C. Spoor', *Onze Kunst*, viii/2 (1909), pp. 97–8.

23 – Frederik van Eeden, 'Gezondheid en verval in kunst naar aanleiding van de tentoonstelling Spoor-Mondriaan-Sluyters', *Op de hoogte*, vi (1909), pp. 79–85.

24 – J. F. Heijbroek, with the assistance of Herbert Henkels, 'Het Rijksmuseum voor Moderne Kunst van Willem Steenhoff: Werkelijkheid of utopie?', *Bulletin van het Rijksmuseum*, xxxix (1991), pp. 163–231, especially pp. 180–90.

25 – For the Esser circle, see *Les vibrations des couleurs: Mondriaan, Sluyters, Gestel*, exhibition catalogue by Herbert Henkels: Galerie 't Mondriaanhuis (Winterswijk, 1985–6).

26 – Letters from artist friends, including Mondrian, to Cornelis Spoor have been published by Lily van Ginneken, with the assistance of Joop Joosten, 'Documentatie: kunstenaarsbrieven Kees Spoor', *Museumjournaal*, xv (1970), pp. 206–8 and 261–7.

27 – Information kindly supplied by Marty Bax, who is preparing a dissertation on Theosophy and art in the Netherlands.

28 – Notes made by the collector Sal Slijper, Slijper Archives, Haags Gemeentemuseum, The Hague.

29 – Michel Seuphor, *Piet Mondrian: Life and Work* (New York, 1956), pp. 52–8; *'t Is alles een groote eenheid, Bert, op. cit.* (Introd., note 8), pp. 22–8, 60–62.

30 – Israël Querido, 'Piet Mondriaan', *De Controleur*, 29 May 1909.

31 – Quoted in full in Israël Querido, 'Van menschen en dingen', *De Controleur*, 23 October 1909. There is an English translation in Robert P. Welsh and J. M. Joosten, *Two Mondrian Sketchbooks 1912–1914* (Amsterdam, 1969), pp. 9–10; certain inaccuracies in the final sentences have been corrected here.

32 – H. L. Berckenhoff, 'Mondriaan-Sluyters-Spoor', *Nieuwe Rotterdamsche Courant*, 8, 9 and 10 January 1909.

33 – Reproduced in van Eeden, *op. cit.* (note 23), p. 84.

34 – Welsh, *op. cit.* (Introd., note 4), especially pp. 37–8; Blok, *op. cit.* (note 8), p. 26.

35 – Els Hoek, 'De Passiebloem. Een dateringsprobleem bij Mondriaan', *Metropolis M*, iii/2 (1981), pp. 31–40.

36 – Loosjes-Terpstra, *op. cit.* (note 8), p. 56; Blok, *op. cit.* (note 8), pp. 27–9.

37 – Information kindly supplied by Frits Keers and Joop Joosten. The exhibition was reviewed by N. H. Wolf, 'De Zwitserse schilder Ferd. Hodler te Amsterdam', *Het Leven*, 26 June 1907. Joosten has also drawn my attention to a statement by Mondrian in his New York years, which clearly refers to the Amsterdam period: 'When Mondrian was asked even in his seventieth year, what he thought of Hodler, for example, he replied: "Toorop liked him very much"'; James Johnson Sweeney, 'Piet Mondrian', *Museum of Modern Art Bulletin*, xii/4 (1945), pp. 2–3.

38 – Robert Rosenblum, 'Notes on Mondrian and Romanticism', in *Piet Mondrian 1872–1944*, exhibition catalogue: Art Gallery of Toronto; Haags Gemeentemuseum, The Hague (Toronto, 1966), pp. 17–21; idem, *Modern Painting and the Northern Romantic Tradition: Friedrich to Rothko* (New York, 1975), pp. 173–94. Around 1908, several critics started to use the term Neo-Romanticism in relation to recent developments in Dutch painting, including Mondrian's work; see A. Ligthart, 'De Neoromantiek in Nederland', in *Nederland 1913: Een reconstructie van het culturele leven*, ed. J. de Vries (Amsterdam, 1988), pp. 190–203.

39 – Blotkamp, *op. cit.* (note 6), pp. 20–22, 26–8; Ype Koopmans, 'In het voetspoor van Pythagoras: Kosmische symboliek in de Nederlandse architectuur tussen 1900 en 1940', *Jong Holland*, v/5 (1989), pp. 23–34.

40 – Ernst Braches, *Het boek als Nieuwe Kunst 1892–1903: Een studie in Art Nouveau* (Utrecht, 1973), pp. 210–35, 334–40; Frans van Burkom and Marty Bax, 'Lauweriks en Cuypers: een langdurig afscheid', *Jong Holland*, v/4 (1989), pp. 8–19.

41 – Braches, *op. cit.* (note 40), p. 234.

42 – *Kunstenaren der Idee, op. cit.* (note 12), p. 142; Marty Bax, 'De onbekende Walenkamp', *Jong Holland*, iv/4 (1988), pp. 2–13, especially p. 11.

43 – Welsh, *op. cit.* (Introd., note 4), pp. 39–42; Imanse and Steen, *op. cit.* (note 14), pp. 28–32; *The Spiritual in Art, op. cit.* (note 14), Index sub Besant, Leadbeater, Steiner.

44 – Rudolf Steiner, *Verslag van de voordrachten gehouden voor de Ned. Afd. Theos. Ver., 4–11 maart 1908* (Amsterdam, 1908); because the title-page of the copy in Mondrian's estate is missing, the book is sometimes referred to as *Mystiek en Esoteriek*, after the title of the first lecture.

45 – David Shapiro, *Mondrian's Flowers* (New York, 1991).

46 – Welsh, *op. cit.* (Introd., note 4), pp. 40–42.

47 – W. Steenhoff, 'Tentoonstelling C. Spoor, Piet Mondriaan, Jan Sluyters in het Stedelijk Museum II', *De Amsterdammer*, 31 January 1909.

48 – Information kindly provided by Marty Bax.

49 – Van Ginneken and Joosten, *op. cit.* (note 26), p. 263.

50 – Loosjes-Terpstra, *op. cit.* (note 8), p. 78.

51 – Welsh and Joosten, *op. cit.* (note 31), pp. 16–24.

52 – M. D. Henkel, 'St. Lucas-Ausstellung', *Kunstchronik*, xxiv/6 (1910), pp. 490–92.

53 – W. Steenhoff, 'Naar aanleiding van de Sint Lucas-Tentoonstelling', *De Ploeg*, iii (1910), pp. 364–71; quotation on pp. 366–7.

54 – Welsh, *op. cit.* (Introd., note 4), pp. 37, 43–8; Imanse and Steen, *op. cit.* (note 14), pp. 30–31, 139; Blotkamp, *op. cit.* (note 6), pp. 103–9.

55 – Cornelis Veth, 'De internationale tentoonstelling van den Modernen Kunstkring', *De Wereld*, i (1911), pp. 7–8; J. H. de Bois, 'Van Kunst en Kunstenaars XXVII', *Haarlems Dagblad*, 26 October 1911; Frans Vermeulen, '"De Moderne Kunstkring" in het Stedelijk Museum te Amsterdam', *De Ploeg*, iv (1911), pp. 137–47, the quotation on p. 144; N. H. Wolf, 'De Modernen in het Stedelijk Museum', *De Kunst*, 28 October 1911.

56 – Loosjes-Terpstra, *op. cit.* (note 8), pp. 109–11; Adriaan Venema, *Nederlandse schilders in Parijs 1900–1940* (Baarn, 1980), pp. 89–106; Jan van Adrichem, 'The Introduction of Modern Art in Holland: Picasso as *pars pro toto*, 1910–1930', *Simiolus*, xxi (1992), pp. 162–211, especially pp. 169–80.

57 – Mieke Rijnders, *Willem van Konijnenburg 1868–1943* (The Hague, Utrecht and Assen, 1990); *Jan Toorop: De Nijmeegse jaren 1908–1916*, exhibition catalogue: Nijmeegs Museum Commanderie van St Jan (Nijmegen, 1978).

58 – Unpublished letter in the archives of the RKD, The Hague.

59 – Referred to by Mondrian himself in a letter of 12 June 1914 to Schelfhout, published in J. M. Joosten, 'Documentatie over Mondriaan (1)', *Museumjournaal*, XIII (1968), pp. 208–15; the quotation on p. 215.

60 – Ibid.

61 – In October 1911, Mondrian's betrothal to Greta Heijbroek (the daughter of a well-to-do merchant) was announced, but it was soon broken off. Not much is known about the circumstances, but apart from artistic motivations, these events in his personal life may also have induced him to move to Paris. In the recently discovered correspondence with Aletta de Jongh, there is an interesting reference to the betrothal. In an undated letter (spring 1912) he wrote from Paris: 'You must have heard that last autumn I almost got married, but I am glad I realized in time that it had been an illusion, all those beautiful things. Although I have always lived for art, I am also attracted to the beautiful in life and so I sometimes do things that seem strange for me.'

62 – Information from Mary Simon, a friend of Mondrian in Amsterdam, kindly provided by N. van der Schoot.

63 – Matsya Hoogendoorn, 'Nederlanders in Parijs', *Museumjournaal*, XVII (1972), pp. 247–53; Venema, *op. cit.* (note 56), passim.

64 – Jan F. van Deene, 'Rechtvaardiging', *Centraal Museum Utrecht Mededelingen*, 16/17 (1977), p. 79.

65 – See note 59.

66 – *Copier/Créer: De Turner à Picasso: 300 oeuvres inspirées par les maîtres du Louvre*, exhibition catalogue: Musée du Louvre (Paris, 1993), pp. 374–5.

67 – Schelfhout's painting *Still-life with Jug* is reproduced in Loosjes-Terpstra, *op. cit.* (note 8), illus. 147. The catalogue is in the archives of the RKD, The Hague. Mondrian's sketch bears a certain relationship to Jean Metzinger's painting *Le Goûter*, which was known in Paris avant-garde circles as 'the Mona Lisa of Cubism'; the painting may have been a source of inspiration for Mondrian's *Nude*. Cf. John Golding, *Cubism: A History and an Analysis 1907–1914* (London, 1971, 3rd edition), pp. 158–9, illus. 77B.

68 – This drawing is usually dated 1909–10, which would imply it preceded the painting by several years. Recently it has been suggested that it is a portrait of Eva de Beneditty, a young member of the Jewish upper class of Amsterdam, who, as witness her Diary, admired and loved Mondrian greatly (it is not known if this was mutual); see *Mondriaan aan de Amstel 1892–1912*, exhibition catalogue by Robert Welsh, Boudewijn Bakker and Marty Bax: Gemeentearchief (Amsterdam, 1994), p. 33. However, in my opinion the identification of the sitter is not substantiated by photographs of De Beneditty (of a much later date), which show facial characteristics that are quite different. I believe that the drawing was made in Paris in 1912. Although naturalistic, it is stylistically incongruous with the portrait drawings that Mondrian made in 1909–10 (illus. 27), and in fact much closer to the Cubist drawings of 1912. This is also true for the drawing – a nude – of the same woman that was discovered a few years ago on the *verso* of a Cubist self-portrait of 1912; see *Mondrian: From Figuration to Abstraction, op. cit.* (note 3), p. 122.

69 – The title usually given to this drawing, *Nude, Dunes and Sea*, is misleading in that it suggests the *simultanità* of the Futurist painters. It is highly unlikely that it was Mondrian's intention to represent such a mixture of subjects.

70 – Welsh and Joosten, *op. cit.* (note 31), p. 22.

71 – Reproduced in *Mondrian: Drawings, Watercolours, New York Paintings, op. cit.* (note 6), p. 148.

72 – In the collection of the Rijksmuseum Kröller-Müller, Otterlo. For the identification of the mill motif, see Robert Welsh, 'The Birth of De Stijl, Part I: The Subject-matter of Abstraction', *Artforum*, XI/8 (1973), pp. 50–53.

73 – Welsh and Joosten, *op. cit.* (note 31); Joop Joosten, 'Mondrian's lost Sketchbooks from the Years 1911–1914', in *Mondrian: Drawings, Watercolours, New York Paintings, op. cit.* (note 6), pp. 63–73.

74 – Piet Mondrian, 'Natuurlijke en abstracte realiteit, *De Stijl*, III (1920), p. 75.

75 – C. W. Leadbeater, 'Centres du magnétisme – Cités modernes', *Le Lotus Bleu*, XXIII (1912), pp. 319–26.

76 – Welsh and Joosten, *op. cit.* (note 31), p. 61.

77 – Letter of 29 January 1914, published in Joosten, *op. cit.* (note 59), p. 211.

78 – For the window motif, also in Delaunay's and Mondrian's work, see J. A. Schmoll gen. Eisenwerth, 'Fensterbilder, Motivketten in der europäischen Malerei', *Studien zur Kunst des 19. Jahrh.*, VI (1970), pp. 13-166.

79 – See note 31.

80 – W. Steenhoff, 'Beeldende kunst: Opmerkingen over de tentoonstelling van den "Modernen Kunstkring" en over enkele der aanwezige werken', *De Ploeg*, V (1912), pp. 142–7; quotation on p. 147.

81 – Joosten, *op. cit.* (note 59), p. 215.

82 – Letter of 8 April 1914, ibid., p. 212.

83 – Joosten, *op. cit.* (note 73).

84 – Welsh and Joosten, *op. cit.* (note 31).

85 – See note 82.

86 – Welsh and Joosten, *op. cit.* (note 31), p. 44.

87 – Ibid., p. 21.

88 – Ibid., p. 68.

89 – Ibid., p. 57.

90 – Ibid., p. 71.

91 – Michael Govan, 'Da Platone al plasticismo: Mondrian e la rappresentazione dell' ideale moderno', *Mondrian e De Stijl: L'ideale moderno*, exhibition catalogue: Fondazione Giorgio Cini, Venice (Milan, 1990), pp. 7–16; Mark A. Cheetham, *The Rhetoric of Purity: Essentialist Theory and the Advent of Abstract Painting* (Cambridge, 1991), passim.

92 – Piet Mondrian, 'Het bepaalde en het onbepaalde', *De Stijl*, II (1918), p. 15.

93 – Welsh and Joosten, *op. cit.* (note 31), p. 61.

94 – Joosten, *op. cit.* (note 59), pp. 211–12.

Chapter Two

1 – Kenneth E. Silver, *Esprit de Corps: The Art of the Parisian Avant-Garde and the First World War 1914–1925* (Princeton, 1989).

2 – For van Assendelft's collection and Mondrian's correspondence with him, see J. M. Joosten, 'Documentatie over Mondriaan (4)', *Museumjournaal*, XVIII (1973), pp. 172–9, 218–33.

3 – Loosjes-Terpstra, *op. cit.* (ch. 1, note 8).

4 – For Mondrian's later 'naturalistic' works, commissions or otherwise, see Blok, *op. cit.* (ch. 1, note 8), pp 44–5.

5 – For a survey of the various avant-garde groups active in the Netherlands during these years, see Geurt Imanse, 'Die Entwicklung der abstrakten Kunst und das künstlerische Klima von 1900 bis 1915', and idem, 'Die Jahre 1915–1918: Entstehung von "De Branding" und "De Stijl"', in *Van Gogh bis Cobra: Holländische Malerei 1880–1950*, exhibition catalogue: Württembergischer Kunstverein, Stuttgart; Centraal Museum, Utrecht (Stuttgart, 1980–81), pp. 104–85.

6 – Welsh and Joosten, *op. cit.* (ch. 1, note 31), p. 22.

7 – Ibid., p. 12, note 31.

8 – Alfred H. Barr Jr., 'Abstract Art in Holland: De Stijl and Neo-Plasticism', in *Cubism and Abstract Art*, exhibition catalogue: Museum of Modern Art (New York, 1936), p. 142; L. Moholy-Nagy, *Vision in Motion* (Chicago, 1947), p. 141.

9 – J. M. Joosten, 'Documentatie over Mondriaan (2)', *Museumjournaal*, XIII (1968), pp. 267–70; quotation on p. 268.

10 – N. H. Wolf, 'Hollandsche Kunstenaarskring II', *De Kunst*, 8 April 1916.

11 – It was in fact the critic Steenhoff who, in a letter to Bremmer, asked him to help Mondrian financially; see Joosten, *op. cit.* (note 9), p. 270.

12 – J. M. Joosten, 'Documentatie over Mondriaan (3)', *Museumjournaal*, XIII (1968), pp. 321–6; quotation on p. 324.

13 – Ibid.

14 – It was probably through van Doesburg that this photograph was published in El Lissitzky and Hans Arp, *Die Kunstismen* (Zurich, 1925), p. 12.

15 – For a discussion of the role of drawing in Mondrian's work, see Robert Welsh, 'Mondrian as Draftsman', in *Mondrian: Drawings, Watercolours, New York Paintings*, op. cit. (ch. 1, note 6), pp. 35–61; Carel Blotkamp, 'De tekeningen van Mondriaan', *De Revisor*, VIII/3 (1981), pp. 36–9; Yve-Alain Bois, 'Mondrian, Draftsman', *Art in America*, LXIX/8 (1981), pp. 95–113.

16 – Joosten, op. cit. (ch. 1, note 59), p. 211.

17 – Joosten, op. cit. (note 9), p. 269.

18 – Joosten, op. cit. (note 12), p. 322.

19 – Imanse, op. cit. (note 5), pp. 151–85.

20 – Theo van Doesburg, 'Kunst-kritiek', *Eenheid*, 6 November 1915.

21 – Joosten, op. cit. (note 9), p. 269.

22 – For the early work of van Doesburg, see J. M. Joosten, 'Rondom van Doesburg', *Tableau*, V/1 (1982), pp. 49–61; Carel Blotkamp, 'Theo van Doesburg', in Carel Blotkamp et al., *De Stijl: The Formative Years 1917–1922* (Cambridge, Mass., and London, 1986), pp. 3–37, especially pp. 3–14.

23 – Joosten, op. cit. (note 12), p. 323. For the early work of van der Leck, see R. W. D. Oxenaar, *Bart van der Leck tot 1920: Een primitief van de nieuwe tijd* (The Hague, 1976); Cees Hilhorst, 'Bart van der Leck', in Blotkamp et al., op. cit. (note 22), pp. 153–85.

24 – Oxenaar, op. cit. (note 23), pp. 24–32, 91–101, 114–18.

25 – Mondrian himself acknowledged his debt to van der Leck's 'exact technique' in a short text that he contributed to *De Stijl*, last issue (1932), pp. 48–9.

26 – Blotkamp, op. cit. (ch. 1, note 6), pp. 109–14.

27 – Oxenaar, op. cit. (note 23), p. 104.

28 – For the significant changes in Mondrian's work during the years 1916–19, see also Blok, op. cit. (ch. 1, note 8), pp. 50–65; Joop M. Joosten, 'Abstraction and Compositional Innovation', *Artforum*, XI/8 (1973), pp. 54–9; Els Hoek, 'Piet Mondriaan', in Blotkamp et al., op. cit. (note 22), pp. 39–75, especially pp. 48–61.

29 – The photograph was first published in Joop Joosten, 'Painting and Sculpture in the Context of De Stijl', in *De Stijl 1917–1931: Visions of Utopia*, exhibition catalogue: Walker Art Center, Minneapolis; Hirschhorn Museum and Sculpture Garden, Smithsonian Institution, Washington D.C.; Stedelijk Museum, Amsterdam; Rijksmuseum Kröller-Müller, Otterlo (Minneapolis and New York, 1982), p. 59; see also Blotkamp, op. cit. (ch. 1, note 6), pp. 114–19.

30 – Letters to the author, 28 July and 21 August 1976.

31 – J. Greshoff, 'Amsterdamsche tentoonstellingen: Hollandsche Kunstenaarskring III', *De Telegraaf*, 26 May 1917.

32 – For a discussion of these questions in the work of the various artists connected with De Stijl, see Blotkamp et al. (note 22), passim.

33 – Letter quoted in Blotkamp, op. cit. (ch. 1, note 6), p. 43.

34 – Reproduced, recto and verso, in Hoek, op. cit. (note 28), p. 54.

35 – Joosten, op. cit. (note 12), p. 326.

36 – The photograph was first published by Ankie de Jongh, 'De Stijl', *Museumjournaal*, XVII (1972), p. 273; also reproduced in Hoek, op. cit. (note 28), p. 56.

37 – *Verzameling van mevrouw Kröller-Müller*, ed. H. P. Bremmer (The Hague, 1921), p. 78.

38 – Joosten, op. cit. (note 2), p. 178.

39 – Ibid., p. 218.

40 – Ibid., p. 220; the complete text of this letter was kindly provided by Lien Heyting.

41 – Ibid.

42 – *The New Art – The New Life*, op. cit. (Introd., note 1), pp. 27–8.

43 – Piet Mondrian, 'De Nieuwe Beelding in de schilderkunst', *De Stijl*, I (1918), p. 54.

44 – Ibid., pp. 127–8.

45 – For a more detailed discussion of the role assigned to Schoenmaekers in the literature on Mondrian, see Blotkamp, op. cit. (ch. 1, note 14), pp. 110–11, notes 24 and 49. Cf. Henk de Jager and G. Matthes, *Het beeldende denken: Leven en werk van Matthieu Schoenmaekers* (Baarn, 1992).

46 – H. L. C. Jaffé, *De Stijl 1917–1931: The Dutch Contribution to Modern Art* (London, 1956), pp. 53–62.

47 – Welsh, op. cit. (Introd., note 4), pp. 35–7, 51.

48 – *Theo van Doesburg 1883–1931: Een documentaire op basis van materiaal uit de Schenking Van Moorsel*, ed. Evert van Straaten (The Hague, 1983), p. 56.

49 – J. H. de Groot, *Vormharmonie* (Amsterdam, 1912), pp. 18–24.

50 – Andrea Gasten, 'Pseudo-mathematica en Beeldende kunst', in *Kunstenaren der Idee*, op. cit. (ch. 1, note 12), pp. 59–66; Koopmans, op. cit. (ch. 1, note 39); Marty Bax, 'Het "Sfeeren" systeem 1898–1900: Berlage, Van den Bosch, De Groot, Lauweriks en Walenkamp', *Jong Holland*, VI/4 (1990), pp. 17–29.

51 – See ch. 1, note 57.

52 – Sjarel Ex and Els Hoek, *Vilmos Huszár schilder en ontwerper 1884–1960: De grote onbekende van De Stijl* (Utrecht, 1985), pp. 46–53; Sjarel Ex, 'Vilmos Huszár', in Blotkamp et al., op. cit. (note 22), pp. 77–121, especially pp. 98–103.

53 – For different views of the diamond format, see *Mondrian: The Diamond Compositions*, exhibition catalogue by E. A. Carmean Jr.: National Gallery of Art (Washington, 1979), pp. 17–29; Carel Blotkamp, 'Mondrian's First Diamond Compositions', *Artforum*, XVIII/4 (1979), pp. 33–9; Erik Saxon, 'On Mondrian's Diamonds', *Artforum*, XVIII/4 (1979), pp. 40–45.

54 – Quoted in Oxenaar, op. cit. (note 23), p. 128.

55 – Ibid., p. 129.

56 – Theo van Doesburg, 'Aantekeningen bij Bijlage XII: De zaag en de goudvischkom van P. Alma', *De Stijl*, I (1918), pp. 91–4; quotation on p. 93.

57 – Among others, Oxenaar, op. cit. (note 23), p. 130.

58 – Herman Hana, *Ornament-ontwerpen voor iedereen: Het stempelboekje* (Amsterdam, 1917), illus. 59.

59 – Joosten, op. cit. (note 2), p. 222.

60 – Joosten, op. cit. (note 28), pp. 57, 59.

61 – Quoted in Hoek, op. cit. (note 28), pp. 54–5, an important discussion of the differences between the painters of De Stijl in the use of colour.

62 – Ibid., p. 74, note 48.

63 – Ibid., p. 50.

64 – Ibid., p. 55.

65 – Ibid., p. 57.

66 – Ibid., p. 59.

Chapter Three

1 – Piet Mondrian, 'De Nieuwe Beelding in de schilderkunst', *De Stijl*, I (1917), pp. 2–6; quotation on p. 3.

2 – Ibid., p. 4.

3 – Quoted in Blotkamp, op. cit. (ch. 2, note 22), p. 18.

4 – Nancy J. Troy, *The De Stijl Environment* (Cambridge, Mass., 1983).

5 – Joosten, op. cit. (ch. 1, note 59), p. 211.

6 – For the analogy between (abstract) painting and music, see Evert van Uitert, 'Beeldende kunst en Muziek', in *Kunstenaren der Idee*, op. cit. (ch. 1, note 12), pp. 67–75; *Vom Klang der Bilder: Die Musik in der Kunst des 20. Jahrhunderts*, exhibition catalogue: Staatsgalerie (Stuttgart, 1985).

7 – Theo van Doesburg, 'Schoonheids-en liefdesmystiek', *Het Getij*, III (1918), pp. 180–90, 212–15, 242–50; quotation on p. 214.

8 – Theo van Doesburg, 'Opstanding: een historisch gedachtenspel van schoonheid en liefde', *Eenheid*, 4, 22 and 29 March and 5 April 1913.

9 – Theo van Doesburg et al., 'Manifest II van "De Stijl" 1920: De literatuur' (also in French and German translations), *De Stijl*, III (1920), pp. 49–50. The manifesto was also published in *Eenheid*, 20

May 1920; it was van Doesburg's last appearance in that weekly, in which he had made his debut in 1912.

10 – Van Doesburg's published and unpublished poems were collected in I. K. Bonset, *Nieuwe Woordbeeldingen: De gedichten van Theo van Doesburg*, ed. K. Schippers (Amsterdam, 1975); see also Egbert Krispijn, 'Literature and *De Stijl*', in *Nijhoff, Van Ostayen, 'De Stijl': Modernism in the Netherlands and Belgium in the First Quarter of the Twentieth Century*, ed. Francis Bulhof (The Hague, 1976), pp. 58–75; Hannah Hedrick, *Theo van Doesburg: Propagandist and Practitioner of the Avant-Garde 1909–1923* (Ann Arbor, 1980).

11 – Piet Mondrian, 'De groote boulevards', *De Nieuwe Amsterdammer*, 27 March 1920, pp. 4–5, 3 April, p. 5. 'Greetchen', of course, refers to the pure soul in Goethe's *Faust*.

12 – L. van Deyssel, 'Futurisme', *De Nieuwe Gids*, XXXV (1920), pp. 703–23; reprinted in L. van Deyssel, *Werk der laatste jaren* (Amsterdam, 1923), pp. 104–34.

13 – Mondrian's piece 'Small Restaurant – Palm Sunday', and his letters to Van Deyssel were published in Carel Blotkamp, 'Mondriaan als literator', *Maatstaf*, XXVI/4 (1978), pp. 1–30; reprinted in *Piet Mondriaan: Twee verhalen*, ed. August Hans den Boef (Amsterdam, 1987), pp. 21–7, 29–73.

14 – Yve-Alain Bois, 'Le Néo-plasticisme', *La Part de l'Oeuil*, 3 (1987), pp. 183–9.

15 – P. Mondrian, *Le Néo-Plasticisme* (Paris, 1921), p. 9 (the title-page is dated '1920').

16 – As noted by the editors of *The New Art – The New Life*, *op. cit.* (Introd., note 1), p. 395, note 8, Mondrian refers here to André Gide, 'Dada', *Nouvelle Revue Francaise*, 1 April 1920, pp. 477–81.

17 – Mondrian, *op. cit.* (note 15), p. 10.

18 – The quotation, in Mondrian's letter in French, was taken from a letter by Léonce Rosenberg, published in *Valori plastici*, 2/3 (1919).

19 – L. van Deyssel, 'Neo-Plasticisme', *De Nieuwe Gids*, XXXV (1921), pp. 523–31, reprinted in L. van Deyssel, *Werk der laatste jaren* (Amsterdam, 1923), pp. 227–38.

20 – Anon., 'Bij Piet Mondriaan', *Nieuwe Rotterdamsche Courant*, 23 March 1922; translation published in *Mondrian: From Figuration to Abstraction*, *op. cit.* (ch. 1, note 3), pp. 26–30.

21 – *L'Éphémère est éternel: Teatro antiteatro 1926*, ed. Michel Seuphor (Turin, 1972); *Seuphor*, ed. Herbert Henkels (Antwerp and The Hague, 1976), pp. 53–61.

22 – Of the extensive literature on De Stijl and architecture, see in particular: Yve-Alain Bois, 'Mondrian et la théorie de l'architecture', *Revue de l'art*, 53 (1981), pp. 39–52; Carel Blotkamp, 'Mondriaan – architectuur', *Wonen/TABK*, 4/5 (1982), pp. 12–51, reprinted in Blotkamp, *op. cit.* (ch. 1, note 6), pp. 9–101; *De Stijl 1917–1931: Visions of Utopia*, *op. cit.* (ch. 2, note 29); Troy, *op. cit.* (note 4); *Het Nieuwe Bouwen: De Nieuwe Beelding in de architectuur/Neoplasticism in Architecture: De Stijl*, exhibition catalogue: Haags Gemeentemuseum, The Hague (Delft and The Hague, 1983); Giovanni Fanelli, *De Stijl* (Rome and Bari, 1983, also German edition); Blotkamp *et al.*, *op. cit.* (ch. 2, note 22); Paul Overy, *De Stijl* (London, 1991).

23 – Caroline Boot and Marijke van der Heijden, 'Gemeenschapskunst', in *Kunstenaren der Idee*, *op. cit.* (ch. 1, note 12), pp. 36–47.

24 – B. van der Leck, 'De plaats van het moderne schilderen in de architectuur', *De Stijl*, 1 (1917), pp. 6–7; idem, 'Over schilderen en bouwen', *De Stijl*, 1 (1918), pp. 37–8.

25 – Allan Doig, *Theo van Doesburg: Painting into Architecture, Theory into Practice* (Cambridge, 1986); Evert van Straaten, *Theo van Doesburg, Painter and Architect* (The Hague, 1988).

26 – Undated letter to Theo van Doesburg (October 1918).

27 – Piet Mondrian, 'De Nieuwe Beelding in de schilderkunst', *De Stijl*, 1 (1918), p. 31.

28 – The line 'my work must be executed in relation to a particular site' has been misinterpreted as an indication that Mondrian painted after nature; see Welsh, *op. cit.* (ch. 1, note 72), p. 53.

29 – Mondrian, *op. cit.* (ch. 1, note 74), pp. 69 and 73.

30 – The late Mrs M. van Domselaer-Middelkoop, Jan Maronier, Adriaan Roland Holst and Paul Sanders. The suggestion, which appeared in Nancy Troy's dissertation (New Haven, 1979) has been corrected in the book edition, *op. cit.* (note 4), pp. 64–6.

31 – Herbert Henkels, citing an interview which appeared in the Dutch newspaper *Het Vaderland*, 9 July 1920, has convincingly argued that the description in the trialogue refers to Mondrian's studio at rue de Coulmiers: *op. cit.* (ch. 1, note 6), pp. 262–3.

32 – Mondrian, *op. cit.* (ch. 1, note 74), pp. 58–9.

33 – Cees Boekraad and Rob de Graaf, 'Mondriaan maquette. Nieuw onderzoek van het atelier aan de Rue du Départ', *Archis*, 5 (1988), pp. 28–37. See also the colour photograph of the reconstruction of the rue du Départ studio in *Mondrian e De Stijl. L'Ideale moderno*, *op. cit.* (ch. 1, note 91), p. 211.

34 – In the 1920 interview referred to in note 31, it was reported that a diamond-shape painting was hanging over the door of the studio. It is quite inconceivable that Mondrian would have placed it against a railing such as the present one.

35 – Anon., 'Een bezoek bij Piet Mondriaan', *Het Vaderland*, 9 July 1920.

36 – Ibid.

37 – Mondrian, *op. cit.* (ch. 1, note 74), p. 67.

38 – Yve-Alain Bois and Nancy Troy, 'De Stijl et l'architecture à Paris', in *De Stijl et l'architecture en France*, ed. Bruno Reichlin and Yve-Alain Bois (Paris, 1985), pp. 25–90, especially pp. 36–9; Doig, *op. cit.* (note 25), pp. 149–56; van Straaten, *op. cit.* (note 25), pp. 108–13.

39 – J. J. P. Oud, 'Over de toekomstige bouwkunst en hare architectonische mogelijkheden', *Bouwkundig Weekblad*, XLII (1921), pp. 147–60.

40 – Piet Mondrian, 'De realiseering van het Néo-plasticisme in verre toekomst en in de huidige architectuur', *De Stijl*, V (1922), pp. 41–7, 65–71.

41 – Undated letter to Theo van Doesburg (late March 1922).

42 – Van Straaten, *op. cit.* (note 25), pp. 109–51.

43 – Mondrian, *op. cit.* (note 40), p. 68.

44 – Nancy Joslyn Troy, 'Piet Mondrian's Atelier', *Arts Magazine*, LIII/4 (1978), pp. 82–8; Henkels, *op. cit.* (ch. 1, note 6), pp. 257–67; Blotkamp, *op. cit.* (ch. 1, note 6), pp. 86–101; Boekraad and de Graaf, *op. cit.* (note 33), pp. 28–37; Twan Jütte, *26, Rue du Départ: een theoretische analyse* (Delft, 1989).

45 – Anon., *op. cit.* (note 20).

46 – Undated letter to J. J. P. Oud (September or October 1925).

47 – Anon., 'Bij Piet Mondriaan', *De Telegraaf*, 12 September 1926, translation published in *Mondrian: From Figuration to Abstraction*, *op. cit.* (ch. 1, note 3), pp. 30–32.

48 – To my knowledge, the earliest reproductions of this photograph appeared in *Das Werk*, VII (1926), p. 209, and *i10*, 1 (1927), p. 13.

49 – The earliest reproduction in Anon., *op. cit.* (note 47).

50 – Troy, *op. cit.* (note 44), p. 84.

51 – The earliest reproduction in *Das Kunstblatt*, XIV (1930), p. 66.

52 – The earliest reproduction in *Cercle et Carré*, I/3 (1930), n.p.

53 – The reproduction of the carboard decoration of the easel in *A bis Z*, III (1932), p. 85.

54 – In an interview published by Jan van Geest in *Vrij Nederland*, 11 January 1975, the painter Wim Schuhmacher, who often visited Mondrian during the 1920s, remarked: 'We should have bought the whole studio [. . .]. We should have bought the easel, with the back of the legs sawn off.'

55 – Jean Gorin, 'Fonction de la plastique pure et son avenir', in *Jean Gorin: schilderijen, reliëfs en ruimtelijke constructies*, exhibition catalogue: Stedelijk Museum (Amsterdam, 1967), n.p.

56 – Nancy J. Troy, 'Mondrian's Designs for the Salon de Mme B . . . à Dresden', *Art Bulletin*, LXII (1980), pp. 640–47.

57 – Sophie Lissitzky-Küppers, *El Lissitzky: Life, Letters, Texts* (London, 1968), p. 74.

58 – See note 21.

59 – Reproduced in H. van Loon, 'Piet Mondriaan, de mensch, de kunstenaar', *Maandblad voor Beeldende Kunsten*, IV (1927), p. 196. In

1964 the Dutch artist Ad Dekkers, under the supervision of Michel Seuphor, made a reconstruction of the scale model, now in the collection of the Van Abbemuseum, Eindhoven. I have the impression that in some cases the colours do not correspond with the original model. What the colours were like can be concluded from the photographs showing the model, together with Mondrian's paintings, such as illus. 152.

60 – Karin von Maur, 'Mondrian and Music', in *Mondrian: Drawings, Watercolours, New York Paintings, op. cit.* (ch. 1, note 6), pp. 287–311.

61 – Mentioned in Mondrian's letter to Willy Wentholt, 10 October 1919.

62 – Maaike van Domselaer-Middelkoop, *Overzicht over leven en werken van Jakob van Domselaer* (n. pl., n.d.), p. 29.

63 – Letter to Theo van Doesburg, late 1915; letter to Willy Wentholt, 4 December 1919.

64 – Henriëtte Mooy, *Maalstroom* (Amsterdam, 1927), pp. 226–7.

65 —Van Domselaer-Middelkoop, *op. cit.* (note 62), p. 32.

66 – Paul F. Sanders, 'Herinneringen aan Piet Mondriaan', *Maatstaf*, XXVII/12 (1979), pp. 1–7.

67 – Mondrian, *op. cit.* (note 15), p. 11.

68 – Mondrian, *op. cit.* (ch. 1, note 74), p. 67.

69 – Mondrian, *op. cit.* (note 15), p. 13.

70 – P. Mondrian, 'De "bruiteurs futuristes italiens" en "het" nieuwe in de muziek', *De Stijl*, IV (1921), pp. 114–18, 130–36.

71 – P. Mondrian, 'Het Neo-plasticisme (de Nieuwe Beelding) en zijn (hare) realiseering in de muziek', *De Stijl*, V (1922), pp. 1–7, 17–23.

72 – Mondrian, *op. cit.* (note 70), p. 136.

73 – Ibid., p. 133.

74 – Ibid.

75 – Mondrian, *op. cit.* (note 71), p. 19.

76 – Ibid., p. 20.

77 – Ibid., p. 22.

78 – Ibid., p. 23.

79 – In the interview that appeared in *Het Vaderland*, 9 July 1920, Mondrian refers to one of his new paintings as *Foxtrot*.

80 – Mondrian, *op. cit.* (note 70), p. 116.

81 – Letters to Willy Wentholt, 10 October 1919 and 13 April 1921.

82 – Mondrian, *op. cit.* (note 71), p. 21.

83 – Mondrian, *op. cit.* (ch. 1, note 74), p. 68.

84 – Piet Mondrian, 'De Jazz en de Neo-Plastiek', *i10*, I (1927), pp. 421–7.

85 – Ibid., p. 423.

86 – First published in *The New Art – The New Life, op. cit.* (Introd., note 1), pp. 242–3; the quotation is on p. 243.

Chapter Four

1 – Letter to Theo van Doesburg, 1 August 1919.

2 – Ibid.

3 – Letter to Theo van Doesburg, 4 December 1919.

4 – Silver, *op. cit.* (ch. 2, note 1); Christopher Green, *Cubism and its Enemies* (New Haven and London, 1987).

5 – See note 3.

6 – In fact, during the War Mondrian had already, on the basis of the scant information provided by Severini's articles in *De Stijl*, voiced his doubts about the state of the avant-garde in Paris. In an undated letter to van Doesburg (December 1917) he wrote: 'Severini now so clearly writes that they wish to depict "les objets, les corps", and that is precisely the point. We want only to represent what these objects express: relationships'; quoted in van Adrichem, *op. cit.* (ch. 1, note 56), p. 204.

7 – Undated letter to Theo van Doesburg (November 1919).

8 – This emphasis on the importance of the environment for the changes in his work has a decidedly Darwinian flavour: Darwin saw the adaptation of all living beings to their environment as the main force in their evolution.

9 – The changes in Mondrian's work after his return to Paris are discussed in detail in Hoek, *op. cit.* (ch. 2, note 28), pp. 61–9.

10 – See *Piet Mondrian 1872–1944, op. cit.* (ch. 1, note 38), pp. 174–96; Blok, *op. cit.* (ch. 1, note 8), pp. 65–70; Hoek, *op. cit.* (ch. 2, note 28), pp. 64–9.

11 – Hoek, *op. cit.* (ch. 2, note 28), pp. 62–4. For the discussions between Vantongerloo and Mondrian on 'the new harmony' and on colour theory, in which van Doesburg and Severini also became involved, see Helma Heijerman-Ton, 'Gino Severini en *De Stijl*', *Jong Holland*, I/4 (1985), pp. 28–47, especially pp. 38–42; Angela Thomas, *Denkbilder: Materialien zur Entwicklung von Georges Vantongerloo* (Düsseldorf, 1987), pp. 133–61.

12 – See ch. 3, note 20.

13 – E. Tériade, 'Nos Enquêtes: Entretien avec M. Léonce Rosenberg', *Feuilles Volantes* (Supplément à la Revue *Cahiers d'Art*), II/6 (1927), pp. 1–3; quotation on p. 1.

14 – 'I don't mean to say that life has nothing unclear to me: on the contrary, I think we don't know anything specific. But in art it is possible to attain great "clarity" by clear visualization. And this is more obvious in my latest work. So I am also of the opinion that man will never get to know life in its absolute form, as *man*. That is why I think that people who try to go beyond being human are mistaken; this is only for a few *true* spiritual people. Just as there always have been so-called great "Initiés". I am now thinking of a book by a certain Ed. Schuré: "Les grands Initiés", which I read long ago and which is beautifully written: it deals with the life of those few.' This fragment of a letter by Mondrian (late 1920s?), probably to Albert van den Briel, is taken from 'Enkele gedachten uit brieven van *Piet Mondriaan*', see Introd., note 8.

15 – Léonce Rosenberg, 'Parlons peinture . . .', *De Stijl*, IV (1921), pp. 36–40; the quotation is on p. 37.

16 – First published in Blotkamp, *op. cit.* (ch. 1, note 6), with the kind permission of Dr R. Friedenthal and the Rudolf Steiner Nachlassverwaltung, Dornach. For Steiner's lecture tour in the Netherlands, see Emanuel Zeylmans, *Willem Zeylmans van Emmichoven: Ein Pionier der Anthroposophie* (Arlesheim, 1979), pp. 94–9.

17 – For Schoenmaekers, see ch. 2 note 45. G. J. P. J. Bolland was professor of philosophy at the University in Leiden and a follower of Hegel; during the first decades of this century, his writings were very popular, also among artists. Mondrian quotes them approvingly in 'De Nieuwe Beelding in de schilderkunst'; see *The New Art – The New Life, op. cit.* (Introd., note 1), pp. xxi, 394, note 6.

18 – Malcolm Gee, *Dealers, Critics, and Collectors of Modern Painting: Aspects of the Parisian Art Market between 1910 and 1930* (New York, 1981), pp. 54–7.

19 – For the portrait of Mrs Cabos, which Mondrian painted in 1924, see Welsh, *op. cit.* (ch. 1, note 9), pp. 359–60. Mondrian's letters make it clear that the painting was commissioned (and not done on his own initiative, as is stated by Welsh). Actually, he was so dissatisfied with the result that he refused further portrait commissions.

20 – Shapiro, *op. cit.* (ch. 1, note 45). In the ambitious exhibition *Bilderstreit: Widerspruch, Einheit und Fragment in der Kunst seit 1960*, Museum Ludwig, Rheinhallen (Cologne, 1989), Mondrian's position as one of the major influences on contemporary art, was illustrated, surprisingly, with a 1919 painting and a whole series of watercolours of flowers done during the 1920s.

21 – On 31 July 1923, for instance, Mondrian wrote to Sal Slijper: 'As you know, I have not been doing my own work for a long time, but now that Neo-Plasticism has been established I do not bother with that much anymore, only that other type of work [flowers, etc.] annoys me. But I may be glad that I earn something and keep myself alive.'

22 – See ch. 3, note 46.

23 – Piet Mondrian, *Neue Gestaltung, Neoplastizismus, Nieuwe Beelding* (Munich, 1925).

24 – Evert van Straaten, 'Theo van Doesburg', in the sequel to Blotkamp *et. al., op. cit.* (ch. 2, note 22), which deals with De Stijl during the years 1922–32; to be published in 1994.

25 – Georges Vantongerloo, 'L'art Plastique (L^2) = (S) Néo-Plasticisme', *Vouloir*, 22 (1926), n.p.; see also Yve-Alain Bois, 'Mondrian en France: sa collaboration à "Vouloir", sa correspondance

avec Del Marle', *Bulletin de la Société de l'Histoire de l'Art français* (1981), pp. 281–98.

26 – *Mondrian: The Diamond Compositions, op. cit.* (ch. 2, note 53), pp. 32–5, 73–84.

27 – Ibid., pp. 35–9.

28 – Van Doesburg had published and praised a poem by Brugman in *De Stijl*: I. K. Bonset, 'Symptomen eener réconstructie der dichtkunst in Holland', *De Stijl*, VI (1923), pp. 44–56, the poem on p. 54, but slightly later he spoke of her in a most disparaging tone in letters to several friends.

29 – Theo van Doesburg and C. van Eesteren, ' – [] + = R4', *De Stijl*, VI (1924), pp. 91–2.

30 – P. Mondrian, 'De huif naar den wind', *De Stijl*, VI (1924), pp. 86–7; Piet Mondrian, untitled text, *De Stijl*, last issue (1932), pp. 48–9.

31 – Piet Mondrian, 'Neo-plasticisme: De Woning – De Straat – De Stad', *i10*, I (1927), pp. 12–18, quotation on p. 16.

32 – The composition is quite similar to fig. 2 in Theo van Doesburg, 'Schilderkunst: Van Kompositie tot contra-kompositie', *De Stijl*, VII (1926), pp. 17–28, illustration on p. 28.

33 – Ibid., p. 17.

34 – Undated letter to J. J. P. Oud (early 1926); a photograph of Palucca's dance studio with Mondrian's painting on the wall in Troy, *op. cit.* (ch. 3, note 56), p. 647.

35 – Champa, *op. cit.* (Introd., note 3), pp. 108–11.

36 – Piet Mondrian, 'L'expression plastique nouvelle dans la peinture', *Cahiers d'Art*, I (1926), pp. 181–3, quotation on p. 183.

37 – Yve-Alain Bois, 'Lettres à Gorin', *Macula*, II (1977), pp. 128–34; quotation on p. 130.

38 – This was kindly suggested to me by Els Hoek.

39 – Green, *op. cit.* (note 4), p. 221–98.

40 – Michel Seuphor, 'L'Art nouveau', *Abstraction-Création art non-figuratif*, I (1932). Seuphor quotes here one of the Surrealists themselves.

41 – P. Mondrian, 'L'art réaliste et l'art superréaliste (La morphoplastique et la néoplastique)', *Cercle et Carré*, I/2 (1930), n.p.; the unabridged article in *The New Art – The New Life, op. cit.* (Introd., note 1), pp. 227–35; quotation on p. 228.

42 – Rudolf Steiner, *Graden van Hoogere Kennis* (Amsterdam, 1908).

43 – Piet Mondrian, 'Plastic Art and Pure Plastic Art (Figurative Art and Non-Figurative Art)', in *Circle: International Survey of Constructive Art*, ed. J. L. Martin *et al.* (London, 1937), pp. 41–56; quotation on p. 51.

44 – Alfred Roth, *Begegnungen mit Pionieren: Le Corbusier, Piet Mondrian, Adolf Loos, Josef Hoffmann, Auguste Perret, Henry van de Velde* (Basle and Stuttgart, 1973), p. 164.

45 – From his published writings, this becomes most clear in Mondrian, *op. cit.* (note 41).

46 – Ibid., p. 150. Mondrian's views on the expressive effects of colour are discussed in Hoek, *op. cit.* (ch. 2, note 28), pp. 67–8.

47 – J. M. Joosten, 'De sporen van het penseel', *Jong Holland*, IX/4 (1993), pp. 44–9.

48 – J. M. Joosten, 'Grenzen van Mondriaan', *Kunstschrift*, XXI (1977), pp. 182–6.

49 – On 19 December 1927 Mondrian wrote to Oud that the two paintings which he had sent to an exhibition in the Netherlands were enough: 'Too many together is not good'. Obviously, he was of the opinion that his paintings served their role as model even better in mixed exhibitions than in large one-man shows. Although he appreciated the efforts of his friend to organize a retrospective exhibition in Amsterdam on the occasion of his fiftieth birthday in 1922, he was not enthusiastic about it and he did not travel to Amsterdam to see the exhibition. This was the only retrospective held during his lifetime.

50 – A peculiar Mondrian-type composition with double lines on a wall of a building by Gropius in Karlsruhe (1929) predates Mondrian's use of double lines by several years. It is however doubtful that Mondrian knew reproductions of this wall painting, which is attributed to Kurt Schwitters; see John Elderfield, *Kurt Schwitters* (London, 1985), p. 187, illus. 228.

51 – *Abstraction-Création art non-figuratif*, I (1932), p. 26.

52 – *Abstraction-Création art non-figuratif*, III (1934), pp. 30, 32.

53 – Bois, *op. cit.* (note 37), pp. 128–9.

54 – Information kindly provided by Ankie de Jongh.

55 – Roth, *op. cit.* (note 44), pp. 167–8.

56 – Bois, *op. cit.* (note 37), pp. 130–31.

57 – Cf. Robert Welsh, 'The Place of "Composition 12 with Small Blue Square" in the Art of Piet Mondrian', *Bulletin of the National Gallery of Canada*, XXIX (1977), pp. 3–31.

58 – *Abstraction-Création art non-figuratif*, IV (1935), p. 20 and V (1936), p. 9.

59 – Bois, *op. cit.* (note 37), p. 129.

60 – Published posthumously in H. L. C. Jaffé, *op. cit.* (ch. 2, note 46), pp. 209–54 (translation by Til Brugman). A revised translation and useful information on this text in *The New Art – The New Life, op. cit.* (Introd., note 1), pp. 244–76.

61 – C. van Dijk, *Alexandre A. M. Stols 1900–1973: Uitgever/typograaf. Een documentatie* (Zutphen, 1992), p. 316.

62 – Yve-Alain Bois, *Arthur Lehning en Mondriaan: Hun vriendschap en correspondentie* (Amsterdam, 1984), pp. 23–7.

63 – *The New Art – The New Life, op. cit.* (Introd., note 1), p. 256.

64 – Bois, *op. cit.* (note 62), pp. 27, 34; for Mondrian's relationship with Hoyack, see also my Introduction.

65 – *The New Art – The New Life, op. cit.* (Introd., note 1), pp. 268–9.

66 – Ibid., pp. 320–30.

67 – Bois, *op. cit.* (note 62), p. 36.

68 – The two compositions, confiscated in the museums of Hanover and Essen, have since disappeared. See *Degenerate Art: The Fate of the Avant-Garde in Nazi Germany*, exhibition catalogue: Los Angeles County Museum of Art; Art Institute of Chicago; International Gallery, Smithsonian Institution, Washington D.C.; Altes Museum, Berlin (New York and Los Angeles, 1991).

69 – *Circle: Constructive Art in Britain 1934–40*, exhibition catalogue: Kettle's Yard Gallery (Cambridge, 1982); see also the special section on Mondrian in London, *Studio International*, CLXXII (1966), pp. 285–99.

70 – Els Hoek, 'Mondrian in Disneyland: Ongepubliceerde brieven', *Jong Holland*, introductory number (1984), pp. 5–13; quotation on p. 7. Also published in *Art in America*, LXXVII/2 (1989), pp. 136–43, 181; quotation on p. 138.

71 – Barbara Rose, 'Mondrian in New York', *Artforum*, X/4 (1971), pp. 54–63; *Mondrian and Neo-Plasticism in America*, exhibition catalogue by Nancy J. Troy: Yale University Art Gallery (New Haven, 1979); Harry Holtzman, 'Piet Mondrian: The Man and His Work', in *The New Art – The New Life, op. cit.* (Introd., note 1), pp. 1–10.

72 – *The New Art – The New Life, op. cit.* (Introd., note 1), p. 275.

73 – Champa, *op. cit.* (Introd., note 3), p. 128.

74 – Yve-Alain Bois, 'Piet Mondrian, *New York City I*', in *Painting as Model, op. cit.* (Introd., note 5), pp. 157–83.

75 – Ibid., p. 166.

76 – Von Wiegand's sketch is reproduced in *Piet Mondrian 1972–1944: Centennial Exhibition, op. cit.* (ch. 1, note 34), p. 82; *Mondrian: The Diamond Compositions, op. cit.* (ch. 2, note 53), pp. 57–66.

77 – Quoted in *The New Art – The New Life, op. cit.* (Introd., note 1), p. 356.

78 – The letter is reproduced in *Piet Mondrian: The Earlier Years*, exhibition catalogue: Solomon R. Guggenheim Museum (New York, 1957–8), n.p.; see also Mondrian's short notes on destruction in *The New Art – The New Life, op. cit.* (Introd., note 1), pp. 380–81.

79 – Henkels, *op. cit.* (ch. 3, note 21), p. 224.

Bibliography

This Bibliography is organized chronologically.

A. Writings by Mondrian published during his lifetime (first publication only)

'De Nieuwe Beelding in de schilderkunst', *De Stijl*, I (1917–18), pp. 2–6, 13–18, 29–31, 41–5, 49–54, 73–7, 88–91, 102–8, 121–4, 125–34, 140–47; II (1918–19), pp. 14–19.

'Dialoog over de Nieuwe Beelding (zanger en schilder)', *De Stijl*, II (1918–19), pp. 37–9, 49–53.

'Natuurlijke en abstracte realiteit', *De Stijl*, II (1918–19), pp. 85–9, 97–9, 109–13, 121–5, 133–7; III (1919–20), pp. 15–19, 27–31, 41–4, 54–6, 58–60, 65–9, 73–6, 81–4.

'De groote boulevards', *De Nieuwe Amsterdammer* (27 March 1920), pp. 4–5 (3 April 1920), p. 5.

Le Néo-Plasticisme, Principe général de l'équivalence plastique (Paris, 1921) ['1920' on title-page].

'De "bruiteurs futuristes italiens" en "het nieuwe" in de muziek', *De Stijl*, IV (1921), pp. 114–18, 130–36.

'Het Neo-plasticisme (de Nieuwe Beelding) en zijn (hare) realiseering in de muziek', *De Stijl*, V (1922), pp. 1–7, 17–23.

'De realiseering van het Neo-plasticisme in verre toekomst en in de huidige architectuur', *De Stijl*, V (1922), pp. 41–7, 65–71.

'Moet de schilderkunst minderwaardig zijn aan de bouwkunst?', *De Stijl*, VI (1923–4), pp. 62–4.

'Het Neo-plasticisme', *Merz*, no. 6 (October 1923).

'Geen axioma maar beeldend principe', *De Stijl*, VI (1923–4), pp. 83–5.

'De huif naar den wind', *De Stijl*, VI (1923–4), pp. 86–8.

'Les arts et la beauté de notre ambiance tangible', *Manomètre*, no. 6 (August 1924).

'L'Evolution de l'humanité est l'évolution de l'art', *Bulletin de l'Effort Moderne* (November 1924).

'L'Architecture future néoplasticienne', *L'Architecture vivante*, III/9 (1925), pp. 11–13.

'Art. Pureté + Abstraction', *Vouloir*, no. 19 (March 1926).

'L'Expression plastique nouvelle dans la peinture', *Cahier d'art*, I (1926), pp. 181–3.

'Neo-plasticisme. De Woning – De Straat – De Stad', *i10*, I (1927), pp. 12–18.

'Diskussion über Ernst Kallai's Artikel "Malerei und Photographie"', *i10*, I (1927), p. 235.

'De jazz en de Neo-plastiek', *i10*, I (1927), pp. 421–7.

'Die rein abstrakte Kunst', *Neue Zürcher Zeitung* (26 October 1929).

'L'Art réaliste et l'art superréaliste; la morphoplastique et la Néoplastique', *Cercle et Carré*, no. 2 (April 1930).

'De l'art abstrait', *Cahiers d'art*, VI (1931), pp. 41–3.

[Untitled, in memoriam Theo van Doesburg], *De Stijl*, last issue (January 1932), pp. 48–9.

'La Néo-plastique', *Abstraction-Création art non-figuratif*, no. 1 (1932), p. 25.

[Untitled], *Abstraction-Création art non-figuratif*, no. 2 (1933), p. 31.

[Untitled], *Abstraction-Création art non-figuratif*, no. 3 (1934), p. 32.

'Réponse à une enquête', *Cahiers d'art*, X (1935), p. 31.

'Plastic Art and Pure Plastic Art (Figurative Art and Non-Figurative Art)', ed. J. L. Martin, Ben Nicholson, and N. Gabo, *Circle: An International Survey of Constructive Art* (London, 1937), pp. 41–56.

'Three notes', *Transition*, no. 26 (1937), pp. 118–19.

'Kunst zonder onderwerp', *Abstracte Kunst*, exhibition catalogue, Stedelijk Museum, Amsterdam, 1938, pp. 6–8.

'Neo-Plastik', *Werk*, XXV/8 *(1938)*, pp. 118–19.

'De werkelijke waarde der tegenstellingen', *Kroniek van hedendaagsche kunst en kultuur*, V/3 (1939), pp. 34–6.

Toward the True Vision of Reality (New York, 1942).

'Abstract Art', *Art of This Century*, exhibition catalogue; Art of This Century Gallery, New York, 1942.

B. Writings by Mondrian published posthumously

'Klein restaurant – Palmzondag' [1920], *Maatstaf*, XXVI/4 (1978), pp. 28–30.

'Principes généraux du Néo-plasticisme' [1926], *Art d'aujourd'hui*, no. 5 (1949), pp. 1–2.

'Art and Life' [1931], in H. L. C. Jaffé, *De Stijl 1917–1931* (Amsterdam, 1956), pp. 209–54.

'Liberation from Oppression in Art and Life' [1940], in Mondrian, *Plastic Art and Pure Plastic Art 1937 and Other Essays, 1941–1943* (New York, 1945), pp. 37–48.

'A new realism' [1943], in Mondrian, *Plastic Art and Pure Plastic Art 1937 and Other Essays, 1941–1943* (New York, 1945), pp. 16–26.

'Writings' [notes, 1940–1944], *Tracks*, III/1–2 (1977), pp. 19–43.

C. Collected Writings (including some unpublished essays and notes)

Harry Holtzman and Martin S. James, eds, *The New Art – The New Life: The Collected Writings of Piet Mondrian* (Boston, 1986).

D. Published Letters by Mondrian

Many publications on Mondrian contain fragments from his correspondence. This list is restricted to published complete correspondences, or complete letters.

Israël Querido, 'Van menschen en dingen', *De Controleur* (23 October 1909) (letter to Israël Querido).

Piet Mondrian: The Earlier Years, exhibition catalogue, Solomon R. Guggenheim Museum, New York, 1957–8 (letter to James Johnson Sweeney).

J. M. Joosten, 'Documentatie over Mondriaan', *Museumjournaal*, XIII (1968), pp. 208–15, 267–70, 321–6 (letters to H. P. Bremmer and Lodewijk Schelfhout).

L. van Ginneken and J. M. Joosten, 'Kunstenaarsbrieven Kees Spoor (2)', *Museumjournaal*, XV (1970), pp. 261–7 (letters to Cornelis Spoor).

Richard Kostelanetz, *Moholy-Nagy* (London 1971), pp. 176–7 (letter to László Moholy-Nagy).

Carola Giedion-Welcker, *Schriften 1926–1971. Stationen zu einem Zeitbild* (Cologne, 1973), pp. 495–6 (letters to Carola Giedion-Welcker).

J. M. Joosten, 'Documentatie over Mondriaan (4)', *Museumjournaal*, XVIII (1973), pp. 172–9, 218–23 (letters to H. van Assendelft).

Alfred Roth, *Begegnung mit Pionieren. Le Corbusier, Piet Mondrian, Adolf Loos, Josef Hoffmann, Auguste Perret, Henry van de Velde* (Basle and Stuttgart, 1973), pp, 125–95 (letters to Alfred Roth).

Herbert Henkels, ed., *Seuphor* (Antwerp, 1976), pp. 44, 62, 76–7, 88, 106, 175 (letters to Michel Seuphor).

Yve-Alain Bois, 'Lettres à Jean Gorin. Vantongerloo, Torrès Garcia, Mondrian, Hélion, Bill', *Macula* II (1977), pp. 128–34 (letters to Jean Gorin).

Carel Blotkamp, 'Mondriaan als literator', *Maatstaf*, XXVI/4 (1978), pp. 1–23 (letters to Lodewijk van Deyssel).

Mondrian and Neo-Plasticism in America, exhibition catalogue by Nancy J. Troy, Yale University Art Gallery, New Haven, 1979, pp. 61–2 (letters to Katherine Dreier).

Adriaan Venema, *Adriaan Lubbers' New York* (Mijdrecht, 1980), pp. 13–18 (letters to Adriaan Lubbers).

Yve-Alain Bois, 'Mondrian en France, sa collaboration à "Vouloir", sa correspondance avec Del Marle', *Bulletin de la Société d'histoire de l'art français* (1983), pp. 281–98 (letters to Félix Del Marle).

- *Arthur Lehning en Mondriaan. Hun vriendschap en correspondentie* (Amsterdam, 1984) (letters to Arthur Müller Lehning).

Els Hoek, 'Mondriaan in Disneyland. Ongepubliceerde brieven', *Jong Holland*, introductory issue (1984), pp. 5–13 (letters to Carel and Mary Mondriaan).

Das Legat Clara und Emil Friedrich-Jetzler im Kunstmuseum Winterthur. Eine Pioniersammlung moderner Kunst, ed. Brigit Blass and Rudolf Koella (Zurich, 1985), p. 73 (letter to Clara Friedrich).

Mondrian: From Figuration to Abstraction, exhibition catalogue by Herbert Henkels; The Seibu Museum of Art, Tokyo, 1987 (some letters to Willi Baumeister, Theo van Doesburg, Ella and Louis Hoyack, Anthony Kok, Winifred Nicholson, J. J. P. Oud, Michel Seuphor, Sal Slijper and Charmion von Wiegand).

Angela Thomas, *Denkbilder. Materialien zur Entwicklung von Georges Vantongerloo bis 1921* (Dusseldorf, 1987), p. 110 (letter to Georges Vantongerloo).

't Is alles een groote eenheid, Bert. Piet Mondriaan, Albert van den Briel en hun vriendschap, ed. Herbert Henkels (Haarlem, 1988), pp. 9–20 (letters to Albert van den Briel).

W. H. K. van Dam, 'Een onbekende brief van Piet Mondriaan', *Oud Holland*, CIV (1990), pp. 341–3 (letter to Augusta de Meester-Obreen).

Sophie Bowness, 'Mondrian in London: Letters to Ben Nicholson and Barbara Hepworth', *The Burlington Magazine*, CXXXII (1990), pp. 782–8 (letters to Ben Nicholson and Barbara Hepworth).

C. van Dijk, *Alexandre A. M. Stols 1900–1973: Uitgever/typograaf. Een documentatie* (Zutphen, 1992), p. 316 (letter to A. A. M. Stols).

E. Works on Mondrian

I. Works published during Mondrian's lifetime.

Is. Querido, 'Van menschen en dingen', *De Controleur* (23 October 1909).

Arnold Saalborn, 'Piet Mondriaan en anderen', *De Kunst*, IV (1911), pp. 74–7.

A. O. [Augusta de Meester-Obreen], 'Piet Mondriaan', *Elsevier's Geïllustreerd Maandschrift*, XXV (1915), vol. L, pp. 396–9.

Theo van Doesburg, 'Aantekeningen hij twee teekeningen van Piet Mondriaan', *De Stijl*, I (1917–18), pp. 108–11.

Anon, 'Een bezoek bij Piet Mondriaan', *Het Vaderland* (9 July 1920).

Anon., 'Bij Piet Mondriaan', *Nieuwe Rotterdamsche Courant* (23 March 1922).

Herman Hana, 'Piet Mondriaan, de pionier', *Wil en weg*, II (1923–4), pp. 602–8, 635–9.

Anon., 'Het Neo-plasticisme in Schilderkunst, Bouwkunst, Muziek, Litteratuur', *Het Vaderland* (17 October 1924).

Georges Vantongerloo, 'L'art plastique (L²) = (S) Néo-Plasticisme', *Vouloir*, no. 22 (1926).

Anon., 'Bij Piet Mondriaan', *De Telegraaf* (12 September 1926).

H. van Loon, 'Piet Mondriaan, de mensch, de kunstenaar', *Maandblad voor beeldende kunsten*, IV (1927), pp. 195–9.

M. Seuphor, *Greco* (Paris, 1930).

Sven Bocklund, 'Piet Mondrian', *Hyresgasten*, no. 20 (1931), pp. 1–3.

J. Bendien, 'Piet Mondriaan 60 jaar', *Elsevier's Geïllustreerd Maandschrift*, XIIL (1932), vol. LXXXIV, pp. 168–74.

M. Seuphor, 'Christen-calvinist', *Opbouwen*, no. 10 (1937).

H. Buys, 'Piet Mondriaan: de werkelijke waarde der tegenstellingen', *Kroniek van hedendaagsche kunst en kultuur*, V/3 (1939), pp. 34–6.

Charmion von Wiegand, 'The Meaning of Mondrian', *Journal of Aesthetics and Art Criticism*, II/8 (1943), pp. 62–70.

II. Publications during 1944–69.

Jay Bradley, 'Piet Mondrian 1872–1944: Greatest Dutch painter of our time', *Knickerbocker Weekly* (14 February 1944).

- 'As Ernst remembers Mondrian', *Knickerbocker Weekly* (14 February 1944), pp. 16–25.

James Johnson Sweeney, 'Piet Mondrian', *Partisan Review*, XI (1944), pp. 173–6.

- 'Piet Mondrian', *Museum of Modern Art Bulletin*, XII/4 (1945), pp. 1–12.

Piet Mondriaan herdenkingstentoonstelling, exhibition catalogue, with texts by Michel Seuphor, Til Brugman, Peter Alma, J. J. P. Oud, C. van Eesteren and Piet Mondrian; Stedelijk Museum, Amsterdam, 1946.

James Johnson Sweeney, 'An interview with Mondrian', *Museum of Modern Art Bulletin*, XIII/4–5 (1946), pp. 35–6.

Maud van Loon, 'Mondriaan, zoals hij leefde te Parijs', *De Groene Amsterdammer* (7 December 1946).

A. M. Hammacher, 'Piet Mondriaan 1872–1944', *Kroniek van Kunst en Kultuur*, VIII (1947), pp. 233–7.

Mondrian, exhibition catalogue by James Johnson Sweeney, Museum of Modern Art, New York, 1948.

Mondriaan, exhibition catalogue, with texts by Michel Seuphor and Piet Mondrian, Haags Gemeentemuseum, The Hague, 1955.

J. J. P. Oud, 'Mondriaan', *De Groene Amsterdammer* (12 February 1955).

G. Th. Rietveld, 'Mondriaan en het nieuwe bouwen', *Bouwkundig Weekblad*, LXXIII (1955), pp. 127–8.

Louis Saalborn, 'Herinneringen aan Mondriaan', *De Telegraaf* (17 March 1955).

Ottavio Morisani, *L'Astrattismo di Piet Mondrian* (Venice, 1956).

Michel Seuphor, *Piet Mondrian: Life and Work* (New York, 1956).

Carl Holty, 'Mondrian in New York, a Memoir', *Arts*, XXXI (1957), pp. 17–21.

Martin S. James, 'The Realism behind Mondrian's Geometry', *Art News*, LVI/8 (1957), pp. 34–7.

D. Lewis, *Mondrian* (London, 1957).

Piet Mondrian: The Earlier Years, exhibition catalogue, Solomon R. Guggenheim Museum, New York, 1957–8.

Sam Hunter, *Mondrian* (London, 1959).

H. L. C. Jaffé, *Inleiding tot de kunst van Mondriaan* (Assen and Amsterdam, 1959).

M. van Domselaer-Middelkoop, 'Herinneringen aan Piet Mondriaan', *Maatstaf*, VII (1959–60), pp. 269–93.

Charmion von Wiegand, 'Piet Mondrian: A Memoir of his New York Period', *Arts Yearbook*, IV (1961), pp. 57–66.

Cor Blok, 'Mondriaans vroege werk', *Museumjournaal*, VIII/2 (1962), pp. 34–8.

Filiberto Menna, *Mondrian: cultura e poesia* (Rome, 1962).

Carlo Ragghianti, *Mondrian e l'arte del XX secolo* (Milan, 1962).

L. J. F. Wijsenbeek and J. J. P. Oud, *Mondriaan* (Zeist and Antwerp, 1962).

Martin S. James, 'Mondrian and the Dutch Symbolists', *Art Journal*, XXIII (1963–4), pp. 103–11.

Piet Mondrian, exhibition catalogue by Robert P. Welsh, Allan Frumkin Gallery, New York, 1964.

'Mondrian in London', reminiscences by Miriam Gabo, Naum Gabo, Barbara Hepworth, Ben Nicholson, Winifred Nicholson and Herbert

Read; introd. by Charles Harrison, *Studio International*, CLXXII (1966), pp. 285–92.

Piet Mondrian 1872–1944, exhibition catalogue by Robert P. Welsh; Art Gallery of Ontario, Toronto; Philadelphia Museum of Art, Philadelphia; Haags Gemeentemuseum, The Hague; 1966.

Robert Rosenblum, 'Mondrian and Romanticism', *Art News*, LXIV/10 (1966), pp. 33–7, 69–70.

Michel Seuphor, 'Mondrian et la pensée de Schoenmaekers', *Werk*, LIII (1966), pp. 362–3.

Robert P. Welsh, 'Landscape into Music: Mondrian's New York Period', *Arts*, XL/4 (1966), pp. 33–9.

Cor Blok, *Mondriaan in de collectie van het Haags Gemeentemuseum* (The Hague, 1968).

Frank Elgar, *Mondrian* (London, 1968).

Anthony Hill, 'Art and Mathesis: Mondrian's Structures', *Leonardo*, I (1968), pp. 233–42.

H. L. C. Jaffé, 'Een gedateerde plafondschildering door Piet Mondriaan', *Oud Holland*, LXXXIII (1968), pp. 229–38.

L. J. F. Wijsenbeek, *Piet Mondrian* (New York, 1968).

Mondrian, exhibition catalogue, with text by Michael Seuphor, Orangerie, Paris, 1969.

Piet Mondrian and The Hague School of Landscape Painting, exhibition catalogue, with texts by Nancy E. Dillow and Robert P. Welsh; Norman Mackenzie Art Gallery, Regina; Edmonton Art Gallery, Edmonton; 1969.

Marcelin Pleynet, 'Mondrian vingt-cinq ans après', *Art International*, XIII (1969), pp. 23–6, 31–3, 57–8.

Robert P. Welsh and J. M. Joosten, *Two Mondrian Sketchbooks 1912–1914* (Amsterdam, 1969).

III. Publications since 1969.

H. L. C. Jaffé, *Piet Mondrian* (New York, 1970).

Mondrian: The Process Works, exhibition catalogue, with texts by Harry Holtzman and Piet Mondrian; Pace Gallery, New York, 1970.

Virginia Pitts Rambert, *Mondrian, America and American Painting* (New York, 1970).

Piet Mondrian 1872–1944: Centennial Exhibition, exhibition catalogue, with texts by L. J. F. Wijsenbeek, Robert P. Welsh, Joop Joosten, Nelly van Doesburg, Max Bill and Margit Rowell; Solomon R. Guggenheim Museum, New York, 1971.

Barbara Rose, 'Mondrian in New York', *Artforum*, X/4 (1971–2), pp. 54–63.

William Seitz, 'Mondrian and the Issue of Relationships', *Artforum*, X/6 (1971–2), pp. 70–75.

Joop M. Joosten, 'Abstraction and Compositional Innovation', *Artforum*, XI/8 (1972–3), pp. 55–9.

Robert P. Welsh, 'Piet Mondrian: The Subject-Matter of Abstraction', *Artforum*, XI/8 (1972–3), pp. 50–53.

Alfred Roth, *Begegnung mit Pionieren. Le Corbusier, Piet Mondrian, Adolf Loos, Josef Hoffmann, Auguste Perret, Henry van de Velde* (Basle and Stuttgart, 1973), pp. 125–95.

Robert P. Welsh, 'The Portrait Art of Mondrian', *Album Amicorum J. G. van Gelder* (The Hague, 1973), pp. 356–60.

Cor Blok, *Piet Mondriaan. Een catalogus van zijn werk in Nederlands openbaar bezit* (Amsterdam, 1974).

Mondrian: Paintings, Drawings, Constructions, Documents, exhibition catalogue, with a text by Harry Holtzman; Sidney Janis Gallery, New York, 1974.

Maria Grazia Ottolenghi, *L'Opera completa di Mondrian* (Milan, 1974).

Joseph Masheck, 'Mondrian the New Yorker', *Artforum*, XIII/2 (1974–5), pp. 58–65.

Peter Gay, *Art and Act: On Causes in History – Manet, Gropius, Mondrian* (New York, 1976), pp. 175–226.

Gérard Sondag, 'Couleur/non-couleur dans la peinture de Mondrian', *Critica d'arte*, XIL (1976), pp. 47–56.

Joop Joosten, 'Grenzen van Mondriaan', *Kunstschrift*, XXI (1977), pp. 182–6.

Robert P. Welsh, *Piet Mondrian's Early Career: The 'Naturalistic' Periods* (New York, 1977) [dissertation 1965]

– 'The Place of "Composition 12 with Small Blue Square" in the Art of Piet Mondrian', *Bulletin of the National Gallery of Art of Canada*, XXIX (1977), pp. 3–32.

Carel Blotkamp, 'Mondriaan als literator', *Maatstaf*, XXVI/4 (1978), pp. 1–24.

Kermit S. Champa, 'Piet Mondrian's Painting Number II: Composition with Grey and Black', *Arts Magazine*, LII/2 (1978), pp. 86–8.

Meyer Schapiro, 'Mondrian, Order and Randomness in Abstract Painting', in *Selected Papers: Modern Art, 19th and 20th Centuries* (New York, 1978), pp. 233–61.

Tim Threllfall, 'Piet Mondrian: An Untitled and Unknown Drawing circa 1918', *Art History*, I (1978), pp. 229–35.

Nancy Joslin Troy, 'Piet Mondrian's Atelier', *Arts Magazine*, LII/4 (1978), pp. 82–7.

Carel Blotkamp, 'Mondrian's First Diamond Compositions', *Artforum*, XVIII/4 (1979), pp. 33–9.

Herbert Henkels, *Mondriaan in Winterswijk: een essay over de jeugd van Mondriaan, z'n vader en z'n oom* (The Hague, 1979).

Mondrian and Neo-plasticism in America, exhibition catalogue by Nancy J. Troy; Yale University Art Gallery, New Haven, 1979.

Mondrian: The Diamond Compositions, exhibition catalogue by E. A. Carmean Jr., National Gallery of Art, Washington, DC, 1979.

Paul F. Sanders, 'Herinneringen aan Piet Mondriaan', *Maatstaf*, XXVII/12 (1979), pp. 1–7.

Clara Weyergraf, *Piet Mondrian und Theo van Doesburg. Deutung von Theorie und Werk* (Munich, 1979).

Mondrian and The Hague School, exhibition catalogue, with texts by J. Sillevis and Herbert Henkels; Whitworth Art Gallery, Manchester, 1980.

Nancy J. Troy, 'Mondrian's Designs for the Salon de Madame B . . . à Dresden', *Art Bulletin*, LXII (1980), pp. 640–7.

Mondrian: Drawings, Watercolours, New York Paintings, exhibition catalogue, with texts by Herbert Henkels, Harry Holtzman, Robert Welsh, Joop Joosten and Karin von Maur; Staatsgalerie, Stuttgart; Haags Gemeentemuseum, The Hague; Baltimore Museum of Art, Baltimore; 1980–81.

Carel Blotkamp, 'De tekeningen van Mondriaan', *De Revisor*, VIII/3 (1981), pp. 36–9.

Yve-Alain Bois, 'Mondrian, Draftsman', *Art in America*, LXIX/8 (1981), pp. 94–113.

– 'Mondrian et la théorie de l'architecture', *Revue de l'art*, 53 (1981), pp. 39–52.

Els Hoek, 'De Passiebloem. Een dateringsprobleem bij Mondriaan', *Metropolis M*, III/2 (1981), pp. 31–40.

Carel Blotkamp, 'Mondriaan – architectuur', *Wonen-TABK*, 4/5 (1982), pp. 12–51.

Els Hoek, 'Piet Mondriaan', in Carel Blotkamp et al., *De beginjaren van De Stijl 1917–1922* (Utrecht, 1982), pp. 47–82; English trans. as *De Stijl: The Formative Years, 1917–1922* (Cambridge, MA, and London, 1986), pp. 39–75.

Yve-Alain Bois, 'Mondrian en France, sa collaboration à "Vouloir", sa correspondance avec Del Marle', *Bulletin de la Société de l'histoire de l'art français* (1983), pp. 281–94.

Jean-Claude Lebensztejn, 'Mondrian: la fin de l'art', *Critique* (1983), pp. 893–912.

Yve-Alain Bois, *Arthur Lehning en Mondriaan. Hun vriendschap en correspondentie* (Amsterdam, 1984).

Piet Mondrian: The Wall Works, 1943–44, exhibition catalogue, text by Harry Holtzman; Carpenter & Hochman Gallery, New York, 1984.

Yve-Alain Bois, ' "New York City I", 1942, de Piet Mondrian', *Cahiers du Musée national d'art moderne*, 15 (1985), pp. 60–85.

Kermit Swiler Champa, *Mondrian Studies* (Chicago and London, 1985).

Gregory Schufreider, 'Overpowering the Center: Three Compositions by Mondrian', *Journal of Aesthetics and Art Criticism*, XLIV (1985), pp. 13–28.

Beat Wismer, *Mondrians ästhetische Utopie* (Baden, 1985).

H. L. C. Jaffé, 'Een preekstoel naar ontwerp van Piet Mondriaan', *Nederlands Kunsthistorisch Jaarboek*, XXXI (Haarlem, 1981), pp. 533–43.

Pieter J. van den Berg, 'Mondriaan, wat we niet op zijn schilderijen zien. Een psychoanalytische visie', *Kunstlicht*, 19 (1986), pp. 15–30.

Carel Blotkamp, 'Ceramiek met een décor van Piet Mondriaan', *Antiek*, XXI (1986), pp. 287–90.

Nancy Troy, 'To Be Continued: A Note on Some Recent Mondrians', *October* (1985), pp. 75–80.

Jean Guiraud, 'Etudes sur Mondrian. Première partie: les facteurs photochromatiques', *La part de l'oeuil*, II (1986), pp. 33–66.

Jacques Guillerme, 'Timides apostilles aux essais de Jean Guiraud', *La part de l'oeuil*, II (1986), pp. 67–70.

Herbert Henkels, ed., *Piet Mondriaan. Gedurende een wandeling van buiten naar de stad* (The Hague, 1986).

Carel Blotkamp, *Mondriaan in Detail* (Utrecht, 1987).

Yve-Alain Bois, 'Le Néo-plasticisme', *La part de l'oeuil*, III (1987), pp. 183–9.

Mondrian: From Figuration to Abstraction, exhibition catalogue by Herbert Henkels; Seibu Museum of Art, Tokyo; Miyagi Museum of Art; Museum of Modern Art, Shiga; Fukuoka Art Museum; Haags Gemeentemuseum, The Hague; 1987–8.

Cees Boekraad and Rob de Graaf, 'Mondriaan maquette. Nieuw onderzoek naar het atelier aan de Rue du Départ', *Archis*, 5 (1988), pp. 28–37.

Herbert Henkels, ed., *'t 'Is alles een groote eenheid, Bert. Piet Mondriaan, Albert van den Briel en hun vriendschap* (Haarlem, 1988).

Lien Heyting, 'Mondriaan in Laren', *NRC-Handelsblad* (20 and 27 May, 10 and 17 June 1988).

Mondriaan/Aanwinsten/Acquisitions/1979–1988, exhibition catalogue by Herbert Henkels; Haags Gemeentemuseum, The Hague, 1988.

Mondrian in the Sidney Janis Family Collections, New York, exhibition catalogue, with texts by Sidney Janis and Harriet Janis; Haags Gemeentemuseum, The Hague, 1988.

Coos Versteeg and Herbert Henkels, *Mondriaan. Een leven in maat en ritme* (The Hague, 1988).

J. M. de Jong, 'Piet Mondriaan en de gereformeerde kerk van Amsterdam', *Jong Holland*, V/3 (1989), pp. 20–23.

Aleid Loosjes-Terpstra, 'Mondriaan in een donkere spiegel', *Jong Holland*, V/5 (1989), pp. 4–15.

Eric Melse, 'Blauwen van Piet Mondriaan. Kleurbeoordeling van Compositie met rood, geel en blauw in het Stedelijk Museum te Amsterdam', *Kunstlicht*, X/4 (1989), pp. 16–22.

Piet Mondriaan. Een jaar in Brabant, 1904–1905, exhibition catalogue by Ch. C. M. de Mooij and M. S. Trappeniers; Noordbrabants Museum, Den Bosch, 1989–90.

'Incontrando Mondrian'. Ritratto di un'epoca in 80 fotografie, exhibition catalogue; Rabo Bank, Milan, 1990.

Jacques Meuris, *Mondrian* (Paris, 1991).

Ina Rike, *Piet Mondrian's Nieuwe Beelding in English* (Amsterdam, 1991).

David Shapiro, *Mondrian: Flowers* (New York, 1991).

John Milner, *Mondrian* (London, 1992)

Martin S. James, 'Piet Mondrians Theorie der Geschlechterrollen', in Susanne Deicher, ed., *Die weibliche und die männliche Linie, Das imaginäre Geschlecht der modernen Kunst von Klimt bis Mondrian* (Berlin, 1993), pp. 201–20.

Joop M. Joosten, 'De sporen van het penseel. Textuur in het werk van Mondriaan', *Jong Holland*, IX/4 (1993), pp. 44–9.

Mondrian in New York, exhibition catalogue, with texts by Herbert Henkels and Christian Derouet; Galerie Tokoro, Tokyo, 1993.

Mondriaan aan de Amstel 1892–1912, exhibition catalogue by Robert Welsh, Boudewijn Bakker and Marty Bax; Gemeentearchief, Amsterdam, 1994.

IV. Context.

Charles Biederman, *Art as the Evolution of Visual Knowledge* (Red Wing, MN, 1948).

Michel Seuphor, *L'art abstrait, ses origines, ses premiers maîtres* (Paris, 1949).

De Stijl, exhibition catalogue, Stedelijk Museum, Amsterdam, 1951.

Bruno Zevi, *Poetica dell'architettura neoplastica* (Milan, 1953).

Bettina Polak, *Het fin-de-siècle in de Nederlandse schilderkunst. De symbolistische beweging 1890–1900* (The Hague, 1955).

H.L.C. Jaffé, *De Stijl 1917–1931: The Dutch Contribution to Modern Art* (Amsterdam, 1956).

A. B. Loosjes-Terpstra, *Moderne kunst in Nederland 1900–1914* (Utrecht, 1959).

Mondrian, De Stijl and their Impact, exhibition catalogue, text by A. M. Hammacher, Marlborough-Gerson Gallery, New York, 1964.

H.L.C. Jaffé, *De Stijl* (London, 1970).

Museumjournaal, XVII 6/(1972), special issue on the occasion of the exhibition *Het Nieuwe Wereldbeeld. Het begin van de abstracte kunst in Nederland 1910–1925*, Centraal Museum, Utrecht.

Cor Blok, *Geschichte der abstrakten Kunst 1900–1960* (Cologne, 1975).

Kunstenaren der idee. Symbolistische tendenzen in Nederland ca. 1880–1930, exhibition catalogue, Haags Gemeentemuseum, The Hague; Groningen Museum, Groningen; 1978–9.

Abstraction: Towards a New Art. Painting 1910–1920, exhibition catalogue, Tate Gallery, London, 1980.

Towards a New Art: Essays on the Background to Abstract Art, 1910–1920 (London, 1980).

Van Gogh bis Cobra. Holländische Malerei 1880–1950, exhibition catalogue, Württembergischer Kunstverein, Stuttgart; Central Museum, Utrecht; 1980–81.

De Stijl: 1917–1931. Visions of Utopia, exhibition catalogue, ed. Mildred Friedman; Walker Art Center, Minneapolis; Hirschhorn Museum and Sculpture Garden, Smithsonian Institution, Washington, D.C.; Stedelijk Museum, Amsterdam; Rijksmuseum Kröller-Müller, Otterlo, 1982.

Nancy J., Troy, *The De Stijl Environment* (Cambridge, MA, 1983).

Herbert Henkels, *La vibration des couleurs. Mondriaan, Sluyters, Gestel* (The Hague, 1985).

Bruno Bois, Yve-Alain and Reichlin, eds, *De Stijl et l'architecture en France* (Liège and Brussels, 1985).

Carel Blotkamp et al., *De Stijl: The Formative Years, 1917–1922* (Cambridge, 1986).

The Spiritual in Art: Abstract Painting 1890–1985, exhibition catalogue, ed. Maurice Tuchman; Los Angeles County Museum of Art; Museum of Contemporary Art, Chicago; Haags Gemeentemuseum, The Hague; 1986–7.

Christopher Green, *Cubism and its Enemies* (New Haven, 1987).

Kenneth E. Silver, *Esprit de Corps: The Art of the Parisian Avant-garde and the First World War, 1914–1925*, (Princeton, 1989).

Mondrian e De Stijl, L'ideale moderno, exhibition catalogue, ed. Germano Celant and Michael Govan, Fondazione Girogio Cini, Venice, 1990.

The Age of Van Gogh: Dutch Painting 1880–1895, exhibition catalogue, ed. Richard Bionda and Carel Blotkamp; Burrell Collection, Glasgow Museum & Art Galleries, Glasgow; Rijksmuseum Vincent van Gogh, Amsterdam; 1990–91.

Mark A. Cheetham, *The Rhetoric of Purity: Essentialist Theory and the Advent of Abstract Painting* (Cambridge, 1991).

Paul Overy, *De Stijl* (London, 1991).

List of Illustrations

Measurements in the captions and in the list of illustrations are given in centimetres, and have been rounded out to the nearest half-centimetre. This is necessary because many of Mondrian's canvases and drawings are not perfect squares or rectangles.

Frontispiece: A photograph by Arnold Newman of Mondrian in his studio, 353 East 56th Street, New York, 1942. Photo: © Arnold Newman.

1 Piet Mondrian (*left*) and Lodewijk Schelfhout in the latter's studio at 26 rue du Départ, Paris, 1912. Photo: Rijksbureau voor Kunsthistorische Documentatie, The Hague.

2 Piet Mondrian in his studio, 10 Rembrandtplein, Amsterdam, 1905.

3 *Still-life with Herring*, 1893, oil on canvas mounted on cardboard, 66.5 x 74.5. Stedelijk Museum, Amsterdam.

4 Illustration from D. P. Rossouw, *Medeërfgenamen van Christus (Joint Heirs of Christ)*, Amsterdam, 1896–7.

5 Isaac Israëls, *Two Women on a Canal in Amsterdam, c.* 1894, pastel and crayon on paper, 17.5 x 25. Van Voorst van Beest Gallery, The Hague.

6 *Women and Child in front of a Farm, c.* 1900, oil on canvas, two panels, 33 x 22 and 33.5 x 22.5. Haags Gemeentemuseum, The Hague.

7 *The Lappenbrink, c.* 1900, oil on canvas mounted on cardboard. Private collection.

8 *View of Winterswijk, c.* 1898, gouache on paper, 52 x 63.5. Private collection.

9 Jan Voerman, *Cattle by the River IJssel, near Hattem, c.* 1895, watercolour and gouache on paper, 63 x 82.5. Private collection.

10 *Village Church, c.* 1898, gouache on paper, 75 x 50. Private collection.

11 *Farmyard at Winterswijk, c.* 1900, crayon on paper. Private collection. Photo: Rijksbureau voor Kunsthistorische Documentatie, The Hague.

12 *Spring Idyll*, 1900, oil on canvas, 75 x 64. Private collection.

13 Jan Sluyters, *Spanish Dancer*, 1906, oil on canvas, 95 x 107. Private collection.

14 *Calves in a Field bordered by Willow Trees, c.* 1904, oil on canvas mounted on cardboard, 31.5 x 39. Private collection. Photo: Christie's, Amsterdam.

15 *Mill by the Water, c.* 1905, oil on canvas mounted on cardboard, 30 x 38. Museum of Modern Art, New York, purchase.

16 Mondrian's application form for membership of the Theosophical Society, dated 14 May 1909.

17 Helena Petrovna Blavatsky, *c.* 1888. Photograph from Mondrian's estate.

18 *Devotion*, 1908, oil on canvas, 94 x 61. Haags Gemeentemuseum, The Hague.

19 *Passion-flower, c.* 1908, watercolour on paper, 72.5 x 47.5. Haags Gemeentemuseum, The Hague.

20 *Woman at Prayer, c.* 1908, crayon on paper, 82 x 60. Private collection.

21 Ferdinand Hodler, *Communion with the Infinite*, 1892, oil and tempera on canvas, 159 x 97. Kunstmuseum, Basel.

22 *Two Women in the Woods, c.* 1908, oil on canvas mounted on cardboard, 27.5 x 38. Musée Départemental Maurice Denis, Le Prieuré, St-Germain-en-Laye.

23 *Woods near Oele*, 1908, oil on canvas, 128 x 158. Haags Gemeentemuseum, The Hague.

24 J.L.M. Lauweriks, cover for the journal *Theosophia*, 1896.

25 H.J.M. Walenkamp, *Enlightened Figure, c.* 1895, watercolour on paper, 61.5 x 44. Nederlands Architectuurinstituut, Rotterdam.

26 Anonymous, *Musical Forms (Gounod's Faust)*, illustration from A. Besant and C. W. Leadbeater, *Thought Forms*, London, 1905.

27 *Self Portrait, c.* 1909, charcoal on paper, 30 x 25.5. Haags Gemeentemuseum, The Hague.

28 *Portrait of a Man, c.* 1909, charcoal on paper, 72.5 x 51. Private collection. Photo: Allen Finkelman, courtesy Sidney Janis Gallery, New York.

29 *Dying Chrysanthemum*, 1908, oil on canvas, 84.5 x 54. Haags Gemeentemuseum, The Hague.

30 *Tiger-lilies*, 1909, watercolour on paper, 39 x 44. Private collection.

31 *Cat's-tail, c.* 1909, charcoal on paper, 46 x 69. Haags Gemeentemuseum, The Hague.

32 *Haystacks*, 1908, oil on canvas mounted on cardboard, 34 x 44. Private collection.

33 *Haystacks*, 1908, oil on canvas mounted on cardboard, 30.5 x 43. Private collection. Courtesy Sidney Janis Gallery, New York.

34 *Haystacks*, 1908, oil on canvas mounted on cardboard, 34 x 44. Private collection.

35 Jan Toorop. *Trust in God*, 1907, crayon on paper, 55.5 x 42. Museum Boymans-van Beuningen, Rotterdam. Photo: Frequin-Photo.

36 *Lighthouse in Westkapelle*, 1909, oil on canvas, 39 x 29. Galleria d'Arte Moderna, Milan. Photo: Foto Saporetti.

37 *Dune II*, 1909, oil on canvas, 37.5 x 46.5. Haags Gemeentemuseum, The Hague.

38 *Sea after Sunset*, 1909, oil on cardboard, 63.5 x 76. Haags Gemeentemuseum, The Hague.

39 *Church in Domburg*, 1911, oil on canvas, 114 x 75. Haags Gemeentemuseum, The Hague.

40 *Evolution*, 1911, oil on canvas, triptych, 178 x 84, 184 x 87, 178 x 84. Haags Gemeentemuseum, The Hague.

41 *Windmill*, 1911, oil on canvas, 150 x 86. Haags Gemeentemuseum, The Hague.

42 Installation photograph of works by Braque and Picasso at the 'Moderne Kunst Kring' exhibition, Amsterdam, 1911. Photo: Rijksbureau voor Kunsthistorische Documentatie, The Hague.

43 *Mertites, portrayed twice, with the young scribe and priest Chennoe*, Sakkara, 5th Dynasty, *c.* 2400 BC, painted limestone, 69 x 55 x 34. Rijksmuseum van Oudheden, Leiden.

44 Copy by Piet Mondrian after Enguerrand Quarton, *Pietà of Avignon*, 1913, oil on canvas, 105 x 140. Haags Gemeentemuseum, The Hague.

45 *Still-life with Ginger-Jar II*, 1912, oil on canvas, 91.5 x 120. Haags Gemeentemuseum, The Hague.

46 *Nude*, 1912, oil on canvas, 140 x 98. Haags Gemeentemuseum, The Hague.

47 *Nude*, 1912, pencil on paper, 21 x 13.5. Rijksbureau voor Kunsthistorische Documentatie, The Hague.

48 Lodewijk Schelfhout, *Still-life with Jug*, 1912, pencil on paper, 21 x 13.5. Rijksbureau voor Kunsthistorische Documentatie, The Hague.

49 *Woman*, 1913, oil on canvas, 76 x 57.5, Rijksmuseum Kröller-Müller, Otterlo. Photo: Tom Haartsen.

107 The front wall of Mondrian's studio, 5 rue de Coulmiers, Paris, in a provisional reconstruction by the author, 1994.

108 A photograph by Alfred Roth of Mondrian's studio, top floor, 26 rue du Départ, Paris, 1928.

109 Mondrian in his studio, 26 rue du Départ, Paris, c. 1923, reproduced from De Stijl no. VI/6–7, 1924.

110 Mondrian's studio, 26 rue du Départ, Paris, 1926.

111 Photomontage of Mondrian in his studio, 26 rue du Départ, Paris, c. 1926, as published in De Telegraaf, 12 September 1926.

112 Floor-plan of Mondrian's studio, 26 rue du Départ, Paris, c. 1926; a reconstruction by Frans Postma, Twan Jütte and Luc Veeger, 1988.

113 Mondrian's studio, 26 rue du Départ, Paris, c. 1927.

114 A photograph by Michel Seuphor of Mondrian's studio, 26 rue du Départ, Paris, c. 1930.

115 Exploded box-plan of the Salon for Ida Bienert, 1926. Gouache and ink on paper, 75 x 75. Kupferstichkabinett, Staatliche Kunstsammlungen, Dresden. Photo: Herbert Boswank.

116 Isometric perspective of the Salon for Ida Bienert, 1926. Gouache and ink on paper, 37.5 x 57. Kupferstichkabinett, Staatliche Kunstsammlungen Dresden.

117 El Lissitzky, Kabinett der Abstrakten, 1926, Landesmuseum, Hanover; photograph, c.1930, showing, on the right, two paintings by Mondrian, 1923 (upper), 1929 (lower).

118 Mondrian's stage-set for Michel Seuphor's L'Ephémère est éternel, 1926, paint on canvas, cardboard and wood. Lost.

119 Mondrian's last studio, 15 East 59th Street, New York, 1944. Photo: Fritz Glarner, courtesy Sidney Janis Gallery, New York.

120 Luigi Russolo (left) and an assistant with 'bruiteurs', c. 1920.

121 Mondrian and Gwen Lux playing jazz records on the gramophone in his studio, 26 rue du Départ, Paris, 1935.

122 Pablo Picasso, The Italian Woman, 1917, oil on canvas, 149.5 x 101.5. E. G. Bührle Collection, Zurich. © DACS 1994.

123 Gino Severini, Motherhood, 1916, oil on canvas, 92 x 65. Museo dell'Academia Etrusca, Cortona. © DACS 1994.

124 Composition with Red, Yellow, Blue and Black, 1919, oil on canvas, 90 x 91. Galleria Nazionale d'Arte Moderna, Rome.

125 Composition with Large Blue Plane, 1921, oil on canvas, 60.5 x 50. Dallas Museum of Art Foundation of the Arts; Gift of Mrs James A. Clark.

126 Composition with Red, Yellow and Blue, 1920, oil on canvas, 67 x 57.5. Wilhelm-Hack-Museum, Ludwigshafen.

127 Composition with Red, Yellow and Blue, 1920, oil on canvas, 51.5 x 61. Stedelijk Museum, Amsterdam.

128 Installation photograph of the exhibition 'Maîtres du Cubisme', Galerie de L'Effort Moderne, Paris, 1921.

129 Composition with Red, Yellow and Blue, 1921, oil on canvas, 103 x 100. Haags Gemeentemuseum, The Hague.

130 Composition with Red, Yellow and Blue, 1922, oil on canvas, 53 x 54. Staatsgalerie, Stuttgart.

131 Composition with Red, Yellow and Blue, 1921, oil on canvas, diagonal 84.5. Art Institute of Chicago, Gift of Edgar Kaufmann, Jr.

132 Letter from Mondrian to Rudolf Steiner, dated 25 February 1921.

133 Blue Lily, c. 1924, watercolour and gouache on paper, 26.5 x 17.5. Photo courtesy Sidney Janis Gallery, New York.

134 Theo van Doesburg, Sketch for diamond-shape composition, 1924, gouache on paper, 12 x 12. Rijksdienst Beeldende Kunst, The Hague.

135 Theo van Doesburg, Contra-Composition IV, 1924, oil on canvas, 51.5 x 50.5. Private collection.

136 Composition with Red, Yellow and Blue, 1924, oil on canvas, diagonal 143. National Gallery of Art, Washington, DC, Gift of Herbert and Nannette Rothschild.

137 The Composition with Red, Yellow and Blue, (illus. 136), in its original state, c. 1922.

138 Composition with Red, Yellow and Blue, 1925, oil on canvas, diagonal 109. Private collection. Photo: Christie's, New York.

139 Theo van Doesburg, Contra-Composition VII, 1924, oil on canvas, diagonal 63.5. Private collection.

140 A photograph by Hannah Höch of Mondrian and Til Brugman in Mondrian's studio, 26 rue du Départ, Paris, 1927.

141 Theo van Doesburg, Contra-Composition V, 1924, in its original diamond-shape position, oil on canvas, diagonal 142. Stedelijk Museum, Amsterdam.

142 Theo van Doesburg, Contra-Composition XIV, 1925, oil on canvas, 50 x 50. Private collection.

143 Theo van Doesburg, Contra-Composition VIII, 1924, oil on canvas, diagonal 142.5. Art Institute of Chicago, Gift of Peggy Guggenheim.

144 Sketch of diamond-shape compositions, c. 1925, pencil on paper, 27.5 x 14. Private collection.

145 Composition, 1926, oil on canvas, diagonal 113.5. Museum of Modern Art, New York, Katherine S. Dreier Bequest.

146 Composition with Grey and Black, 1925, oil on canvas, 50 x 50. Kunstmuseum, Bern, Professor Max Huggler-Stiftung.

147 Composition with Blue and Yellow, 1925, oil on canvas, diagonal 112. Kunsthaus, Zurich, Vereinigung Zürcher Kunstfreunde.

148 Composition with Blue, 1926, oil on canvas, diagonal 84.5. Philadelphia Museum of Art, Philadelphia, A. E. Gallatin collection. Photo: Graydon Wood.

149 Composition with Yellow, 1930, oil on canvas, 46 x 46.5. Kunstsammlung Nordrhein-Westfalen, Düsseldorf.

150 Jean Gorin, Composition no. 10, 1926, oil on cardboard, diagonal 70.5. Private collection.

151 Installation photograph of Picasso's The Studio (1927–8), flanked by paintings by Mondrian, Miró and Hélion, at an exhibition of the Renaissance Society of the University of Chicago, 1935.

152 Installation photograph of Mondrian's studio, 26 rue du Départ, Paris, 1929, including four paintings and Mondrian's 1926 stage set for Michel Seuphor's L'Ephémère est éternel.

153 Installation photograph of the 'De Onafhankelijken' exhibition at the Stedelijk Museum, Amsterdam, 1926, including paintings by Smits, Servranckx, Huszár and Mondrian.

154 Composition with Red, Yellow and Blue, 1930, oil on canvas, 45 x 45. Kunsthaus, Zurich. Donated by Alfred Roth.

155 Composition with Grey and Red, 1932, oil on canvas, 50 x 50. Private collection. Photo: Christie's, London.

156 Composition with Two Lines, 1931, oil on canvas, diagonal 114. Stedelijk Museum, Amsterdam.

157 Composition with Black Lines, 1930, oil on canvas, 50.5 x 50.5. Stedelijk van Abbe Museum, Eindhoven. Photo: M. Coppens.

158 Composition with Yellow Lines, 1933, oil on canvas, diagonal 113. Haags Gemeentemuseum, The Hague.

159 Composition with Yellow and Grey, 1932, oil on canvas, 50 x 50. Private collection. Photo: LAC.

160 Marlow Moss, Composition, 1931, oil on canvas. Location unknown.

161 Composition with Black Lines, 1933, oil on canvas, 60 x 60.5. Dallas Museum of Art, anonymous loan.

162 Marlow Moss, Composition, 1933, oil on canvas. Location unknown.

163 Composition with Blue and Yellow, 1935, oil on canvas, 72.5 x 69. Hirshhorn Museum and Sculpture Garden (Smithsonian Institution), Washington, DC. Gift of the Joseph H. Hirshhorn Foundation, 1972. Photo: Lee Stalsworth.

164 Composition with Blue, 1937, oil on canvas, 80 x 77. Haags Gemeentemuseum, The Hague.

165 Composition with Blue, 1936, oil on canvas, 121.5 x 59. Kunstsammlung Nordrhein-Westfalen, Düsseldorf.

166 Jean Gorin, Composition no. 28, 1935, oil on canvas, 49 x 115. Private collection.

167 Mondrian in his studio, 26 rue du Départ, Paris, 1933.

168 Painting by Mondrian in the 'Entartete Kunst' exhibition, Munich, 1937.

169 Composition with Red, Yellow and Blue, 1935–42, oil on canvas, 108 x 58.5. Private collection. Photo: Christie's, New York.

170 *Composition with Red, Yellow and Blue*, 1939–42, oil on canvas, 79.5 x 71. Private collection.

171 *Composition with Red*, 1939, oil on canvas, 105 x 102.5. Museum of Modern Art, Venice. Photo: David Heald.

172 *Composition with Red, Yellow and Blue*, 1939–42, oil on canvas, 79.5 x 74. Phillips Collection, Washington, DC. Bequest of Katherine S. Dreier.

173 *New York – New York City*, 1941–2, oil and charcoal on canvas with coloured tape, 117 x 110.5, before a 1977 restoration. Fundación Colección Thyssen-Bornemisza, Madrid.

174 *New York*, 1941–2, oil on canvas, 95.5 x 92. Private collection.

175 *New York City I*, 1942, oil on canvas, 119.5 x 114. Musée Nationale d'Art Moderne, Paris. Photo: Service Documentation Photographique, Musée Nationale d'Art Moderne, Paris.

176 *New York City II*, 1941–2, oil on canvas with coloured tape, 119.5 x 114.5. Kunstsammlung Nordrhein-Westfalen, Düsseldorf.

177 *New York City III*, 1942, oil on canvas with coloured tape, 114.5 x 99. Photo: Allan Finkelman, courtesy Sidney Janis Gallery, New York.

178 *Victory Boogie Woogie*, 1942–4, oil on canvas with scotch tape, diagonal 178.5. Private collection. Photo: Jim Strong.

179 *Broadway Boogie Woogie*, 1942–3, oil on canvas, 127 x 127. Museum of Modern Art, New York, Anonymous gift.

Index

Page numbers *in italics* indicate an illustration